⚭ LADDER TO THE CLOUDS ⚭

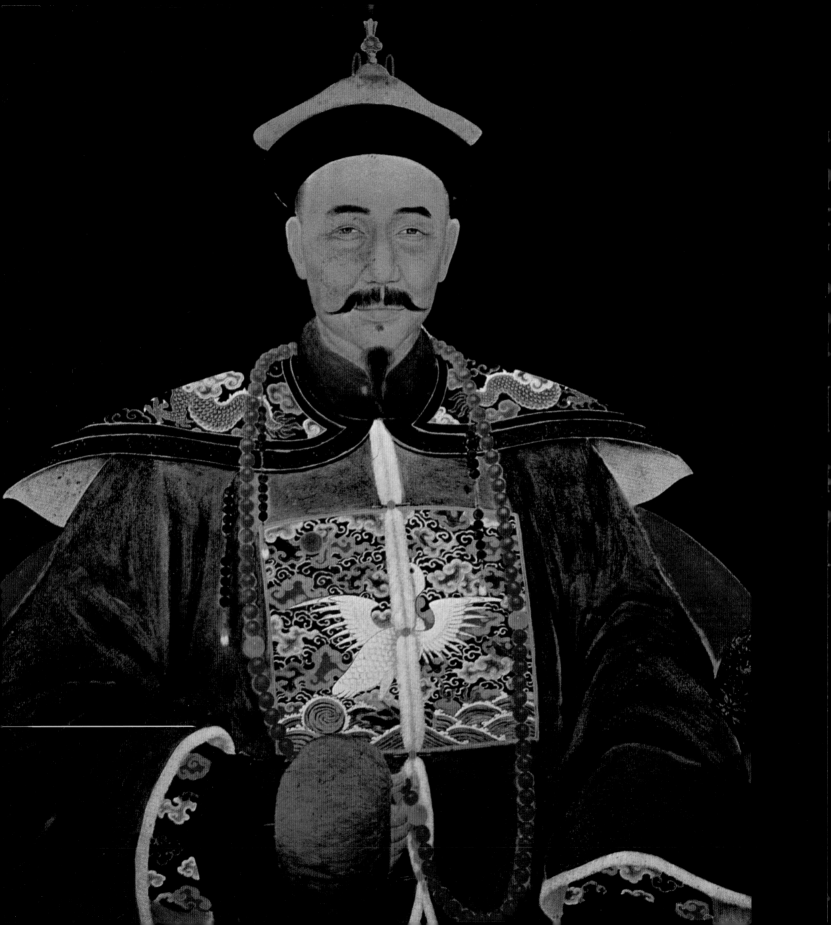

LADDER TO THE CLOUDS

Intrigue and Tradition in Chinese Rank

Beverley Jackson
and David Hugus, Ph.D.

TEN SPEED PRESS
Berkeley, California

 TEN SPEED PRESS

PO Box 7123

Berkeley, California 94707

Ten Speed titles are distributed in Canada by Ten Speed, Canada, in the United Kingdom and Europe by Airlift Books, in South Africa by Real Books, in Australia by Simon & Schuster, Australia, in New Zealand by Southern Publishers Group, and in Southeast Asia by Berkeley Books.

 Frontespiece: Magnificent portrait of P'an Ki-gua by Father Giuseppe Castaglione, an Italian Jesuit artist whose Chinese name was Lang Shih Ning. He reached Peking, 1715 and worked as a painter and architect at the imperial court for fifty years. (Courtesy of the Gotesborgs Stadmuseum, Gotesborg, Sweden)

Cover design, text design and composition by Brad Greene, Greene Design
Front cover, Peacock, early *Kangxi,* gold couching and silk embroidery, female.
(From a private collection, Larry Kunkel Photography)
Back cover, Tiger, mid-1600s, brocade, male. (David Hugus, photography by John Levin)
Printed in Singapore

Library of Congress Cataloging-in-Publication Data

Jackson, Beverley.
 Ladder to the clouds : intrigue and tradition in Chinese rank / by Beverley Jackson and David Hugus, Ph.D..
 p. cm.
 Includes bibliographical references and index.
 ISBN 0-580-08127-4
 1. Insignia—China. 2. China—Costume—History—Ming-ch'ing dynasty, 1368-1912. 3. China—Officials and employees. I. Title. II. Hugus, David.

 CR6020.A2 J33 1999
 929.9'0951'0903 21—dc21 99-042578
 CIP

First Printing, 1999
1 2 3 4 5 6 7 8 / 05 04 03 02 01 00 99

ACKNOWLEDGMENTS

FOR TAYLOR

My seven-year-old granddaughter—the best sales rep any author ever had. She not only checks the New York bookstores to see if they have Maw's book—she demands to know why it isn't in the window! and for Fernando Diaz-Plaja with thanks for his four wonderful words of advice. With love and thanks to my wonderful friend and editor Veronica Randall who gives me endless support, friendship, understanding, encouragement, advice and a beautiful book every time. Deepest gratitude to Dr. Raymond Lum of the Harvard-Yenching Library, who is always there for me with friendship and help on my Chinese projects. Special thanks for service beyond the call of friendship goes to Joan Ahrens; Diana and Tim Boyd-Wilson; Steve Boyiajian; Marie and Bob Carty; Douglas Chang; Anna Chi; Vince Comer; Suzanne Cuze; Shelley Davidson; Laure de Gramont; Mary Douglas; Anita and Yasu Eguchi; Kathleen Fetner; Natasha Fraser-Cavassoni; Eva Friden; Flavia and Barden Gale; Nancy Hugus; Dr. Lee Kavaljian; Joyce and Wing Mar; Jane McGowan; Jeffrey Moi; Jon Riis; Glenn Roberts; Virginia and Sandor Vanocur; Robert Walker; Dolores Wong; Athena Zonar.

◻ ◻ ◻

FOR NANCY RITZ HUGUS, WIFE, FRIEND, LOVER, COMPANION.

My greatest debt goes to the people listed in the bibliography whose intellectual efforts were necessary for mine to come into being. But special thanks are also due to Nancy Ritz Hugus for finding the best possible title for the book and enduring my less than perfect personality while it was written; to Ta and Karen Shiah who introduced me to real mandarin squares; to Gim Fong for quiet inspiration and subtle encouragement; to Beverley Jackson, Veronica Randall, and Phil Wood for the opportunity to get my ideas out of my head on onto paper; to the late Professor Schuyler V. R. Cammann who provided the intellectual and scholastic foundation for all subsequent study of mandarin squares. And to the following for their valuable individual contributions: Vincent Comer, Deanna Cross, Laura Einstein, Barden and Flavia Gale, John R. Finlay, Gim Fong, Hanni Forester, Dodi Fromson, Valery Garrett, Corrie and Elise Grové, Chris Hall, Shirley Z. Johnson, Anu Liivandi, Richard Mafong, Stephen Markbreiter, Tuyet Nguyet, Jon Eric Riis, Judith Rutherford, John Stuckley, John M. Weeks, and Linda Wrigglesworth.

CONTENTS

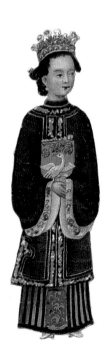

PART TWO *by David Hugus*

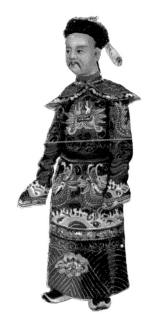

AUTHORS' PREFACE

For hundreds of years throughout China boys studied diligently, in hopes of passing the competitive state examinations. In many cases, the achievement of this goal took a lifetime. This system of examinations and resultant civil and military rank enabled the Chinese empire to maintain the highest possible standard of intelligence, ability and learning in their administrative personnel.

The examinations were supposedly an opportunity for the best in the land, rich or poor, to have an equal opportunity at participating in the administration of their country. However, it was usually only the wealthy families that could afford to give their sons a classical education. Poor boys could participate, but at great personal sacrifice for themselves and their families. Once they proved themselves worthy, they did indeed stand an equal chance of attaining rank. Some even rose to the very top. My tale of Yong Shang and Bao Gui has endeavored to illustrate this for the reader.

In addition to using the examinations to ensure a supply of highly trained candidates for the civil service, the provincial quotas for the *chin-shih* degree allowed a guarantee of nationally balanced participation. Several regions of China, such as Chekiang and Kiangu, were known for having a centuries-old high quality of scholarship, with fine libraries, teachers and schools. The candidates from these provinces in the southeast continually scored much higher than students from the western provinces such as Yunnan, Shansi and Szechwan.

Another important result of the traditional examination system was the adherence to a conservative classical Confucian curriculum that discouraged individual thinking. Free-thinking men were a threat to the rulers of China. There was no room for nonconformist ideas.

Westerners were not oblivious to the merits of the Chinese examination system. In fact, it influenced the British civil service exams. As Dr. Sun Yat-sen once explained, "The civil service examinations in Western countries are based on the English examinations. However, tracing the history of their examinations we find that they copied them from the Chinese examination system, which was the earliest and most elaborate in the world."

—*Beverley Jackson*

□ □ □

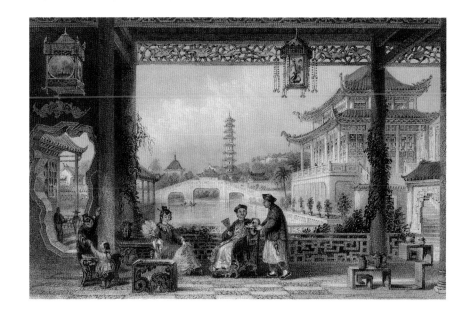

The goal for Part Two of the book is to provide the information necessary for your personal relationship with mandarin squares. To this end we have tried to arrange and organize the book for your easy reference. For those just interested in a general understanding of the subject, we have provided general Ming and Ch'ing summaries, a discussion of additional badges of rank, a dab of Chinese history, and some commentary on a few of the interesting controversies that surround this subject. For those interested in a more concentrated study, the sections on the identification of the birds and animals, Chinese iconography, the examination process and the salaries and positions commanded by mandarins should prove useful. For the serious collector or dealer, the chapter on the evolution of the Ch'ing Dynasty squares will hopefully be of benefit in your professional pursuits, protecting you from the vagaries of the marketplace.

But whatever your intent or needs, I hope that this book has served as an introduction to the subject of mandarin squares and provided a foundation for your own association with this fascinating and wonderful area of study. While this book brings together material from a variety of sources and has attempted to address more mandarin square topics than any previous effort, it is clearly impossible to anticipate the needs of all the readers. If you have a question, please contact me at DHugus@aol.com.

—*David Hugus*

∽∽ An English artist's rendering of the luxurious pavilion and gardens in a nineteenth-century mandarin's compound. (From the author's collection)

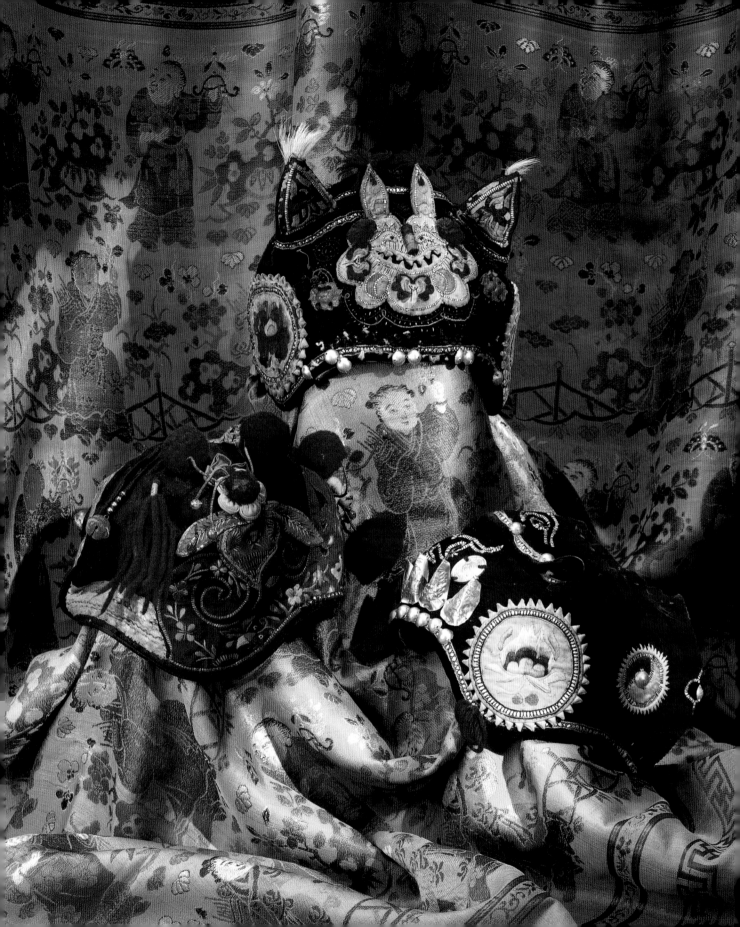

CHAPTER I

TRADITION DICTATES ALL IN THE LIFE OF A CHILD

Great panels of red silk hung like brilliant banners of birth, covering every window and door. Servants padded across polished ebony floors to the opulent chamber where mother and child would remain isolated for one month following the birth. Bearing tempting offerings of sugared fruits and nuts for the expectant mother, they left her presence as hastily as possible, carrying messages into other parts of the palatial compound. Yu Lian (Jade Lily) issued her orders with great drama, wildly flinging her slender arms encased in exquisitely embroidered silk sleeves, and stamping her tiny, tightly bound feet. She was the center of attention in her cloistered world now—and she intended to take advantage of it. "Within my beautiful body, the body of the favored concubine, grows the first son of the master. It will be a boy. And he will be my status, my power," she thought to herself, as a subtle smile slithered across her heavily made-up face.

Excitement and anticipation ran high throughout the hundred rooms of the vast estate. Had she not already joined her ancestors, the baby's maternal grandmother would, according to tradition, have made the layette. Now, sewing amahs labored long hours on the many delicate little items of clothing needed for the master's new child.

The cooks worked ceaselessly over hot coal stoves, striving to create dishes to tempt the appetite of the arrogant mother-to-be. Exquisite lacquered bowls filled

◎◎ *Opposite:* Three delightful examples of children's hats worn to protect the wearer from evil spirits. Tassels, tufted ears, and grinning faces were sewn by loving grandmothers to keep their little ones safe. (From the author's collection, Larry Kunkel Photography)

with red bean cake cooked in goose oil, lotus root simmered with pork preserves, soup made of the rarest bird nests brought from deep caves in southern China, the first asparagus of the season steamed with fresh scallops, smaller than the nail of your smallest finger, were offered—only to be sent flying across the room with an imperious sweep of her hand tipped with two-inch-long scarlet fingernails.

Far away in a mountainous region of Yunnan province, another mother prepared for the birth of her first child. With great effort she swept the hardened dirt floor of her hut and lined a basket with clean rags in which her baby would swing gently to sleep suspended by ropes from the roof beam. She hung worn pieces of cloth, loaned by kind neighbors, over her one window and the low door. She too would be confined inside this room with her baby for one month following the birth.

Outside above the door hung a bunch of strong-smelling talisman plants, mugwort, sprigs of garlic, wormweed, sagebrush, and leaves of sweet-flag. "He who hangs out no mugwort on the fifth day of the fifth moon will eat no new wheat," a neighbor had reminded her. These plants would also protect her baby from the insects

A young father proudly shows off his son. (From *In the Land of the Blue Gown* by Mrs. Archibald Little, T. Fisher Unwin, London, 1902)

of approaching summer. Lan Xiang (Fragrant Flower) would protect her son from all things evil. "My baby will be a son," she thought, smiling happily. "When the first month is up, I will rise with the sun to collect fresh dew for the little one. I will moisten a bit of ink with the first dew of the dawn and with that ink paint tiny dots on my new son's forehead to protect him from illness. I will love him and protect him with my life. And somehow, I will see that he is educated. My son will not plow fields in the mud as we do. My boy will be a scholar.

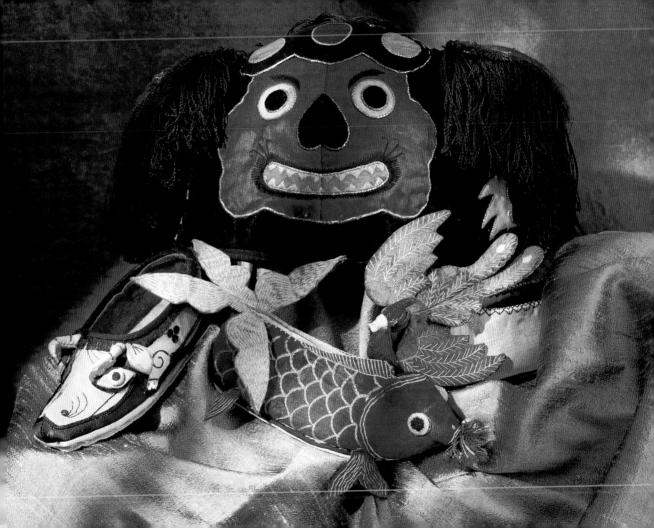

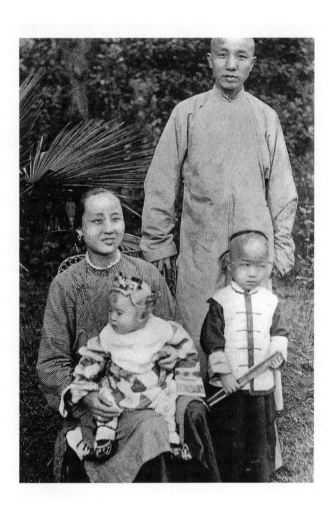

An early twentieth-century Chinese family. (From *The Uplift of China* by the Church Missionary Society, London, 1909)

This is but a dream now, but it will grow into a reality just as he grows within me now."

And so, in the month of the fifth moon, the Dragon Moon, two baby boys were born in China. In the splendid palace, a tiny baby elevated a mere concubine to the place of honor above the master's three wives. In a poor mountain hut, surrounded by tall pines in forests filled with wild azalea and the early berries of summer, another baby boy was born, this one into a world with little to offer but hardship, the beauties of nature, and much love.

□ □ □

Because they were born on the fifth day of the fifth moon, the two little boys were subjected to a tradition related only to that date. It was believed that noon on the fifth day of the fifth moon was the most dangerous hour for poisonous centipedes, spiders, snakes, lizards and frogs known as the Five Poisons. And so, immediately after their birth, the midwife made a mixture of wine and yellow powder, something like sulphur, and with a small brush, dabbed spots of this mixture under the infants' ears and nostrils to prevent any poisonous creatures from entering these areas.

On the morning of the third day, each boy received his first bath. The *lao lao* (midwife) who had assisted at the birth presided over this very important event. The father, female relatives and possibly a few close friends, were allowed to enter the isolation room and brought the new mother gifts of food, such as red hard-boiled eggs for joy, chickens and various sweets. The baby was fed ginseng for the first three days of his life, because it was thought to both strengthen and assist the soul in becoming properly coordinated.

Tradition demanded that a table was placed beneath portraits of the divinities Yin Meng Niang Niang, Protectress of Little Children and Sung Sheng Niang Niang, the Goddess of Birth. Upon this table rested an unusual assortment of items, including a mirror, a padlock, an onion, a sieve made of straw, and a small heavy weight. To one side of the table was a small stove upon which

sat a pan of bubbling, boiling water filled with the leaves and tiny yellow flowers of artemisia, and locust branches. The locust was believed to disinfect the air in the isolation room where the baby was kept safe from diseases and threats of the outside world, while the artemisia leaves perfumed the close, heavy atmosphere.

Fruits, nuts and red and white hard-boiled eggs also crowded the altar table. As each guest filed in, they selected bits of fruit, nuts and one egg for a boy baby, and two for a baby girl. The white egg signified wishes for the baby to grow to white-haired old age. Red eggs were wishes for abundant luck. (The Chinese words for abundant and luck have the same sound.) The offerings were dropped into a basin filled with fresh spring water before the happy mother was greeted. At this time the guests placed into the basin gifts of silver objects and coins. They also took a spoonful of tepid water from a container on the table and poured it into the bathing basin while extending wishes for many years of added life for the newborn.

Several sticks of incense were lit, placed in a bowl of uncooked rice and set before the family's ancestor tablets which would have been moved into the isolation room. Then, into the basin already nearly overflowing with fruit, nuts, eggs and silver, plus a slice of fresh ginger, the tiny baby was lowered for his first bath. It was the midwife who did the bathing rather than the mother. While chanting, she held the baby with one hand and stirred the bathwater with the other. Then she plucked the slice of ginger from the basin and rubbed it on the baby's navel in hopes of preventing sickness.

When the traditional bath was finished, the baby was dried and tucked into protective blankets. Then the *lao lao* picked up the small weight from the altar table and held it against the baby, chanting *"Ch'eng t'o hsiao yu ch'ien chin,"* indicating that the small weight held great power. Traditional belief held that when a child died he had run away from his home and family. Thus, the weight symbolically prevented the child from running away (dying).

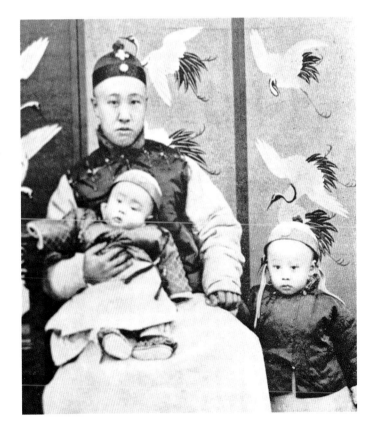

◎◎ *Below:* Prince Ch'un with his two sons, Prince P'u Chieh sitting in his lap and Emperor P'u Yi, the last emperor of China, standing to his left. (From *China Under the Empress Dowager* by J. O. P. Bland and E. Backhouse, William Heinemann, London, 1908)

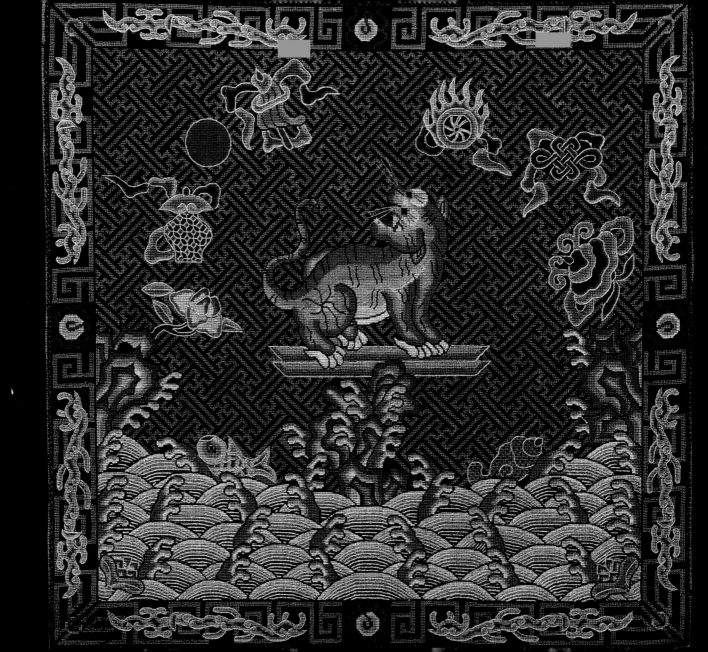

Then the midwife selected the onion from the table and tapped the child several times with it chanting, "Once touched and wisdom came. Twice touched and great was his fame." The lowly onion became part of this ceremony because the Chinese characters for "onion" and "clever" are similar.

The padlock, another object on the altar table, was used ceremonially in one more attempt to prevent the death of the baby. The open padlock was moved over the little one's body, as he was held in a standing position by the midwife. When the lock touched the ground it was closed, symbolically locking him down to earth and to life.

Of particular interest for this book is what happened with the comb. The *lao lao* pretended to comb the infant's very fine, probably nonexistent, hair while singing a little song at the same time:

> *San shu tzu, liang lung tzu*
> *Chang ta la, tai hung ting tzu*

"Thrice comb, twice comb, carefully comb the hair
And when he is grown, a red button he will wear."

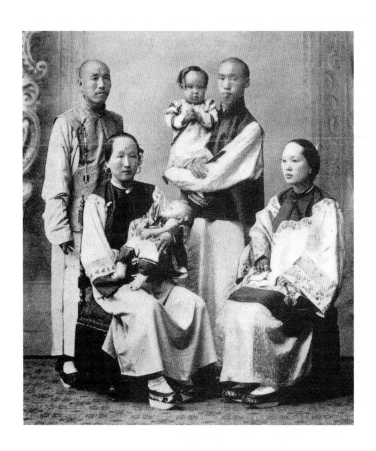

The red button she sang about referred to the red button or jewel worn on the hats of officials of the first rank. To have their son pass his exams and achieve high civil or military rank was every parents' dream.

Still only three days old, the little boy was a long way from all this. Next, he was placed in the straw sieve which the *lao lao* shook fiercely. It was believed that the dreaded smallpox would fall from above, pass through the sieve, and never reenter the life of the boy.

The midwife's chores were finished when she took away the pictures of the goddesses and the remaining tributes and burned them in the courtyard. She, or a grandmother, would rescue some of the ashes and tie them into a piece of red

◎◎ *Opposite:* Late nineteenth-century Ch'ing-style tiger square of the fourth rank with stylized dragons and *shou* symbols in the border. Buddhist symbols for good luck and protection surround the tiger. (From a private collection, Douglas Chew Ho Art & Photographics) ◎◎ *Above:* These little boys pose with their affluent parents (right) and grandparents (left). (From *Chinese Heroes* by Isaac Taylor Headland, Eaton & Mains, New York, 1902)

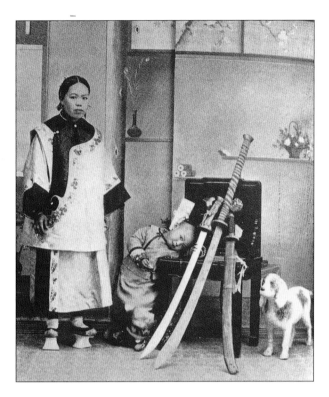

⊚⊚ *Above:* This little boy poses with his father's swords. His mother is elegantly attired in silk and stands on platform shoes that were typically worn by the Manchus. (From *Chinese Heroes* by Isaac Taylor Headland, Eaton & Mains, New York, 1902) ⊚⊚ *Opposite:* This Ch'ing-style sixth rank panther was worn by the wife of a military man. The canopy (top, center) represents Buddha's protection of the weaver. Good luck symbols abound in the water beneath the panther's feet. (From a private collection, Douglas Chew Ho Art & Photographics)

silk that was sewn on to the baby's rice-filled pillow to further protect him against evil. The last action of the *lao lao* was to scoop up all the silver articles from the basin as her payment for performing her duties at the third-day bath.

The ceremony over, all the guests departed, leaving the mother and baby in their room where the mother remained in her bed. In fact, it would be twelve days before she was finally allowed up to walk around. But she could venture no further than this room for one full month. If the maternal grandmother were alive she would have visited with her daughter and brought her gifts of food, such as special meat dumplings to give her strength. At this time the new mother was restricted not only in her mobility, but also in her diet. She could not eat any fresh fruits or vegetables, nor drink anything cold. A thick broth made of pig's feet, black vinegar and ginger was supposed to help her produce more milk for her child. "Mother's Brew" was another allowed beverage. Made of chicken, raw peanuts, red dates, ginger root, dried wood fungus and dried lily buds cooked together, it was seasoned with great quantities of rice wine or whiskey and was supposed to build up the mother's strength after the ordeal of birth. Golden needle soup made of the dried yellow lily flower bud boiled with small pieces of meat was another soup given to new mothers.

One month after the baby's birth was cause for a great celebration. The mother was allowed to go out into the world and a party was planned, the very best party a family could afford. Friends and relatives all participated in the preparation of food for the big event, except in the case of those who had servants to do the work. The mother appeared wearing her finest clothing for this important occasion.

Guests were not only invited to dine, but, if it could be managed financially, a theatrical troupe was hired to entertain them. It was traditional for small and large theatrical companies to perform in private homes, courtyards, or on makeshift stages in village squares. Princes, wealthy eunuchs and powerful mandarins

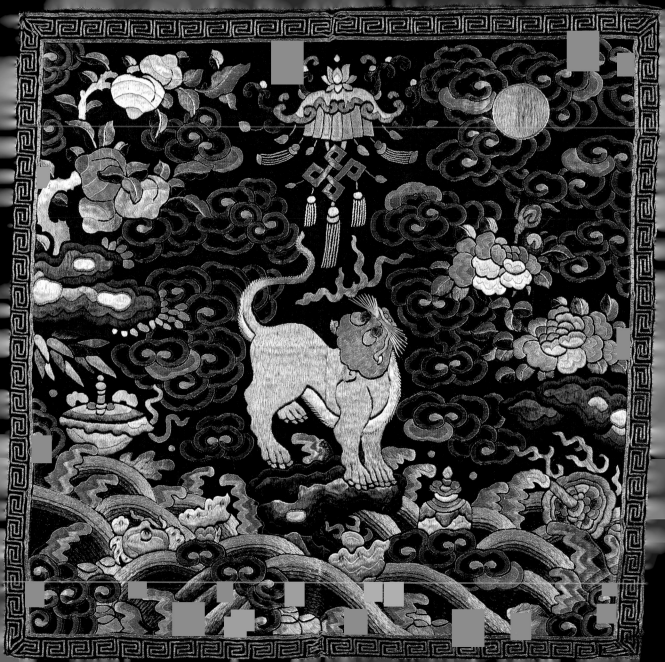

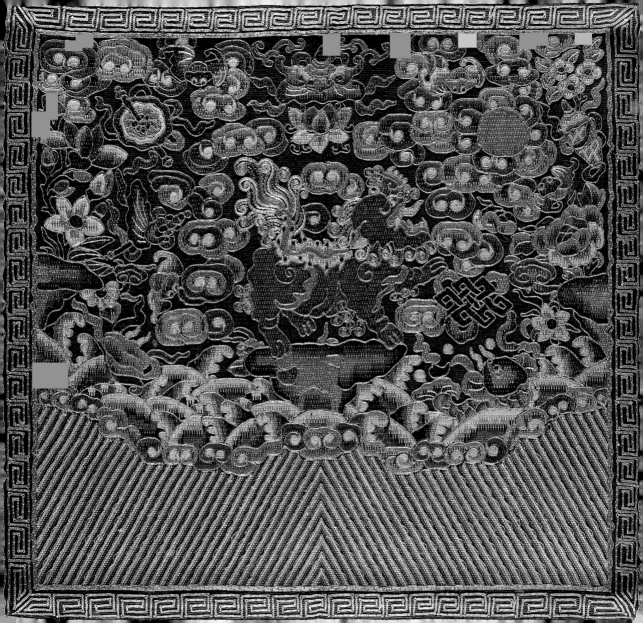

in Peking had magnificent theatres within their palaces for private performances. Itinerant troupes of actors traveled from village to village throughout China, unrestricted by any need for formal indoor stages.

The food prepared for a poor peasant's first-month party would be simple, based on what was grown in the area. It was usual to have a chicken or a pig for this important event, though this probably meant great sacrifice on the part of the family. The fat from a pig killed many months earlier was saved for treasured cooking oil to be used at this special time. Every part of the chicken, duck or pig would be served. Some parts would be steamed, the feet would be boiled, the innards deep-fried. In wheat-growing regions there would be dumplings, noodles and bread. In rice-growing areas wheat would be replaced with rice dishes. Vegetables were served according to season, fresh, steamed, pickled or preserved. There was no refrigeration, so salting, pickling or sundrying were very important techniques for food preservation. Walking down a village street, one might encounter strips of duck, whole fish from the sea or a lake, peelings from tangerines, long green beans, ears of corn, all hanging out in the sun to dry along with the family's freshly washed clothes.

Guests attending a one-month party would not arrive empty-handed. They brought the best gifts they could afford, including money in little red envelopes, and jewelry if possible. The one-month-old boy often received several sets of certain items: nine small idols to be sewn onto his little hat for good luck; pairs of matching bracelets; small silver bells to be sewn to the ends of the ties for his hat; and of course an assortment of baby clothes. Hats were frequently given as gifts and were worn from infancy as protection against evil spirits.

The most important hat received at one month was usually made by the maternal grandmother. It was embroidered with symbols wishing long life, of which the Chinese have a tremendous number, good luck, and whimsical designs added for amusement. There would also be an assortment of little metal idols or amulets sewn onto the hat as further protection against evil and disease. Frequently the amulets were cut from peach wood, which was supposed to have special powers to protect the child against the Demon Stealer of Life. If the family were wealthy, the charms would have been real gold, silver or jade. The child's

❧ *Opposite:* Ch'ing-style military square of the second rank that was worn by a woman. The lion is accompanied by Buddhist symbols of protection. The diagonal lines at the bottom are a mid-nineteenth-century design that mirrored the borders on the bottom of court robes. (From a private collection, Douglas Chew Ho Art & Photographics)

number-one aunt in particular would be expected to give the little one real gold ornaments for his hat. Grandmothers with imagination created intriguing little hats for their grandsons shaped like the face of a lion, pig, dog or tiger with a tail hanging down the back. The hats had to have large, protruding eyes to spot danger, ears to hear evil approaching and a mouth full of bared teeth to further frighten away evil spirits.

The tiger represented strength and was thought to protect children and was therefore the most important of the animals for little boys at their first-month celebration. If the infant boy was given shoes to match his new hat, they would probably have big eyes embroidered near the toe so that the little one could "see where he was walking" and not trip or bump into things.

The guests at the one-month party arrived with gifts for the new baby, but they did not go home empty-handed. They departed with gifts of red-dyed eggs and pickled ginger from their hosts.

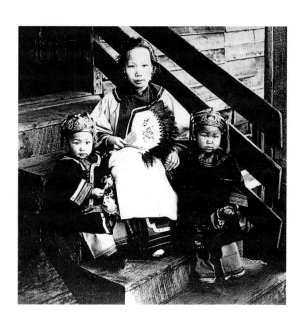

◎◎ Chinese children and their mother in Olympia, Washington circa 1900. (From the author's collection)

First-month parties in the homes of the wealthy were lavish beyond imagination. Vast displays of the finest, most perfectly prepared foods were offered. And guests would go home with little jeweled treasures or other expensive gifts, along with the obligatory red-dyed eggs and pickled ginger from their hosts.

A highlight of the one-month party was the baby's first haircut. His little head was dampened and then shaved of whatever bits of hair might have been growing. Before this was done the baby was presented with, and encouraged to touch, a dried gourd, theoretically so that he could experience the similarity between the gourd and his own head. Following the haircut, the grandmother's little tiger hat was placed on his head. If the event took place in winter, the hat would have been lined and padded to keep the little head warm.

The hair shaved from the baby's head was wrapped in a piece of red fabric and saved until he had lived one hundred days. On that day the little red package of hair was thrown into a nearby lake, river or ocean to insure that the baby would be courageous in life and in the afterlife.

The one-hundredth day of the baby's life was another day of celebration. Again friends and relatives gathered, this time bringing gifts of chickens and fish. And on this day the paternal grandmother presented her grandchild with a rocking chair.

A boy's first-year birthday was an especially auspicious occasion for parents with aspirations for future positions of civil rank for their sons. The baby was dressed in special little clothes and set upon a big bed or a large covering on the floor. Placed before him were a book, a flower, rouge, powder, toys, paper and pen. The family and guests watched closely to see what the baby reached for from this assortment. Their hope was that he would reach for the paper and pen of a scholar. Reaching for what would have probably appealed to a child most, playthings, was not seen as a good sign. Rather, it indicated he would not be serious about, or successful in, business. And to reach for the makeup meant a playboy in the making!

□ □ □

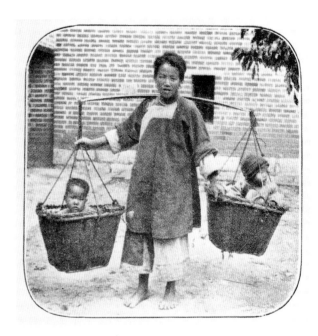

The time was approaching for the first-year birthday celebration for the boy child Bao Gui (Treasured and Honored) and once again everyone in the palatial compound was in a state of anticipation and agitation. Yu Lian's disposition had not improved in the year since the birth of her baby boy. As a concubine she should have relinquished her son to the number-one wife of the master, a mother of only girls. But that was not in Yu Lian's game plan. Bao Bao, as she called him, her double treasure, was going to be raised in luxury, totally without discipline, and by his real mother.

When a fourteen-year-old slave girl dared call attention to an irreplaceable two-humped braying green and brown glazed camel figurine from the T'ang dynasty, flung to the ground in childish rage by Bao Bao, she was flogged by order of Yu Lian. Her son was above the rules of civilized behavior. He was the male heir and future master.

Secretly, the wives and other women of the household worried about the child. Bao Bao's emotional outbursts and temper tantrums were thought to be the work of evil spirits. One old amah made a point of remembering the exact spot

◎◎ Instead of bearing produce from the fields, this peasant woman carries her boys to a local village in baskets suspended from a shoulder pole. (From *An Epic of the East* by Nathan Sites, Fleming H. Revell Co., London, 1912)

An amah with her young charge.
(From Dennis G. Crow, Ltd.)

where each tantrum took place and would return late at night, holding near the ground a piece of clothing the child had worn, calling out "Bao Bao, you must return!" as if part of him had been taken at that spot. Then she stole into the baby's room and placed the garment on him as he slept, hopeful that the evil spirits known as the "Stealers of Children" had been humbled once again.

First birthdays were very important. They were the last individual birthday to be celebrated until the boy reached the age of sixty, after which there was a major celebration every tenth year. Birthdays became a communal family event at the New Year holiday during the years in between.

Lan Xiang's young son, Yong Shang (Forever Rising), also approached his first birthday. Although he bore a fine name offering hope for a better life, the little one was called Shou Shou (Double Pig). His mother took no chances that the evil spirits would discover that her beloved baby was a desirable boy to be spirited off in infancy. He was an undesirable pig, a double pig. No evil spirit would bother about a pig. Her cousin in the next village had lost her first son to the evil spirits when he was only three months old. When her second son was born, she dressed him as a girl, gave him a girl's name, put earrings in his ears, and bound his feet when he turned three. The evil spirits would know for sure that she was raising a miserable girl!

Life was not easy for Lan Xiang. Each morning before sunrise she went out to gather firewood. Then she fetched the day's supply of water for the family that had to be brought up from far down the mountain in a bucket on her back. When Shou Shou reached the age of seven or eight it would be his task to carry the water, as the other children in the area did. With these basic chores out of the way, Lan Xiang prepared a family breakfast of wheat flour paste or boiled potato, and set aside some potatoes to take to the fields for the midday meal.

When the sun rose out of the darkness, it was time to head down the mountain for the day's work. Shou Shou rode in a basket on his mother's back down the steep winding trail to the little plot the family farmed. His father carried the old wooden hand plow that both mother and father pulled through the earth. On

his head Shou Shou wore a little hat shaped like a pig. He delighted in pulling it off and tugging at the funny ears. His mother stopped her work to return the hat to the little head, so that the evil spirits would see that her beloved son was nothing but a pig.

The family owned a small plot of land on a steep slope far below their mountain hut. The soil was poor and required much back-breaking labor all year round. They grew mainly potatoes, sweet potatoes, corn and, in good years, wheat and soybeans—all in small quantities. During famine years, they lived on wild roots from the forest that Lan Xiang ground to a paste and mixed with grasses, water and any sort of edible berry or nut she could find.

While his mother worked from sunrise to sunset on the family's tiny plot, Shou Shou amused himself in his reed basket—looking up at the clouds floating by and the birds swooping and soaring above him, reaching for a blade of grass or a wild flower, laughing happily at nothing and everything. Although his world was poor in material wealth and comfort, it was rich in love and the wonders of the mountains, meadows and forests.

Dwelling side-by-side with the benign creatures of the countryside were the spirits inhabiting the supernatural world. Of these, Lan Xiang feared the fox fairies most. For centuries, the Chinese both feared and revered these cunning spirits. In a hidden spot in the forest nearest their hut was a shrine to fox fairies that Lan Xiang visited weekly, always leaving meager offerings of food or flowers. At the end of autumn, in anticipation of the long flowerless winter, she selected a small pine bough and hung it with paper flowers, then attached it to a ball of clay-like earth to hold it upright, and placed it before the secret shrine. One evening she found a lovely wild white orchid in a crevice along the mountain path. She had been tempted to take it home. But no, better to delight the fox fairies. They had to be kept happy. Her Shou Shou had to be saved from the fury of the fox fairies. As darkness fell, exhausted from long hours in the field, Lan Xiang made her way into the dark forest to place the lovely spray of wild orchid at the shrine.

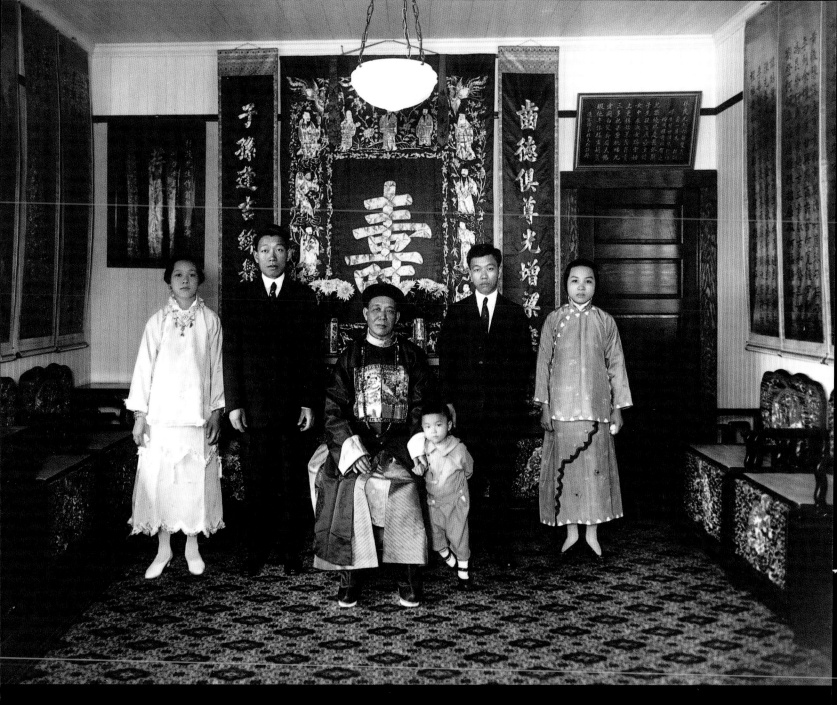

◎◎ Lum Mow Pang (center) and family. In this portrait, taken around 1920. The patriarch's commitment to traditions is shown by wearing court costume after it had lost all relevance due

CHAPTER 2

CITY LIFE AND
THE SPIRIT WORLD

Bao Bao enjoyed his excursions out of the compound into the marketplace with his amah, in part because his mother didn't know of these secret adventures. The smells and sounds of the town excited the little boy more than any of the extravagant gifts or smothering attention showered upon him at home. He had to be dragged away from the fishmongers where he would watch with fascination as long, glistening eels writhed and slithered in the crowded water-filled basins. He marveled at the many colors and types of eggs, both fresh and hard-cooked, filling the baskets and bowls at the egg sellers. Pathetic little skinned sparrows lying in orderly rows waiting to be grilled on hot coals brought up no normal childish feelings of sympathy within Bao Bao. Instead, they quite excited him in a way that bewildered and alarmed his amah as she watched him jab at the pitiful naked creatures, eyes closed and beaks pointed skyward.

Her alarm increased when he menaced the tiny white dogs housed in large bamboo box cages near the bird market outside the Sung-a-men gate. Even old men, passing judgment on the musical quality of nearby songbirds perched in wicker cages, watched the boy's behavior with concern. What a strange child she cared for. His passions were so strong for one so young, both the good and the bad.

Bao Bao's good passions were evidenced once again when they lingered in the area of bonsai trees. The miniature trees growing in contorted, twisting shapes,

Opposite: An imperial dragon insignia that would have been worn by a lower level prince as the dragon is portrayed in profile. (From the author's collection, Douglas Chew Ho Art & Photographics)

truly delighted him. "When I grow up I shall have all of these. I shall have all the baby trees in China." There was no moderation in anything for this child.

The little boy loved the activity of the city—the deep rumbling of the big wooden wheels the Peking carts made as they lurched along the rough stone streets and bumpy dirt tracks, the fragrant aromas and spicy smells carried on the air as he passed the food vendors, the shouted conversations and raucous laughter between the merchants, so different from the dignity of his home. He was endlessly excited by the coarse, rough atmosphere of the streets.

When he heard *"Kuo tzu kan erh lai, Mei kuei tsao erh ai"* ("Fruit paste and stuffed dates have arrived") being sung in the distance, he tugged at Amah's trousers and begged, "Amah get me *mei kuei tsao erh.*" And knowing how the boy loved the date treats stuffed with dried rose petal and sugar paste, she would take two copper coins from the little embroidered silk pouch that hung from the belt at her waist under her jacket and off they would go to find the dried fruit peddler.

The cry *"Shua hao tzu,"* accompanied by the *so na* (small horn) announced the presence of the trained-mouse man to people living behind the high windowless walls that lined the *hutungs* (narrow lanes). It also always brought a prompt reaction from Bao Bao. Like the poorest children in the city, this affluent little boy responded with joy to the charming entertainment offered by the mouse man. Slung over his shoulder was a rectangular box fixed with a pole that held a round platform near its top. There were small decorative flags atop the pole and a rope ladder ran from the platform back to the box. Attached to the platform were a miniature temple and pagoda, a wooden peach with a hole cut through it, a bucket hung on a string, some wooden fish also hanging from a string and a small revolving wheel.

Whether performing on the street, or inside a compound upon request from a family, the mouse man began each performance the same way. To the delight of his audience, he carefully opened a series of tiny drawers tucked inside the box, each revealing a mouse curled up in its own cotton nest. The mice were removed

꩜ A busy street in China. (From *Things Seen in China,* by J. R. Chitty, Seeley, Service & Co., Ltd., London, 1922) ꩜ *Opposite:* A Chinese bird seller. (From the author's collection)

20

from their drawers individually and performed one at a time. Each mouse had a specialty—one ran around the wheel, one pulled the string of fish, one scampered through the temple, one through the pagoda, and one through the peach. Throughout the performance, the mouse man sang and tapped the box with a small stick, which actually gave the mice their cues.

Bao Bao even loved the dirt of the city and the strange, sometimes unpleasant, smells. He was not upset by the nightsoil collectors, carrying their human and animal manure in buckets hanging from shoulder poles, passing closely by him. Although nothing like the refined cuisine to which he was accustomed, the strange, tantalizing aromas from foods simmering on the little charcoal stoves along the streets intrigued him. When he was older and could roam as he pleased, he would try it all.

The cry of *"Ch'ui t'ang jen erh ti"* accompanied by slow single strokes on a gong was guaranteed to inspire Amah's young charge to drag her at a semi-run in search of sugar-figure blower. Running wasn't an easy feat for a woman who was no longer young, and Amah had to totter on tiny three-and-a-half-inch bound feet. But she too loved the sugar-figure blower. This peddler carried a small, round wooden box called a *yuan lung*, topped by several racks, on one side of a shoulder pole. Within the *yuan lung* a small charcoal fire burned under an iron bowl filled with thick rice syrup. From the other side of the pole hung a similar box which held all the ingredients needed for making the syrup, pieces of charcoal for his fire, and other necessities.

The old woman and the little boy stood wide-eyed as they watched the sugar-figure blower take a small dab of warm syrup from the bowl and mold it into miniature sugar people, ears of corn, birds, animals, fish. Sometimes he inserted a hollow straw into a dab of the warm syrup and blew it into similar shapes. Lastly, he added bits of color to make his figures more lifelike and attractive. Amah and Bao Bao marveled at their little sugar treasures, but always consumed the delightful confections before they reached their compound.

◎◎ Ch'ing-style wild goose square of the fourth rank made for the wife of a mid-level civil official. The extensive use of Peking knot embroidery made this an unusually expensive square. (From a private collection, Douglas Chew Ho Art & Photographics)

Occasionally on these forays into the bustling world of Peking, a mandarin and his entourage passed them in the street. Alarmed for fear it was someone who would recognize them, Amah would pull the little boy quickly into the crowd as the outriders and servants cleared their master's way with flicks of their bamboo rods. She could tell the rank of the mandarin by the number of outriders and other men in his retinue, and by the color of his Peking cart. If the cart was green, the man inside was a first or second rank civil official. If it was blue, he was third or fourth rank. And high ministers and princes rode in sedan chairs. Fortunately however, they never ran into anyone who knew them.

Once, they had the thrill of seeing the imperial procession of the emperor returning from the Temple of Heaven. It was the time of the Lantern Festival when the entire city was illuminated by the warm glow of thousands of lighted paper lanterns. They flickered in windows, winked from the high walls, and swayed suspended from ropes strung from rooftop to rooftop over the streets. The emperor's arrival was heralded by shouting from the mounted life guards as they cleared the road. The crowds immediately fell to their knees, their foreheads touching the street, for they were forbidden to gaze upon the imperial presence as he passed. Bao Bao cleverly positioned himself in a spot where he could peek at the passing procession without being perceived. His heart beat wildly as the men carrying long gleaming horns adorned with golden tinkling bells paraded by. Then came hundreds of soldiers bearing lighted torches and lanterns shaped like tigers, fish or birds. Others carried great banners of red cloth decorated with the signs of the Chinese zodiac in gold. Hundreds more men marched past, many carrying long golden poles ornately carved with exotic birds. Four-hundred soldiers dressed in the uniform of the emperor, almond-colored silk with a dragon embroidered on the chest. The last of them carried great umbrellas also of yellow silk heavily embroidered with gold thread.

Bao Bao was totally exhilarated by the excitement of the event, as well as the danger of daring to look upon the face of the Son of Heaven. He could barely breathe as the great white horse carrying the emperor came within his limited view. There he was, passing only yards from him, the emperor of all China,

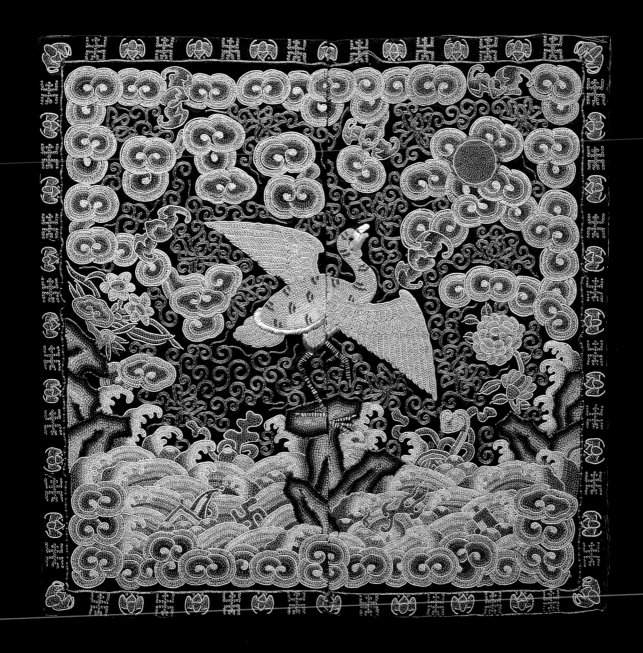

dressed in blue silk covered with gold embroidery and jewels. High ministers of the court rode on either side of him carrying great umbrellas of imperial yellow silk, and ten riderless white horses followed wearing elaborate jeweled harnesses. Behind the Son of Heaven followed the imperial princes and the important men of the court. The procession continued with another five hundred men from the court with a thousand footmen in red robes embroidered with silver stars. The procession concluded with the emperor's golden chair of state, carried by thirty-six men, escorted by elephants, and at least a thousand mandarin wearing robes bearing their badges of rank, both civil and military.

Amah forbade Bao Bao from telling his mother, or anyone else at home, about this adventure, or of any of their secret trips into the city. The servants who saw them steal in and out through a forgotten gate in the compound wall behind the Garden of Sweet Perfumes knew better than to mention it and risk Amah's formidable wrath. They also knew these glimpses into the real world delighted the little one and gave Amah some leverage in controlling his frightening outbursts of rage.

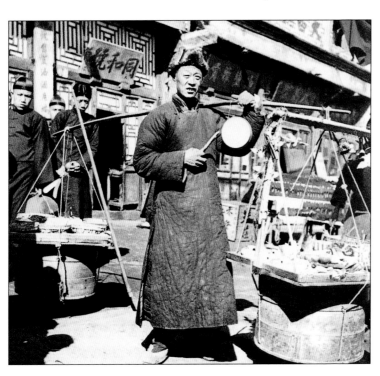

The sugar-figure blower sounds his gong to announce his presence. (From *Peking Studies* by Ellen Catleen, Kelly & Walsh, Ltd., Shanghai, 1922)

Shou Shou found pleasure in the beauty of nature and the excitement of learning. He observed, he listened, he questioned. The forest held great fascination for him. He would return from a berry hunt with tales of young fawns running and playing with him. Sometimes he rushed out of the hut before sunrise to sit in a field of wild daisies and watched as they opened with the sun. Then at sundown he watched the petals close up and go to sleep as darkness approached. He enjoyed watching the full moon rise just as the sun set, like two giant juggler's balls arcing across the sky in slow motion. And he delighted in lying in the deep grass on his back, looking up at the full moon through pine boughs, the slender needles etching a design of fine lines across its face. Why did the moon go from small to

large, and then finally disappear, until it returned like a slice of winter melon to grow progressively large again, Shou Shou wondered. He lay looking at the night sky, wondering about all the places beyond his village the moon could see. Would he ever see the wonders beyond his little world?

□ □ □

Whether searching for the beautiful woman whom they believed to be a transformed one-hundred-year-old fox, or binding the feet of a baby boy to fool the evil spirits into believing he was a girl, through the centuries the Chinese have been deeply superstitious and placed strong faith in many myths.

Thus, the watchtowers built into a city walls were always exactly ninety-nine feet high to allow good spirits, who always flew at one hundred feet, to fly into the city without incident or impediment.

Conversely, any evil spirit trying to follow someone through an entrance gate into a home was bound to end up with a sore head, if not dead. Because evil spirits always flew in a straight line, each home had a spirit wall inside the entrance, directly in front of the door or gate. When a guest walked through the gate. he or she went to the left or right and around the spirit wall. If an evil spirit was following directly behind the person entering, it would fly straight into the wall, head first!

Even the domestic art of needlework had superstitions connected with it. On the second day of the second lunar month women never did any type of sewing or embroidery. This was the day the dragon awakened from his long winter sleep, and if a woman were to prick herself with a needle it was thought she would prick the dragon in the same spot. In his anger at the sudden pain, the dragon would cause a large sore or boil to rise at the corresponding place on the woman's body.

Dragons have always been powerful figures in Chinese mythology. Traditional sky-dwelling dragons weren't the only ones inhabiting the Chinese spirit world.

❧ A horse-drawn Peking cart. (From *Peking Studies* by Ellen Catleen, Kelly & Walsh, Ltd., Shanghai, 1922)

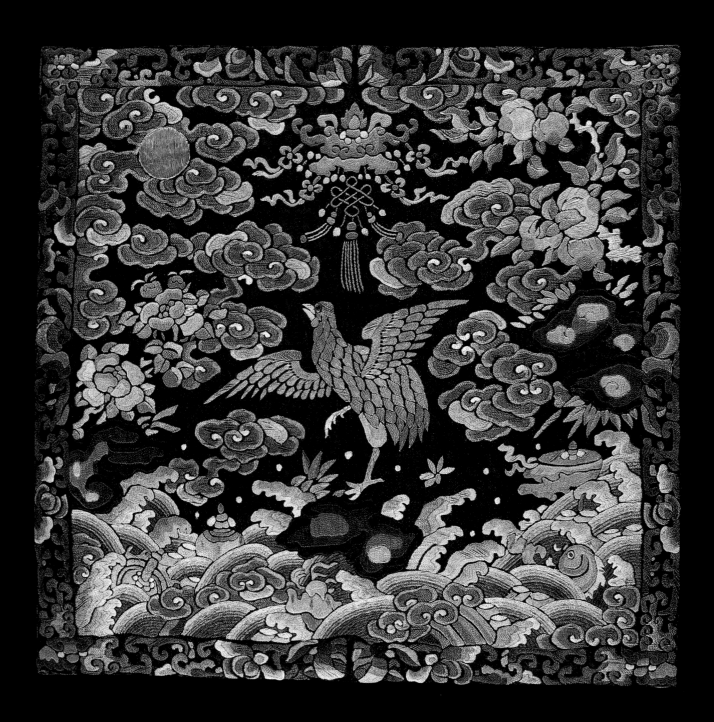

People living near the sea went to the shore in the early morning and gazed into the water, searching for the palaces of colored stones with crystal doors where the five Sea-Dragon Kings dwelt.

These fearsome creatures were thought to eat only pearls and opals. Their breath could boil fish, if the heat from their sinewy bodies had not already done so. When the immortal, gigantic five Sea-Dragon Kings walked across the ocean floor, the vibrations could cause mountains on shore to collide with one another. Each of the hideous beasts was covered with yellow scales, sported a hairy tail, and had a bulging forehead that projected over huge blazing eyes. It was thought the dragons could cause typhoons to rage and water spouts to shoot into the air when they rose to the ocean surface.

Because fire was a constant threat, both in the city and the countryside, the fire gods were always appeased in China. There was a celestial organization of fire presided over by a president, with five subordinate ministers. Four of these ministers were star gods and the fifth was called the Celestial Prince Who Receives Fire.

The president, Lo Hsuan, had three eyes and a red beard. He wore a red cloak and rode a spirit horse who snorted flames from its nostrils and kicked sparks of fire into the atmosphere from his hoofs. He was known to be fearsome with many magical tricks, such as the ability to change himself into a giant with three heads and six arms. He carried magic weapons in his hands, including a seal reflecting the heavens and earth, a gourd holding ten thousand fire crows, and a column of smoke thousands of miles long that concealed swords of fire.

Lo Hsuan was proven not to be invulnerable, however. On one occasion he went into the city of Hsi Ch'i, causing a tremendous fire throughout the city. But out of the sky came the Princess Lung Chi who spread a shroud of mist and dew over the city followed by heavy rain, saving it from destruction, and at the same time depriving Lo Hsuan of all his magical mischief. After making his escape from the city, he encountered Li, the Pagoda-bearer and Prime Minister of Heaven. Knowing the damage Lo Hsuan had caused, Li threw his golden pagoda into the air, causing it to land on Lo Hsuan's head, breaking his skull.

∽ *Opposite:* Early nineteenth-century Ch'ing-style quail square of the eighth rank. The Buddha's canopy above the quail protected the wearer while the white dots (representing pearls) hoped for additional wealth. (From a private collection, Douglas Chew Ho Art & Photographics)

27

Mandarins, as well as other important people, rode in sedan chairs. (From *A Descriptive Catalogue of the Chinese Collection* by William Langdon, G. M'kewan, London, 1844) *Opposite:* An elegant Ch'ing-style egret square of the sixth rank. The relatively small scale of the good luck symbols allow the egret to be the main focus of the square. (From a private collection, Douglas Chew Ho Art & Photographics)

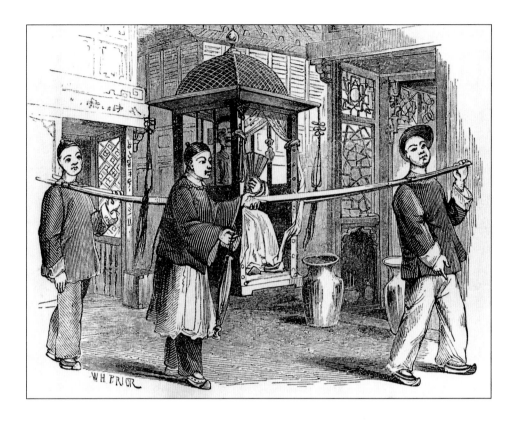

Before there were clocks, calendars and computers, there was the sky. It was upward that shepherds and sailors and farmers gazed, to the sun, moon, and stars, for their sense of time. And eventually there came a logical system for setting the seasons. The year 2857 B.C. is claimed as the date of China's earliest records of astronomical annals. These were basically the dates of solar eclipses. From ancient times the Chinese people were taught that an eclipse meant a horrendous monster dog was nibbling away at the sun or moon. This monster became known as the Heavenly Dog and he lived on a very special star. A remembered eclipse was referred to as when "the Heavenly Dog almost ate up the sun up." Eclipses were of particular importance to emperors who looked upon them as signs from heaven that personally affected their own lives, their empire, and their reign.

In 2254 B.C. Emperor Yao assigned his astronomers the task of establishing the equinoxes and solstices, and fixing the time of the four seasons. Later emperors established official Boards of Mathematicians whose work on such problems

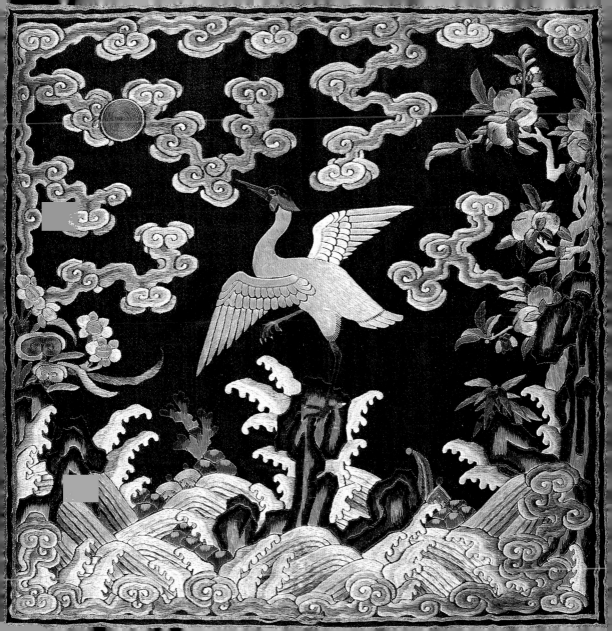

was submitted directly to the emperor. The mathematicians were looked upon with great importance. When their research was ready for presentation to the emperor, it was carried imperiously in special sedan chairs, and received at the palace with great ceremony.

Following the acceptance of the lunar calendar, legends and myths concerning the moon developed, grew and were passed down through the centuries. These stories delighted little children, and stayed with them as fact, governing their lives as they grew to adulthood. It was such stories that Lan Xiang shared with Shou Shou.

Boys particularly liked the tales of Ch'u Yuan, a high official appointed by the King of Lieh (a mythical kingdom) to bring an end to a rebellion in the area of the Great River. Proving unsuccessful, he petitioned the king to replace him with a more capable official. When the king refused, Ch'u Yuan jumped to his death in the raging river because he felt unworthy of his position. But local people, knowing of his sincere attempts to bring peace and his sadness at failing, revered and honored him by preparing food so that he would not be hungry in the next world. First they prepared sticky rice but feared that when the rice was thrown into the river where Ch'u Yuan had gone to his death, it would be eaten by fish before it reached him in the next world. So they changed their tributes and wrapped a combination of fruit (or dates), sticky rice, small pieces of bacon and sugar in bamboo leaves (in southern China, reed leaves in other areas), then boiled the bundles for about an hour. These bundle cakes, or *tsung tzu,* were offered to Ch'u Yuan via the Great River. And to this day, every year at the Fifth Moon Festival, or the Dragon Boat Festival as it is also known, *tsung tzu* can be found in shops and sold by street peddlers crying *"Chiang mi ti, tsung tzu ai"* ("Here are *tsung tzu* made of glutinous rice"). No longer thrown in rivers, these edible treats are enjoyed by the living today.

Some of the most often-repeated moon myths concern Heng O, the Moon Lady. Her birthday is still celebrated by many Chinese on the fifteenth day of the eighth moon. On this night it was believed that the Moon Lady left her palace on the moon and descended to earth. A birthday table laden with bowls of fruits

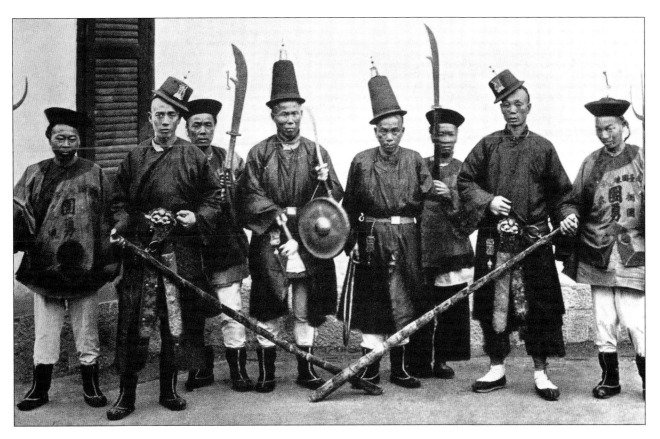

and moon cakes was placed in a candlelit garden where burning incense mingled with the fragrance of the flowers. In the center of the table sat a clay pagoda with a burning candle inside, representing the Moon Lady's palace. And nearby stood the Moon Rabbit dressed in a mandarin's gown and standing upright on his hind legs, just like a person.

As the moon rose into the dark, star-filled sky, the eldest woman of the family knelt before the table, performed a kowtow of respect and called to the Moon Lady, "O Light One, O Bright One, We bow tonight, Bless thou our rice." The Moon Lady, Heng O, was the beautiful sister of the God of the Waters, Ho Po. During a period of terrible floods that devastated the country, the Emperor sent his Imperial Archer, Hou Ye, to kill the God of the Waters for causing the devastation. Hou Ye shot his swift arrow at Ho Po, but only managed to wound him, and Ho Po flew away and was never seen again. Heng O had been standing next

∾ When a mandarin traveled to a town or city, he was accompanied by a retinue of men who went ahead of him carrying bamboo sticks to beat back the curious crowds. (From *In the Land of the Blue Gown* by Mrs. Archibald Little, T. Fisher Unwin, London, 1902)

31

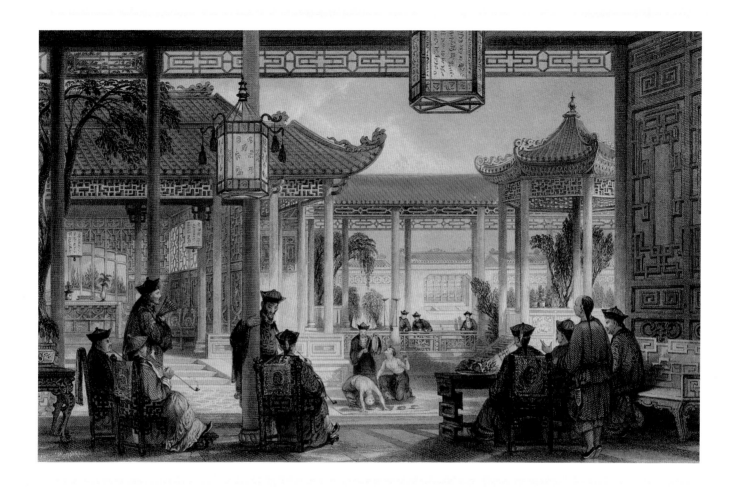

to her brother, but she was so beautiful that the Imperial Archer could not bring himself to shoot her. Instead, he aimed his arrow into the top of her elaborate coiffeur where it lodged deep in the shiny black hair. Heng O was so grateful to him for sparing her life, that she agreed to become the Imperial Archer's wife.

Not long after they were married, tragedy struck again. Ten great suns appeared in the sky, scorching the earth. Again, the emperor sent for the Imperial Archer. One after another he shot the suns out of the sky. Nine were gone, and as he took aim on the tenth he heard a voice: "Great Archer, I am the Sun God. Listen to me. Leave one sun in the sky or the earth will live in darkness. Without the warmth and light of the sun, everything on earth will die."

32

Word of the Imperial Archer's deed spread throughout the kingdom. When the Empress of the West in her palace atop Kun Lun Mountain heard of it, she sent for Hou Ye. In gratitude, she gave him a precious pill of long life. "Hide this pill for twelve months while you prepare yourself to fly to the heavens. There you will live forever after you take the pill. You must tell no one about the magic pill until it is time for your journey to the sky," she cautioned.

Before the twelve months were up, during a brief period when Hou Ye was off on an assignment for the emperor, Heng O found the hidden pill, swallowed it, without knowing what it was. Right away she felt that she could fly like a bird.

When Hou Ye returned and found his precious pill gone, he questioned his wife about it. Afraid to tell him the truth, she flew off to the moon to hide from him. But immediately after landing she started to cough violently and the shell that encased the pill of longevity shot out of her mouth, instantly assuming the form of a pure white jade rabbit.

Calling up a strong wind to carry him, Hou Ye tried to follow his wife, but he could not find her. The Empress of the West watched his search and finally felt sorry for him. "You too shall live forever," she told him. With that, she gave him another magic pill designed to help him withstand great heat, and then sent him off to live in a great palace on the sun.

The Empress gave him an additional gift of a golden bird with a high red comb atop his head. "This golden bird will awaken you each morning so that you can make the sun rise," she informed him. This is thought to be the ancestor of all roosters who crow each day at sunrise.

Once Hou Ye settled in, he took a trip to the moon to tell his wife Heng O he forgave her for swallowing his precious pill. He was shocked at how cold and lonely his wife's moon home was. The only company she had was the Jade Rabbit stirring the ingredients for the pill of longevity in a little stone bowl. He decided he would come and visit her every month. And so he did and still does. And it is on the night that he visits her each month that the moon is at its fullest and brightest, filled with the radiance Hou Ye brings to the moon from his sun kingdom.

❦❧ Jugglers perform in the courtyard of a mandarin's compound. There is an interesting inaccuracy in this nineteenth-century English print. The mandarin seated second from the left is the only one wearing a summer hat, the rest of the company wear winter hats. This would never have happened, because on the day the emperor announced that hats would change from winter to summer, every mandarin in China would have switched. (From the author's collection)

One of the best-loved moon stories is about Chih Nu, the Weaving Lady, who was one of the seven daughters of the Kitchen God. She spent her days weaving garments for the other deities, but sometimes she and her sisters went down to earth to bathe in a lovely cool stream. On one such day, a poor cowherd was in the pasture nearby, watching over his magical talking cow. The cow told the cowherd about the seven maidens bathing in the stream. "The seventh maiden is beautiful and kind and wise," the cow told him. "She spins the cloud silk for the gods, and is the patroness of the loom and needle for women on earth. You could become her husband and gain immortality if you take her clothes away while she is bathing in the stream."

The cowherd did indeed hide Chih Nu's lovely red silk robe, so she was unable to fly back to heaven with her sisters when they left the stream. She remained on earth and married the cowherd, and for three years they lived together very happily. They were blessed with two fine children who brought them great joy. But in heaven, Chih Nu's loom was silent, and the gods grew angry because there was no one to weave the diaphanous silks for their clothes. They ordered her to return to heaven, and return she did.

Saddened by her master's grief at losing his beloved wife, the cow told the cowherd, "When I am dead, wrap yourself in my skin, and you will be able to fly to heaven to be with your wife." The cowherd did as the cow instructed, but the cowherd's arrival in heaven was not greeted with joy by his celestial mother-in-law. She traced a line across the sky that became the Celestial River (or Milky Way). Then she changed the Weaving Lady and the cowherd into stars, and placed them so that they were separated by the Celestial River. So great was their sadness that the Jade Emperor decided to intervene and granted them a meeting once a year on the seventh night of the seventh moon. On that night, he decreed that all the magpies and crows in the world would gather together and spread their wings to make a bridge over the Celestial River so that Chih Nu could go to her husband. Some say that she wrapped her feet in lengths of silk to make them smaller so that she move more easily across the narrow bridge of birds.

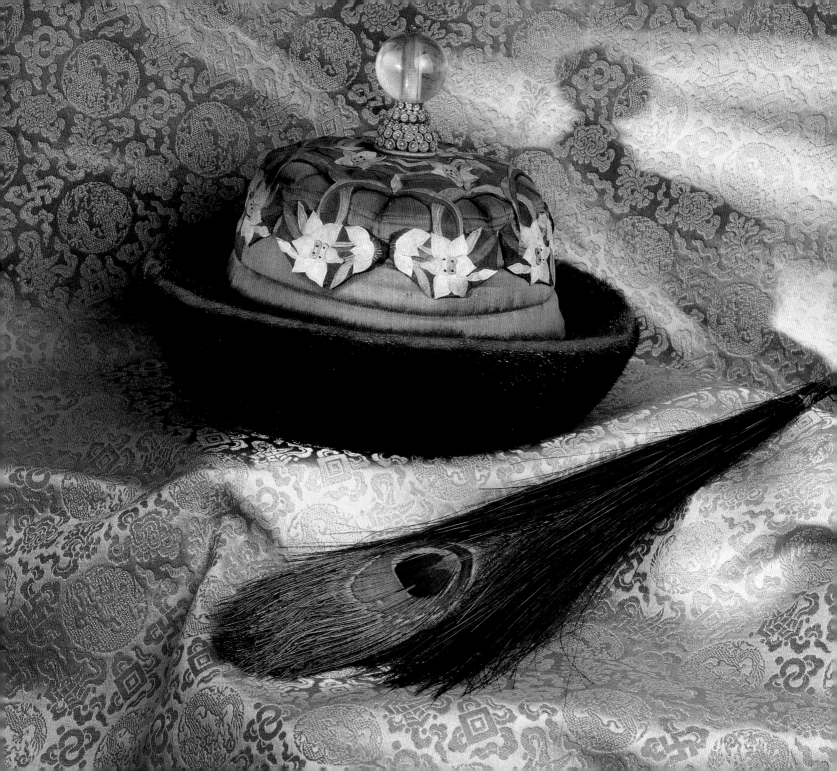

CHAPTER 3

KITES SOAR
ALONG WITH HOPES
FOR THE FUTURE

At home Bao Bao was surrounded by every toy imaginable, most of which he ignored or treated with contempt. There was one amusement, however, that truly delighted the spoiled little boy. He loved to fly his colorful collection of kites. The ninth day of the ninth month, the Festival of Ascension associated with scholars and their civil examinations, was the most revered day of the year for kite flying. But Bao Bao was ready to fly them whenever there was a favorable wind.

The son of one of the chefs in his father's main kitchen was a wonder at designing and making kites. Other than his old amah, Ho, the maker of kites, was Bao Bao's only real friend. Throughout the year Ho worked on a variety kites for the boy and helped him raise them high into the sky. But at the beginning of the eighth month he began to create the very special kite that the two boys would fly together on the ninth day of the ninth month. He had started when Bao Bao was very small and only a spectator of Ho's kite-flying demonstrations. Now Bao Bao was old enough to be a participant and received great joy from both the ascent of his kite and the admiration it garnered.

Rushing through his lessons with even less attention than usual, Bao Bao hastened to meet his friend every afternoon. Ho found a small unused room in a remote part of the compound and the two used it as their kite-making workshop. Amah's glowing reports to the Master of his son's fascination with kite making guaranteed that the boys had the finest materials to work with. No ordinary bam-

@@ *Opposite:* Fur-trimmed hat with the fifth rank crystal finial with a peacock feather hat tassel in the foreground. Peacock feathers were reserved for those of the fifth rank or higher. They were awarded by the emperor for special services in the civil ranks and for bravery in the military. Up to three feathers could be worn. The extent of the honor was measured by how many "eyes" were seen. (From the author's collection, Larry Kunkel Photography)

boo and paper kites for them. Fine silk, good enough for special New Year's gowns for the ladies of the house, was ordered. Strong, light in weight and wondrous in color, it was the perfect material for the sky-born works of art.

◎◎ These little boys will be educated, but their sisters will not. (From *Chinese Heroes* by Isaac Headland Taylor, Eaton & Mains, New York, 1902)

Ho taught Bao Bao how to split pieces of bamboo to just the right width, then soak them in water to make them pliable enough to bend into circles or any needed shape. They might be round like the sun or the moon, or octagonal, or shaped like a butterfly, a goldfish, a hawk, a caterpillar or a centipede, which was made with a series of round frames that wiggled through the air in the same manner the creature crawled over the ground. If the kite was shaped like a bird, somewhere in the frame Ho secreted a whistle that trilled loudly, or a little wheel that hummed, as the bird rose and fell on the wind.

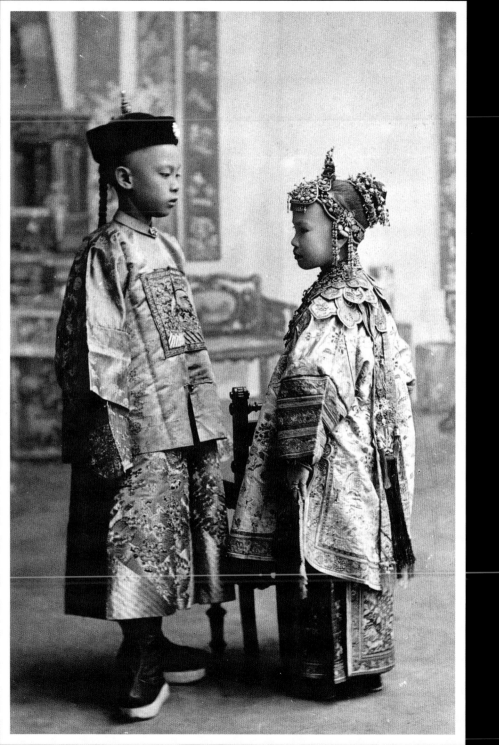

◎◎ A young boy and girl pose in fancy dress. During the Ch'ing dynasty unmarried daughters and minor (second, third, etc.) sons were authorized to wear the costume of their father, but not his rank square nor his hat ornaments. However, late in the dynasty the clothing regulations were treated rather loosely by the wealthy Chinese. (Courtesy of the Peabody & Essex Museum, Salem, MA)

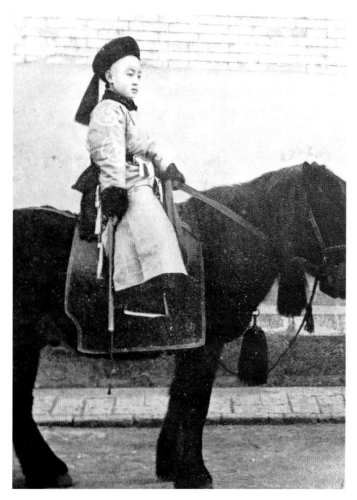

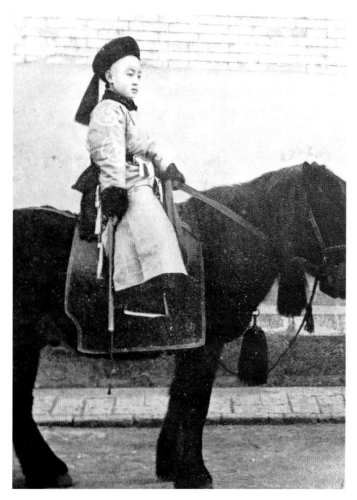

Young P'u Ju, cousin of the Emperor Kuang Hsu, takes time out from his studies to go riding in style. (From *China Under the Empress Dowager* by J. O. P. Bland and E. Backhouse, J. P. Lippincott Co., London, 1911)

Opposite: An elegant young boy in winter robes. (From *In the Land of the Blue Gown* by Mrs. Archibald Little, T. Fisher Unwin, Ltd., London, 1902)

Spectators in the compound and elsewhere were always awed by the creations Ho and his little helper sent aloft on the ninth day of the ninth month. Bao Bao's proud father, normally a distant austere man, watched the beautiful kite handled by his only son soar skyward and float on the breeze, and smiled.

Yu Lian watched with an expression of arrogant self-satisfaction, while fingering the strand of one hundred and eight perfectly matched jadeite beads of deep lavender tone, which she had received after her son's birth. Was she anticipating a matching bangle, or possibly another necklace she coveted, one of translucent apple-green jade? She had dressed with great care for this occasion, knowing that many eyes would be upon her as well as her little kite flyer. Her hairdresser had spent hours on her coiffeur, first creating a special preparation from very thin shavings of a wood called *pau-hua-mo* soaked in water until a sticky, jelly-like substance was achieved. Yu Lian was so prideful of her long black hair, she would allow only shavings from trees grown in Kwangtung Province, supposedly the best in all China, to be used. This mixture, applied with boxwood combs from the city of Kiangsu, made her hair shiny and strong.

After a thorough combing with the sticky gel, the hair was worked into elaborate coils that were literally sewn into place, the intricate construction hiding the threads. Dagger-like golden hair ornaments embellished with flowers, birds, bats and butterflies of vibrant blue kingfisher feathers, pearls, bits of coral, and carved jade were inserted into the hair at interesting angles. The birds and butterflies were often on tiny, hidden gold springs so that they danced and fluttered as Yu Lian moved her head.

She always wore earrings, as did most women in China, rich and poor. Little girls usually had their ears pierced by the age of five. The most auspicious day for this procedure was the tenth day of the tenth moon, when it was believed that no inflammation of the ears would develop from the piercing. But as extra insurance,

the needle used to pierce the ears was thrown down the nearest well immediately following the operation. (I personally know of no medical reason for this bit of precaution!)

Yu Lian was understandably proud of her tiny feet—perfect three-inch golden lotuses covered by exquisite little shoes embroidered in gold and silver thread and appliquéed with freshwater pearls. Yu Lian was the only woman in the entire compound who did not make her own shoes. Even the very old mother of the Master made her own little black velvet slippers. But Yu Lian had no interest in sewing. She bribed the most skilled of the compound's many sewing amahs to make original slippers to match her gowns. Tiny bells were sewn into the heels, and on very special shoes, butterflies quivered on silver springs attached at the toes.

The Master particularly enjoyed the celebration of the ninth day of the ninth month and it was more than just pride in his only son's prowess with kites. There was some happy memory from his own childhood, about which no one knew, involved with this holiday. But he was not a man to share his inner thoughts. As a special treat for his household and guests on this special day, he invited entertainers into the main courtyard of the vast estate. Among the most popular performers were stilt-walking boys, many of whom were colorfully dressed as women right down to their imitation bound feet. The women in the audience giggled behind their fans as the boys imitated the distinctive lotus gait, while the men and children roared with laughter quite openly.

A special treat for the children and servants was a puppet show, complete with a small stage set on tall poles at the far end of the courtyard. The puppeteer was hidden beneath heavy curtains descending from the stage. His

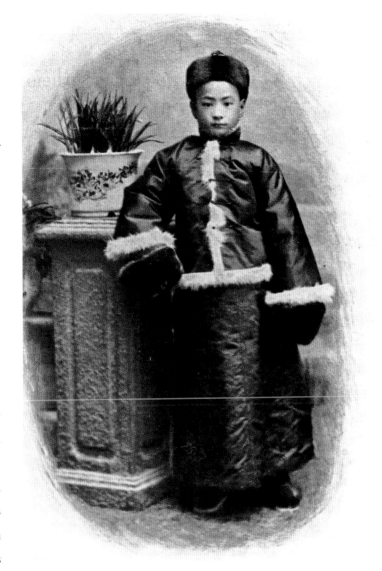

plays were based on popular legends from the past involving emperors, empresses, members of their court, mighty military warriors, ferocious or gentle animals, favored lohans. Each performance was a surprise that was seldom repeated.

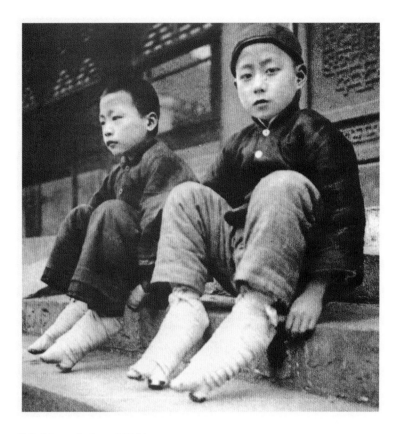

⊚⊚ Up until about 1900 boys or men played female roles in Chinese theatrical companies. If a character had bound feet, the actor would have his feet strapped to a wooden contraption (see above). Some young boys preparing for a career in classical opera playing female roles often had their feet bound permanently. (From the author's collection)

Celebration of this holiday was not confined to affluent city dwellers. As the persimmons on trees, bare of leaves, turned bright orange and the chrysanthemum moon rose in the sky, Shou Shou prepared for the event with the help of a young uncle, Sih Su, who lived in a village at the foot of the mountain. Shou Shou had the advantage of having wide fields and rolling meadows where he could run far and fast to raise his kite. Of course, he and Sih Su worked only with paper and paint. But even without costly silks and the finest bamboo, their creations were startlingly real, thanks to a firsthand understanding of birds and flowers and animals gained only by living closely with them.

When Shou Shou was still very young, Sih Su taught him how to participate in kite fights, and built ferocious looking hawks or snakes to intimidate his opponents. After building the fighting kites, Sih Su dipped the kite strings into a glue made from fish, then into powdered porcelain or glass so that his strings could cut through an opponent's kite string.

Another favorite plaything for young Shou Shou was a jump rope given to him by Sih Su. It was fashioned from a large elastic loop that was anywhere from six to twelve feet in diameter. Three children worked the jump rope together. Standing inside the rope, two of them stretched it into a long rectangle, one with the rope at his ankles, the other with it up at the waist, or even higher. The third person (sometimes there were several jumpers) took turns jumping over the lower end of the rectangle. After each jump, the two "holders" raised the lower end a little bit. Anyone touching the lower side of the jump rope was

counted out. The winner was the last jumper remaining. And that was very frequently Shou Shou.

While Bao Bao had been assigned a tutor at the age of three to start him on his path toward the civil exams, Shou Shou's family could not afford this luxury. When he was three years old, he was foraging for firewood and carrying water up the mountain. But his inquiring mind never stopped, and he learned eagerly from by his young uncle Sih Su who had spent five years at a village school.

By the time Shou Shou was five years old, his family was aware that he was a very exceptional child. At Sih Su's urging, it was decided that he was to be liberated from working in the fields and allowed to attend a village school. Because the distance was great, and weather was unpredictable in the mountains, Shou Shou went to live with Sih Su's family in the village. This almost broke Lan Xiang's heart, but she knew that the gods had planned a very special future for her little boy and she must not prevent him from fulfilling his destiny.

Although Shou Shou missed his family terribly, and sometimes felt homesick for the mountains and forests, he was such a happy, loving child that he quickly grew quite fond of his relatives. And, of course, Sih Su became his closest friend.

He settled in quickly and everyone adored him. A short time after his arrival, he lost his first tooth. Word spread quickly through the village and each relative that came took turns rubbing their fingers in Shou Shou's mouth on the place where the lost tooth had been to bring the little boy good luck.

Shou Shou and his male cousins all slept on the same *kang* (bed) in the crowded room where the family slept. The *kang* was made of bricks covered with

Servants in the home of Bao Gui had little time to rest like these fellows. (From *Things Seen in China* by J. R. Chitty, Seeley, Service & Co., Ltd., London, 1922)

43

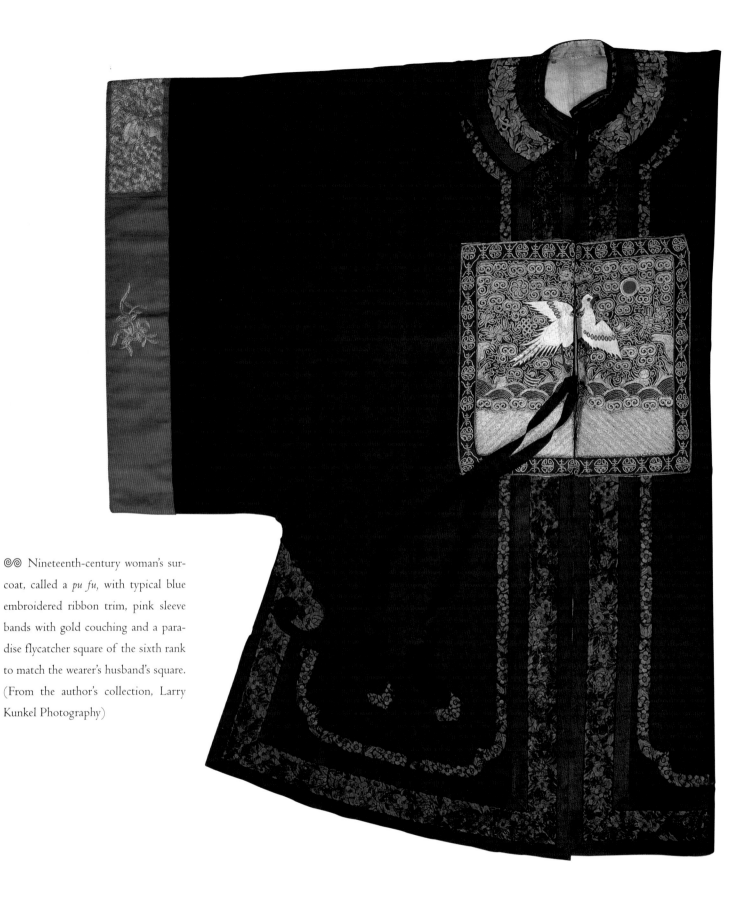

⊙⊘ Nineteenth-century woman's sur-
coat, called a *pu fu,* with typical blue
embroidered ribbon trim, pink sleeve
bands with gold couching and a para-
dise flycatcher square of the sixth rank
to match the wearer's husband's square.
(From the author's collection, Larry
Kunkel Photography)

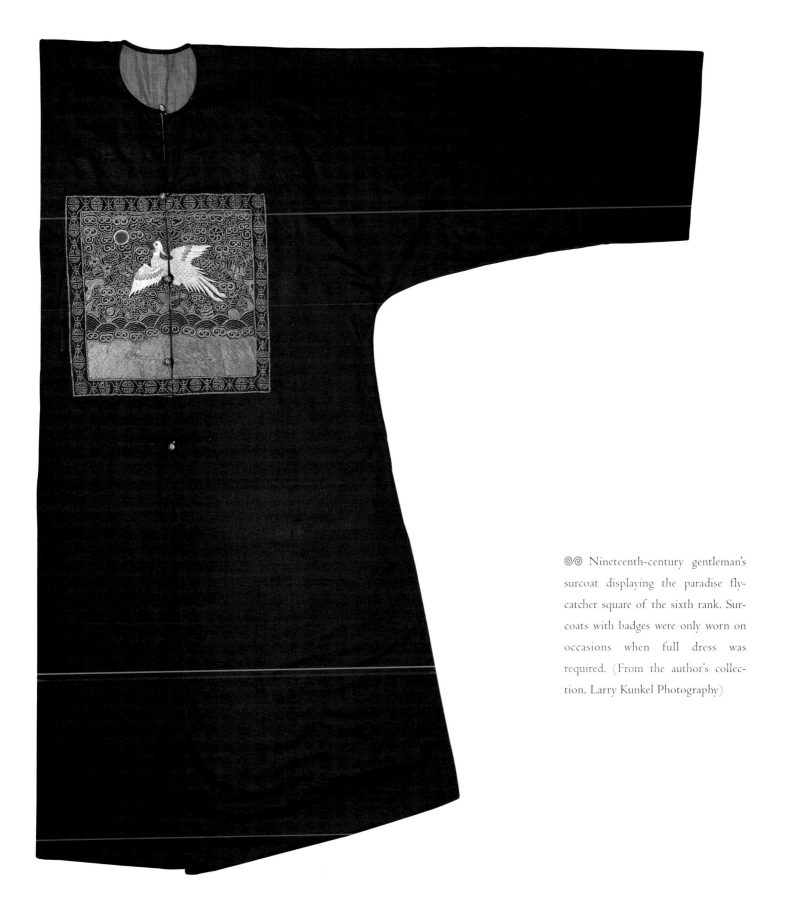

Nineteenth-century gentleman's surcoat displaying the paradise fly-catcher square of the sixth rank. Surcoats with badges were only worn on occasions when full dress was required. (From the author's collection, Larry Kunkel Photography)

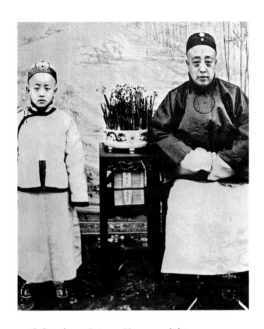

a reed mat and a thin comforter. In cold weather, the *kang* was warmed by hot air that flowed from the kitchen stove into the space beneath the bricks. The boys' pillows were very small and stuffed with chaff or seeds.

Together they would rise before the sun was up. "Awake in the morning, arise with the sun. Retire late at night when your lessons are done." They folded up their bedding and stored it away in the bedding chest, then ate a simple breakfast, and set off for the village school. Each carried a pile of books wrapped in a blue cotton square. The books had come down through the generations of male family members who had also received an education. There was no question of them being outdated because the curriculum in Chinese schools changed very little through the centuries. Many of the books used had been written by the followers of Confucius and Mencius.

The little school house was cold and damp in winter and unbearably hot in summer. And the school master was not a very learned man. But he was not a cruel man either, which was very unusual. The Chinese believed that severity was a teacher's prime virtue. So the fact that he didn't beat or punish his pupils was virtually unheard of according to the standard of the day.

Shou Shou learned so quickly that by the time he was seven his young uncle realized he had outgrown the village school. The family had to find a real scholar to tutor their young ward. Shou Shou was a prime candidate to take the civil exams one day, which, should he pass them, would make him a very important man, a man of rank, a man of status. He would bring fame, pride and privilege to his family and to their village.

▢ ▢ ▢

The old formal Chinese learning process was based almost exclusively on noisy repetition. First, the master introduced a small selection of characters (of which there are some seven thousand) to the class. Then his pupils were expected to recite each character after him, first in a normal speaking tone, then over and over again at a shout. (Because the Chinese believed that the intellectual faculties were centered in the stomach, the purpose of this teaching method was to literally "put them in their stomachs.") Thus, the boys learned the sound of

each character, but seldom had any real knowledge of what it meant.

After they had learned at least a thousand characters it was time to start reading the classics. This was, in reality, a memorization marathon, with few of them really understanding what they were reading or reciting out loud.

The curriculum always began with the book known as the *Three Character Classic.* The boys had to memorize passages exactly as they were written—no personal interpretations were allowed. Individuality was not only discouraged, it was forbidden.

The *Three Character Classic* describes large, important concepts in terms of numbers, beginning with the number three. The book recognized three powers: heaven, earth and man; and three lights: the sun, the moon and the stars; and then three relationships: between a prince and his minister there is justice, between a father and son there is affection, and between a husband and wife there is harmony. No further elaboration was offered to illuminate these cosmic principles.

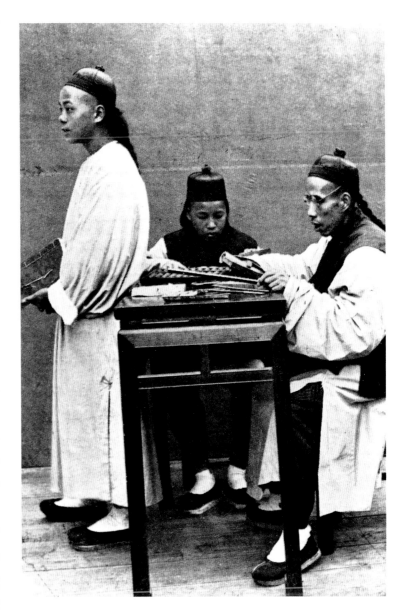

The student had to recite these concepts aloud over and over until they were thoroughly digested. Then he went down on all fours, a symbolic gesture signifying the number four, which was also symbolized by the four seasons. The number five was represented by the five directions: north, south, east, west and center; and by the five cardinal virtues: humanity, justice, propriety, wisdom and truth. The sixes included the six types of grain grown in China: rice, millet, rye, barley, wheat and pulse; and the six most common domestic animals raised in China: pigs, cows, sheep, horses, dogs, and fowl. The number seven listed the passions: love, hatred, fear, joy, sorrow, anger and desire. The number

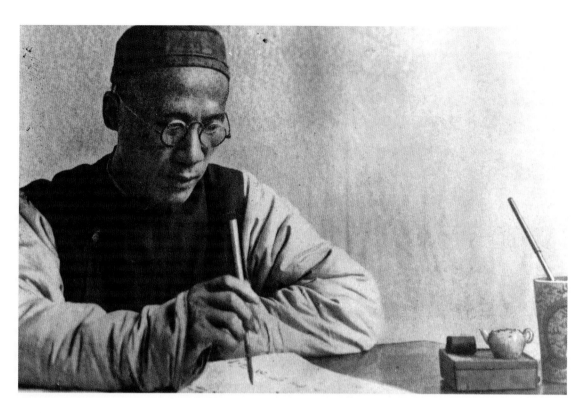

❀❀ A Chinese scholar practicing calligraphy. (From *The Uplift of China* by the Church Missionary Society, London, 1909)

eight was paired with eight musical instruments and/or the materials from which they were made: silk for stringed instruments, bamboo for flutes, skin for drums, gourds, earth to make porcelain, wood, metal and stone. The number nine was concerned with relationships between four senior and four junior generations, with the student in the center as the ninth. Ten was represented by ten moral relationships that included the affection between father and son; concord between husband and wife; the proper dealings between an elder and a younger brother; friendship between friends; proprieties to be maintained between seniors and juniors; and the relationship between a prince and his minister. When all this was memorized and repeated by rote, with no true understanding, it was time to move on to the classics, including the works of Confucius and Mencius.

Gold and jade although so dear
Waste away and disappear
Education is kept within you.

48

At the beginning of the twentieth century Professor and Dr. Isaac Taylor Headland went to China to live and work. Professor Headland taught at Peking University and his wife spent twenty fascinating years as physician to the family of the Empress Dowager's mother, the Empress' sister, many of the princesses and several wives of high officials.

The Headlands cared deeply about the Chinese people and made careful observations of their many customs. In 1914 Professor Headland published a book titled *Home Life in China*. In this book he "put to verse" some of the stories passed down through the generations about boys, their schooling, and their study habits, which were governed by such handicaps as little or no lighting facilities in their dark homes:

Sun K'ang was a diligent boy.
As almost all of you know;
For he studied at night by the pale moonlight,
Reflected in the snow.

Little Ch'e Wu
Was diligent too;
For he studied at night,
By a fire-fly's light,
As diligent boys should do.

K'ang Hung's house was a house of clay,
He studied hard throughout the day,
And made a hole through his wall at night,
To study by his neighbour's light.

Sitting on a rock, the student,
Who assistance will not ask,
Takes advantage of the moonlight
To prepare tomorrow's task.

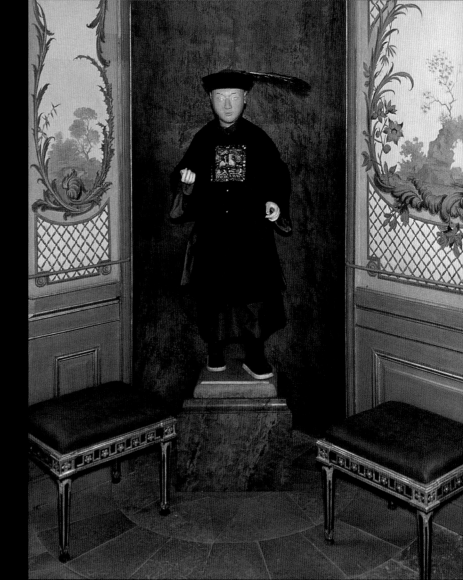

A figure of a mandarin, about half life-size, complete with rank badge, silk surcoat, boots, winter hat and peacock feather tassel resides in the Green Salon of the Chinese Pavilion. (Courtesy of the Royal Collection at Drottnigholm, Sweden)

The life led by students and their tutors in China was not easy. In 1902 Isaac Taylor Headland wrote *China Heroes*, a book about his experiences living and working in China. On one occasion in Peking he encountered a young Chinese man.

"Where do you live?" Headland inquired.

"I live in the Province of Shantung, the village of An Chia, near T'ai-an Fu," his acquaintance replied.

"What is your business, sir?" Headland queried further.

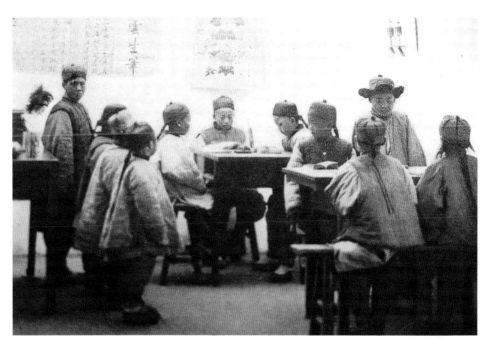

Chinese students at school sat on hard narrow benches when writing, but stood for recitation. (From *Chinese Characteristics* by Arthur H. Smith, Fleming H. Revell Co., New York, Chicago, Toronto, 1894)

"I have no business at present, but am in Peking to attend the examinations."

Headland went on to explain: "Teacher Wang was of delicate constitution, with much of the appearance of one in the later stages of consumption. He was a first graduate and was in Peking preparing to enter the examinations for the master's degree. He had left his home in Shantung, four hundred miles distant, where he dwelt in a small country village in the neighborhood of the tomb of Confucius, the great master of Chinese morals, and had spent two months on the road to the capital, where he arrived in time for the great examinations. These he failed to pass."

The unfortunate young man walked four hundred miles back home to his village, to face the disappointed relatives and friends who had financed his trip to Peking to take the higher exams. No, the life of a student was not an easy one!

Chinese students worked in the same way for hundreds of years. Education in China was not based upon advanced learning, new technology, discovery. It was based entirely upon memorizing entire books, some filled with more than 100,000 characters written hundreds of years before. One never deviated from the past when it came to educating the young.

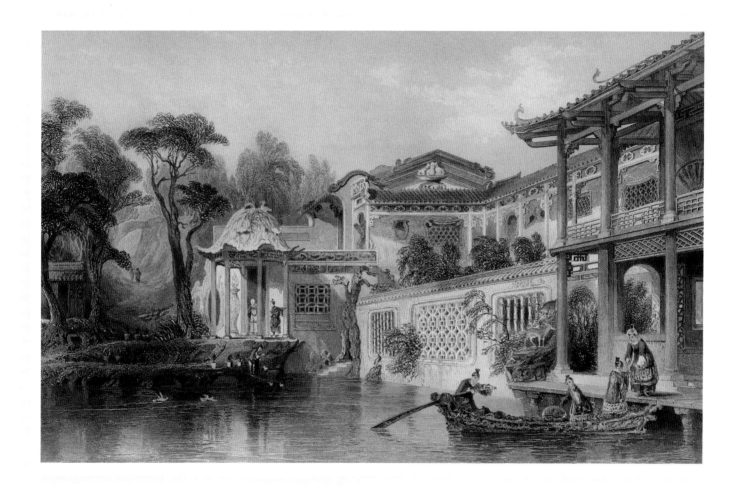

The compound and gardens of a wealthy Chinese merchant in the suburbs of Canton, as interpreted by a nineteenth-century English artist. (From the author's collection)

By today's standards, this system of education was supposed to instill conformity and subservience, as well as the mindless memorization of "information." It was not only out of touch with the real world, but basically unfair, particularly to any young man with a creative a curious mind, and an inability to memorize. Such a student didn't stand a chance unless he was very clever at cheating!

Confucian thought was part of a boy's education from the beginning. For those who attended school, instead of being tutored at home, it began on the first day with each pupil bowing in reverence before the Tablet of the Great Sage Confucius. Then the boys prostrated themselves in front of their teacher, offering him little packages of money wrapped in red paper.

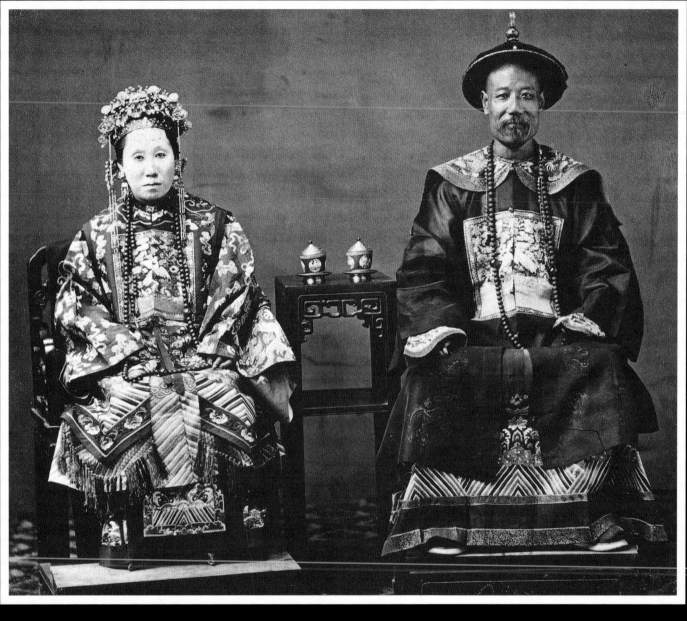

◎◎ A mandarin of third rank with his wife. Notice the peacocks in their badges face one another. (Courtesy of the Peabody & Essex Museum, Salem, MA)

CHAPTER 4

CLIMBING THE LADDER
TO THE CLOUDS

Shou Shou's young uncle, Sih Su, sent out the word that a learned tutor was needed for Shou Shou. His message spread throughout the entire province, almost as quickly as it would have today with the telephone, fax and e-mail. Family members traveling on horseback or on foot passed it along from village to village. It was picked up by a distant relative who made his living on the canals by driving hundreds of ducks to market ahead of his small boat along the waterway. The ducks were kept in order with a long, slender bamboo rod with a palm leaf attached at the end. This man passed the word to other boat people and they carried it along the Grand Canal, the artificial river built centuries ago to join central and northern China, all the way to the capital.

Somewhere along the way the message from Sih Su found a distant member of the clan who knew of an elderly scholar who had passed his exams and achieved the lowest rank. He had served his government faithfully for many years. But when his retirement came, illness, famine and accident took all his close relatives. Finding himself alone and getting on in years, he moved very near to Shu Shu's village, to be cared for by a grand-nephew and his family.

And so Professor Wu Kuan-Ming, a man who had passed his civil exams thirty-five years previously, came into Shou Shou's life. Professor Wu had achieved the distinguished honor of being allowed to wear the seventh rank badge

◎◎ *Opposite:* A winter hat topped by a crystal finial of the fifth rank with a couched gold and silver pheasant badge of the fifth rank and a complete set of nine hat finials. (Ruby finial from the collection of Jon Riis, other hat finials from the author's collection, couched badge from a private collection, Larry Kunkel Photography)

55

◎◎ Shen Toh, an imperial tutor.
(From *A Cycle of Cathay* by W. A. P. Martin, Oliphant, Anderson & Ferrier, Edinburgh & London, 1896)

of a mandarin duck on his black surcoat. And on his hats he wore the finial of plain gold, the hat button of seventh rank civil.

On the day Shou Shou was to commence his studies, the usually enthusiastic pupil dragged his feet and trudged slowly along the dirt road that lead to Professor Wu Kuan-Ming's grand-nephew's home. Shou Shou would be spending much of his life in the coming years with Professor Wu, and he knew how important this meeting would be to him, and to all the relatives and friends who had shown so much faith in his potential. What if the professor did not like him? What if he proved unable to learn? What if he turned out to be a disappointment to all those who had been so supportive.

The modest house of Professor Wu's grandnephew's family was a far cry from the fine quarters in which he would have received his new pupil when he had held an important post and lived in a large *yamen* (district headquarters) in Yunnan Province. On this day, Professor Wu had only his knowledge to offer, the knowledge that was hard-won from long years of preparing for his own examinations and garnered from a career of dealing with people of all types in his government position.

Professor Wu stood tall in his worn pale gray scholar's robe, looking kind and weary. Shou Shou kept his eyes respectfully downcast but managed to steal a swift glance at the old man. The professor didn't seem to be the menacing monster Shou Shou had imagined. He spoke gently to the little boy, asking if he was tired from the long walk. Would he like a drink of water from their well? Slowly, Shou Shou's confidence grew, because his respected professor was a kind man.

Bao Bao began his formal education at the age of three with the finest tutors available. His lack of interest in his studies and his terrible temper tantrums did nothing to endear him to his tutors. And there were many. When the Master was

∞ This dour looking gentleman is probably not a mandarin at all, but has dressed up to look like one (or so he thinks) for his portrait. The robe he is wearing is not a *pu-fu*, but is a regular right-side closing robe. We recall that *pu-fus* were split down the front which caused front badges to be split also. The badge does not appear to be fixed to the robe. The badge placement is wrong in that it encroaches on the border along the side closure. And, finally, the badge is a female badge. (Courtesy of the Peabody & Essex Museum, Salem, MA)

not pleased with the boy's progress, however, it was always the tutor who was at fault. Just as Bao Bao had been indulged with toys, he was also indulged with blamelessness at a time when he most needed discipline.

57

◎◎ An eighteenth-century French artist's view of one of the many canals that were conduits of commerce and communication to the city. (From the author's collection)

The years passed quickly for the two boys. Shou Shou lived for his studies and was a joy to Professor Wu. Not only did he memorize quickly and accurately, but he added the dimension of personal reasoning and human feeling to his studies. And he was fortunate to have such an unusual teacher who did not try to discourage these traits.

He studied the required classical books and still found time to devour the works of such philosophers as Lao Tzu, Chuang Tzu and other apostles of the Tao. Unlike most teachers, Professor Wu did not adhere strictly to the established

curriculum but tried to make the studies interesting for the inquisitive boy. His own curiosity had led the elderly tutor to knowledge beyond the memorized classics, and he was happy to share some of it with the youth who brought him such pleasure and pride. After a few months of working with Shou Shou, Professor Wu shared his thoughts with Sih Su: "Shou Shou has such a fine mind. I foresee one day he shall be a great tree in the Forest of Pencils[1] and then a high minister of state."

When it was time for Shou Shou to learn to write, his tutor not only taught him the characters, he also gave him a historical context for writing, including the development of paper in China. He told the story of Ts'ai Lun, a man of high rank who was Director of the Imperial Arsenals, a man who also had a lively mind who came up with the formula for making paper by combining old rags, tree bark, fishing nets and hemp. In 105 A.D. Ts'ai Lun went to the Emperor with his invention and paper was born.

From the first day that Shou Shou learned how to pour a few drops of water onto an ink stone, a mixture of pine soot and glue, and clasped his fox hair brush in his small hand, he felt a passion for calligraphy. He placed the thin paper over the sheet he was to copy, and moved the brush with care.

When Shou Shou returned home for the annual New Year's holiday, he took fine samples of his calligraphy as gifts to his parents. They could not read them of course, but marveled at the beauty of the brush strokes, and hung them with pride in a place of honor in their tiny home.

Schooling went on seven days a week. There were no weekends off or regular holidays from school except at the New Year, and occasionally for the Dragon Boat Festival, which fell on the very day both Shou Shou and Bao Bao were born. Shou Shou was always home with his family on New Year's. On the first day of the Chinese lunar year, he helped his mother clean every corner of their humble dwelling. Every item in the house was scrubbed and dried in the sun and the beaten mud floor was swept and swept and swept. Even the little basket lined with clean rags that had served as Shou Shou's cradle, which Lan Xiang saved as a treasure from the past, was washed and dried with great care.

Above: A European gentleman at the examination cells of a provincial examination hall. (From *The Lore of Cathay*, Fleming H. Revell Company, New York, 1901) Right: A European gentleman at the furnace for burning examination papers. (From *The Lore of Cathay*, Fleming H. Revell Company, New York, 1901)

Here in the home of his childhood, he paid homage to his ancestors with kowtows, prayers, incense and food offerings, and delighted everyone with his musical accomplishments. A friend of Professor Wu, who had followed the boy's studies with interest, taught Shou Shou to play the *san-hsien*, a long-necked lute with three strings. With time, Shou Shou grew into a first rate musician and on some nights in the village, down in the valley, he entertained groups of his tutor's friends and contemporaries with favorite songs from the past. Shou Shou brought great joy to these old men, and in appreciation they pooled their resources and bought him a *san-hsien* of his own. It was this instrument that he carried up the mountain each year at New Year's to play for his own family who claimed they had never heard such beautiful music. They probably, in fact, never had.

Bao Bao followed a very different path as the years passed. He studied little and played hard, and his forays into the city were no longer accompanied by his

◌◌ A European gentleman at one of the gates on the examination grounds. (From *The Lore of Cathay*, Fleming H. Revell Company, New York, 1901)

old amah. She would have been horrified by the places he frequented, although word of his escapades did get back to her through the servants' gossip.

The music Bao Bao preferred was played on the *p'i-p'a* (2) by sing-song girls in the blue-shuttered flower houses (houses of prostitution) he visited regularly in the city.

If Bao Bao's father recognized the path his son was following, he gave no indication. Bao Bao kept up a convincing pretense of studiousness, for he was a very cunning young man, and, besides, his father was preoccupied with his beautiful new young bride.

His mother, Yu Lian, had eventually received her coveted green jade necklace, and, for awhile, she had kept the Master in the palm of her hand. After all, she had produced his eldest son. But her ugly temper began to manifest itself in his presence, and he spent fewer and fewer nights with her in her intricately carved rosewood bed. Soon a new young concubine joined the household. Then another. And, finally, his beautiful, new, even younger bride arrived.

Yu Lian was seen and heard from less and less, as she fell deeper and deeper under the spell of her opium pipe. The only activity that seemed to rouse her was watching her maid take a bit of the gummy opiate from the little engraved silver opium box, shaped like one of her tiny lotus shoes the master had most admired in the days when they were together. Yu Lian's eyes glowed with anticipation as the opium was held on a spindle-shaped needle over a candle-lit burner. When the opium bubbled, it was placed in the silver, tortoiseshell and ivory opium pipe, and the maid handed it to Yu Lian. Reclining on her splendidly carved bed, the once beautiful woman held the bowl of the pipe over the candle and began to inhale the smoke that slowly spiraled upward, hovering over her in a heavy, sweet-smelling haze. Slowly she slipped into another world, a world that had become her primary reality.

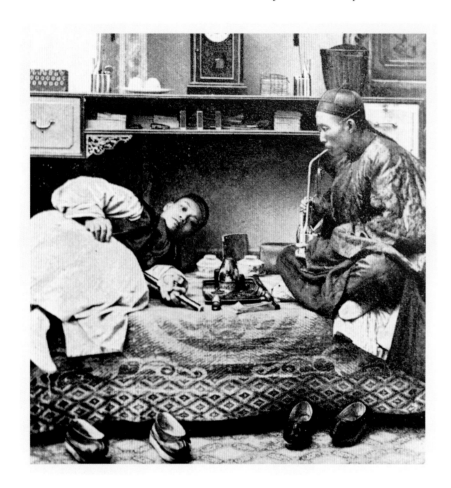

❀ In China men could go to public opium houses or brothels, but women had to smoke behind closed doors at home. (From *John Stoddard's Lectures* by John L. Stoddard, Balch Brothers Co., Boston, 1897)

□ □ □

"One might be a farmhouse lad in the morning:
But by dusk is elevated to the court of the Son of Heaven."[3]

Students who trained to take the examinations for civil rank in China were also taught to memorize and recite, rather than to analyze and think. They were taught to read the old classics aloud as though singing a song. It was felt that by learning this way, the emotional content of the writing was absorbed. In fact, it did teach them to utilize their memory to the fullest. By the time they were considered ready to sit for the exams, the students should have been able to recite from memory most of the Six Classics or "sacred literature," as well as poems by the great poets. This was crucial because when

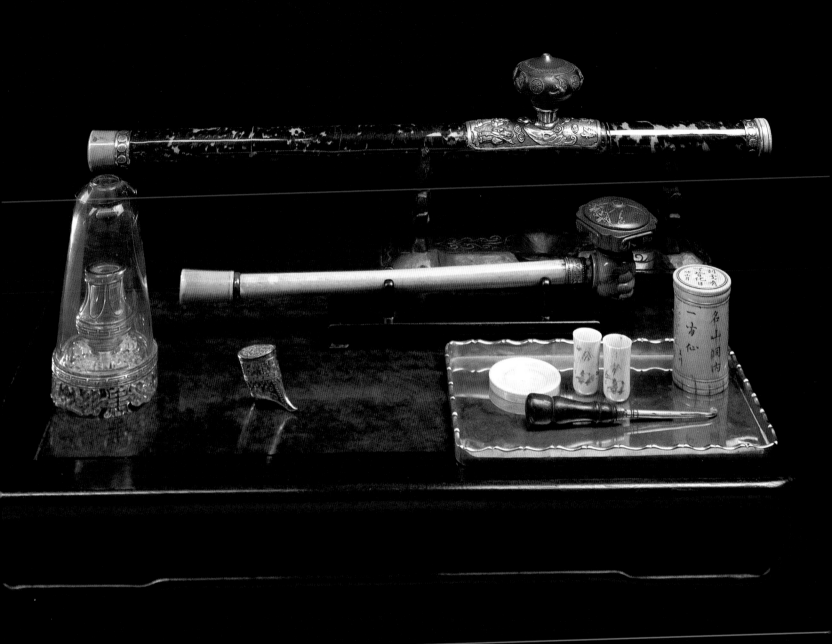

Accessories for smoking opium. The pipe is covered in tortoiseshell with silver fittings, the lamp is Peking glass, and other accoutrements are silver and ivory. (Courtesy of Philippe Bosio)

Plan of the examination halls in Peking. The central buildings housed the exam graders and administrative staff. The students were in the multitude of cells that filled the grounds. (From *In Search of Old Peking* by L. C. Arlington and William Lewishon, Henry Vetch, The French Bookstore, Peking, 1935)

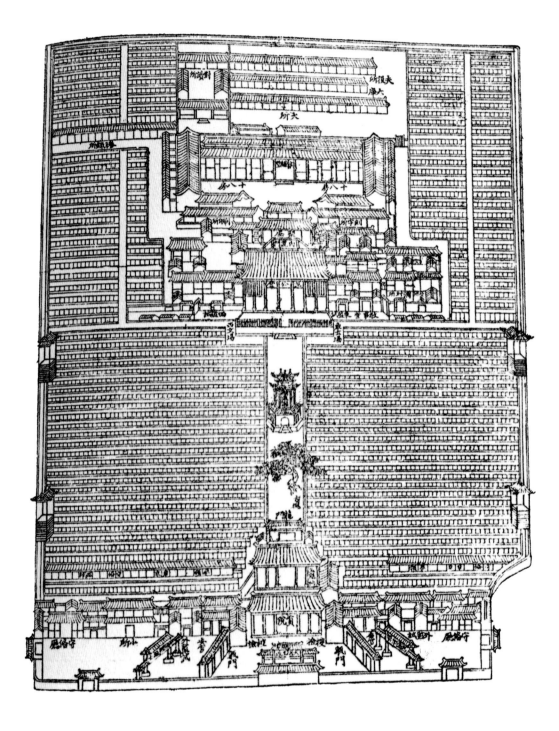

୧୨ *Above:* The examination halls in Peking. (From *In Search of Old Peking* by L. C. Arlington and William Lewishon, Henry Vetch, The French Bookstore, Peking, 1935) ୧୨ *Left:* A view of the vast rows of tile-roofed cells within the walls of the examination grounds in Nanking. (From *National Geographic Magazine,* 1927)

writing their exam compositions they had to be able to cite passages word for word from the classics.

The imperial examination system in China was in place by the T'ang Dynasty which used it for staffing their complicated government bureaucracy. There was a very well-organized Confucian order of government with the Emperor at the apex, and the examination degree-holders and scholarly civil servants sharing the bureaucracy with the military leaders.

The nomadic invasions that followed resulted in the rule of tribal law during the Liao, Jin, and Yuan dynasties. Thus the examination system disappeared, and was not to be restored until 1315 AD.

Under the Manchus, the civil administration of China became a dual system of appointments with Chinese and Manchus placed in important positions. Although Manchus predominated in the capital where the emperor resided, out in the provinces it was Chinese officials who predominated. For this reason the Manchus enforced the process of examinations, keeping them at a very high level of efficiency to give their government the best Chinese officials possible. The machinery of Chinese government became very complex, with tremendous numbers of men involved. And at the apex of this governmental system, along with the emperor, was the examination system.

How did it all work? In every district of China there were two resident examiners who each held the title of professor. Their duty was to keep a register of names of all the boys in their district who would be taking the preliminary examinations. They were also expected to keep track of the boys and encourage them in their studies.

In every province of China there was a superintendent of instruction, or chancellor, who was in office for three years in one location. He was required to visit every district in his province once a year, and there might have been as many as sixty or seventy districts in his area. Under each chancellor there was a resident sub-chancellor. It was the latter's duty to evaluate the potential candidates for examinations before the arrival of the provincial chancellor. The age-range of men preparing to take the exams was astounding. While the majority were young,

◎◎ Another view of the examination grounds in Canton. (From *Things Seen in China* by J. R. Chitty, Seeley, Service Co.,Ltd., London, 1922) ◎◎ *Opposite:* The examination grounds in Canton. The characters on the ends of each cell were taken from the *Primer of a Thousand Characters*, a poem of 250 lines with no character repeated. Since each character was unique, a character was used to designate a row, and a number to designate a cell in that row was used to assign students to their respective cells. (From *A Little Journey to China and Japan* by Marion M. George, Flanagan Co., 1900)

there could be men of seventy or eighty years old who had spent their entire lives studying for the exams, and in many cases had had to repeat them again and again in hopes of eventually passing.

The provincial chancellor was responsible for awarding the first degree only. There were usually about two thousand boys in each district preparing for the first degree examination. Generally fifteen or twenty in each department would be awarded *Hsiu-ts'ai*, the first degree or Flower of Talent degree, which could be compared with today's bachelor of arts degree. The successful students, one per-

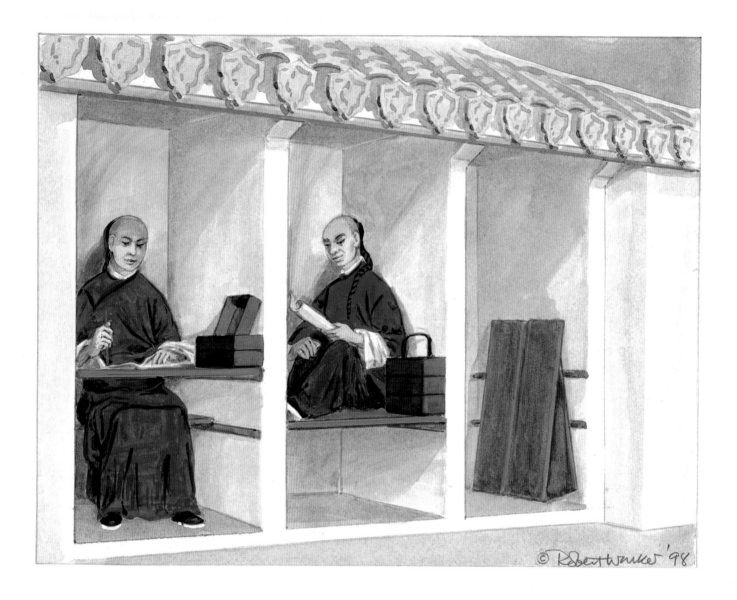

cent of the candidates, would then be entitled to wear the ninth rank insignia, the paradise flycatcher.

The second degree *Chu-jen* or Promoted Scholar can be compared to a Western masters degree. And the third *Chin-shih* or Fit for Office compares to doctor of laws degree. There was also a possible fourth honor, the *Han-lin* or member

of the Forest of Pencils, which granted membership in the Imperial Academy that was located in Peking.

By the early nineteenth century the legitimate students who passed the first degree examinations were joined by another large group called *chien-sheng* who had secured their positions through monetary exchanges rather than passing a written exam. During this period there were approximately 1,100,000 men with *Hsiu-ts'ai* or first level degree rating. And, rather shockingly, it has been recorded that possibly as many as a third of this number secured their position by making financial contributions, at an established rate, to the government.[4] Wan Guifei, the very powerful number-one concubine of emperor Chenghua (1465–1487), along with her favorite eunuch, Liang Fang, and a notorious eunuch chief of police Wang Zhi, had an imperial shop that sold ranks and titles.

□ □ □

By the time they were about fifteen, the boys had reached an age where these childhood names could no longer continue. The spoiled, cunning Bao Bao was now known as Bao Gui (Treasured and Honored) though he was no longer his mother's double, or single, treasure. Shou Shou was now called Yong Shang (To

天開文運

Above: Entrance to a provincial examination hall. (From the author's collection) *Opposite:* Examination halls at Chengtu. (From *In the Land of the Blue Gown* by Mrs. Archibald Little, T. Fisher Unwin, London, 1902)

Have a Better Life) and did his best to live up to his mother's dream when she selected a name for her new baby boy.

What both boys had been studying for, one more seriously than the other, was the first of their civil exams. Yong Shang was well prepared. Bao Gui spent more time scheming how he could get crib notes into the examination than studying for it. He finally resorted to asking his old amah, who had denied him little in his life, to sew an inner lining into the robe he would wear for the exams. The answers he needed would be written on the silk inside the secret lining. Thus, each in his way, the boys were ready to take the first competitive exam for the first

and lowest rank, Hsiu-ts'ai at, their local examination grounds. If successful, they would be part of the one percent of the candidates who were chosen.

Financed by the people of Young Uncle's village, Yong Shang made his way to the chief city of his province for the big event. Bao Gui went to his exam with something that Yong Shang neither had nor actually needed. Inside the simple robe he would wear during the examination was the inner lining his amah had made on which he had written everything he would need to enable him to pass. Bao Gui was by no means the first student to employ such creative methods. Students had been known for centuries to go to rather extravagant lengths to conceal such aids. Some had handkerchiefs embroidered with the exam notes done in the finest calligraphy and worked into an elaborate design. Another equally ingenious technique was to write the notes on the interior edges of the bamboo or wicker parts of the exam basket which held the necessary pens, inks and other

supplies, that students were allowed to take with them into their cells. One very popular method of cheating was to hide notes inside hollowed out writing brushes. Some students were known to have their heads totally shaved and the exam notes written on the hairs of the wig and queue they wore to replace their own hair. A book from the fifteenth century has been discovered in which more than one hundred thousand Chinese characters were written, covering the *Annotated Five Classics* needed for the examinations. The characters were printed so small that a grain of rice covered eight characters!

Those who sat for the exam ranged in age from the mid-teens to the mid-seventies. The latter groups was comprised of elderly men who had competed unsuccessfully many times before. In Canton, *Kuung-Uuen* (the examination hall) consisted of eleven thousand, six hundred and seventy-three cell-like rooms situated side by side along narrow streets. Each cell was numbered, and each street was named. The examinations lasted one day and one night. In other cities, the examination facilities accommodated thousands more.

The cells were open in front, five feet, six inches long and three feet, eight inches wide, with very low ceilings. They were "furnished" with two wooden planks, one was a seat and the other functioned as a writing table. If a student wanted to try and get some rest, he lowered the table plank and placed it parallel with the seat to form a sleeping platform. At night they worked by candlelight. Meals, provided by the emperor, allowed each student four taels of boiled pork, four taels of ham, congee-water, six taels [5] of salt fish, a preserved egg, pickled vegetables, rice and four moon cakes. Bathroom facilities consisted of a container in their cell, or a trip to the public latrine at the end of each street of cells.

Once the candidates were closed into the examination compound, they had to remain inside. The gates were locked to the students as well as to the examination officials. There were no exceptions—not for medical reasons, not for death. Should the examiners decide it was necessary to remove a body to prevent contagion, a hole was cut in one of the exterior walls and the body was carried away. The gates were never unlocked.

The two chief examiners who were sent to each city to administer the examinations arrived in great style in open sedan chairs, each carried by eight men. The seat of the sedan chairs was covered with tiger's skin. Each examiner's seal of office was carried in front of his sedan chair on a platform beneath an ornately carved wooden canopy. Their escort to the examination hall included all city officials, a band, groups of banner men and a large contingent of soldiers.

Both Yong Shang and Bao Gui survived the harsh conditions and completed the two essays assigned by the chancellor. Of great importance on this first exam was penmanship and grace of expression.

Upon completion, the candidates went home to await the results. With such a tremendous number of exams to be checked, the chancellor and his clerks had an enormous task ahead of them. Only a small number of candidates passed and the chosen ones were the new holders of the Hsiu-ts'ai, or Flower of Talent, degree.

When a candidate was awarded this degree he was feted with feasts and parades in his home town or village. Placards announcing his success were sent to family and friends and these were often posted outside the recipient's home to show that they were friends with such an important man.

❦ Silk rondel showing Cao Guo-jiun, one of the Eight Immortals, carrying his signature castanets. (From a private collection, Douglas Chew Ho Art & Photographics)

(1) *Forest of Pencils* is a name given to the famous Hanlin College in Peking

(2) The *p'i-p'a*, an instrument with four strings and reversed peg-box, has been played in China since the Han dynasty (202 B.C.–A.D. 220). Its music is programmatic and allows the performer to display great virtuosity.

(3) One of the first things little boys were taught in school, to encourage all to study for the civil examinations.

(4) Fairbank and Twitchett: *The Cambridge History of China, Volume 10,* p. 12.

(5) Equivalent to one Chinese ounce.

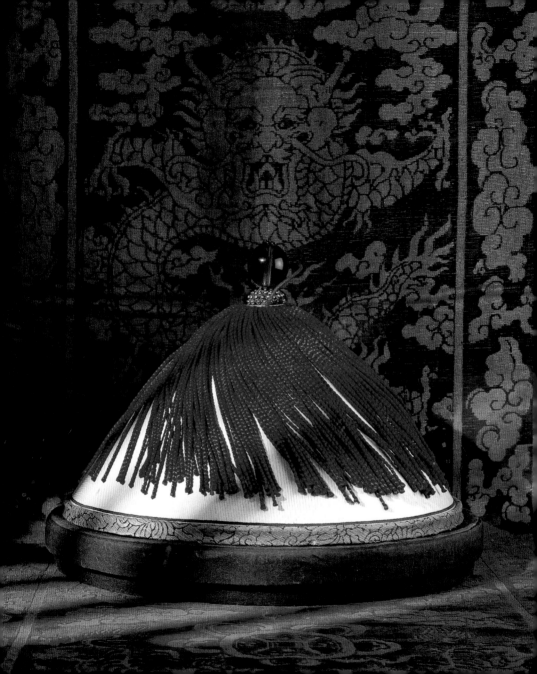

CHAPTER 5

ONE ASCENDS THE LADDER, ONE FALLS

Bao Gui's father hosted a tremendous feast for his eldest son when word came that he was a successful candidate. Friends and relatives poured into the compound for the joyous event. Sadly, Bao Gui's mother was in no condition to attend. But she was hardly missed.

An hour before the guests were scheduled to arrive, the guest of honor was summoned to meet his father in the Garden of Harmonious Pleasures. There the proud old man told his son of the pleasure his success with the exams had given him. Then, with stately formality, his father removed the *chao zhu* he was wearing and lowered it over his son's head.

Bao Gui looked down at the ancient court necklace composed of one hundred and eight amber colored Peking glass beads, divided into groups of twenty-seven by the four large rose quartz beads called "Buddha's Head." The long tape at the back held beads and pendants of rose quartz, and the three side strands of ten smaller beads were purple amethyst. He knew the significance of this gift. Officially, no one below fifth rank was privileged to wear the *chao zhu*. With this gesture, his father was telling him he expected Bao Gui to rise quickly in rank so that he could wear it in the near future with honesty.

But in the meantime, the feast that was prepared in his honor was the most elaborate the family chefs had ever created. The finest classical Chinese opera company was engaged to perform after the meal. The household maids who had

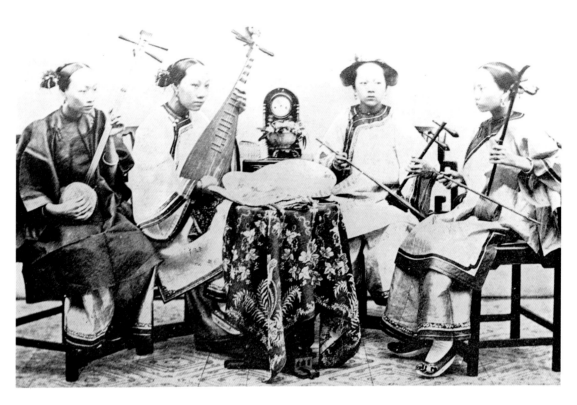

been trained as sing-song girls played for the guests while they dined. One of the girls had mastered the *cheng*, a kind of harpsichord, and played a solo to the delight of everyone in attendance. The fireworks display that ended the celebration was talked about for years afterwards by those who witnessed the incredible two-hour explosion of color patterns high in the moonless sky.

None of this really meant very much to Bao Gui. He had endured the seemingly endless evening just to please his father, whose vast wealth subsidized the undisciplined lifestyle he had chosen. Now Bao Gui was anxious to forget all about his studies and the exams and get back to his degenerate life of drinking, gambling and carousing with the flower girls.

Except for Ho the kite maker, Bao Gui had few friends as a child. After passing his exams, he found a new friend, Li. Li was a palace eunuch with a position important enough for him to have earned the sixth rank military badge embroidered with the panther cat, awarded by the emperor himself. It was very rare for a eunuch to ever achieve either military or civil rank.

Bao Gui met Li at a gambling party late one night, after he'd spent a few hours on a flower boat and grew bored with the girls. After several weeks of drinking and gambling together, one evening the eunuch offered to introduce the jaded young man to something new and took him on a tour of several of Peking's many male houses of prostitution. The city that had provided Bao Gui innocent diversions as a child now offered him very different diversions as a grown man.

The village where Yong Shang had lived with Sih Su and his family was overwhelmed with joy when word arrived that he had been a successful candidate. There was a parade through the village, and the men carried the new holder of the "Flower of Talent" degree on their shoulders. Yong Shang wore the emblem of his newly achieved rank on his hat and his insignia told the world that he was a successful man, an honor to his family, his professor, the school he had attended, and his village. After the feast the villagers participated in the *yang*, a rural village folk dance form dating back to the Song Dynasty (960-1279).

Everyone on the mountain where Yong Shang was born made the descent to the village for the celebration. Even the very old ladies with their three-inch or four-inch bound feet made the journey, with the help of stout walking sticks and young relatives. And no one who made that trip down the mountain was more proud than Lan Xiang. She stood tall in the village square as the civic authorities publicly thanked Shou Shou's parents for having given birth to so talented a son. She had dared to dream an impossible dream, and her son had made it a reality.

□ □ □

When used in terms such as "flower houses" or "flower boats," the word "flower" has nothing to do with anything one might find growing in a garden, but actually refers to prostitutes. In this book that deals with male rank, it is interesting to note that there was also an organized hierarchy among female prostitutes. At the top of the list were courtesans called *shuyu*. These women entertained their clients by singing and telling stories, and were the highest ranking class of courtesans. *Shuyu* performed in storytelling houses, but it was sometimes possible to arrange a visit at their private residences following a performance.

However, they were not required to do this, nor did they have to drink or dine with the men. *Shuyu* were known for selling their musical talent rather than their sexual favors.

Next in rank came the *chansan* courtesans who not only drank with the men, but also attended the opera and theatrical performances with them, and in many cases recreated scenes from the operas themselves for their clients. However, sexual favors from *chansan* could be difficult to obtain. A sort of courtship was necessary before a man could establish a paid sexual relationship with a *chansan*.

◎◎ A Chinese flower boat of the type Bao Gui enjoyed visiting. (From *John Stoddard's Lectures* by John L. Stoddard, Balch Brothers Co., Boston, 1897)

Lower down the scale of prostitutes were the *ersan* and *yao er*. They sold their sexual favors without offering classical entertainment. Even further down in rank were prostitutes called "salt pork," girls who generally worked in small cell-like rooms just large enough for a single bed. Finally there were the streetwalkers who were called "pheasants" and were known for their aggressive pursuit of customers.

A very common term for prostitutes was "flowers" and the establishments where they worked were frequently called flower houses. Small, filthy brothels called flower smoke rooms were popular with men who wanted both opium pipes and sex, and didn't care about the surroundings or the sanitary conditions.

A "flower boat" was a type of Chinese brothel that has been glamorized in literature. Large and covered with gilded carving, they could be quite spectacular as their glittering lanterns or chandeliers lit up the night. Frequently, two boats were anchored side-by-side with planks linking one to the other. Inside they were elaborately decorated with sparkling mirrors and ebony furniture. In the public

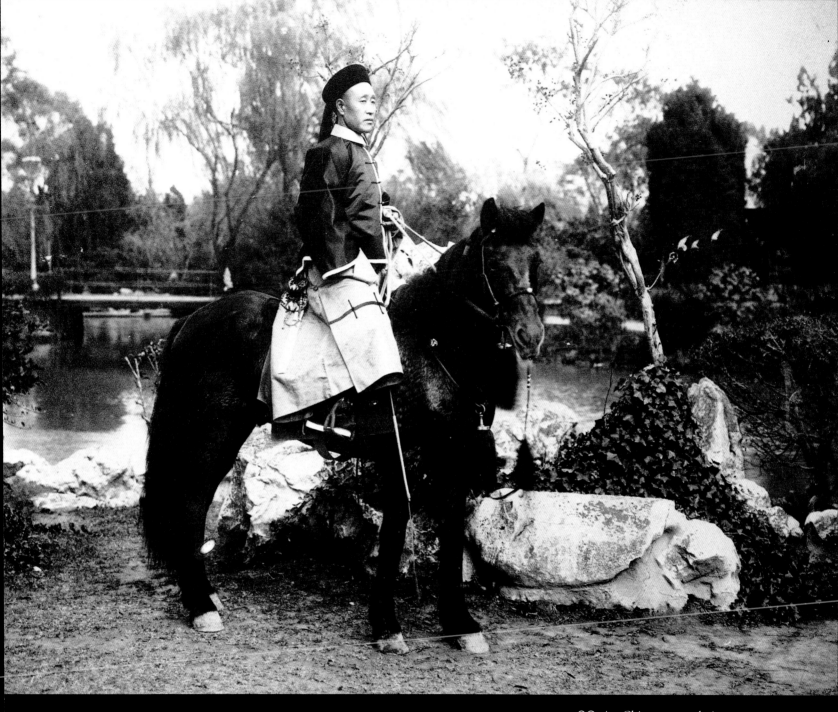

⚭ A Chinese mandarin poses astride his horse beside a lake. (Courtesy of the Peabody & Essex Museum,

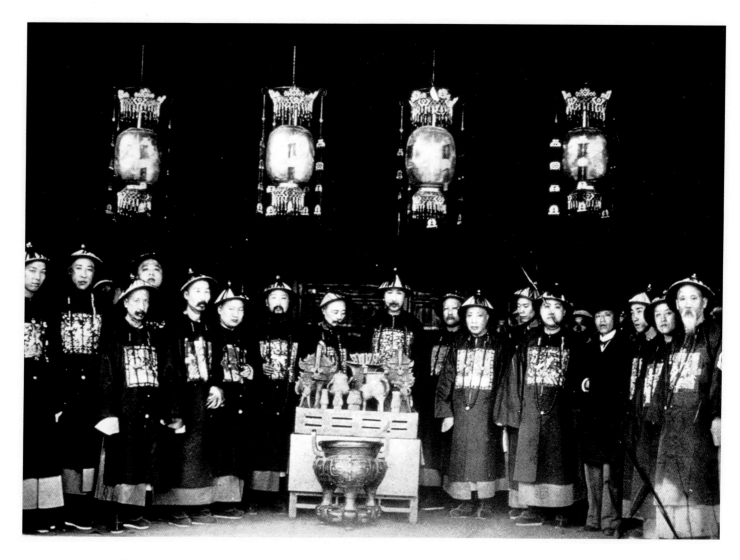

⊚⊚ Mandarins of different ages and ranks at an official gathering wearing summer robes and hats. (From the author's collection)

rooms customers drank and ate while listening to professional singing girls hired by the boat owners, since the glamorously dressed and heavily made up flowers only offered sexual entertainment.

There has always been a tenebrous quality to information on eunuchs and their world. These castrated men, found in the imperial palaces of China as early as 1700 B.C., primarily served the wives and concubines of the emperor. This position, while menial, gave them a great intimacy with the rulers of China and

80

led ultimately to their being more highly trusted than the government's basic bureaucrats. During the Ming dynasty as many as ten to fifteen thousand palace eunuchs were sent to the provinces by the emperor, where they took over the civil bureaus and kept tabs on the activities of local military leaders.

The eunuch presence in the provincial *yamen* was not welcome. Their assignments frequently overlapped the authority of the provincial administrators, and this was just what the palace wanted. The eunuchs served as a covert spy network for the emperor, who worried that his military leaders might gain excessive power.

Eunuchs were given the chance to enter the military during the civil war of 1402–1403, and by 1411 three eunuchs Wang An, Wang Yanzhi and Sanbao Tuo-tuo, were supervising military units. Ultimately, the capital guards in Peking were supervised by the castrated men of the palace rather than the regular military hierarchy. And this power continued through the Ming and Ching dynasties. So it is not surprising that some eunuchs did manage to achieve military rank. The Emperor Yongle (who reigned from 1403 to 1424) in particular appointed eunuchs to high positions and one of his favorites, Zheng He, was elevated to the first rank.

However, it was not until 1678 that six eunuchs from the palace finally achieved civil rank. Four were appointed as officials to the fifth rank and two to the sixth rank. During the rein of Emperor Guangxu (1875–1908) eunuchs finally were able to achieve ranks higher than fifth. The last Empress Dowager, Cixi, ultimately elevated her favorite eunuch Li Lian Ying to the second rank, enabling him to wear the badge of the golden pheasant and the carved coral or opaque red stone finial on his hats.

There are many stories about the dishonesty and viciousness of some palace eunuchs. Many who were close to the emperor became fabulously rich men, mostly from the bribes they demanded from those wishing an audience with the Son of Heaven, and from the lavish gifts intended for the emperor that they confiscated for themselves. For these men it was well worth the pain and degradation of the operation, performed in a public square across from the Forbidden City, when they would otherwise have faced an early death from starvation and disease. A sin-

◔◝ A eunuch from the Imperial Palace, Peking. The harsh reality of this brutal procedure was a high price for a young boy to pay, but often promised unthinkable wealth and status, including the opportunity to Climb the Ladder to the Clouds. (Courtesy of the British Library)

gle swoop of a small curved knife, performed with only hot chili sauce as a local anesthetic, could mean the difference to a poor young boy between premature death and a private mansion, as well as warehouses filled with furs, jewels, and great works of art. Many of the men who achieved this status also established a family to inherit their wealth by adopting handsome young boys.

The last palace eunuch, Sun Yaoting, died on December 16, 1996, at the age of ninety-three. He served the last emperor of China, P'u Yi, before the Ching

dynasty fell, and during the ten years that followed was allowed to continue living in the Forbidden City. While he was not a rich man at his death, his obituary in the *New York Times* mentioned that his adopted son and grandson were taking his ashes home to their village.

<center>□ □ □</center>

Bao Gui went no farther with his studies or exams. Instead, he settled back into his degenerate life in Peking with neither pride nor interest in his new rank and position. Yong Shang on the other hand immediately returned to Professor Wu to prepare for the next step up the ladder of rank, the ladder to the clouds.

<center>□ □ □</center>

The next step was to take the examination for *Chu-jen* or Promoted Scholar, which would have been comparable to a Western master's degree. This exam was held in the capital of each province once every three years for the Flowers of Talent who wished to advance further. Approximately ten-thousand of them descended upon the provincial capital for the event. And that number could swell much higher, as wealthy boys always brought servants to help make life more comfortable for them.

This event did not last for one day as the first examination had. The second rank exams consisted of three sessions of three days and two nights each and were conducted in those same tiny cells under horrendous conditions of climate and cleanliness, leading in many cases to illness and death.

Communal bathrooms were shared at the end of each lane. Men drew their own water from the designated water platforms along the main avenues, and their only meals came from the food supply they brought with them. And as before, the compound was locked once all candidates and officials were inside.

The men administering this second examination journeyed to the provincial capitals from Peking. Again compositions in prose and verse on assigned themes were required. This time the examiners looked for the depth of scholarship the candidates had achieved through their extensive reading and memorization. There were no points awarded for penmanship. Scribes copied each exam paper and passed their copies on to the examiners so that it was impossible to match

◠◠ *Opposite:* The title of this marvelous painting is *Queen Victoria Opening the Great Exhibition in Hyde Park, 1 May 1851.* Painted by Henry Courtney Selous (1803–1890) it was the official painting of the opening ceremony. The central group shows the Queen, the Prince Consort to her left, the Prince of Wales (in Highland dress) to her left, and other members of the royal family. A group of British commissioners and officials occupy the foreground with the Archbishop of Canterbury and the Duke of Wellington beneath the equestrian statue. Also in the foreground is Hee Sing, an entertainer on a Chinese ship docked in London. He spoke no English, but because of his splendid attire, complete with rank badge, mandarin beads and winter hat, the British assumed he was the Chinese ambassador and put him in a place of honor. (Courtesy of the Victoria and Albert Museum, London)

<center>83</center>

a candidate with an examination paper. This avoided the possibility of an examiner giving preferential treatment to a paper or a student.

□ □ □

Out of the ten-thousand or more who went through this grueling ordeal, only about one hundred passed. Yong Shang was one of them and upon returning home was able to place a tablet over his door informing everyone who passed that inside this home lived a literary prize winner.

In the spring following the second examination, aided once again by money from friends and relatives, Yong Shang headed for Peking to take the final Triennial Examination. This was the big test—the one that could lead to great honors and possibly great wealth. As he passed through the Yung Ting gate into the city of Peking, he followed a caravan of camels laden with treasures from the silk road. Having walked part of the way, and then ridden canal boats for many weeks to reach Peking, he should have been weary, but he was wide-eyed with excitement at the great wide streets lined with shops, the high red walls of the Forbidden City, and the knowledge that inside those walls

◎◎ Two American visitors to China pose with their hosts, an impressive group of mandarins. (From the author's collection)

lived the Son of Heaven. And it was within those red walls, and in the presence of the Emperor, that he took his next examination. The highest honor given for passing this exam was the title of *Chung-yuan* or Laureate. This honor is beyond any Western degree. We have nothing comparable.

Yong Shang passed with the highest honors. For his audience with the emperor, and for the official banquets given in honor of the successful candidates, he wore the formal attire of graduates in government exams, the *gong fu*. This was a blue ceremonial robe with tapered sleeves and horsehoof cuffs, and a wide black border at the hem. With this he wore a traditional collar called a *pi ling*, like a small detachable cape. Until he was given an official appointment he could not wear a jewel of rank on his hat, or the usual formal robe known as *chao*

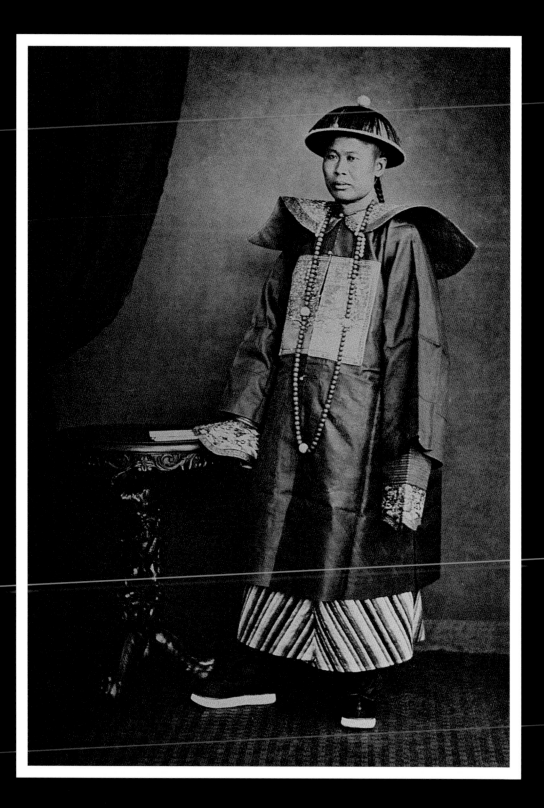

An early photograph of a mandarin, Cochin, circa 1866–68. (From Dennis G. Crow, Ltd.)

Right: A young prince, eldest son of a member of the imperial clan, with his bride on their wedding day. (From *Everyday Customs in China* by Mrs. J. G. Cormack, The Moray Press, Edinburgh and London, 1935)

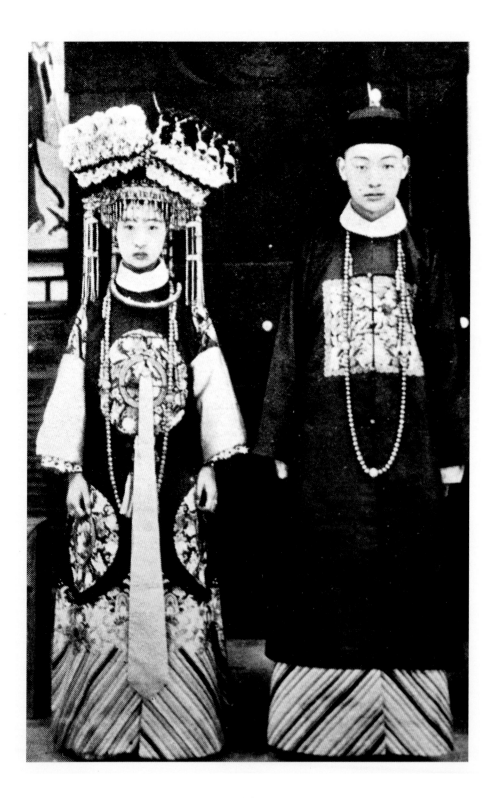

fu. However, with his *gong fu* robe he wore a hat with a tassel made of red silk floss, decorated with a gilt spike. Because he was a scholar holding the highest degree, he was entitled to have a tiny golden bird in the top section of the spike.

Many of the men who achieved this rank simply were assigned to provincial posts, and never rose any higher in the Chinese bureaucracy. But Yong Shang continued his meteoric rise and he was admitted into the famed Hanlin Academy in Peking, the very center of literary activity of all China. This College of Literature also served as a College of Heralds and its members all came from the highest ranking graduates of the Triennial Examinations.

In addition to the literary importance of the Hanlin Academy, it was also a government organ, a body of civil functionaries. It was here that over the next ten years Yong Shang rose to such positions as Expositor-in-Waiting, Reader-in-Waiting and Vice Minister of Rites. Ultimately he was sent to work in the Forbidden City itself.

Sometimes Yong Shang felt it was all a dream, that he was back in his mountain village and none it was real. But when he looked around him he saw the blood-red lacquer pillars, thick silk carpets of imperial yellow upon which he stood, silk lanterns fringed with strands of pearls hanging from the high ceilings, exquisite objects of gold, ivory, ebony, precious jewels, porcelain, rare woods, that sat on every surface and the thousands of servants. He was a trusted official of high rank in the home of the emperor of China. He continued receiving higher and higher promotions, rising through the years until he found himself the Junior Preceptor of the Emperor, one of the five highest civil offices in all of China.

As his importance and power rose, Yong Shang was able to bring his widowed mother and Sih Su, who was no longer young, to Peking to share his palatial home with him, his wife and children. He regretted that Professor Wu had not lived long enough to enjoy this same pleasure. And sometimes in the evenings when his many officials duties were finished, surrounded by those he loved, he would take out the *san-hsien* the old gentlemen had bought for him so long ago. He could well afford a beautiful new instrument now of the finest woods with

ivory and gold trim, but he loved the feel of the old instrument and the memories it held for him. As he played, his elderly mother cried softly and whispered, "I've never heard such beautiful music." Sih Su rocked back and forth to the rhythm of the music, smiling, remembering, fighting back tears of joy.

No tears of joy were shed for Bao Gui. His lifestyle brought no pride to anyone. His amah, who had loved and protected him from the day he was born, died within months after he passed his first exam. The servants whispered that she died not of illness or of age, but of a heart overburdened with sadness.

◎◎ A lady's purse made from a silk needlepoint crane square of the first rank with a carved tortoiseshell frame and clasp. After the revolution in 1911, textiles from the imperial period were often demeaned for mundane use by Westerners. (From the author's collection)

88

◎◎ A lady's evening bag, made in France, circa 1930, was created with a pair of late Ch'ing-style wild goose squares of the fourth rank. Note the bright colors of the aniline dyes. (From a private collection, Larry Kunkel Photography)

◎◎ *Opposite:* A mandarin necklace of amber-colored Peking glass beads with five large rose quartz beads, two rose quartz tassels, thirty purple amethyst beads, and two blue Peking glass tassels. The evolution of the mandarin necklace can be traced back to a Tibetan rosary sent in 1634 by the Dalai Lama to the reigning Manchu ruler. The long tape at the back, which served as a counterweight, and the three counting strings of ten beads each were all Manchu embellishments. Dynastic regulations determined the appropriate occasions for wearing them, as well as who could wear them. Materials for beads often coincided with the wearer's rank and the particular occasion. Men wore one necklace while women wore three. (From the author's collection, Larry Kunkel Photography)

Although deeply involved with his new bride and their expected first child, Bao Gui's father could not avoid hearing bits of scandal about his firstborn son. In the beginning, he had brushed it off as the coming-of-age escapades of a high-spirited young man. He himself had made the rounds of flower houses and gambling dens in his youth. But as time went on he could not ignore the rumors about Bao Gui's world of gambling, female prostitutes, palace eunuchs and the male houses of prostitution, the drugs and the brawls with men of dangerous reputation. How could he bow down before his ancestor altar knowing great dishonor was being brought to the family by his only son, the son whose duty it would be to worship their ancestors when he was gone. Cutting off Bao Gui's financial support was his one hope of bringing the wild young man home to his studies and filial responsibilities.

But Bao Gui was past the point of a possible return to his old life. With the funds from his father terminated, he sold everything he owned to subsidize his gambling and drugs. The last thing to go was the *chao zhu* his father had taken from around his own neck and proudly lowered over his son's head not so long before. In desperation following a losing streak at the gambling table one night, he tore off the *chao zhu*, which he should not have been wearing, and tossed it down to cover his bet. And he lost.

Two days later, in the filthy water of a small tributary of the Grand Canal, Bao Gui's body was found floating facedown. The beautiful beads of his father's treasured *chao zhu*, twisted tightly around his neck, sparkled in the light of the police lanterns as his body was brought to shore.

Bibliography

Arlington, L. C., and William Lewishon. *In Search of Old Peking.* Henry Vetch, The French Bookstore Peking 1935.

Bamford, Mary E. *TI: A Story of San Francisco's Chinatown.* San Francisco: David C. Cook Publishing Co., 1899.

Beguin, Gilles, and Dominique Morel. *The Forbidden City: Center of Imperial China.* New York: Discoveries, Harry N. Abrams, Inc., 1997.

Birrell, Anne. *Popular Songs and Ballads of Han China.* Honolulu: University of Hawaii Press, 1993.

Bland, J. O. P., and E. Backhouse. *China Under the Empress Dowager.* London: William Heinemann, 1908.

Blofeld, John. *City of Lingering Splendour.* Boston: Shambhala, 1989.

Bogan, M. L. C. *Manchu Customs and Superstitions.* Tientsin and Peking: China Booksellers, Ltd., 1928.

"Bok." *Corsairs of the China Seas.* London: Herbert Jenkins Ltd., 1936.

Breden, Juliet. *Peking.* Shanghai: Kelly & Walsh, Ltd., 1922.

Browne, G. Waldo. *The New America and the Far East.* Boston: Marshall Jones Co., 1901.

Capon, Edmund. "Chinese Court Robes in the Victoria & Albert." *Victoria and Albert Museum Bulletin.* Vol. IV, No. 1. London, January 1968, pages 8-9.

Catleen, Ellen. *Peking Studies.* Shanghai: Kelly & Walsh, Ltd., 1934.

Chang Chung-li. *The Chinese Gentry: Studies on Their Role in Nineteenth-Century Chinese Society.* Seattle and London: University of Washington Press, 1974.

Chi-Hung and Lynn, Jermyn. *Social Life of the Chinese in Peking.* Peking-Tientsin: China Booksellers Ltd., 1928.

China Hong List a directory Shanghai 1937

Chitty, J. R. *Things Seen in China.* London: Seeley, Service & Co. Limited, 1922.

Chong, Douglas D. L. *Reflections of Time: A Chronology of Chinese Fashions in Hawaii.* Honolulu: Hawaii Chinese History Center, 1976.

Chou, Eric. *The Dragon and The Phoenix: Love, Sex and the Chinese.* London: Michael Joseph, 1971.

Church Missionary Society. *The Uplift of China.* London, 1909.

Colguhoun, Archibald R. *China in Transformation.* New York and London: Harper & Bros., 1912.

Cooper, Elizabeth. *My Lady of the Chinese Courtyard.* London: Frederick A. Stokes Company, 1914.

Cormack, Mrs. J. G. *Everyday Customs in China.* Edinburgh and London: The Moray Press, 1935.

Crossman, Carl L. *The China Trade.* Princeton: The Pyne Press, 1972.

Davidson, Robert J., and Isaac Mason. *Life in West China Described by Two Residents in the Province of Szchwan.* London: Headley Brothers, 1905.

Fairbank, John King. *China: A New History.* Cambridge, MA: Belknap Press of Harvard University Press, 1994.

Fairbank, John King. *The Great Chinese Revolution 1800-1985.* New York: Harper & Row, 1986.

Fawdry, Margaret. *Chinese Childhood.* London: Pollocks Toy Theatres Ltd., 1977.

Fielde, Adele M. *Pagoda Shadows: Studies from Life in China.* Boston: W. G. Corthell, 1890.

La Galarie Joyce. *Dragons et Soie de la Cite Interdite.* Paris: Jardins du Palais Royal, 1995.

Garrett, Valery M. *A Collector's Guide to Chinese Dress Accessories.* Singapore: Times Editions, 1997.

George, Marian M. *A Little Journey to China and Japan.* Chicago: Flanagan Co., 1900.

Gray, John Henry. *Walks in the City of Canton.* Hong Kong: De Souza & Co., 1874.

Gregg, Eva A. *Hints from Squints in China.* Cincinnati: Caxton Press, 1923.

Gregory, Martyn. *Chinnery and Paintings of the China Coast.* London, 1998.

Hardy, E. J. *John Chinaman at Home.* London: T. Fisher Unwin, 1905.

Headland, Isaac Taylor. *Court Life in China.* New York: Fleming H. Revell, 1909.

Headland, Isaac Taylor. *Home Life in China.* London: Methuen & Co., 1914.

Headland, Isaac Taylor. *Chinese Heroes.* New York: Eaton & Mains, 1902.

Hinsch, Bret. Passions of the Cut Sleeve: The Male Homosexual Tradition in China. Berkeley: University of California Press, 1990.

Hosie, Lady. *Two Gentlemen of China.* London: J. P. Lippincott Co., 1924.

Humana, Charles, and Wang Wu. *Chinese Sex Secrets: A Look Behind the Screen.* Hong Kong: CFW Publications Ltd., 1996.

Hummel, Arthur W., ed. *Eminent Chinese of the Ch'ing Period 1644-1912.* Washington, DC: U.S. Government Printing Office, 1944.

Hung Lou Meng. *The Dream of the Red Chamber.* New York: Pantheon Books, 1958.

Hsu, Dolores. *Oriental Musical Instruments: The Henry Eicheim Collection.* Santa Barbara: University of California Santa Barbara Press, 1984.

Huters, Theodore, R. Bin Wong, and Pauline Yu. *Culture & State in Chinese History.* Stanford: Stanford University, 1997.

Hyde, Nina. "Silk, the Queen of Textiles," *National Geographic,* January 1984.

Jagendorf, M. *In the Days of the Han.* Los Angeles: Suttonhouse Ltd., 1936.

Johnson, Reginald. *Twilight in the Forbidden City.* London: Victor Gollancz Ltd., 1934.

Karamisheff, W. *Mongolia & Western China.* Teintsin: La Librarie Francaise, 1925.

Kerr, Phyllis Forbes. *Letters from China: The Canton-Boston Correspondence of Robert Bennett Forbes, 1838-1840.* Mystic, CT: Mystic Seaport Museum, 1996.

Langdon, William K. *A Descriptive Catalogue of the Chinese Collection.* London: G. M'kewan, 1844.

Legge, James, tr. *Li Chi, Book of Rites.* New Hyde Park, NY: University Books, 1997.

Lewis, Elizabeth Foreman. *Young Fu of the Upper Yangtze.* London: George G. Harrap & Co., 1934.

Liu, Ts'un-Yan. *Wu Ch'eng-en: His Life and Career.* Leiden, The Netherlands: E. J. Brill, 1967.

Little, Mrs. Archibald. *In the Land of the Blue Gown.* London: T. Fisher Unwin, 1902 and 1908 editions.

Little, Mrs. Archibald. *Intimate China.* London: Hutchinson & Co., 1901.

Little, Mrs. Archibald. *Round About My Peking Garden.* London: T. Fisher Unwin, 1905.

McCormick, Elsie. *Audacious Angles on China.* New York and London: D. Appleton & Co., 1923.

MacGillivray, D. *A Mandarin Romanized Dictionary of Chinese.* Shanghai: Stationer's Hall, 1921.

Macgowan, Rev. J. *Sidelights on Chinese Life.* London: Kegan Paul, Trench, Trubner & Co., Ltd., 1907.

Mackay, Margaret Mackprang. *Lady with Jade.* New York: John Day Company, 1939.

Marsh, Robert M. *The Mandarins.* New York: Free Press of Glencoe, 1961.

Martin, W. A. P. *A Cycle of Cathay or China, South & North.* Edinburgh & London: Oliphant Anderson & Ferrier, 1896.

Martin, W. A. P. (William Alexander Parsons). *The Lore of Cathay.* New York: Fleming H. Revell Company, 1901.

Maugham, W. Somerset. *On a Chinese Screen.* Oxford: Oxford University Press, 1985. (original Heinemann 1922)

Mackerras, Collin. *Chinese Theatre: From its Origins to the Present Day.* Honolulu: University of Hawaii Press, 1983.

Meadow, Thomas Taylor. *Desultory Notes on the Government and People of China.* London: Wm. H. Allen and Co., 1847.

Metropolitan Museum of Art. *A Chinese Garden Court: The Astor Court at The Metropolitan Museum of Art.* New York, 1981.

Metropolitan Museum of Art. *Textiles in the Metropolitan Museum of Art.* New York, Winter 1995/96, pages 74 & 75.

Mitamura. Taisuke. *Chinese Eunuchs.* Translated by Charles A. Pomeroy. Rutland, VT: Charles E. Tuttle Co., 1970.

National Geographic. "Nanking's Crumbling Examination Halls," June, 1927.

An Official Guide to Eastern Asia. Vol. IV, *China.* Tokyo, 1915.

Peers, C. J. *Ancient Chinese Armies 1500-200 BC.* London: Osprey Publishing Co., 1990.

Plopper, Clifford H. *Chinese Religion Seen Through the Proverb.* Shanghai: Shanghai Modern Publishing House, 1935.

Reynolds, Valrae. "Chinese Costume at the End of the Qing Dynasty: American Collectors and The China Silk Route," *Orientations*, October 1992, pages 60-66.

Rock, Joseph F. "Banishing the Devil of Disease Among the Nashi of Yunnan Province, China," *National Geographic*, November 1924.

Sites, Nathan. *An Epic of the East.* London: Fleming H. Revell Co., 1912.

Smith, Arthur H. *Chinese Characteristics.* New York, Chicago, Toronto: Fleming H. Revell Co., 1894.

Soothill, Lucy. *A Passport to China.* London: Hodder and Stoughton Ltd, 1931.

Spence, Johnathan D. *Emperor of China: Self Portrait of Kang-his.* New York: Alfred A. Knopf, 1974.

Stoddard, John L. *John Stoddard's Lectures.* Boston: Balch Brothers Co., 1897.

Thomas, John Stuart. *The Chinese.* Indianapolis: The Bobbs-Merrill Co., 1909.

Tsai, Shi-shan Henry. *The Eunuchs in the Ming Dynasty.* Albany: State University of New York Press, 1996.

Upward, Rev. Bernard. *The Sons of Han.* London: London Missionary Society, 1908.

Van der Sprekel, Otto P. N. Berkebach. *The Chinese Civil Service.* Canberra: The Australian National University, 1958.

Waley, Arthur. *Ballads and Stories From Tun-Huang.* London: George Allen and Unwin Ltd., 1960.

Waley, Arthur. *Chinese Poems.* London: George Allen and Unwin Ltd., 1946.

Wang, Congren. *Tales About Prime Ministers in Chinese History.* Translated and edited by Zhang Zongzhi. Hong Kong: Hai Feng Publishing, 1994.

Warner, Marina. *The Dowager Empress: The Life & Times of Tz'u-His.* New York: Macmillan Co., 1972.

Watt, James C. Y., and Anne E. Wardwell. *When Silk Was Gold: Central Asian and Chinese Textiles.* New York: Metropolitan Museum of Art distributed by Harry Abrams, 1998.

Werner, E. T. C. *Myths and Legends of China.* London, Bombay, Sydney: George G. Harrap & Co. Ltd., 1922.

White, Julia M. and Bunker,Emma C. *Adornment for Eternity: Status and Rank in Chinese Ornament.* Seattle: Marquant Book, 1994.

Williams, C. A. S. *Outlines of Chinese Symbolism and Motifs.* New York: Dover Publications, Inc., 1976.

Wu, Luxing. 100 Emperors of China. *Singapore: Asiapac Books, 1996.*

Wu Yung. The Flight of An Empress. *Translated by Ida Pruitt. New Haven: Yale University Press, 1936.*

Yee, Chian. A Chinese Childhood. *London: Methuen & Co., 1946.*

Zuan, L. Z. Through a Moon Gate. *Shanghai: Mercury Press, 1938.*

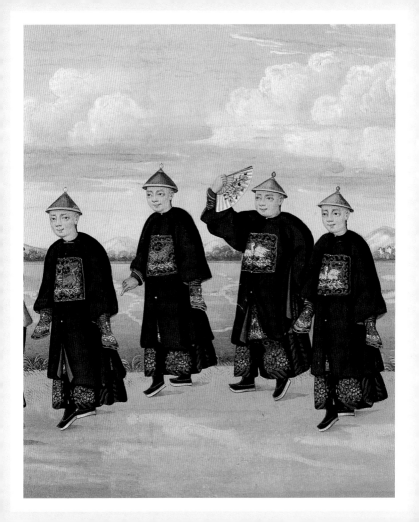

CHAPTER 6

AN INTRODUCTION
TO MANDARIN SQUARES

There are so many fascinating reasons to learn about mandarin squares. First, as my friend and colleague Beverley Jackson has most effectively shown, the preparation required to qualify to wear one of these squares was simply staggering. Young boys started studying as early as three years of age. Some men spent a lifetime trying to qualify to wear a mandarin square. One record of successful candidates for the second degree circa 1900 contained the names of a sixty-two and eighty-three-year-old. The commitment to learning and dedication to the goal of becoming a mandarin was extraordinary. The stress associated with taking the examinations was so extreme that it was unusual for a major provincial test to be conducted without at least one candidate dying from stress or exposure. The Chinese considered this kind of dedication to be a necessary adjunct to success in life. One need go no farther than this traditional Chinese approach to education to explain the apparent success of children of Asian descent in school today. They are merely carrying on a two thousand-year-old commitment to education as the way to improve one's life. The mandarin square is the symbol of that commitment. If you reflect on the effort expended to qualify to wear a mandarin square, then they are justly prized as a physical representation of this dedication. This alone makes them valuable to me.

But mandarin squares are more than symbols of hard-won status. They are, as we will see, a representation of the Chinese universe in a twelve-inch square. As the insignia of the most powerful group of men in imperial China other than

◉◉ *Opposite:* Detail of a procession, eighteenth-century gouache on paper. The two men on the left wear lion squares of the second military rank, while the two on the right wear crane squares of the highest civil rank. (From a private collection)

95

the imperial household, mandarin squares were constructed with care and crafts-manship unequaled anywhere in the world. And nowhere was greater care taken or skill applied than in the clothing worn by the members of the Chinese imperial court. The finest mandarin squares represent the epitome of Chinese embroidery and weaving skills. They are desirable as some of the best examples of craftsmanship and meticulous execution.

Finally, information about mandarin squares is scarce and difficult to find. Each new article or scrap of information is another piece of an incredibly complex puzzle. Frequently, seemingly contradictory or incomplete information waits for years for the final piece of corroborating data to make all the other pieces of the puzzle come together, sometimes with an almost audible click. This challenge is the final reason for my interest and is one of the rewards of studying mandarin squares, and this book will not rob you of the pleasure of personal discovery. The subject of mandarin squares is too complex, detailed and extensive for a single book to encompass the whole picture. This effort will by no means exhaust the subject. So enjoy *Ladder to the Clouds*, but consider it either a starting point if you are new to the subject or a useful reference if you are already a knowledgeable collector.

It is my hope that the information presented here will not only increase the appreciation that one can bring to the collection of these wonderful textiles, but may also allow the reader to bring extra knowledge to the marketplace, avoiding the purchase of incorrectly dated or identified badges and noting bargains where they still exist.

Before we can lay claim to any expertise at identifying and dating squares, there are two areas that must be mastered. The first is the ability to identify the various birds and animals that represented rank during the last two Chinese dynasties. This is not as simple or rudimentary as you might think. I have frequently found squares that were offered at auction by national and international auction houses to be misidentified or misdated. So if you only master the information that allows you to identify the birds and animals, then you will apparently be more knowledgeable than some professionals in this area. The second is at least a rudimentary understanding of the symbology used in the squares. The

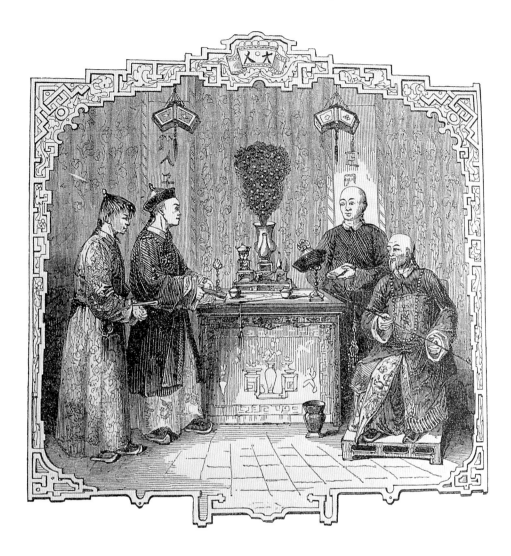

A mandarin pays an official visit to another mandarin of superior rank. (From *A Descriptive Catalogue of the Chinese Collection* by William K. Langdon, G. M'kewan, London, 1844)

design of each square contains a variety of information presented in various forms. Most obviously, the birds and animals represented the rank of the wearer. But each square was also a representation of the Chinese view of the universe, additionally containing a plethora of hopes, wishes and desires of the owner. An understanding of this iconography will prepare you for the real meat of the discussion, which is a review of the evolution of the squares through the Ch'ing Dynasty. This will give you a feel for their development and help the novice and

◎◎ *Opposite:* Late Ming-period lion square for a first or second rank military official. (Provided by the Metropolitan Museum of Art)

expert alike to date squares with greater accuracy, an important skill if you are interested in collecting and don't want to pay eighteenth-century prices for nineteenth-century squares.

Truth in advertising compels me to quickly caveat these aims. Mandarin squares were worn over too long a period of time, were produced over too wide a geographical area, and created by too many artisans to allow for any clear, crisp definition of rules and guidelines. At best, we will be able to lay claim to a basic understanding of them and the general trends that developed over time. But there are always exceptions. As soon as you think you have one small area clearly defined, you will encounter a square that turns your understanding on its head.

This is to be expected. The shear size of China and the time delay associated with travel and communications at the time the squares were worn dictate that styles worn in the capital would be more current than those worn in remote provinces. And while most squares were manufactured by men and young boys in commercial establishments, some badges were made in the households of the mandarins themselves. Almost all Chinese women embroidered, particularly those of wealth with many servants who had little else to do. (see *Splendid Slippers: A Thousand Years of an Erotic Tradition* by Beverley Jackson, Ten Speed Press, 1998). If a lady were particularly skilled, she might produce squares that were worn by the man of the house and showed greater innovation than those produced commercially. The number of sources for squares boggles the imagination. With the changes in style and custom over time, the slow spread of fashion trends, and the myriad sources of squares, uniformity was impossible. To further complicate matters, the Chinese regulations were not very specific. For instance, the number of birds or animals to be shown on the squares was not specified. So one finds Ming badges with as many as three creatures on them. As we will see, other design characteristics were often dictated by custom or fashion, rather than regulation. So while general trends can be noted and certain stylistic forms associated with general time periods, it is futile to try to force squares into well-defined categories and stereotypes. Remember this one unvarying rule for mandarin squares: there are no unvarying rules for mandarin squares.

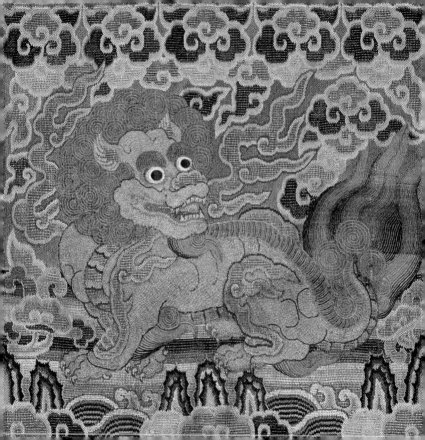

MING SUMMARY

Mandarin squares were worn from 1391 to 1911, which encompasses most of the Ming Dynasty and all of the Ch'ing. Due to continuing military campaigns to subdue the country, clothing regulations were not promulgated until about twenty-three years after the founding of the Ming Dynasty. The squares represent one of the final stages in the evolution of a system of bureaucracy that had existed for nearly two thousand years. Even before the bureaucracy was established during the Ch'in Dynasty (221–207 B.C.), the Chinese had an elective monarchy, an interesting mix of centralized authoritarian and popular rule. In this scheme the will of the people was interpreted as the will of heaven. Hence, it was acceptable to take any expression of popular will into account when selecting a ruler. This existed through at least three ancient reigns (Yao, Shun and Yu) until, inevitably one ruler declined to allow his title to pass to other than a direct descendent. By this point in Chinese history there was a focus on the role that clothing played in society. It was to definitively separate the classes. It was thought that by dividing the high from the low and the honorable from the base, each person would know and adhere to his accepted place and make his mandated contribution to society. A ruler in such an ordered world would have little to do but observe the structured and effective functioning of his realm. As early as the Western Zhou Dynasty (1000–771 B.C.), the criteria for separating the classes had been codified in a set of regulations known as the Rituals of Zhou (*Zhou Li*). This became one of the Confucian Classics that served as the foundation of the later examination process and

⊚⊚ *Opposite:* Ancestor portrait scroll showing several generations of one family. (Courtesy of Dynasty Antiques)

the protocol for court dress for all succeeding dynasties. From this time forward, the Chinese used clothing to reflect a person's status in society. For many centuries the main indicator of rank was the style and shape of a man's hat. Hats became such an important symbol of authority and rank that appearing in public without a hat was considered a singular breach of protocol. In fact, an official who had been found guilty of a serious crime was required to appear in public without a hat to symbolize the degree of his disgrace.

During the Ming Dynasty (1368–1643) mandarin squares were added to the costumes of its officials. Although the Mings did not record their reason for this addition, there was a precedent for wearing animals and bird squares as a part of court dress. The Yuan Dynasty (1279–1368) had incorporated squares of this type into some of their costumes. These squares were considered decorative rather than emblematic but still were the basis for the introduction of this type of decoration as a symbol of rank.

The Ch'ing Dynasty (1644–1911) maintained the tradition of decorative squares as symbols of rank, but added its own unique elements, hat decorations and belt plaques. Like the Mings before them, the Manchus first devoted their attention to the complete subjugation of the country and did not publish a protocol for court costumes until 1652, eight years after the official founding of the dynasty in China proper. During the interim period, the Ming regulations were largely followed.

This book focuses on Ch'ing Dynasty squares. However, some understanding of Ming badges is required since Ming designs were prevalent during the first years of the Ch'ing, and they form the basis from which we observe the initial transitions of Ch'ing badges.

The Ming Dynasty was founded in 1368, but published the first extensive set of clothing regulations in 1391. These regulations specified that each official would wear a decorative square (called *p'u-fang*) on a bright red, full cut robe (called *p'u-fu*). Civil officials wore various birds to denote their rank. Military officers wore animals. Although there is no known record that documents why a particular bird or animal was assigned to denote a specific rank, birds, in general, were

associated with literary elegance and were a fitting symbol for those who earned their rank through arduous years of study. Animals represented the courage and fierceness of the soldiers who wore them. There may also be another, more subtle, reason for the general choice of birds and animals. Birds could fly and were, literally, closer to the heavens (and the Emperor, the Son of Heaven) than the military officers. This interpretation is consistent with the fact that civil officials were always placed to the left of the emperor, in the place of higher precedence.

Ming badges were large, stretching entirely across the front and back of the red robe. Since the Ming robes closed at the side, the badges were constructed whole, without a split. Of course, like every mandarin square "rule" this one has its exception also. Brocade squares were often made as part of the garment and consequently were split and seamed like the garment was, down the middle both front and back. Ming badges had small borders or no borders at all and did not include a sun disk until very late in the dynasty when it appeared sparingly.

One of the important distinctions to make early is that fashion and custom were more important considerations in design than the vague regulations. An example of the lack of detail in the Ming regulations is that the number of birds or animals used on the squares was never specified. Thus, Ming squares may have as many as three creatures in its design or as few as one, though two was the usual throughout most of the dynasty. Another curiosity was that the first Ming regulations didn't designate which creatures were associated with each rank. Instead, the Ming regulations indicated a pair of creatures for each pair of ranks except for the fifth. Apparently the fifth rank was where all the mediocre performers stalled, and formed the largest proportion of the bureaucracy. This flexibility allowed a first or second level civil official to wear either a crane or a golden pheasant (see page 133, Table 3). I have never come across a convincing explanation for this lack of specificity. One theory suggests that it provided a newly promoted official with the option of not replacing his entire wardrobe when he was promoted. Thus, a higher ranking individual could wear either bird, but the lower ranking official was supposed to wear only the lower ranking bird. This explanation, however, seems inconsistent with two facts. First, there was no flexibility

between pairs of ranks. A third rank official who was promoted needed to exchange his peacock for a golden pheasant immediately. Secondly, the abuse of this system was overwhelming. An overabundance of officials in each pair of ranks wore the higher of the two symbols. This form of cheating eventually caused the regulations to be changed in 1527 to specify a single creature for each rank. This didn't stop the cheating, but at least provided a firm basis for correcting the perpetrators.

The Ming regulations included the oriole as one of the insignia of eighth and ninth level civil officials. This bird was lost to the rank system when the Ch'ing Dynasty reissued its clothing regulations. While it never served as an official rank bird in the Ch'ing, it was resurrected late in the dynasty as a symbol of court musicians.

With regulations that didn't even specify the number of creatures to be used, it is no great surprise to find that designs for the badges were also omitted. This regulatory ambiguity was fully exploited by the artists and household members who actually made the squares. Since the insignia were made all over the empire, each square was individually crafted for a specific individual by professional artisans or household members. This diversity produced a great variety of squares with almost no uniformity. For this reason, the evolution of Ming squares is neither well documented nor well understood. However, there were two areas where the general trend of the designs can be followed. The first was the posture of the significant creature or creatures. In early squares, when two birds were used, they were typically shown in flight. Later squares showed one bird on the ground with the second flying. This design may have been a subtle reference to the duality of nature with the resting bird representing the passive, female, yin aspect; the flying bird representing the active, male, yang. Toward the end of the Ming Dynasty some badges had only a single bird.

The second trend was the use of auxiliary symbols for wealth and good fortune. In a pattern that was to be repeated in the Ch'ing, the Ming squares were originally almost devoid of such symbols. As the dynasty declined, the use of these symbols increased, including flowers, typically the lotus for water birds and

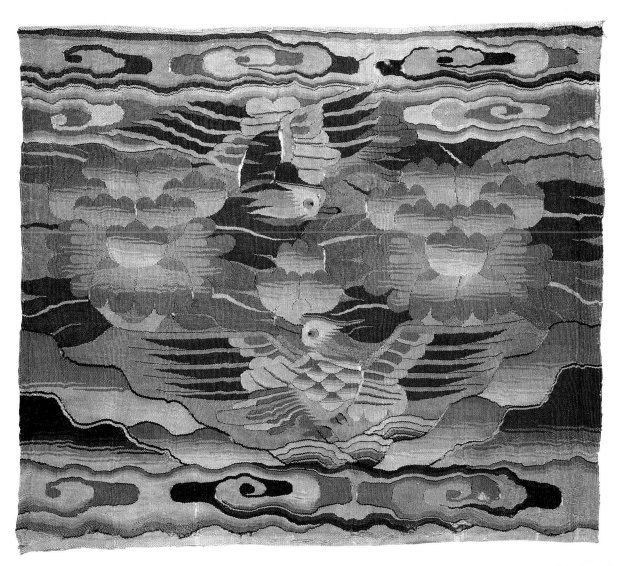

◉◎ 07.001 Mandarin ducks, mid-Ming, *k'o-suu*. (Provided by the Cleveland Museum)

the peony for land birds, and symbols of wealth such as coral, rolls of silk and pearls. In the end, there was a reaction to these overly elaborate squares and a very simple design emerged.

Example 07.001 is the type of square probably worn during the middle of the Ming dynasty. The oversized peonies and the paired birds are shown with one perched and the other in flight, indicate that this is not of the earliest style which tended to show both birds in flight. The representation of the three elements of the universe are not clear in this square. The bird appears to be perched on the

105

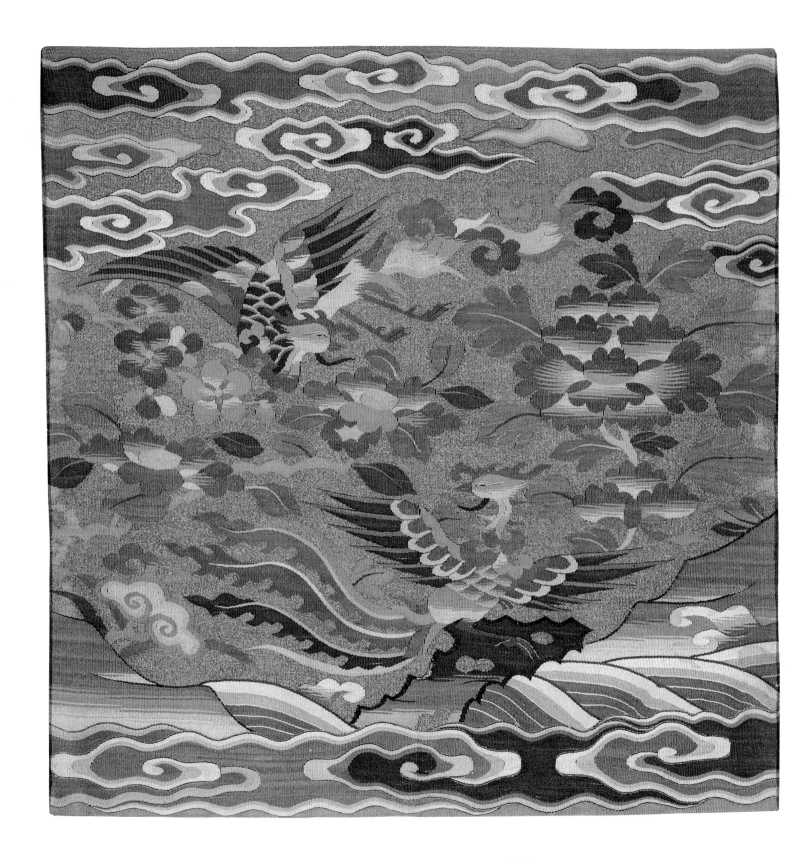

rolling waves of the water, while the two multicolored lines sloping away on each side appear to represent the land form. Clouds appear, not only in the sky, but also below the water. While the condition of this square is remarkable given its age, the colors have faded significantly. Recall that these squares were worn on bright red robes and thus had to be almost garish to avoid being dominated by the surrounding color.

Example 07.002 shows excellently preserved color. All Ming squares were probably this bright and colorful when new. This is a magnificent example of a square that would have been worn by a Ming princess. The phoenixes are typical in that one is male and the other female. The male has three (odd numbers were considered male) serrated tail feathers; the female has four (even numbers being female) curved tail feathers. Typical male phoenixes of this period would have had five tail feathers and the female six. The reduced number of feathers in this example may indicate that the rank of the princess who wore it was not of the highest level. There is another anomaly in the design of this square. The male of a pair was normally shown flying, demonstrating the active nature of the male *yang* aspect. In spite of the traditional display, the male here is perched. The reason for the reversal of roles is not clear, but may be a small, symbolic gesture to the gender of the wearer.

In its other aspects, this square is a more typical example than the mandarin ducks seen previously. Here the perched bird is clearly resting on a traditional pierced rock projecting out of the sea. The wavy red and white masses extending from it are additional land elements. The sea is shown as rolling green and white waves surrounding the central rock. We again see clouds representing the air element both above and below the land. The fact that one of the large peonies seen in the previous square has been replaced with a variety of flowers may indicate that this square was made slightly later than the duck square.

The next Ming square, 07.003, shows a first level lion from a period later than the previous two squares. The land mass has grown considerably, now stretching across the entire square. We also see the beginnings of the obelisk-like rocks that will be a significant feature of the later Ch'ing designs. The water has been

◉◉ *Opposite:* 07.002 Phoenixes, mid-Ming, *k'o-suu*, worn by a princess. (Provided by the Metropolitan Museum of Art)

◎◎ *Above left:* 07.004 The male lion rests his right paw on the globe. (Photo by Nancy Hugus) ◎◎ *Above right:* The female lion rests her left paw on her cub. (Photo by Nancy Hugus) ◎◎ *Opposite:* 07.003 Lion, late Ming, *k'o-suu.* (Provided by the Metropolitan Museum of Art)

reduced to a few wavy lines at the bottom of the design. Clouds inhabit both the water and sky.

The detail of the execution of the lion is sufficient to allow some commentary about the origin of this design. It is reasonably clear that this creature was not patterned after what most Westerners would consider an African lion. And the observation would be accurate for this "lion" is actually a representation of the Chinese temple lions that were placed at either side of a door to frighten away evil spirits. The curly mane shown on this lion is based on the mane of a temple lion. However, the tail is something of a departure. The curls seen on most temple lions appear at the end of the tail. But here we see curls at the base while the end of the tail looks as though the lion has just stuck his toe in an electrical socket. This method of presenting manes and tails was typical of Ming rank animals. We will see another example of this electrically charged mane on an early transitional Ch'ing period censor's square. (For reference, 07.004 are photos of temple lions taken in San Francisco.)

An example of a late period (early to mid-seventeenth-century) Ming square is 07.005. This woven silk crane is an unusual example of the period because it has a sun incorporated into its design. The clouds have also started to transition into a more Ch'ing-like appearance. The earlier Ming squares shown represented the sky with broad bands of color stretching across the square horizontally. While the clouds here show that heritage, they have been separated into distinct masses with tapered ends. The precious things are seen in the water to the left and right of the mound of earth on which the crane is standing. The pearls are clearly identifiable, but the rhinoceros horn or ivory tusk on the left is turned horizontally and colored black so that it blends into the wave pattern.

Most comments to this point have referred to what one might call the official squares of the bureaucrats. There were three other categories of squares in

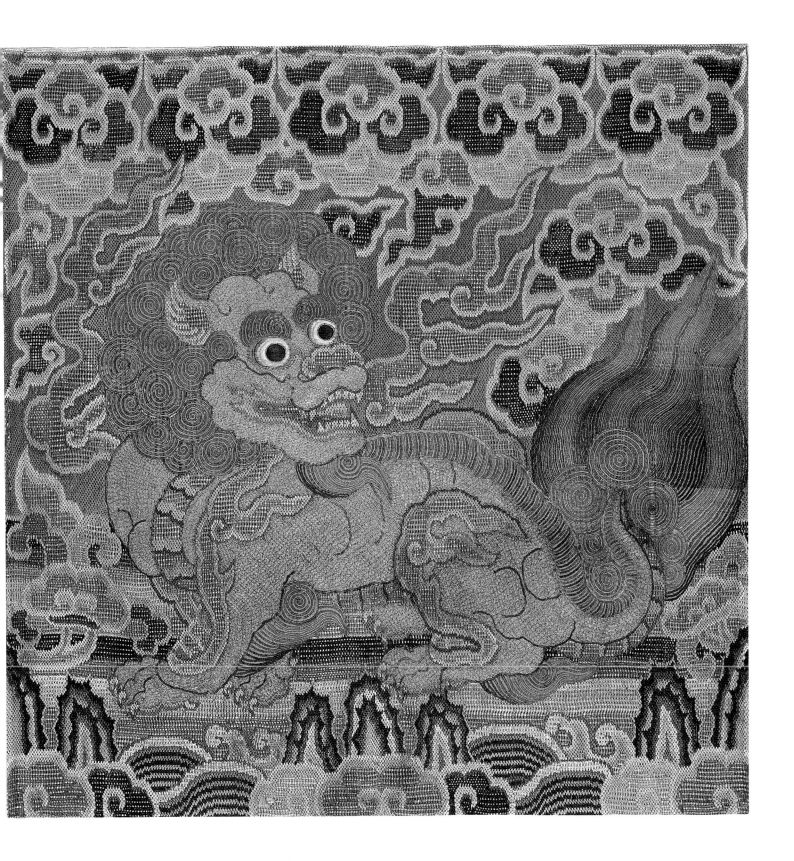

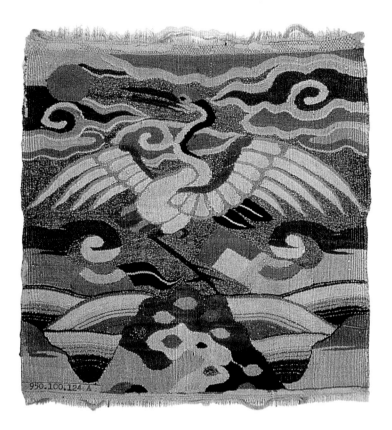

950.100.124 A

◎◎ 07.005 Crane, early to mid-1600s, *k'o-suu*, male (provided by the Royal Ontario Museum) ◎◎ *Opposite:* 07.006 Ch'i-lin, 1600s, brocade. (Provided by Chris Hall Collection Trust)

use during the Ming: imperial insignia, ranks of the nobility, and squares worn by family members. The emperor wore circular badges containing five-toed (*lung*) dragons on yellow robes. Yellow was the color reserved for the emperor. High-ranking princes wore similar dragons on red robes. Lower ranking princes wore four-toed (*mang*) dragons. Ming princesses wore badges decorated with phoenixes (see 07.002). An odd number of serrated tail feathers indicated a male phoenix which was considered higher in rank than the female which had an even number of curling tail feathers.

Nobles, such as dukes, marquises, earls and sons-in-law of the emperor, wore lower ranked dragons or mythical animals. The dragons were either three-toed or winged. The authority to wear lower ranking dragons was normally bestowed by the emperor for special services or meritorious achievement. The mythical creatures were the *ch'i-lin* or the *pai-tse* which were closely related in appearance. Both had the head of a dragon with the two attendant horns and the body of a deer. The *chi-lin* was fully scaled while the *pai-tse* had scales on the shoulders and flanks, a distinction that is often difficult to make. The best way to differentiate the two is by their feet: the *pai-tse* had paws, the *ch'i-lin* hooves.

Our next square, 07.006, is a rare example of a fifteenth-century noble-man's *ch'i-lin* square done in brocade. Since the animal is woven directly into the cloth of the robe, this square is split down the center. In the Ch'ing Dynasty, a split square would indicate that it was worn in front. However, during the Ming dynasty and with this style of robe, both the front and back squares were split when incorporated into the robe itself. The fact that the square was made as a part of the robe it was worn on also provides evidence of the color and type of material that was used for the robes, and, in this instance, the brilliant red that was the Ming dynastic color used for the official court robes. The upper lefthand

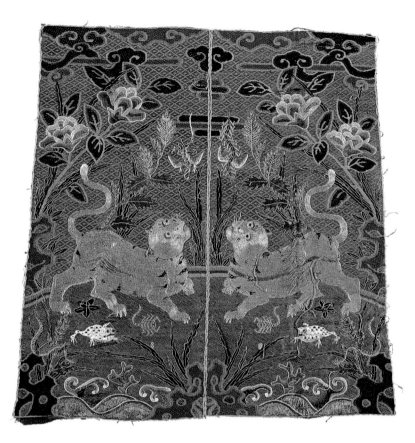

◉◉ 07.007 Dragon Boat Festival badge, Wanli (1573–1619), embroidery. (Provided by Chris Hall Collection Trust)

corner of this square has been repaired with similar fabric that is not as faded as the original material.

The Ming sumptuary regulations did not specify whether squares were to be worn by family members of the officials. However, portraits of the period show that wives wore squares identical to those of their husbands. and, hence, the distinctions between female and male insignia that arose in the Ch'ing Dynasty do not apply to Ming examples.

There were other badges such as festival badges and "longevity" badges, which were not used to denote rank. Festival badges were traditionally Ming, and will be briefly discussed here. Longevity badges will be discussed later.

Festivals were a venerable tradition to the dominant race of the Chinese, the Han Chinese. Festivals took on a special meaning during the Ming Dynasty. From the Han Chinese perspective both the preceding Yuan and succeeding Ch'ing Dynasties were examples of "foreign" oppression of the true Chinese people. During the last six hundred years of imperial rule the Han Chinese controlled the Throne of Heaven only during the Ming Dynasty. After suppression under the Yuan Dynasty, festivals took on special importance to the Han Chinese during the Ming rule. Festivals spawned an entire class of badges that were made to be worn during a particular celebration. Alternatively, some special symbols were incorporated into regular rank squares designed to be worn during a specific season. What follows is a brief discussion of some of the major festivals.

NEW YEAR: This festival marked the advent of spring and was a time to clean house, give gifts and settle debts. It was conducted for several weeks during January or early February on the Western calendar. It was considered unlucky to conduct business during the extended celebration. The New Year's

Festival was represented by the gourd, a traditional symbol of abundance. When the gourd design was embellished with special wealth and good luck symbols, it became the Gourd of Great Good Fortune.

FESTIVAL OF LANTERNS: Also known as the feast of the first full moon, it was held on the fifteenth day of the first month and furnished a finale for the extended New Year's celebration. A display of lanterns and feasting were essential parts of the celebration.

PURE BRIGHTNESS FESTIVAL: Focused on worship of ancestors, it was held on the third day of the third month. Ritual cleaning of the family tomb and offerings to the spirits of the departed were key elements of this festival.

DRAGON BOAT FESTIVAL: Celebrated on the fifth day of the fifth month, it was designed to propitiate the dragon river god who controlled the rain. It was hoped that the offerings made during this festival would assure an adequate, but not disastrous rainfall for the coming harvest. Because it occurred during a month that was prone to the proliferation of pests and diseases that might be associated with the hot season, the Dragon Boat Festival was also associated with efforts to dispel the effects of disease and infestations. It was believed that the spirit tiger had power over evil influences and demons, and so became associated with efforts to cleanse the environment of these evil influences. Badges worn at the Dragon Boat Festival depict the "five poisons" which are dominated by the spirit tiger and medicinal plants. An example of this type of badge, 07.007, is from the Wanli period (1573–1619). The spirit tigers are accompanied by the long thin leaves of sweet flag and the jagged leaves of artemsia, two plants believed to have medicinal power. The five poisons were traditionally the centipede, snake, scorpion, lizard and toad. However, other noxious creatures could be substituted including spiders, wasps and bed bugs. This square has the toad, snake and scorpions duplicated on the bottom of it with a winged (!) centipede and lizard above the tigers. This badge also incorporates the traditional Ming trapezoidal shape and lack of a border.

FOLK TALE FESTIVAL: Celebrated on the seventh day of the seventh month, it was oriented around the myth of a Cowherd and a Spinning Lady,

daughter of a deity. The hapless couple fell so deeply in love that the Spinning Lady neglected her duties. As punishment the couple was separated and forced to live in the sky as two constellations (Aquila and Lyra), but allowed to be together one night each year. Magpies, symbols of marriage and happiness, formed a bridge that allowed the Spinning Lady to cross the Cowherd and share their one night together. Example 07.008 shows the front badge for this festival. The two lovers are shown on each side of the front split with their constellations represented above them. Although numerous magpies and crows are shown in the badge, the bridge between the two lovers is conventionally constructed. Example 07.009 shows the back part of this badge. It shows the Court of the Queen of Heaven where the Spinning Lady created diaphanous silks for the Queen and other deities. The three white rabbits at the bottom are a reference to the Moon Festival which followed the Folk Tale Festival. Due to the expense of these badges, it was not uncommon to have a single badge made that could be worn for two festivals.

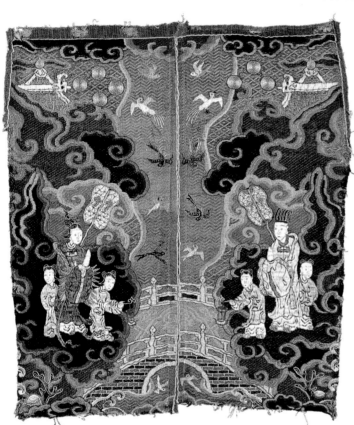

◎◎ 07.008 Folk Tale Festival badge (front), Wanli (1573–1619), embrodiery (provided by Chris Hall Collection Trust) ◎◎ *Opposite:* 07.009 Folk Tale Festival badge (back), Wanli (1573–1619), embrodiery (provided by Chris Hall Collection Trust)

MOON FESTIVAL: Celebrated in the middle of the fall season in the eighth month, the moon is at its farthest distance from the earth and supposedly appears at its roundest. The rabbit is associated with the moon by way of various myths. The Chinese frequently show the rabbit living on the moon, mixing the ingredients of the Elixir of Life (immortality) under a cassia tree. Incidentally, the badge that shows the three rabbits as a symbol of this festival would only have been worn by a woman or eunuch because it was considered bad luck for a man to wear a rabbit.

THE KITCHEN GOD FESTIVAL: Dedicated to the kitchen god who reported to the Jade Emperor (supreme deity) on the behavior of each family member at the end of the year, this celebration was to remind him of the devotion of all people just before he made his report.

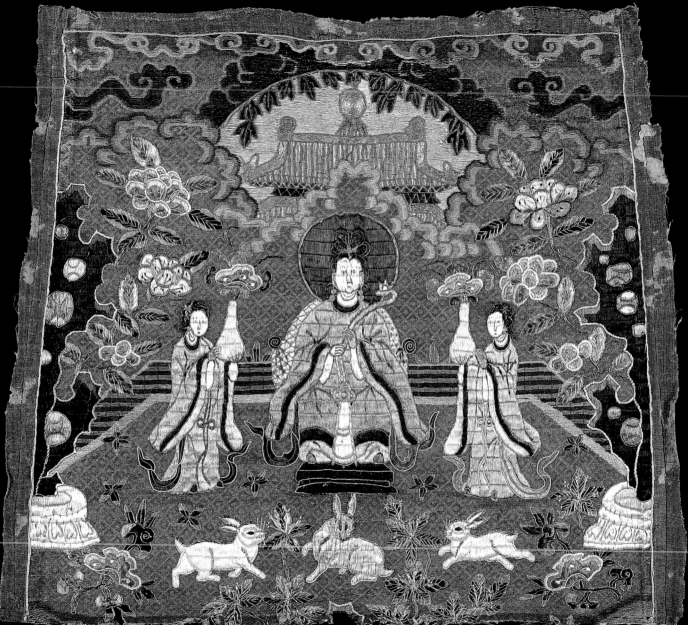

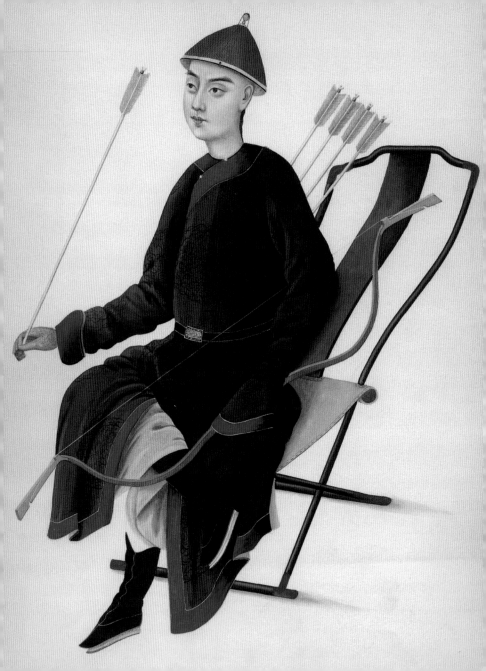

CHAPTER 8
OTHER RANK BADGES

Mandarin squares were not the only way to display rank. Other articles of clothing also carried this message. Although it is not my intent to treat the topic of hat decorations or belt plaques in any detail, it is to useful to understand that these were other badges of rank used by the Ming and Ch'ing Dynasties. I personally prefer the term mandarin square to that of rank badge or badge of rank because it clearly differentiates the squares from the other symbols of rank that were in use at the same time.

Hat decorations were one of the stylistic changes introduced in China by the Ch'ing Dynasty. In fact, using hat ornaments to denote rank preceded the Manchu's conquest of China. In 1635, about the time of the founding of the Ming Dynasty and when the Manchus had no actual power within China proper, the Manchus declared themselves an empire, complete with the clothing regulations denoting rank. Initially, hat ornaments were the primary way the Manchus used to display rank. The Manchu "emperor" wore a many-pearled ornament, nobles wore lesser numbers of pearls and officials wore ornaments based on the colors of the Manchu fighting units: red, blue, white and yellow. Eventually, hat decorations were included in a system for displaying rank in the court regulations when the Manchus came to power and founded the Ch'ing Dynasty.

Like most objects associated with customs, rank and ritual, the hat ornament underwent its own evolution. Initially, they were long, elaborate decorations worn atop a sphere, but worn only on formal hats. However, this restriction of hat-based rank definition to formal occasions did not provide sufficient opportunity

◎◎ *Opposite:* Portrait of an archer. He wears a summer hat with what appears to be a plain gold finial of the seventh rank. He does not wear a corresponding rhinoceros square as these were only worn on official or formal occasions. Nineteenth century, gouache on paper. (From a private collection)

117

for status display and in 1727 less elaborate ornaments in the form of round colored spheres were required on informal hats. They could be real precious stones cut en cabochon, but were more frequently glass. Since glass was very expensive and difficult to work with, it was considered a semiprecious "stone" and thus an acceptable substitute for real gem stones. In 1730, the regulations were revised to include distinctions based on the opacity of the stones with clear stones ranking higher than opaque ones. Thus ruby outranked coral, sapphire had precedence over lapis lazuli, crystal was more prestigious than moonstone, and plain gold was superior to embossed gold. Silver was used to denote the ninth rank until 1880 when it was changed to embossed gold. A description of the different designs for informal hat ornaments is found in Table 1.

The Manchus established the practice of wearing ornamental belt plaques at the same time that they started wearing hat ornaments. When they established the Ch'ing Dynasty, belt ornaments became part of the official court costume. Belt plaques were not only decorative but had side plaques that provided pendant loops from which purses and other accessory-carrying pouches could be suspended, a useful service for someone whose costume had no pockets or trousers. The shape, decoration and ornamentation of the belt plaques determined the wearer's rank. A description of belt plaques is found in Table 2.

Although they were not, strictly speaking, a symbol of rank, one often sees portraits of mandarins wearing long strings of beads. In fact, these beads were a form of a Buddhist rosary. The only function they served in indicating rank was that only officials above the fifth rank could wear them. The bead's substance was not regulated, except that only the emperor could wear beads of pearl. However, the color of the silk that the beads were strung on was regulated (See pages 90-91 in Part One.).

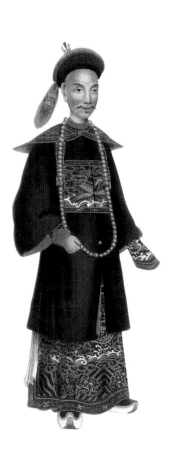

🔄 *Right:* A mandarin dressed for an official occasion with a crane square of the first rank, a corresponding formal hat spike and mandarin necklace. (From *Round My Peking Garden* by Mrs. Achibald Little, T. Fisher Unwin, London, 1905) 🔄 *Below:* A mandarin wearing a golden pheasant square of the second rank with corresponding formal hat spike and necklace. (From *Desultory Notes on the Government and People of China* by Thomas Taylor Meadow, William H. Allen & Co., London, 1847)

⤳ *TABLE 1* ⤳

INFORMAL HAT KNOBS

Rank	1727–1730	1730–1911
1	coral	ruby
2	engraved coral	engraved coral
3	engraved coral	sapphire or clear blue glass
4	lapis lazuli	lapis lazuli or opaque blue glass
5	lapis lazuli	crystal or clear white glass
6	crystal	moonstone or opaque white glass
7	gold, changed in 1728 to engraved crystal	plain gold
8	gold	engraved gold
9	gold, changed in 1728 to engraved gold	silver, changed in 1800 to embossed gold

⤳ *TABLE 2* ⤳

BELT DESIGN

Rank	1727–1911
1	four jade rectangular plaques mounted in gold, one ruby
2	four engraved gold circular plaques, one ruby
3	four engraved circular plaques
4	four engraved circular plaques mounted in silver
5	four plain gold circular plaques mounted in silver
6	four tortoiseshell circular plaques mounted in gold
7	four plain silver circular plaques
8	four clear ram's horn circular plaques mounted in silver
9	four black horn circular plaques mounted in silver

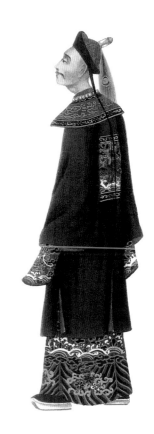

⥀⥁ *Below:* A mandarin wearing a wild goose square of the fourth rank with corresponding formal hat spike and necklace. (From *Desultory Notes on the Government and People of China* by Thomas Taylor Meadow, William H. Allen & Co., London, 1847)

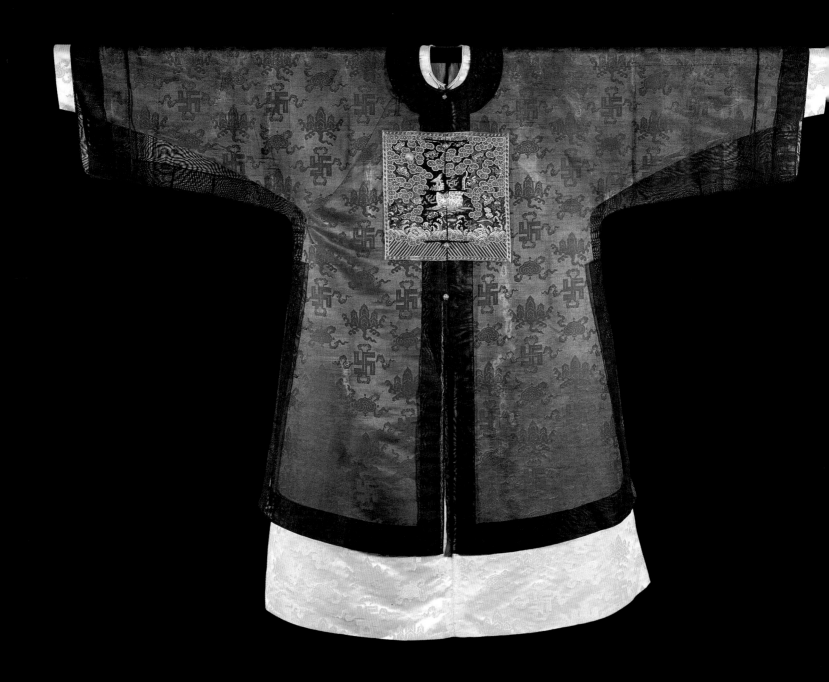

THE EXAMINATIONS

The process of examining officials as a basis for selection for office has a long history. There is an indication that as early as 2200 B.C. the emperor had established a testing process to insure that his court officials did not become lax and indifferent in the execution of their duties. The testing interval was recorded as every three years. The result of the test could lead either to continuation in service or dismissal from all official duties. The Zhou emperors tested candidates for office in the "five arts": music, archery, horsemanship, writing and arithmetic. In addition, knowledge was required in the rites and ceremonies of public and social life, a sixth art. The early Han Dynasty (206 B.C.–220 A.D.) examinations covered the six arts of the Zhou and also a specialty test in one of the following: law, medicine, mathematics and classical knowledge. Each specialty examination was designed to prepare an official for a specific career serving the emperor. By the time of the Tang Dynasty (220–280), the examination process had been fully implemented and lead to one of the most enduring of Chinese traditions. Over time, however, the literary degree became the preeminent and, finally, the only degree awarded by the examination process.

One of the appealing aspects of the examination process was its egalitarian nature. With some exceptions, any young man could sit for the exams and, assuming a competent performance, have as good a chance to pass as anyone. While China was not exempt from the exercise of privilege associated with great wealth (private tutors, relief from having to earn a living while studying), great care was taken to insulate the examination process from influence and bribery during the

Opposite: Elegant slate blue silk gauze mandarin's surcoat, or *pu fu*, adorned with a leopard square of the third rank. (From a private collection, Douglas Chew Ho Art & Photographics)

grading process. These efforts included notifying examination officials of their appointments immediately before their required departure to minimize time for collusion and bribery, isolating the examination officials during the grading process (food was passed into the officials' compound through small openings in the locked doors), and recopying every examination booklet to disguise handwriting or notations on the pages as a method of identifying individuals. These precautions served to reinforce the respect that officials, as learned Confucian scholars, had with the general populace.

There were certain occupations that excluded people from the examination process. Descendents to the third generation of prostitutes, actors, lictors (low-level assistants in the government *yamen*), and slaves were automatically disqualified. There was also a racial and geographical prejudice built into the exclu-

sion process. For instance, musicians from Shansi, the beggars of Kiangnan, and the boat people and fishermen of Canton and Chekiang were not eligible to enter the competition for official positions. This bigotry stands in sharp contrast to the generally permissive and evenhanded management of the examination system.

While the examination process was the vehicle whereby successful candidates were awarded mandarin squares and other badges of rank, this part of the book focuses on the resultant symbols of this process, not the process itself.

We should note here that there was a military testing process that paralleled the civil process in form if not in substance. The civil test process produced most of the scholars that ran the government. In contrast, the military testing system was not the primary source for either military officers or common soldiers. These posts were largely hereditary with specified families providing replacements whenever an officer or soldier was killed or became too old to serve. In compensation, these families were exempt from certain taxes and the conscripted labor levies that the government used to complete public works.

It is also interesting to note that while those who passed the civil service exams were widely respected and honored, neither the general public nor the largely hereditary military structure placed much worth on those who passed the military exam. In large part this was because the military tests were based primarily on the physical prowess of the candidate. The physical test required a demonstration of archery from horseback and the ground, and requirements to bend a wooden bow into a circle, twirl a halberd, and lift a heavy stone. Candidates were graded on the number of arrows that found the target, the sturdiness of the bow, the weight of the halberd, and the weight of the stone. There was a written test also, but it was hardly challenging. It merely required the candidate to write a short excerpt from one of three military classics from memory. Even this relatively modest intellectual requirement was impeached by widespread cheating among the candidates. The scholastic skills of the military candidates were so low that frequently those who smuggled in copies of the texts were passed, even when the texts were miscopied. Given this low level of achievement required by the military tests, it is little wonder that they were not respected by

∾ A young mandarin. (From *John Stoddard's Lectures* by John L. Stoddard, Balch Brothers Co., Boston, 1897)
∾ *Opposite:* Imperial lecture room of a university building. (From *The Lore of Cathay* by W. A. P. Martin, Fleming H. Revell Company, 1901)

any element of society. There is no available record of anyone who entered this way ever achieved prominence in the military.

Given the rigor of the civil admissions tests it may be surprising to know that, once in the system, promotions within the civil service were based primarily on annual evaluations provided by an official's superiors. Every three years

these reports were reviewed by the Board of Civil Office. This board ranked all officials by seniority and performance. Generally the top twenty-five to thirty-three percent of officials in each grade were recommended for promotion. Although we think of the Chinese system as having nine ranks, each rank was really divided into two classes; the *cheng* class was the upper, the *ts'ung* class the lower. Promotions were typically for half of a rank. For example, a fifth rank, lower class would be promoted to a fifth rank, upper class; a second rank, upper class would be promoted to first rank, lower class. Through this process of periodic review, a mandarin would progress through the ranks until his ratings were no longer sufficient to gain further advancement. About fifty percent of the mandarins eventually reached first rank, about twenty-five percent reached the second or third rank, and fully twenty-five percent never progressed above the fourth rank.

Another method for promotion was available to senior civil officials who could recommend a person of extraordinary skill for accelerated promotion directly to the emperor. However, if a person so recommended and promoted was ever punished for violating any laws or regulations, the punishment was meted out not only to the wrongdoer, but also to the

person who had recommended him. Because making such a recommendation carried an open ended liability and since abuse of the system for personal gain by the mandarins was so widespread (leading to the possibility of punishment of almost any mandarin), the special promotion system was too risky to be used very often.

Most people expect that squares representing the higher ranks are more scarce than those of the more common lower ranks. In fact, just the reverse is true. In general, the higher ranks are more easily found. Remember that fully one-half of all mandarins reached the upper rank, and those who did had numerous opportunities to enrich themselves. Few opportunities, it seems, went unused. Consequently, mandarins in the senior ranks surely had many formal outfits, each with its pair of squares as part of the costume. So the large number of officials coupled with the wealth they enjoyed insures a large selection of rank insignia for these grades. On the other hand, the lowest ranking officials were those who had not fully been accepted into the ranks of the intellectual and political establishment and who may have joined the civil service by virtue of their excellent performance in clerical positions. While clerks were allowed to join the ranks of actual officials after a nine-year probation, they were never fully accepted. Nor did they enjoy the same opportunities for advancement as those who had passed the rigorous civil service exam. These officials toiled throughout their lives in menial positions with virtually no chance for advancement or graft. Consequently, they had a limited wardrobe with few squares, and were typically buried in their best costume. So the combination of limited financial resources and burial customs have conspired to limit the number of the lowest ranking squares that we find available.

Incredibly, the salary for an average official was miserly, amounting to only a few hundred dollars a year allocated by taels (about one and one-third ounces) of silver and piculs (about 135 pounds) of rice. A first level civil official had an official salary of about 240 ounces of silver annually (about $1200–$1500 at 1999 prices). In addition, he was provided with 90 piculs of rice. The highest military officials were paid even more poorly: slightly over 100 ounces of silver

࿋ *Opposite:* Young mandarin with a peacock square of the third rank. (From the Vincent Comer Collection)

but over 500 piculs of rice. The lowest civil official received about 100 ounces of silver and 15 piculs of rice annually. Military pay at the lower levels was about 15 ounces of silver and a little over 20 piculs of rice.

This minuscule pay was augmented in some cases. Some officials, who managed to secure positions that were easily converted into sources of personal profit, were paid an "honesty" stipend to discourage bribery and personal corruption. These honesty payments were often over one hundred times a civil official's base pay in silver. Military payments were about twenty-five times the base pay in silver. Despite of the relative generosity of these honesty payments, they paled beside the amount of money that could be gained through skimming a portion of the tax receipts or accepting bribes. Estimates of extralegal income available to a Chinese official range as high as thirty times the amount of his official salary, including the honesty stipend. Given the magnitude of these unofficial payments, it was typical for an official to amass a personal fortune. While not a defense for the graft and corruption that was commonplace, fairness requires us to note that officials were expected to personally support projects that benefited the people he administered. A prime example was support of the school system (for young men studying for the civil service exams, not public education) and other public works. So not all the money was put to personal use, but it is clear that the government administration system was designed to benefit those who ran it.

◎◎ Portrait of an older mandarin winter robe. (Courtesy of the Gr Martyn Gallery, London)

CHAPTER 10
CH'ING INTRODUCTION

The Ch'ing Dynasty was established officially and properly inside China in 1644. That summer the bandit leader Li Tzu-cheng had effectively ended the Ming Dynasty by occupying Beijing and causing the last Ming emperor to commit suicide. Ming officials outside the capital invited the Manchus inside the Great Wall to defeat Li Tzu-cheng and restore the Ming Dynasty. The Manchus readily accepted the invitation to enter China and did vanquish the bandit. However, upon finding themselves in control of the capital, they declared the founding of the Ch'ing (pure) Dynasty rather than turning control back over to the Mings. Although they occupied the capital, the Manchus were not in control of the country. They spent the next eight years subduing the rest of China. The fighting in the southern provinces was fierce and lengthy. The devastation caused by the fighting significantly disrupted the silk industry which was concentrated in the cities of Yangzhou and Nanking. This had an important effect on the design of the early Ch'ing badges.

Early in the Ch'ing reign Chinese bureaucrats complained to Prince Dorgon, the regent for the Ch'ing Emperor, that the Manchus in charge of administration were terrifying bureaucrats by wearing battle armor to all meetings. In August of 1644, the Prince issued a proclamation that all Ch'ing warriors would adopt Ming-style dress until new regulations could be developed. During this interim period, the established Ch'ing practice of denoting rank with hat decorations and belt plaques continued. However, no mandarin squares were worn during this period. Further, the new regulations were not produced quickly. The eventual

◉◉ *Opposite:* A magnificent ancestor portrait scroll painting. (Courtesy of Dynasty Antiques)

subjugation of China would take another eight years. It was not until 1652 that the first complete set of Ch'ing court dress regulations was established. This moratorium on wearing mandarin squares as symbols of rank produced something of an aesthetic vacuum with respect to squares. Perhaps this interval made it easier for the remaining bureaucrats to accept the relatively significant design changes introduced by the Ch'ing Dynasty.

The new look for the squares was simply a part of a larger effort on the part of the Manchus to impose their own style of dress upon the native Chinese. Outer robes were changed from the red, free-flowing, full-cut style of the Ming to a dark blue or black, tighter fitting jacket that could be worn on horseback. The Ch'ing jacket fastened down the front which required that the square on the front be split vertically. Back squares remained intact. The sleeve cuffs for robes were shaped like horse's hoofs. Skirts were also split to accommodate a rider. Hats of different shapes to denote rank were replaced by hat spikes for formalwear and, eventually, hat knobs for informal dress.

Ch'ing squares evolved into smaller badges over a relatively short time period, eventually ending up about twelve inches square with an ornamental border added. The design used the "three parts of the universe:" the sky, the sea and the land, representing the emperor's authority over all of creation. In a notable departure from Ming design, the Ch'ing squares soon contained a sun disk. The multiple creatures of Ming squares were reduced to a single creature, primarily posed in a stiff heraldic position. Although the designs went through innumerable modifications over time, the typical Ch'ing badge had a pedestal of land in the center on which the creature stood surrounded by various depictions of the sea with sky and clouds in the background. Various literary allusions and good luck symbols were added later.

In addition to the design changes, there were some modifications to the last two civil ranks and unclassed officials' insignia. The oriole was discarded and replaced by the quail for the eighth rank. The quail was replaced by the paradise flycatcher for the ninth rank. The unclassed designation was eliminated so the oriole was totally dropped from the rank structure.

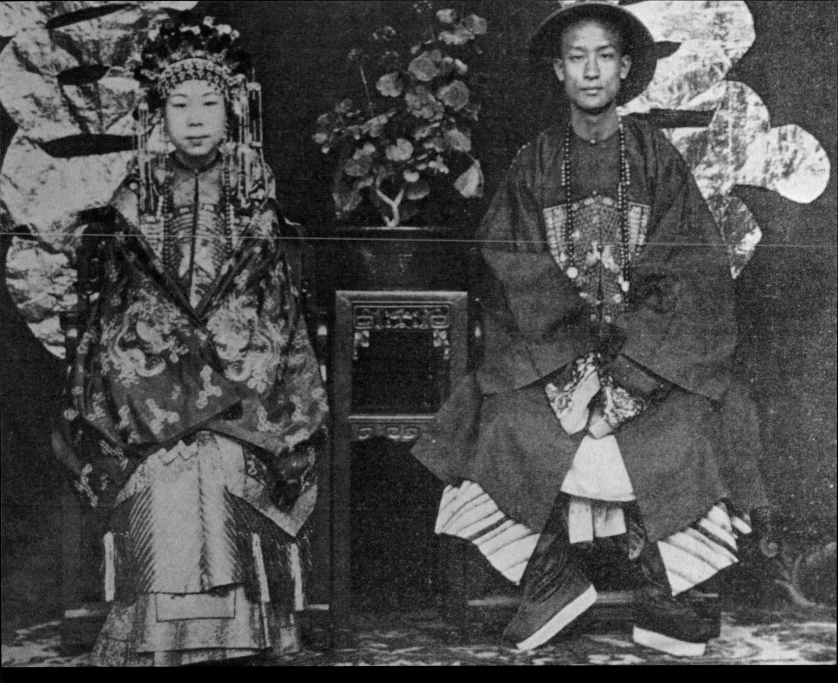

⊚⊚ A young mandarin and his bride
on their wedding day seated in front of
a banner displaying the characters for
"joy." (From *A Cycle of Cathay* by W. A.
P. Martin, Oliphant, Anderson & Ferrier, Edinburgh & London, 1896)

The military ranks also had a relatively minor adjustment. The tiger was unambiguously the insignia for the third rank, as was the leopard for the fourth. These two animals had shared both the third and fourth ranks under the Mings.

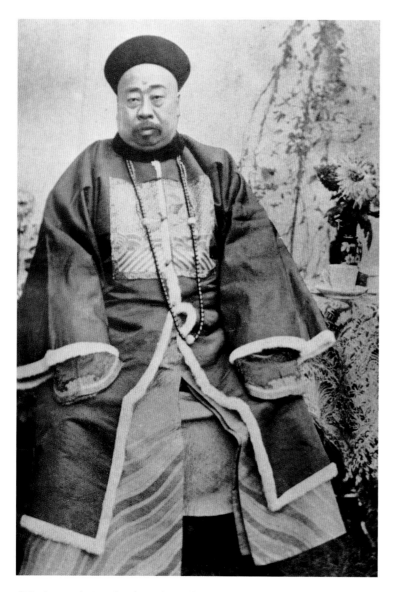

Later, in the first year of the Kangxi Emperor's reign (1662–1722), the *ch'i-lin*, a mythical beast of great power, was introduced as the insignia for the first military rank. In 1664, the leopard and tiger switched places. Finally, in the 1759 regulation revisions, the rhinoceros replaced the panther as the animal for the seventh rank while retaining its place as the insignia for the eighth rank as well. The rank birds and animals as they existed over time are listed on page 133, Tables 3 and 4. Positions held by civil and military officials are found on pages 134, 135, Tables 5 and 6.

The clothing regulations were a combination of Manchu and Chinese traditions. The formal hat spike and, later, the informal hat knob, the split skirts, the riding jacket, and the horseshoe sleeve cuffs were all unique Manchu styles. However, the use of birds and animals as symbols of rank were of Chinese derivation. Only the changes mentioned above were made in the rank symbols when the Ch'ing regulations were published. The jacket or robe upon which the square was worn was by decree to be plain, reasonably tight-fitting, black or dark blue.

The Ming regulations, as you recall, were silent on the subject of squares worn by a mandarin's family. The Ch'ing regulations specifically authorized the wives, sons and unmarried daughters to adopt his rank. However, only the wife was allowed to wear a square. The children wore the costume, hat and belt of the mandarin, but not the square or hat knob. Like most rules, these were ignored to various degrees over time. For future reference we need to

◎◎ A mandarin who has obviously lived well. (From *The Uplift of China* by the Church Missionary Society, London, 1909)

RANK	EARLY MING (1391–1527)	LATE MING (1527–1644)	CH'ING (1652–1911)
1	Crane or Golden Pheasant	Crane	Crane
2	Crane or Golden Pheasant	Golden Pheasant	Golden Pheasant
3	Peacock or Wild Goose	Peacock	Peacock
4	Peacock or Wild Goose	Wild Goose	Wild Goose
5	Silver Pheasant	Silver Pheasant	Silver Pheasant
6	Egret or Mandarin Duck	Egret	Egret
7	Egret or Mandarin Duck	Mandarin Duck	Mandarin Duck
8	Oriole, Quail or Paradise Flycatcher	Oriole	Quail
9	Oriole, Quail or Paradise Flycatcher	Quail	Paradise Flycatcher

☙ *TABLE 4* ☙

RANK	MING (1391–1527)	MING AND CH'ING (1527–1662)	LATE CH'ING (1662–1911)
1	Lion	Lion	C'hi-lin (after 1662)
2	Lion	Lion	Lion
3	Tiger or Leopard	Tiger	Leopard (after 1664)
4	Tiger or Leopard	Leopard	Tiger (after 1664)
5	Bear	Bear	Bear
6	Panther	Panther	Panther
7	Panther	Panther	Rhinoceros (after 1759)
8	Rhinoceros	Rhinoceros	Rhinoceros
9	Rhinoceros	Sea Horse	Sea Horse

∾ *TABLE 5* ∾

RANK	POTENTIAL CIVIL POSITIONS
1a	Attendants to the Emperor, Grand Secretaries in the Forbidden City
1b	Deputy Attendants to the Emperor, Attendants to the Heir Apparent, Presidents of Courts, Boards, and Censorate
2a	Deputy Attendants for Heir Apparent, Vice Presidents of Courts and Boards, Ministers in the Imperial Household, Governor General of the Provinces
2b	Chancellors in the Imperial Household and Hanlin Institute, Superintendent of Finance, Provincial Governor and Assistant Governor
3a	Assistant Vice Presidents in the Censorate, Provincial Judge, Directors of Courts and Activities (e.g. Parks and Horse Care)
3b	Director of Banqueting, Director of Imperial Stud, Salt Controller
4a	Directors and Assistant Directors of Imperial Household, Courts, Censorate, and Foreign Relations (with tributary states), Circuit Intendents
4b	Instructors in the Grand Secretariat and Hanlin Institute, Assistant Salt Controller, Prefects
5a	Deputy Supervisors of Instruction in Imperial and Hanlin Institutes, Inspector of Salt Distribution, Sub-Prefects
5b	Assistant Instructors and Librarians in the Imperial and Hanlin Institutes, Assistant Directors for Boards and Courts, Circuit Censors, Salt Inspector
6a	Secretaries and Tutors in the Imperial Academy and Hanlin Institute, Secretaries and Registrars in Various Imperial Offices, Police Magistrate
6b	Assistant Secretaries in Imperial Offices, Astronomer, Deputy Sub-Prefect in Province, Buddhist and Taoist Priests, Law Secretaries
7a	Assistant Police Magistrates, Registrars of Studies, District Magistrates, Director of Studies in Beijing
7b	Secretaries in the Office of Assistant Governor, Salt Controller and Transport Stations
8a	District Director of Studies, Salt Examiner, Prefectural Secretaries, Assistant District Magistrate
8b	Sub-Director of Studies, Archivists in Office of Salt Controller
9a	Jail Wardens, District Registrars, Prefectural Archivists
9b	Prefectural Tax Collector, Deputy Jail Warden, Deputy Police Commissioner, Tax Examiner

∽ *TABLE 6* ∽

RANK	POTENTIAL MILITARY POSITIONS
1a	Field Martial, Chamberlain of the Imperial Bodyguard
1b	Banner Unit Lieutenant General, Manchu General-in-Chief, Provincial Commander-in-Chief of Chinese Army
2a	Banner Captain General, Commandants of Divisions, Brigade General
2b	Major General, Colonel
3a	Brigadiers of Artillery and Musketry, Brigadier of Scouts, Banner Division Colonel
3b	Banner Brigade Commanders outside Beijing, Lieutenant Colonel, Major
4a	Lieutenant Colonel of Artillery, Musketry and Scouts, Captain, Police Majors in Beijing
4b	Captain, Assiatant Major Domo in Princely Palaces
5a	Police Captain and Lieutenant, First Lieutenant
5b	Gate Guard Lieutenants, Second Captain
6a	Bodyguards, Lieutenants of Artillery, Musketry and Scouts, Second Lieutenants
6b	Deputy Police Lieutenants
7a	City Gate Clerks, Sub-Lieutenant
7b	Assistant Major Domo in Nobles' Palaces
8a	Ensigns
8b	First Class Sergeant
9a	Second Class Sergeant
9b	Third Class Sergeant, Corporal, First and Second Class Privates

note here that the regulations specified that the wife would wear a square identical to her husband's. This will be important shortly when we discuss the sun emblem on the squares.

Mandarin squares were specifically authorized for wear by the emperor. As Beverley has noted in Part One, the testing process required to earn a square was arduous in the extreme. As a result of the pressure and uncertainty associated with the examination process, the bond that developed between students who passed an exam together typically lasted a lifetime. Close relationships also occurred between the examiner and the successful candidates. Some scholars have suggested that the final tier of examinations, the Imperial exam conducted in the Forbidden City, was designed primarily to establish a bond between those about to be elevated to mandarin rank and the emperor. This final bonding was supposed to assure the allegiance of all newly created mandarins to the emperor and avoid the formation of cliques within the bureaucracy. (If this was the intent of the Imperial examination, it didn't work very well.) One datum which supports this view of the Imperial exams is that the conditions under which the examinations were taken was much more humane than previous tests, and the winnowing process was far less strict at the Imperial level. This lack of pressure at the Imperial examination was probably why the bonding, under the extremely harsh conditions of the earlier exams, was relatively more lasting.

In spite of the fact that the emperor had to personally authorize a mandarin to wear a rank, this did not mean that the emperor supplied the squares that were worn. Due to the expense, each mandarin had to procure his own squares. Individual acquisition made designs much more varied and interesting than a standard-issue square would have been.

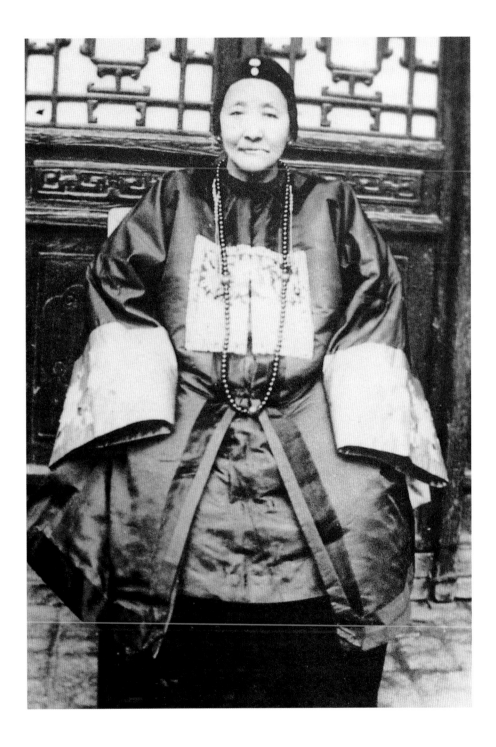

◇◇ An elderly woman wears a square that corresponds to her husband's rank. (From the author's collection)

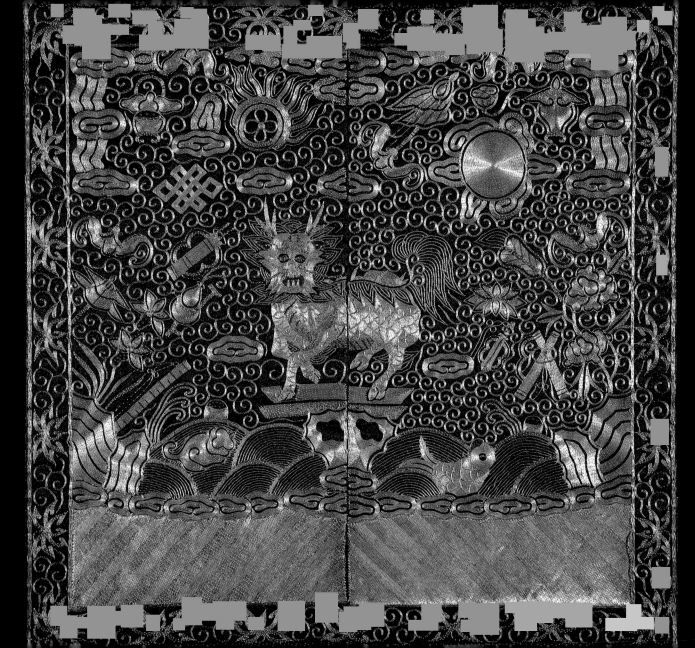

THE SUN DISK

One of the more significant changes in the Ch'ing squares was the addition of a sun disk. This did not occur immediately, but by the early part of the Kangxi Emperor's reign (1662–1722) the sun disk was a permanent part of the design. The use of the sun as a design element for squares was so firmly fixed in Chinese mind that when Ch'ing historians represented Ming squares, they frequently added a sun disk where there would not have been one in reality. The sun, along with the cloud-filled sky, was retained when the reform period of 1898 reduced the design to a minimum number of elements. The rationale for including the sun has never been explained which has lead to speculation as to the meaning of this important element. One interpretation is that the sun represents the emperor, the Son of Heaven. The central creature is normally shown gazing upward, theoretically at the emperor, to show the wearer's respect for his sovereign. This has some credibility since the emperor was typically associated with heaven and things circular. In addition, the sun disk was placed so that the wearer's rank creature faced the emperor when the mandarin attended court. For a civil servant who stood in the place of honor on the emperor's left, the sun was positioned in the wearer's upper right-hand corner. The left side was considered the superior side because the emperor normally faced south when greeting officials or guests at court. Thus, the left side was the side on which the sun rose, the side of princes, the honored side. Military members who stood on the emperor's right placed the sun in the upper lefthand corner of their squares. Thus both sets of creatures would not only

Opposite: Ch'i-lin, after 1850, metallic thread couched on silk, female (Provided by Corrie Grové, Peninsula Photographics)

face the sun on the squares, but would also face toward the emperor at court. Finally, the vast majority of scholars who have written about mandarin squares have stated unequivocally that the sun disk represented the emperor.

There is another theory that the sun represents the Chinese proverb, "Aim at the sun and rise high." This more prosaic wish for advancement does not have nearly the emotional appeal as the former theory, but has several points to support it. First, the civil squares incorporated the sun sooner than the military did. (Examples 15.001 to 15.004 demonstate the military's lag behind the civil adoption of the sun disk.) This seriously undermines the idea that the sun represented the emperor as it is highly unlikely that the military would have been less enthusiastic about paying homage to the sovereign than the civil bureaucracy. This is especially so since the military was composed largely of Manchu bannermen who had a racial identification with the Ch'ing ruler that the Han Chinese scholars in civil service did not. Secondly, the first rank military animal, the *ch'i-lin*, is seldom, if ever, found looking at the sun in Ch'ing badges. Instead, the *ch'i-lin* typically faces front. If the sun had actually represented the emperor, this failure to look at the sun would have been an intolerable affront. (See 13.001 to 13.004 for examples of the *ch'i-lin*.) And there never would have been a group less likely to insult the emperor than his comrades-in-arms from the Manchu banners. Finally, the rank squares of the Ch'ing nobility by birth lacked the sun disk (see 16.007). It is unthinkable that the most senior leaders of the regime would fail to honor the emperor by excluding a symbol that represented him personally. However, if the sun actually referred to the proverb, nobles might well shun such a symbol since the only way a noble could "rise high" would be to replace the emperor himself. This kind of wish on the part of a noble, even subtly expressed, was probably not calculated to produce either long life or happiness. So the lack of a sun disk on a nobleman's square also supports the view that the sun alluded to a proverb. On balance and in opposition to most authorities on the subject of mandarin squares, I feel that the weight of the evidence indicates that the sun disk refers to the Chinese proverb.

The sun disk had an interesting role to play in identifying which Ch'ing badges were worn by women and which by men. Ch'ing regulations specifically authorized wives to wear squares identical to their husbands'. However, this presented an emotional problem for the Chinese. When a wife sat next to her husband, she sat on her husband's right, in the low status position. Consequently if she wore a square identical to her husband's, her bird would face away from his. This implied disharmony and disrespect was so unsettling that, by custom and without regulatory permission, the women soon adopted the practice of wearing a square that was approximately the mirror image of their spouses' square, so that when a husband and his wife sat together, their birds would look at each other in mutual harmony and respect. Hence, by custom, we have one of the more enduring rules of mandarin squares. It specifies that a civil badge with the sun disk in the wearer's upper righthand corner was worn by a male. The sun placed in the wearer's upper lefthand corner was worn by a female. The date of origin for this custom is another area of controversy. Most experts state that the change occurred in the middle of the eighteenth century. However, we have evidence of badges in the Kangxi period (1662–1722) that clearly show this design change. While it is not possible to determine when the majority of badges adopted this change, there were certainly some who adopted this modification to the regulations in relatively short order.

Most discussions with regard to placement of the sun disk typically end at this point. However, we need to consider what this custom did to military men and their wives. First, let's understand the difficulty. Since a military man would have been placed on the emperor's right at court, his rank animal had to face to his left toward the emperor. However, at social functions with his wife, he would occupy the position of honor on his wife's left. In order to avoid projecting an aura of disharmony, his rank animal should face to the right toward his wife. Now what was the poor soldier to do? He certainly could not afford to offend his emperor, but neither could he project disharmony in social settings. There clearly is no complete answer to this question, but this dilemma, I believe, has lead to a certain schizophrenia on the part of military squares. One

possible compromise solution was to have the animal's body face from left to right, but turn its head to look at the sun over its shoulder. This would keep the animal looking at the emperor when at court and the sun disk on the square. But the main part of the animal's body would be positioned from left to right and generally aligned toward his wife. The bear squares, 13.017 and 13.018, illustrate what a man and wife would have worn if they had adopted this approach.

However, this clearly was not the perfect answer. And like most compromises, it lead to its own set of issues. Since wives were supposed to wear a "mirror image" square, should her animal also look at the sun over its shoulder and away from her husband? In addition to the bear squares, 13.017 and 13.018 referenced above, the panther squares, 13.021 and 13.022, demonstrate this solution. Or should her animal look directly at her husband and break the "mirror image" rule? And should the husband not have a special badge that he wore only at social functions with the sun in the righthand corner and the animal looking directly at his wife? The leopard squares, 13.009 and 13.010, and tiger squares, 13.013 and 13.014, illustrate this design approach. Like most mandarin square dilemmas, the answer to all these questions was apparently yes for some, but not for all. As the squares referenced here show, different people choose different answers to these solutions with the result that there is far less uniformity with military squares than with their civil counterparts. We are left with an intriguing variety of designs, sun placements, and body positions on military squares, depending on how the wearer felt about the relative priorities associated with the basic problem. So the enduring rule on sun placement that allows us to identify the sex of the wearer of a civil badge does not have its counterpart in the military arena. It is another of those issues that either makes mandarin squares a richly exciting area for examination or a bewildering morass of conflicting theories.

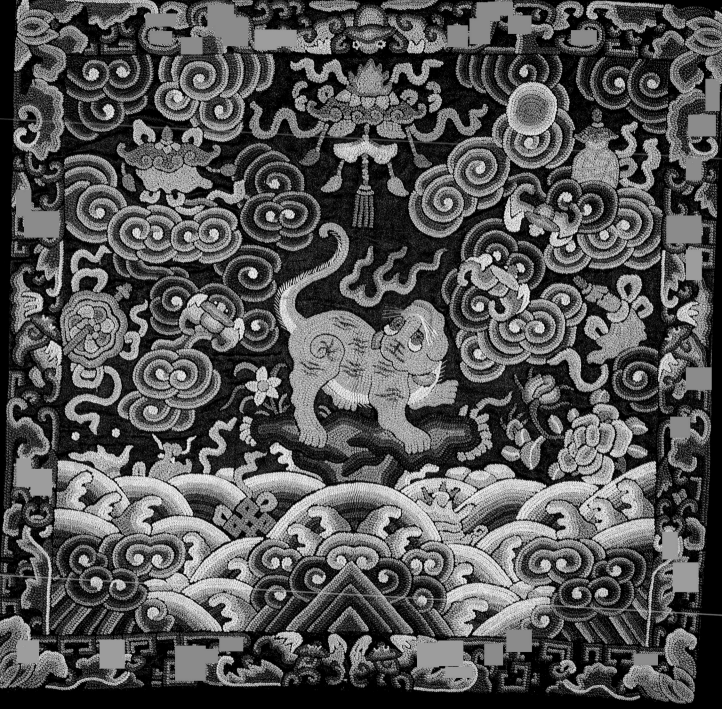

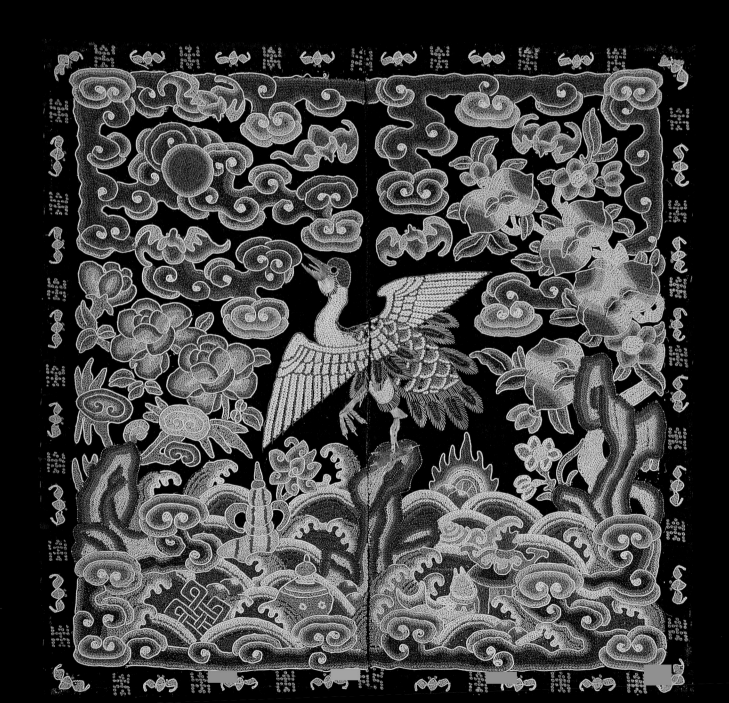

CHAPTER 12

IDENTIFYING BIRDS

Identifying the different rank birds is a basic skill for those who want to deal knowledgeably with mandarin squares. But before we begin, let us first note a few things that are not helpful to this process. Rank creatures, especially toward the end of the Ch'ing Dynasty, were displayed in an artificial pose. Other than in the reform period, which started in 1898, a rank bird perched on a small rock, on one leg, facing to the right or left depending on whether the wearer was male or female. All the birds were about the same size. The wings were typically wedge shaped and spread in the same general pattern. Finally, all birds had clawed feet, even those that had webbed feet in real life. Therefore, these criteria of size and shape, wing position, the pose, and feet do not serve to differentiate the birds. It is the form and shape of the head and neck along with the number and shape of the tail feathers that usually hold the key to identification. Although I will mention the typical coloration of each bird, keep in mind that these cues will not always be present. When designs were executed in certain brocades or with metallic gold and silver thread, the color cues disappeared in the monochromatic materials.

The crane, symbol of the first rank civil official, was venerated as a symbol of longevity and wisdom associated with advanced age. In Chinese mythology, it is associated with the Isle of Immortals where worthy souls were rewarded with eternal life. The crane is most frequently shown as a white bird with a rounded head topped by a red cap. Its neck is long and smooth. Its body may be smooth or with a scale-like design of stylized feathers. Design details on the body are

Opposite: Crane, circa 1840, Peking Knot embroidery, male. (Provided by Judith Rutherford, photography by Jackie Dean)

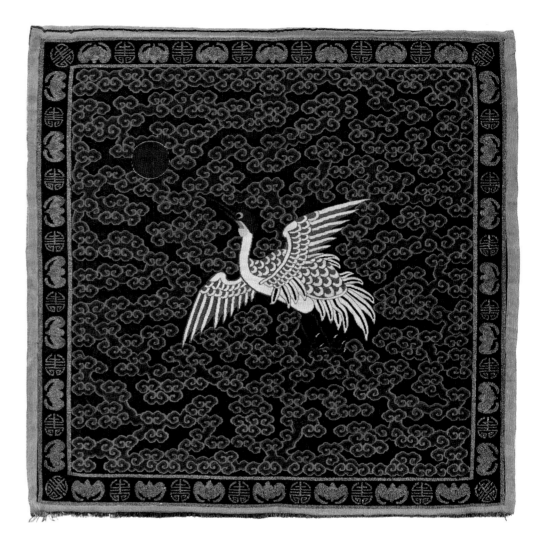

often done in black or gray thread. The tail feathers are short, stubby, spade shaped and black. One of the keys to identifying the crane is that the points of its tail feathers are separated from each other. Cranes normally have long red legs and long beaks, but these are less trustworthy as identifiers. Concentrate on the head and tail feathers for best results.

The four examples of the crane, 12.001; 12.002; 12.003; 12.004, represent four different production techniques. 12.001 is done in an embroidery technique known as Peking knot (sometimes erroneously called the "forbidden stitch" as it never was actually forbidden). Example 12.002 is woven silk (called

k'o-suu or *kesi*). Example 12.003 is a conventional satin-stitch embroidery. 12.004 is a monochromatic brocade popular in the mid-nineteenth century. The three multi-colored examples all show the red cap and white body. Although the style of representation is different for each, they all show the separate tail feathers that are typical of the crane. In the brocade example, they are the only definitive verification. All four squares show feather details on the back of the body. Other examples in the book will show the smooth body design. You should note that 12.002 shows a variation of the normal presentation of the bird because the left wing is raised revealing the breast, rather than the back. The color variations on the crane's body in these examples show that needleworkers often took liberties with reality to provide a greater palette than a truly representative depiction would allow.

The golden pheasant was the symbol of the second rank civil official and symbolized the duties and obligations of a court official. When created in color, this is one of the most variegated of the rank birds. Its head is normally crested and often has black markings on its yellow neck. Its legs are frequently red. However, its most unique distinguishing mark is its tail composed of two long, smooth-edged, sword-like tail feathers usually lightly barred in black. Early Ch'ing examples sometimes had three wavy tail feathers, but maintained the black bars. This tail is unlike any other among rank birds and allows a sure identification.

The golden pheasant examples, 12.005; 12.006; 12.007; 12.008, demonstrate the ease with which one can identify this bird even in the absence of the color cues. The two sword-shaped tail feathers are the key. Even the two

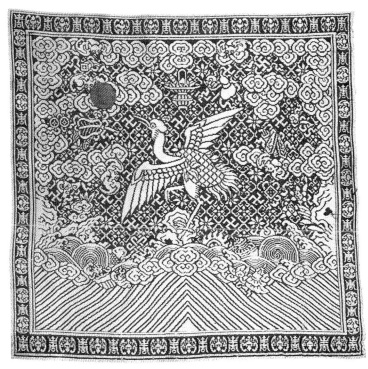

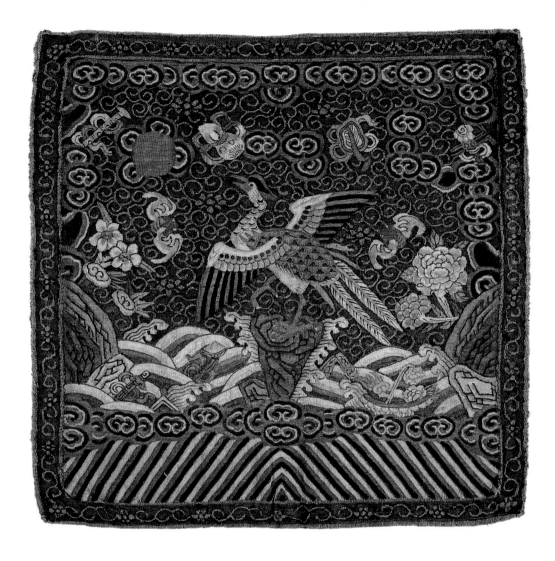

⊚⊚ *Right:* 12.005 Golden pheasant, after 1850, *k'o-suu*, male. (Provided by Corrie Grové, Peninsula Photographics) ⊚⊚ *Opposite:* 12.006 Golden pheasant, after 1850, appliquéd bird, couched metallic thread, male. (Provided by Judith Rutherford, photography by Jackie Dean)

examples in metallic thread show the characteristic light black bars. The square in 12.006 has lost three of the intended bars on the upper tail feather, but all six remain on the lower one. A close examination of the feathers in 12.007 will reveal four small bars on each tail feather. The painted bars in the woven silk square, 12.005, present this design detail in much greater profusion than we typically see. Only 12.008 lacks the tail bars. It is the sole example of a golden pheasant in the book which has this deficiency and simply demonstrates that there is no rule that is not violated at some time. The woven silk and gauze

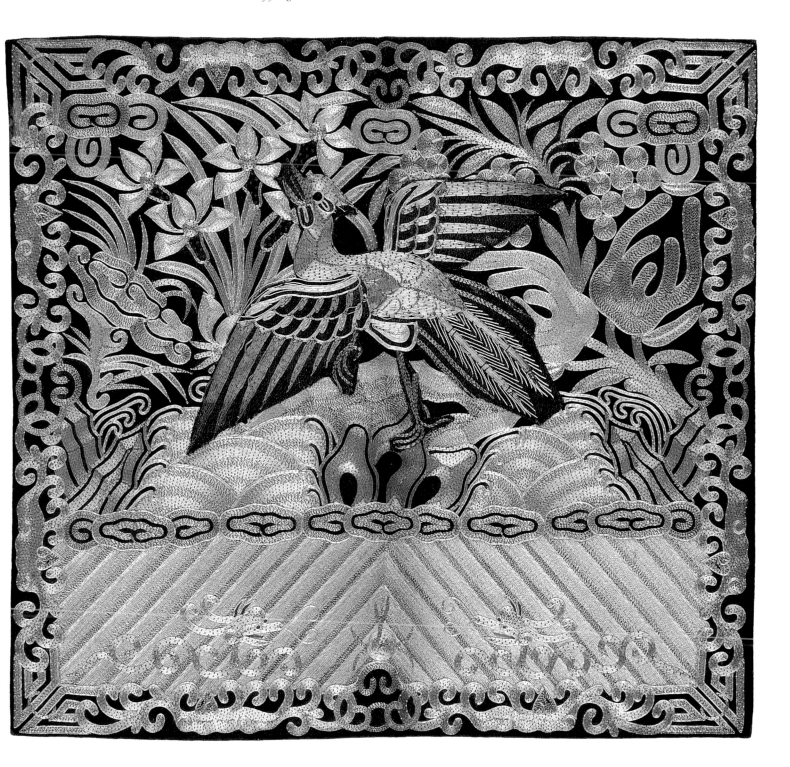

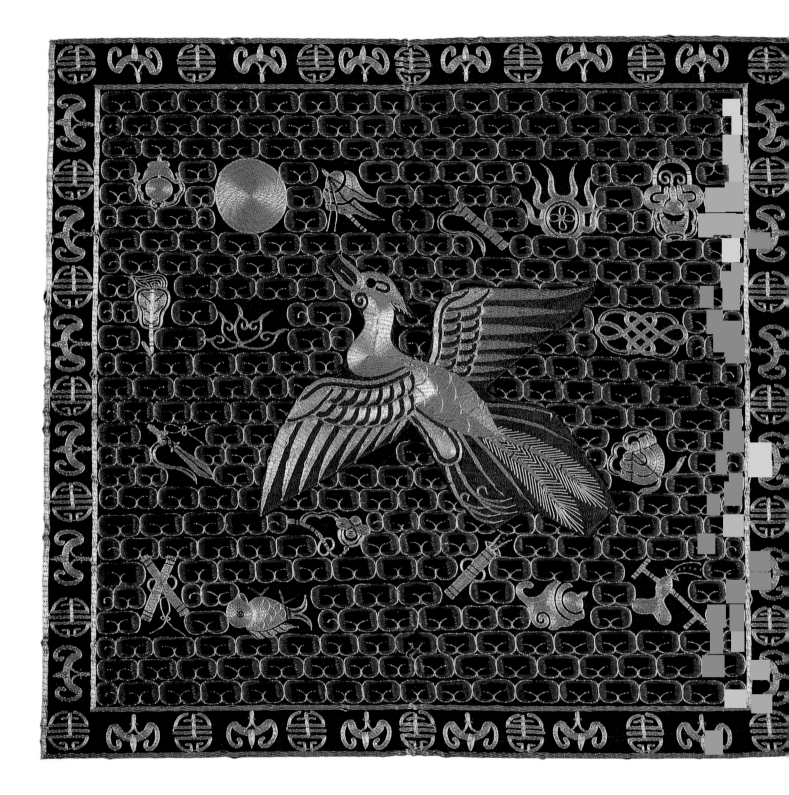

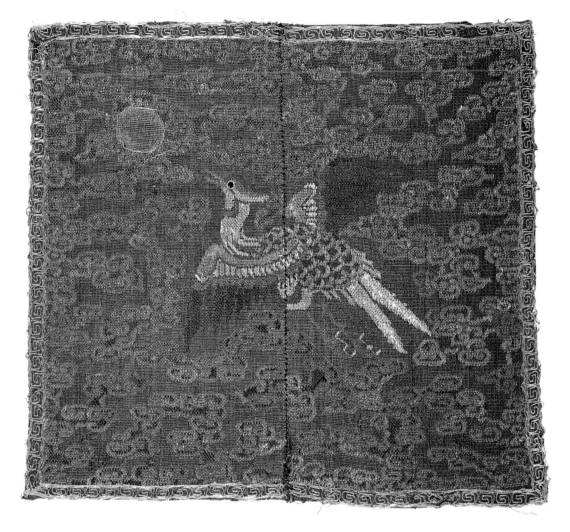

❀❀ *Opposite:* 12.007 Golden pheasant, after 1898, appliquéd bird, couched metallic thread, male. (Provided by Judith Rutherford, photography by Jackie Dean) ❀❀ *Left:* 12.008 Golden pheasant, after 1898, counted stitch on gauze, male. (Provided by David Hugus, photography by John Levin)

squares, 12.005 and 12.008, show the varied hues used to present this bird when colored thread is used. Although the mandarin duck rivals the golden pheasant in coloration, the tails of these two birds are so different that there is no real challenge in differentiating them. All four examples show the crested head typically used for this bird. The absence of a sun in 12.006 is not particularly unusual. Since this is an appliquéd square, the sun was attached at the time of purchase. In this case, the purchaser either opted to forego the sun or it has become detached over time. The dragon design in the water element of this square is an unusual addition and adds appeal to this late period square.

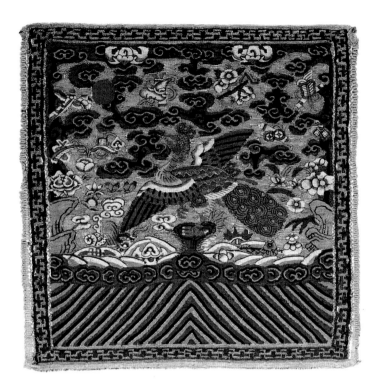

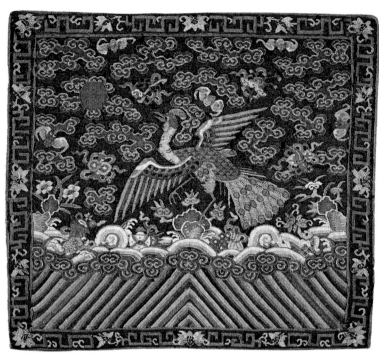

◎◎ *Above left:* 12.009 Peacock, after 1850, *k'o-suu*, male. (Provided by Beverley Jackson, photography by Kevin Delahay) ◎◎ *Above right:* 12.010 Peacock, after 1870, *k'o-suu*, male. (Provided by Corrie Grové, Peninsula Photographics)

The peacock is a symbol of elegance, dignity and beauty and denotes the third civil rank. It is supposed to dance in the presence of a beautiful woman. The peacock normally had a smooth head, sometimes with one or more small feathers of the same design as its characteristic tail feathers. This colorful bird was often embroidered in shades of green. The tail is the most obvious identifying feature with several large flowing feathers featuring the well-known "eye."

Our peacock examples are uniform in the critical identification details. All show the smooth head with one or more eye feathers. The characteristic tail is also evident in all four examples. The bird in 12.012 was embellished with a sequin eye which was added to the metallic thread design. Sadly, only three sequins remain on the tail and none on the head feather. Example 12.009 shows a deterioration that is common for a square of its original manufacture. What now appears to be a solid brown background was originally covered by peacock feathers. These feathers have, for the most part, been eaten by insects since they were incorporated into the design. One seldom sees a peacock feather back-

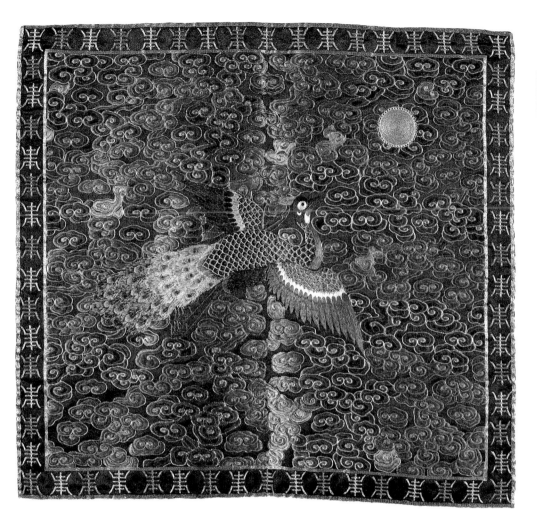

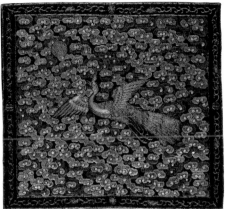

◎◎ *Left:* 12.011 Peacock, after 1898, embroidery, female. (From a private collection) ◎◎ *Above:* 12.012 Peacock, after 1898, metallic thread on gauze, male. (Provided by David Hugus, photography by John Levin)

ground intact today. One rare example that has survived is 12.022. A *k'o-suu* square with a largely intact peacock feather background is shown in 13.005. The use of peacock feathers was a common design choice and was not confined to third rank peacocks squares. The very bright colors in 12.011 were produced by aniline dyes which used late in the Ch'ing Dynasty. Such vivid colors, particularly the purple, are a clear indication of the use of these dyes. Example 12.011 is the first we have had of a square that was made to be worn by a woman. It is faced, as it would have been when sitting next to her husband, by a peacock in the male design, 12.012. This gives an indication of why, when worn by a female, the sun

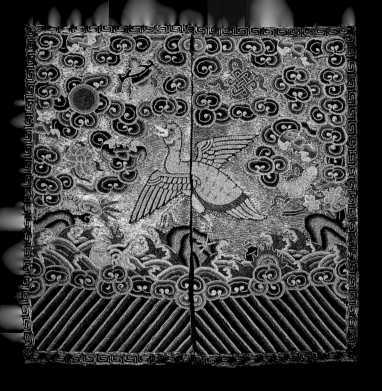

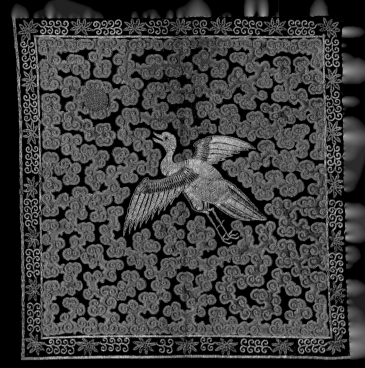

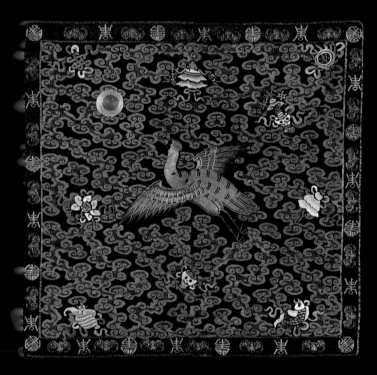

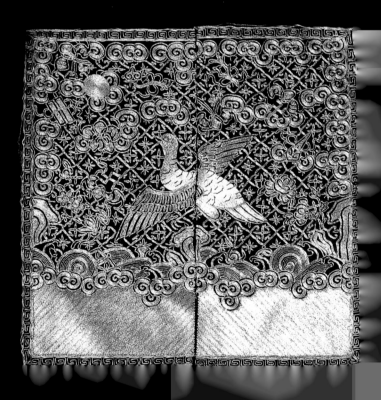

disk was customarily moved to allow a more gracious positioning of the two birds when a couple appeared in public.

The wild goose, or cloud goose, was a symbol of loyalty and marital bliss. It represents the fourth civil rank. Less colorful than other birds, it is usually mustard yellow or tan with lighter shadings on the neck and breast. It is most often shown with a smooth head, short neck and a wedge-shaped tail, typically with the center feather longer than the others. One distinguishing characteristic is the way the body feathers are represented by small pairs of black comma-like marks. Sometimes, with the earlier squares the feathers look more like scales. In keeping with its heraldic, not realistic, nature the feet are seldom webbed and instead they are depicted with claws.

All of our examples here use gold to a greater degree than was typical. Example 12.013 recalls the backgrounds of the earlier Kangxi period. Gold is used to compensate for the plainness that is usually imposed on the goose by its coloration in 12.014 and 12.015. The final example is done entirely in gold bullion thread couched on silk. In spite of the diversity of production techniques, all of these squares show the complete set of typical goose design features: smooth head, short neck, and the distinctive commas or parenthesis-like markings to delineate the feathers on the body. Example 12.013 produces the comma markings by incorporating a different color thread into the Peking knot embroidery. 12.014 and 12.015 also achieve this by overlaying the feather design on the gold background. An unusual technique in 12.016 creates a gap in the gold couched threads which produces darker areas of the design to represent the feathers. While the smooth head and wedged-shaped tail would identify the goose without these unique feather markings, happily they are usually present to help with the identification.

The silver pheasant is the symbol of the most numerous of the civil ranks, the fifth. It is another of the predominately white birds, although it is sometimes shown in blue. It frequently has a crested head and can be identified by its long, scalloped or serrated-edged tail feathers. In the early Ch'ing period, it typically had three of these feathers, later it had five. The silver pheasant seems to be the

◌◌ *Opposite top left:* 12.013 Wild goose, after 1850, Peking knot embroidery, male. (Provided by Gim Fong, photography by Leonard M. Cohen) ◌◌ *Opposite top right:* 12.014 Wild goose, after 1898, metallic thread couched on silk, male. (From a private collection) ◌◌ *Opposite bottom left:* 12.015 Wild goose, after 1898, metallic thread couched on silk, male. (From a private collection) ◌◌ *Opposite bottom right:* 12.016 Wild goose, after 1850, all metallic thread on silk, male. (Provided by Gim Fong, photography by Leonard M. Cohen)

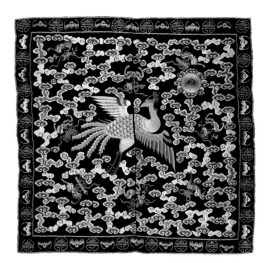

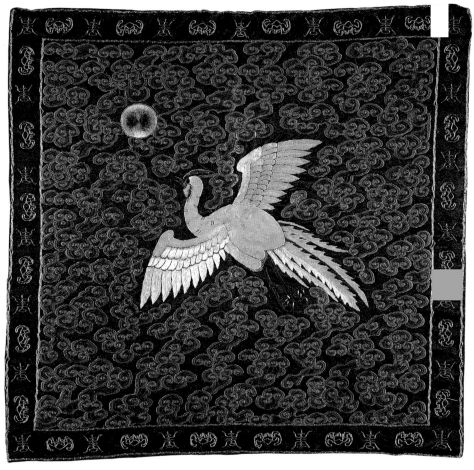

⊚⊚ *Above:* 12.017 Silver pheasant, after 1898, embroidery, female. (Provided by David Hugus, photography by John Levin) ⊚⊚ *Right:* 12.018 Silver pheasant, after 1898, embroidery, male. (Provided by Corrie Grové, Peninsula Photographics)

most common badge found today. Fully twenty-five percent of the mandarins failed to reach the upper ranks of the civil service. Apparently most of these moderately successful bureaucrats accumulated at the fifth rank.

Once again we have a "pair" of reform period squares that indicate how the male and female squares looked together. Three of these birds follow the rules we should look for when identifying the silver pheasant: white bird, crested head, five long tail feathers with serrated or scalloped edges. However, in a subtle attempt to look more like the higher ranking wild goose, the bird in 12.018 has a more rounded head with the crest raised and partially separated from the head. The color scheme of the crest is the same as the surrounding clouds, possibly so

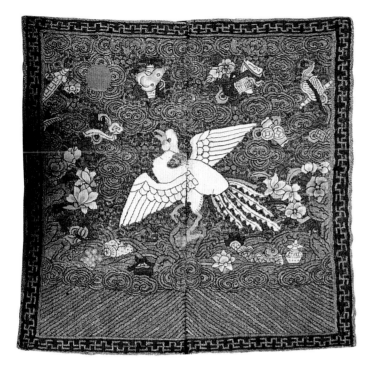

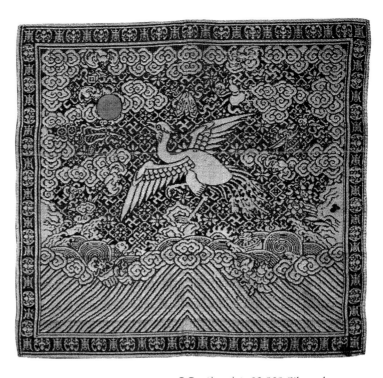

◎◎ *Above left:* 12.019 Silver pheasant, after 1850, *k'o-suu*, male. (Provided by Gim Fong, photography by Leonard M. Cohen) ◎◎ *Above right:* 12.020 Silver pheasant, after 1850, brocade, male. (Provided by David Hugus, photography by John Levin)

that it will blend into and be taken for part of the background, giving the head a more rounded shape. In addition, it has goose-like comma marks on its neck, but not on its body. While the tail feathers clearly identify this as a silver pheasant, a quick glance at the head of the bird would certainly suggest a goose. Since the characteristic tail feathers are included and the deviations from the typical design are subtle, the wearer of this badge could plead innocence if challenged on the ambiguity of his design. Example 12.019 shows traces of the peacock feather that once covered the background. The remains are concentrated around the pheasant and the surrounding Buddhist symbols. The difficulty associated with the identification of monochromatic brocade squares like 12.020 might also have been a purposeful part of its appeal when it was worn. These intricate single-color squares normally require a close look to pick out the actual shape of the bird's design. This difficulty in making a quick identification may have served a purpose similar to that of the design changes in 12.018, that is to encourage a misidentification for a higher ranking bird.

Right: 12.021 Egret, circa 1830, *k'o sun* male. (From a private collection) *Opposite:* 12.022 Egret, Peking knot embroidery, after 1850, male. (From a private collection)

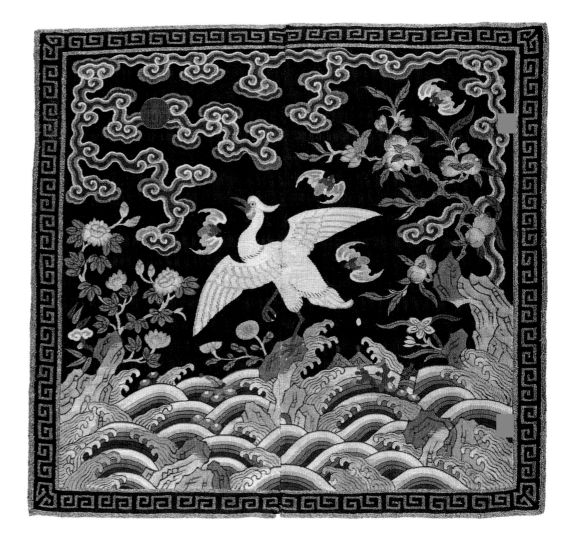

The egret of the sixth rank is the third white rank bird. It may either have a smooth or a crested head. If the head is smooth, it typically has one or two small feathers attached. These can be as subtle as two small trailing threads or one or two more obvious feathers. If it has a crested head, the crest is typically white or blue. The legs appear in a variety of colors. Green and yellow are typical, but red and blue are not uncommon. The egret has a wedge-shaped tail like the wild goose which clearly delineates it from the crane and silver pheasant.

Three of our four examples, 12.021, 12.022, and 12.024 have the crested head and show the egret as a totally white bird. Example 12.023 is the one exam-

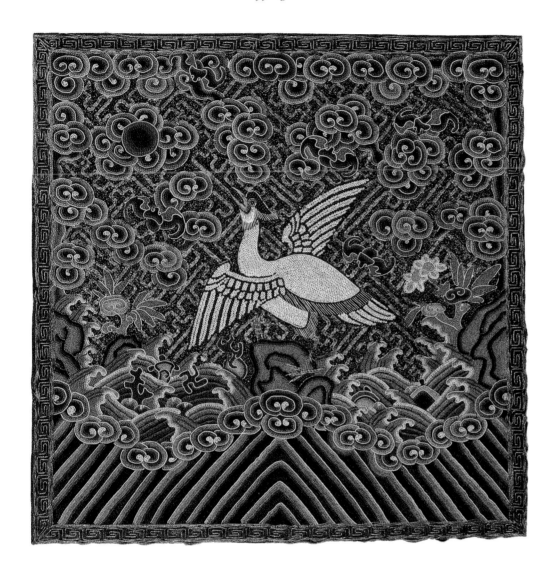

ple of a rounded head with feathers attached. It also deviates from the typical portrayal by using a scale-like design to decorate the body. Since we noted earlier that the crane sometimes had similar body decoration, the choice of a round head and scales for the body feathers may be another attempt to encourage misidentification on the part of a casual observer. I particularly like the elegance of 12.021 which is typical of the early nineteenth-century squares. The light blue designs on the body are woven, while the black details on the neck, at the base of the tail and on the leg are painted. Example 12.022 is wonderfully preserved for

159

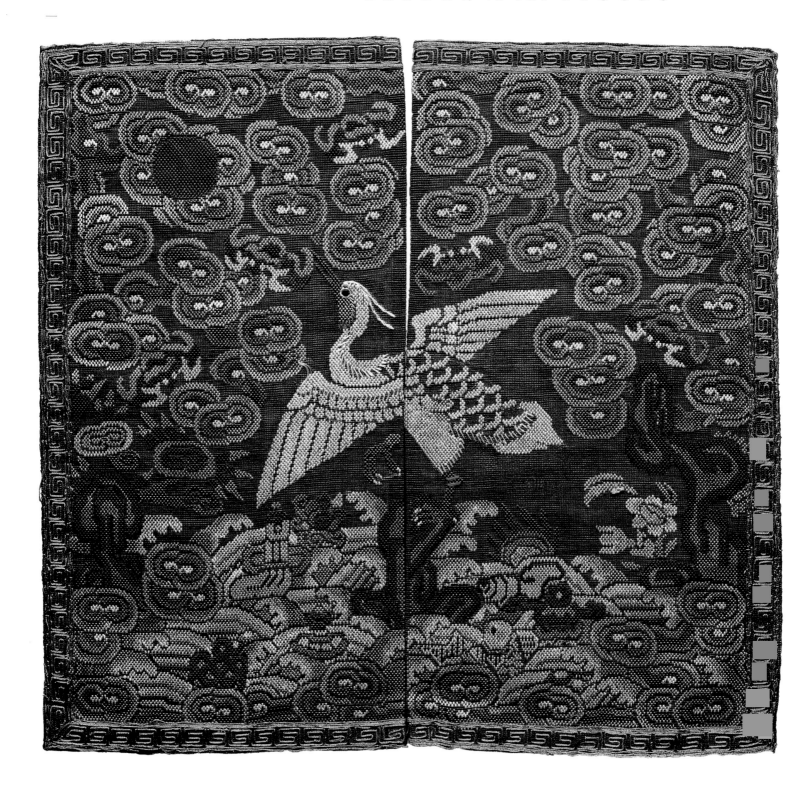

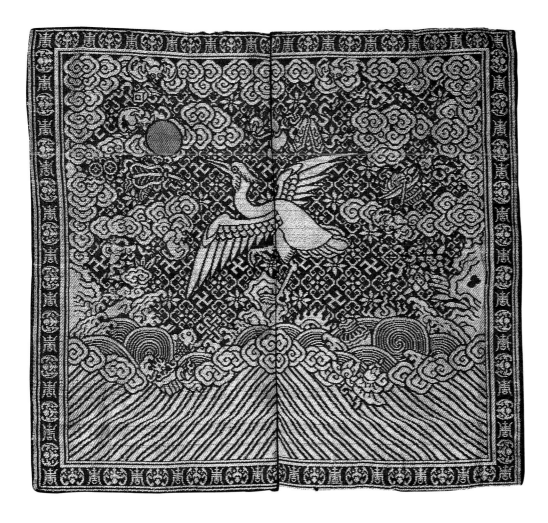

Opposite: 12.023 Egret, circa 1840, counted stitch on gauze, male. (Provided by Beverley Jackson, photography by Kevin Delahay) Left: 12.024 Egret, after 1850, monochrome brocade, male. (Provided by Vincent Comer, photography by John Levin)

its type and gives us a real appreciation of how a square actually looked when new. The use of nothing but the difficult and time consuming Peking knot embroidery, the bright colors, crisp gold thread and the well-preserved peacock feathers in the background make this square both instructive and aesthetically pleasing. Although a relatively low ranking member of the bureaucracy, the person who commissioned this square clearly spared no expense when ordering his rank insignia. He either had family money behind him or had found himself a very lucrative posting giving him an income significantly above that of his peers. The small head crest on 12.024 may be yet another attempt to fool a casual observer into thinking that the egret was actually a crane.

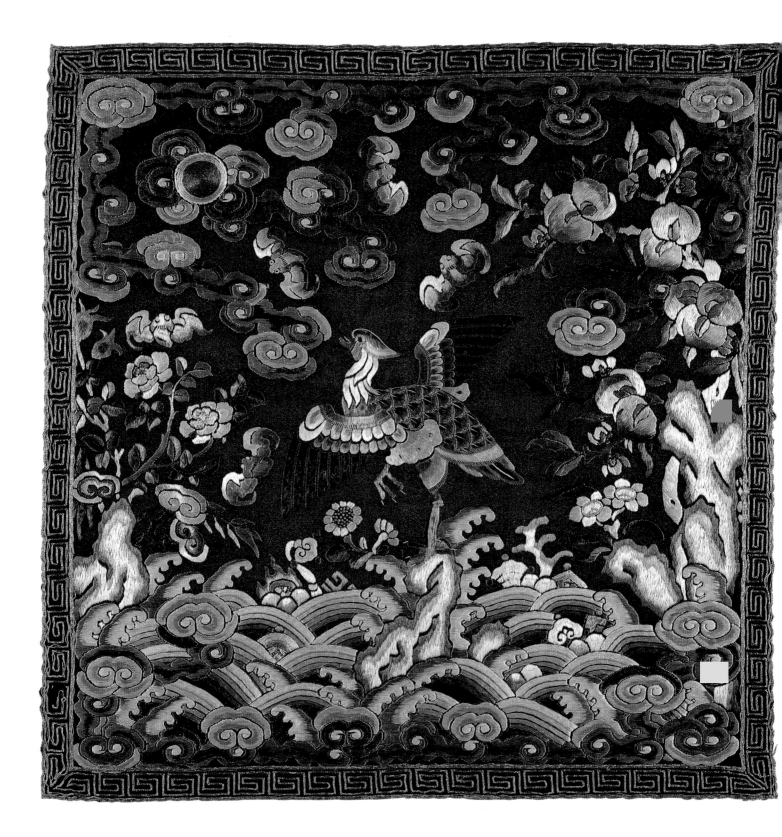

162

The seventh rank mandarin duck is a symbol of marital fidelity and is one of the most colorful of the rank birds. It also typically has a crested head, but its neck design is one of its most distinctive features. The feathers are arranged in two clearly delineated tiers with the wedged-shaped ends usually curled up. These distinctive neck feathers are normally yellow or golden. While its colorful plumage rivals that of the golden pheasant, it is typically dominated by blue. The feathers on its body are often shown in the familiar scale pattern. The legs and bill are frequently red. Like the goose, it has the unnatural but standard clawed feet, and shares the short wedged-shaped tail with the goose and egret.

The mandarin duck has the coloration and scale pattern on its body that is also typical of the golden pheasant. It is the configuration of the tail feathers that distinguishes these two birds: long and sword shaped for the golden pheasant and wedge shaped for the duck. Each of the ducks illustrated here adheres to the usual color scheme: blue-crested head, yellow or golden neck, blue-scaled body and red legs. Example 12.025 has the delicate design typical of the early nineteenth century. Example 12.026 is notable for two reasons. First, the execution of this *k'o-suu* is unusual for the period. Ch'ing *k'o-suu* never rivaled the Ming execution, however, infrequently one comes across a Ch'ing *k'o-suu* that stands out from the typical workmanship of the time. The incorporation of the gold thread edging and the fineness of the detail make this a remarkable square. Secondly, the design of the bird is atypical in one respect: the neck feathers lack the two-tier style that is so characteristic of the mandarin duck. In a more poorly executed example, one could assign this to sloppy execution, but that hardly appears to be the case here. Rather, it is just another example of the fact that no rule ever remained unbroken. We have an example of a late period metallic thread badge in 12.027. It incorporates an interesting feature that one occasionally sees: that of constructing the sun from small beads, rather than thread. It takes a magnified view of a square like this to determine whether the beads are coral or glass. Glass beads tend to have sharp corners on them, while coral tends to be more rounded. Example 12.028 is a typical brocade from the late nineteenth century. Along with 12.027, it provides another example of how the

∞ *Opposite:* 12.025 Mandarin duck, circa 1830, embroidery, male. (Provided by Corrie Grové, Peninsula Photographics)

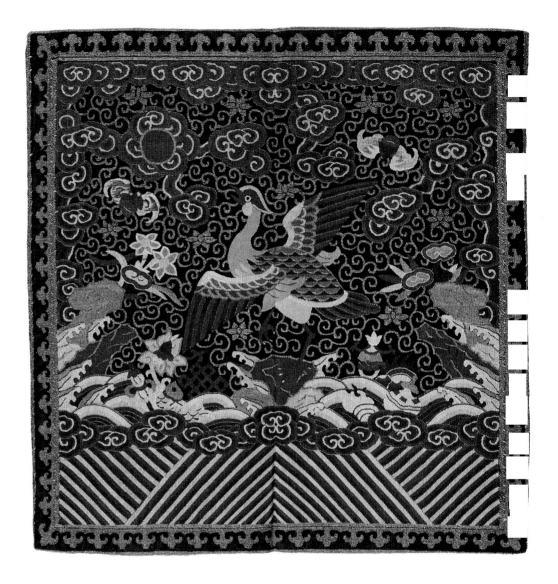

◎◎ *Right:* 12.026 Mandarin duck, after 1850, *k'o-suu*, male. (Provided by David Hugus, photography by John Levin)

birds on squares of a man and his wife would face each other when the couple appeared together in public.

The quail is a symbol of courage; a reference drawn from quail fights that were as popular in China as cock fights are elsewhere today. As the symbol for the eighth civil rank, the quail is a short, squat, usually brown bird. It has a rounded head with no decoration. Its body is often shown with scale-like feathers, frequently with the feather's midrib explicitly shown. Its tail is almost nonex-

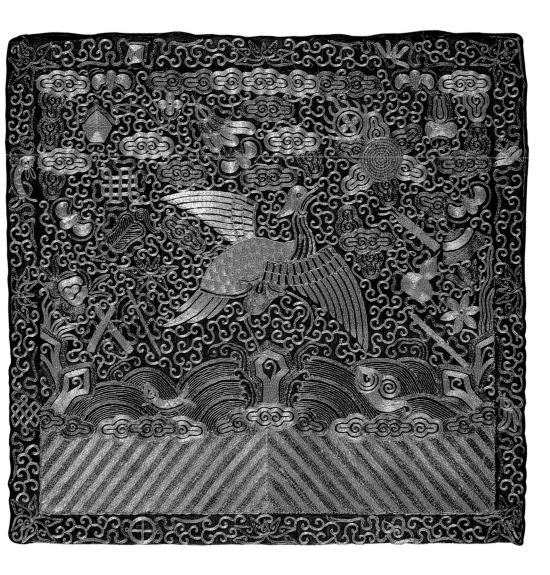

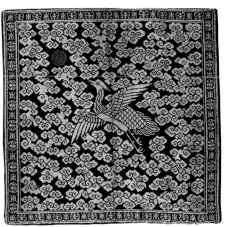

⊚⊚ *Left:* 12.027 Mandarin duck, after 1850, metallic thread on silk, female. (Provided by David Hugus, photography by John Levin)
⊚⊚ *Above:* 12.028 Mandarin duck, after 1898, brocade, male. (Provided by David Hugus, photography by John Levin)

istent with the feathers most often shown as a jagged edge to the bottom of the torso, pointed down.

To many observers quails were dumpy, unattractive birds. I suspect this was because quails were worn by some of the lowest paid members of the bureaucracy, who were, in all likelihood without independent sources of graft and corruption to augment their modest incomes. Thus, I imagine that quail squares suffered from economic deprivation in addition to any intrinsic flaws in their body

composition. All of our examples are typical quail design: rounded head, stubby body with almost no tail. However, 12.029 is a beautifully and expensively executed square, which was undoubtedly a costly proposition when it was made for the wife of a low ranking mandarin. The Peking knot embroidery coupled with the gold bullion background make this a visually arresting square. A typical example of the *k'o-suu* of the mid-nineteenth century is 12.030. The dominant blue and white background helps the quail to stand out. Examples 12.031 and 12.032 show the mid-rib of the body feathers clearly. The shading in 12.031 demonstrates that even the relatively plain coloration of the quail can be

Right: 12.030 Quail, after 1850, *k'o-suu*, male. (Provided by Vincent Comer, photography by John Levin)
Opposite: 12.029 Quail, after 1850, Peking knot embroidery, female. (From a private collection)

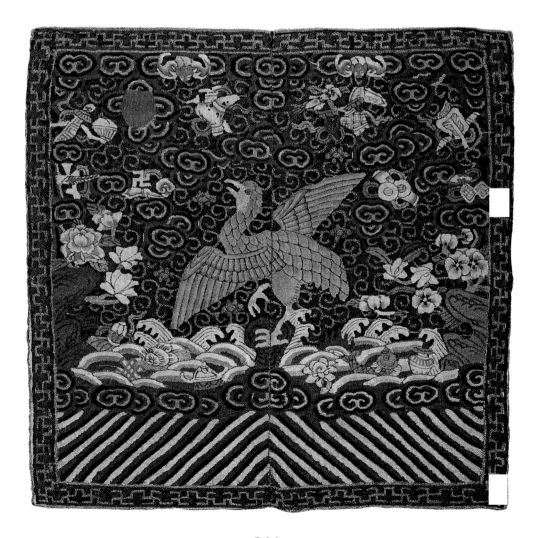

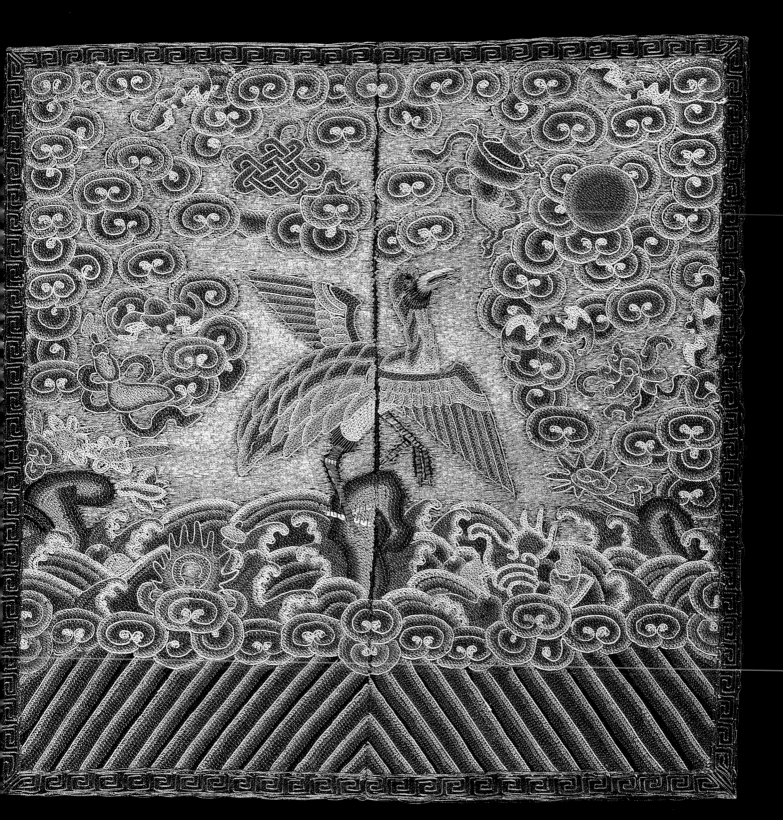

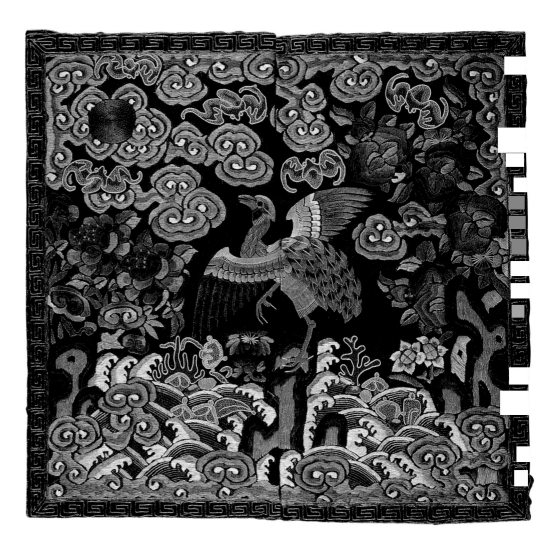

⊚⊚ *Right:* 12.031 Quail, circa 1830, embroidery, male. (Provided by Dodi Fromson, photography by John Levin)

⊚⊚ *Opposite:* 12.032 Quail, circa 1830, embroidery, male. (Provided by Corrie Grové, Peninsula Photographics)

enlivened by an artistic hand. Example 12.032 has a background that occurs in nearly every period throughout the nineteenth century. Decorative scrollwork fills the background if nothing else is available, a characteristic it shares with 12.030.

The paradise flycatcher of the ninth civil rank is the last of the four white rank birds. Like the peacock, its head can be either rounded or crested. If rounded, it normally has one or two feathers attached with the same design as its tail feathers. If crested, its head is usually white or blue. Its tail is primarily composed of two long, flowing feathers which are narrower at the base than at the end. Each tail feather has a single dot or eye which makes it easy to identify this bird.

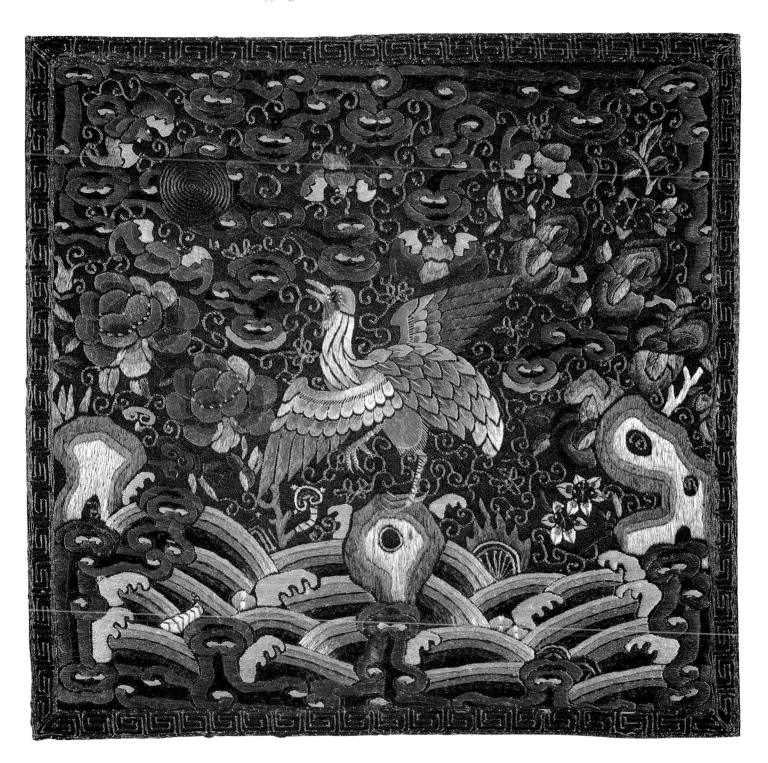

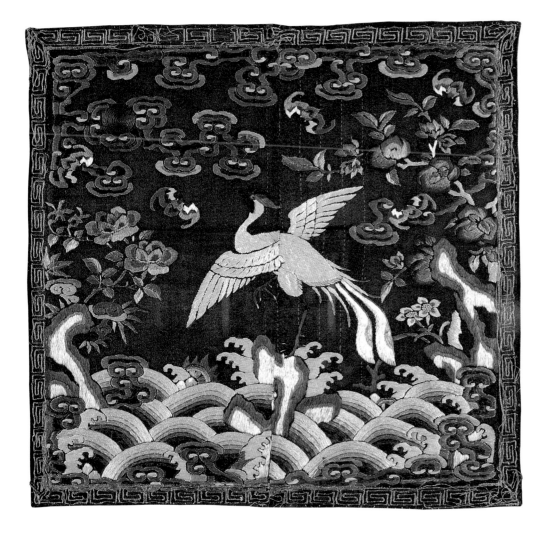

◉◉ *Opposite:* 12.034 Paradise fly-catcher, after 1850, *k'o-suu*, male. (Provided by Beverley Jackson, photography by Kevin Delahay) ◉◉ *Left:* 12.033 Paradise flycatcher, circa 1830, embroidery, male. (Provided by David Hugus, photography by John Levin)

The tail feathers of the paradise flycatcher are the best indicators for identifying this bird. But, in some instances, a close look may be required before you can identify the characteristic dots on the tail. Examples 12.035 and 12.036 will test this ability. In each case the metallic thread medium allows only the outline of the dot to be presented, making the identification difficult. The colorful embroidery in 12.033 and *k'o-suu* in 12.034 make the identification an easy task. While all four examples show the crested head option, recall that some paradise flycatchers have a rounded head with a head feather like the peacock examples shown earlier. However, the paradise flycatcher's feathers have a dot like the one

☙❧ *Right:* 12.035 Paradise flycatcher, after 1898, metallic thread couched on silk, female. (Provided by David Hugus, photography by John Levin)

☙❧ *Opposite:* 12.036 Paradise flycatcher, after 1850, metallic thread couched on silk, male. (Provided by Corrie Grové, Peninsula Photographics)

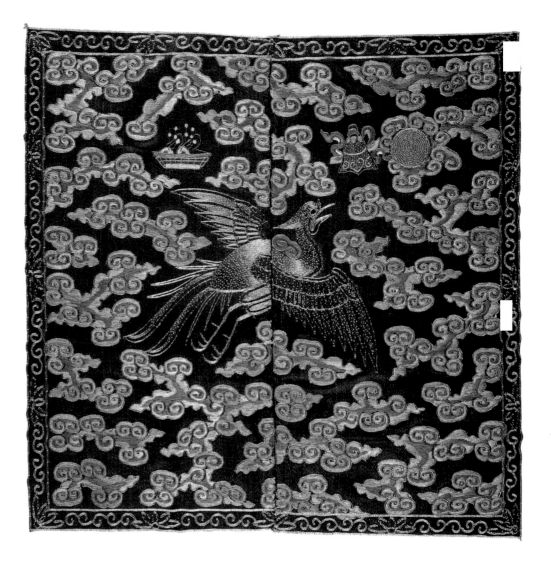

on its tail feathers. Example 12.033 is a particularly fine square from the early nineteenth century. The elegance of design and execution mark this as one of the nicest ninth level squares I have seen. (The faint vertical lines are weaknesses in the silk fabric on which the design was executed.) Example 12.034 shows typical *k'o-suu* work that was done in the latter part of the nineteenth century. The green tinges around the bird and some of the good luck charms are remnants of peacock feathers that were woven into the background. Example 12.036 was originally a two-color metallic display, using both gold and silver-wrapped threads.

172

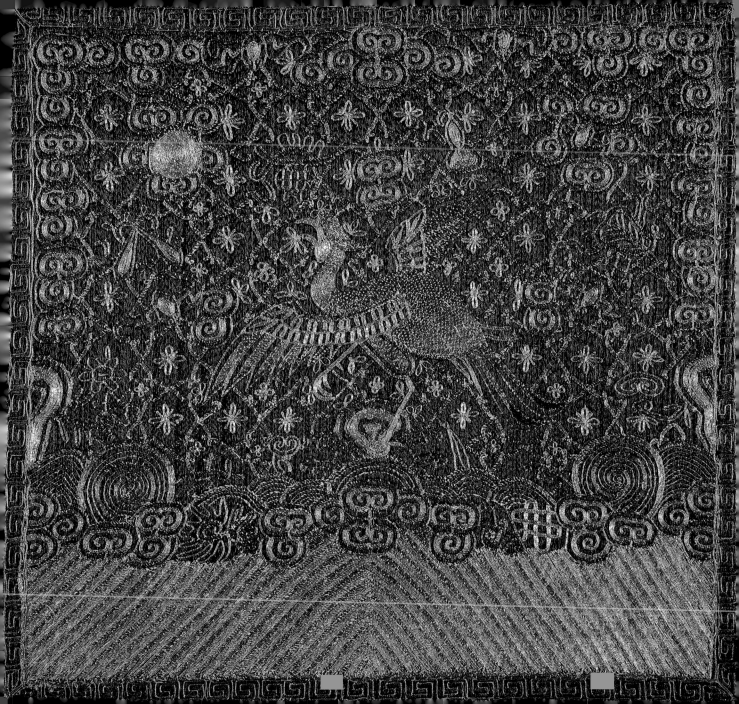

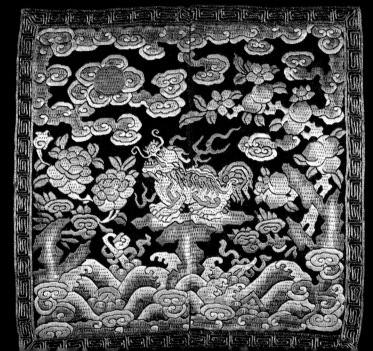

However, unlike gold which is chemically inert, the silver has oxidized with exposure to the air, leaving the base threads exposed. While this still gives the two-color contrast intended by the producer, it does not have the shine that the silver would have had. One often sees squares in this condition. They are no less valuable because of the underlying chemistry associated with their construction, but knowing what the square looked like at the time of its construction may help you appreciate the intent of the artist who made it.

One might imagine that the rule for civil officials wearing birds and military officials wearing animals would be the one instance when exceptions did not apply. Not true. There was a special branch of the civil bureaucracy called the censoriate, a group of specially appointed officials who served a purpose similar to the military's Inspector General branch or the civil arena's special prosecutors. They conducted special investigations for the emperor and generally served to identify wrongdoing and inefficiency among members of the general bureaucracy. These special investigators wore a unique square showing a mythical animal. Known as a *hsieh-chai* (pronounced like the three English letters c-h-i said rapidly in sequence) or *xiezhi*, it was a white creature with a dragon's head, a lion's body, a bear's tail, a mane, paws, and a single horn on it head. Apparently because both the *hsieh-chai* and the rhinoceros had a single horn, some people mistake the two. Since I have never seen what I consider to be a legitimate rhinoceros square, I can not provide definitive instructions for discerning the two. However, if the creature has paws, rather than hooves, it is likely a *hsieh-chai*, not a rhinoceros. According to myth, *the hsieh-chai* was able to determine truth from falsehood and when presented with a lie, promptly gored the liar with its horn. An apt selection for the censors' squares. Late in the Ch'ing Dynasty judges and magistrates started wearing this type of square. This custom continued toward the end of the dynasty, despite several directives prohibiting the practice.

Our four examples of *hsieh-chai* squares show typical designs. Note that all the animals have their mouths open, showing their teeth. Evildoers beware. In no case is the horn so large that it is easily identified at a glance. Hence, these squares are frequently mistaken for lion or bear squares. There are subtle differences between

꧁ *Opposite top left:* 12.037 Hsieh-chai, circa 1830, counted stitch on gauze, male. (Provided by Beverley Jackson, photography by Kevin Delahay) ꧂ *Opposite top right:* 12.038 Hsieh-chai, after 1898, *k'o-suu*, male. (Provided by Beverley Jackson, photography by Kevin Delahay) ꧂ *Opposite bottom left:* 12.039 Hsieh-chai, circa 1840, embroidery, female. (From a private collection) ꧂ *Opposite bottom right:* 12.040 Hsieh-chai, circa 1840, counted stitch on gauze, male. (Provided by Corrie Grové, Peninsula Photographics)

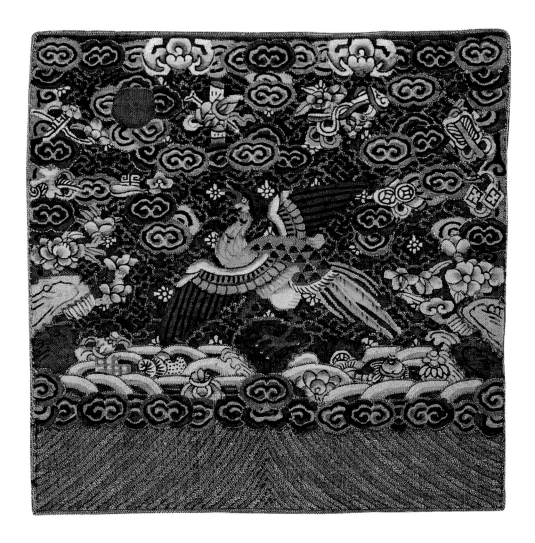

the dragon's head and the lion's, but a close look at squares of this type is essential to insure that the identification is accurate. An interesting aspect of 12.037 is that it does not have the traditional longevity symbols associated with this period. The peach tree, peonies, fungus and narcissus are also missing. Apparently the person who wore this square decided that he didn't need help to grow old and prosper. Example 12.038 is an especially fine *k'o-suu* piece. In its original state the background that now appears brown would have been the bright shimmery green of peacock feathers, matching the hair on the *hsieh-chai's* mane, back and tail. The female square, 12.039, is a mirror image of the male badge. Hence, the positions

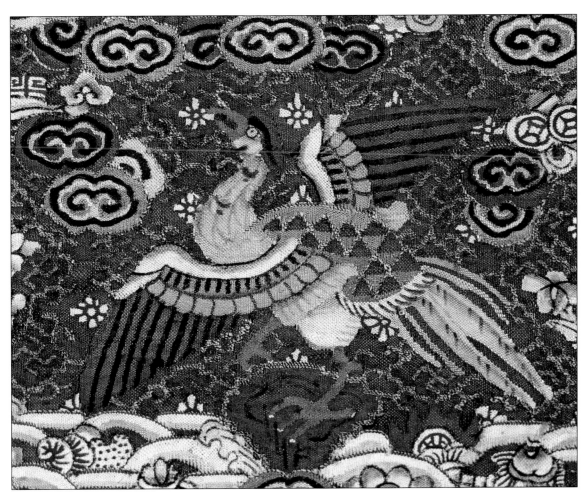

of the peonies and peach tree are reversed. Also note the sparing use of the Peking knot technique. It is limited to the precious things in the water and two of the five bats. At first glance, 12.040 may appear to be different from the others in that the hair is a mixture of blue and green, while all the others had a single color. This, however, is not the case. Since blue and green were the same color to the Chinese, this square is using different shades of blue to depict the hair.

It takes some practice to quickly identify the various birds that were used to denote rank. Visiting museums and trade shows that display mandarin squares will produce a comfortable level of proficiency. It is a task that is made more difficult by the lack of uniformity of the designs used. But when confronted by a

Opposite: 12.041 Golden pheasant (?) after 1850, *k'o-suu*, male. (Provided by David Hugus, photography by John Levin) *Above:* 12.042 Detail golden pheasant, after 1850, *k'o-suu*, male. (Provided by David Hugus, photography by John Levin)

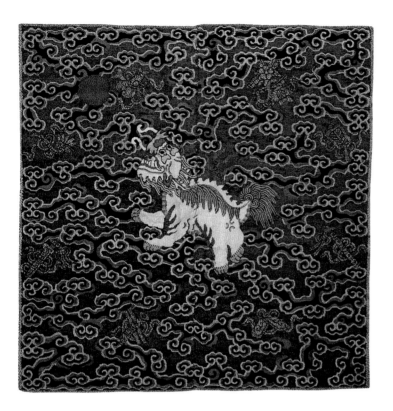

◉◉ *Above:* 12.043 Hsieh-chai, after 1898, *k'o-suu*, male. (Provided by David Hugus, photography by John Levin) ◉◉ *Opposite:* 12.044 Detail hsieh-chai, after 1898, *k'o-suu*, male. (Provided by David Hugus, photography by John Levin)

design that just won't fit into any of the patterns mentioned here and shown throughout the book, you need to keep in mind that you may be confronting a mistake, a square that was improperly made in the first place. While these errors are not common, they do exist. Example 12.041 is a bird square made in the mid-1880s. The detail in 12.042 shows the colorful body and two-tiered neck feathers that clearly make this bird a mandarin duck. However, the colorful body and the two long sword-shaped tail feathers lightly barred in black are equally sure identifiers of the golden pheasant. Now what does one do with these two unambiguous, but conflicting indications of the type of bird shown? As with most questions associated with mandarin squares, there is no definitive answer. I doubt that this is an attempt by a mandarin duck wearer to make his square look like the higher ranking golden pheasant. Such attempts were made (examples have been noted, others will be provided later), but were rarely so blatant as to change the basic shape and design of the bird's body or tail. And it certainly would not be a second rank golden pheasant wearer trying to look like a lower ranking bird—that would be unthinkable. So I am left with the conclusion that this was simply a mistake on the part of the producer. This is reinforced by the painted markings on the bird's neck which are almost surely an attempt to make the neck look more like a golden pheasant's neck (see the neck markings on 15.049 for comparison).

A further example is given in 12.043. This is a nicely made piece *of k'o-suu* showing a censor's *hsieh-chai* with the Taoist Immortals' symbols surrounding him. The minimalist design is, as we will learn later, associated with the reform period that started in 1898. The white body, bear's tail and dragon's head are clear and unmistakable indicators that this is a censor's square. A close look at the detail in 12.044 however, shows that this particular *hsieh-chai* has more horns than specified. The dragon's head is complete with the requisite two horns, while the *hsieh-*

chai is supposed to have only one. Since the body is totally inappropriate for a real dragon, I am again forced to conclude that the two-horned *hsieh-chai* was an aberration of the production process.

While you are practicing your identification skills, be wary of the possibility that the imponderable design you are trying to categorize may be a simple mistake by the square's producer. While rare, mistakes did occur. And the rarity of these mistakes makes the squares that display them more interesting and perhaps more valuable because of their inherent scarcity. Even mandarin square makers had bad days, and their bad days translate into increased collection opportunities for those knowledgeable enough to recognize and capitalize on the errors.

CHAPTER 13

IDENTIFYING ANIMALS

Military badges are much rarer than civil badges and consequently, they often command higher prices than their civil counterparts of the same age and in the same condition would fetch. This rarity exists in spite of the fact that, at least at the higher rank levels, military positions were as plentiful as civilian positions. We know this because the Ch'ing rules required that every senior post be occupied by both a military and a civil official. Since the Manchus controlled the military, this was one way to keep the largely Chinese civil bureaucracy from circumventing the will of the Manchu emperor by failing to implement his edicts or modifying them. Each official document was written in both Chinese and Manchurian to insure that the average relatively uneducated Manchu military man could read it. This dual appointment was one of many ways in which the Ch'ing Dynasty tried to maintain its vigorous lifestyle and cultural purity while surrounded by the Chinese culture. Since the number of senior positions for civil and military bureaucrats were roughly equal, there must be some other rationale for the disparity in the number of military squares available today.

There may be several contributing factors to this scarcity. The military was not viewed with much favor during the Ch'ing Dynasty because it was, after all, the embodiment of China's rule by a foreign conqueror. In addition, the military never had the social status that was commanded by scholars who so rigorously prepared for their grueling examinations. These considerations meant that when ranks were for sale in the later part of the Ch'ing Dynasty, few, if any, merchants

Opposite: Tiger, after 1850, metallic thread couched on silk, female. (Provided by Jon Eric Riis, photography by Bart's Art)

181

wanted to purchase a military rank, while the more prestigious civil ranks were much sought after. In addition, the Manchus used the military as a check on the civil bureaucracy's ability to circumvent the emperor's will. Thus, the Manchus were careful to insure that the military remained their exclusive preserve. So even had there been a demand for military ranks at a price, they would most probably not have been available for sale. And finally, when the republican revolution overthrew the imperial system in 1911, the military were particularly sought out for retribution. Not only because they had been the instrument of the imperial domination over the Chinese, but also because the military was almost exclusively foreign Manchu. In an effort to escape the persecution following the revolution, many military men destroyed their official costumes to evade detection and avoid punishment. In contrast, the new republic still needed a bureaucracy to run the country. The respected Confucian scholars from the civil ranks were largely incorporated into the newly republican government. So unlike the military, there was no need to destroy the civil costumes and badges of rank.

It is even more difficult to find lower ranking military squares than it is to find their civilian counterparts. The same economic considerations that limit the availability of civil squares were also at work in the military arena. This is especially true for the lowest military ranks which were held by enlisted men or low ranking noncommissioned officers. In addition, most of the very junior military officials were sent to remote provincial outposts where, one suspects, the retribution of the revolution was most strongly felt. Consequently, it is, to my knowledge, impossible to find a rhinoceros or sea horse badge in the Western world. No squares of either rank are known to exist outside of China (and no one knows for sure what is available in the People's Republic).

For the first few years of the Ch'ing Dynasty, the lion was the symbol of the first military rank. However, in the first year of the Kangxi Emperor's reign, he, on the advice of his advisors, declared the *ch'i-lin* to be the symbol of the highest military rank. This designation remained unchanged to the end of the imperial system. The *ch'i-lin* was a mythical beast of great powers. It represents longevity, grandeur, felicity, and wise administration. This last attribute may have

❀❀ 13.001 Ch'i-lin, late Chien-lung
(1735–1795), embroidery, male.
(Provided by Beverley Jackson, pho-
tography by Kevin Delahay)

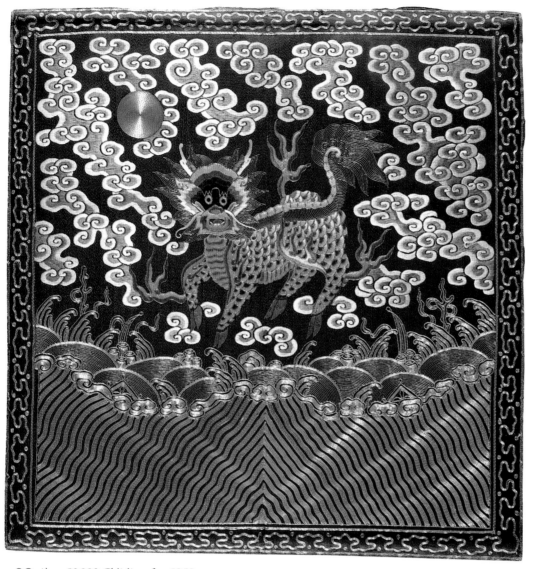

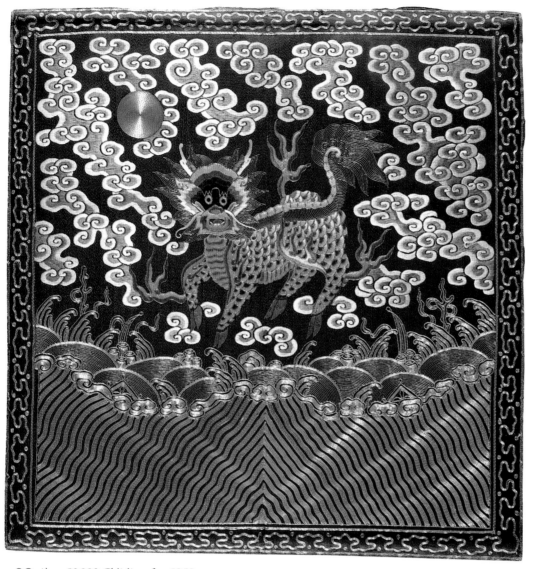 *Above:* 13.002 Ch'i-lin, after 1850, embroidery, male. (From a private collection) 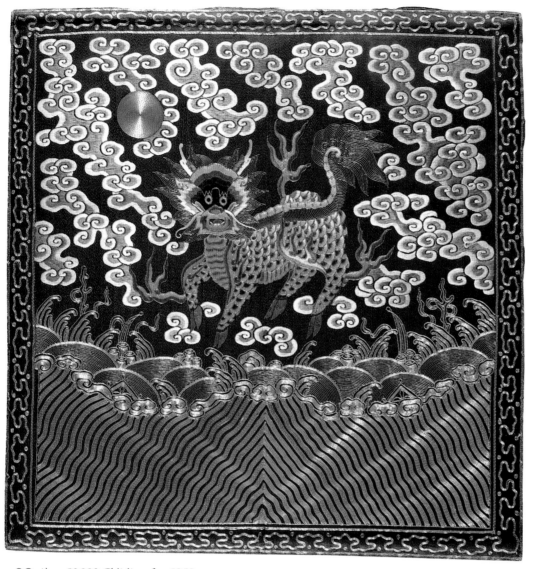 *Opposite:* 13.003 Ch'i-lin, after 1850, *k'o-suu*, male. (Provided by Vincent Comer, photography by John Levin)

contributed to the selection of the *ch'i-lin* as a rank animal and its introduction in the first year of Kangxi's reign. What better way to inaugurate his sovereignty than to decree that *ch'i-lins* should appear on all the costumes of his highest ranking military officers, to mark the beginning of his wise administration? The *ch'i-lin* was a composite mythical beast. It had a dragon's head with two horns, a stag's body, a fish's scales and a Chinese bear's tail. Most descriptions of the *ch'i-lin* describes it's tail as that of a lion, but it is not. A lion's tail has curls at both the base and the tip. A bear's tail has curls only at the base. Since the *ch'i-lin's* tail lacks the curls at its end, it is properly a bear's tail. The *ch'i-lin* is often erroneously called a unicorn, despite its two horns. The flames attendant to its status as a mythical beast were incorporated into the design of its legs in a manner similar to that of the dragon.

All our *ch'i-lin* have the dragon's head, the scaled deer's body and the traditional bear's tail. Note that, in contrast to every other rank creature, the *ch'i-lin* does not look at the sun. Example 13.001 demonstates the outstanding artistry

184

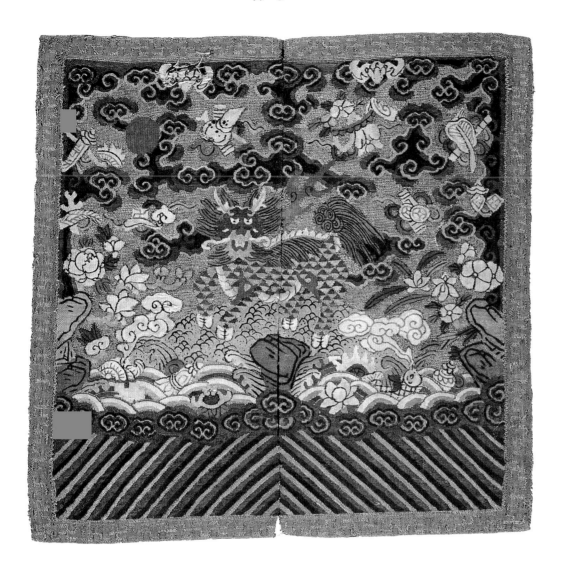

and workmanship of these squares. The design details on the body were overlaid on the white base threads. The details on the peach tree include delicate buds and even spots on the peaches. The scale of the design is one I find personally appealing. Unfortunately, the *ch'i-lin's* horns were executed in silver metallic thread and have largely been lost. Example 13.002 shows that excellence of execution was not lost during the mid-nineteenth century. The outlining of the *ch'i-lin* in gold and the degree of detail used to portray the scales is unusual. The gold metallic couching is exceptionally tight and well done. Example 13.003 is typical of the

k'o-suu work also done in the mid-nineteenth century. The details are painted, rather than woven which was a common practice at the time. The peacock feather background has been lost. An interesting aspect of the design is that the outline of the scales was apparently done in peacock feather, rather than the usual gold.

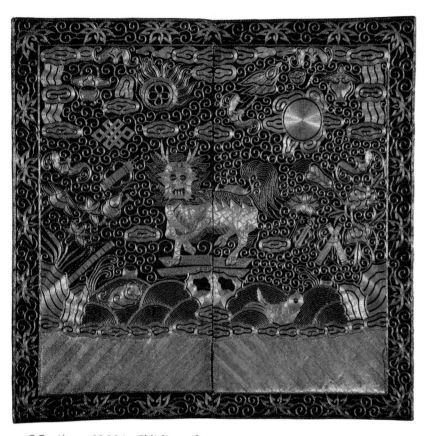

Only the base threads remain now. Example 13.004 is an interesting take on the representation of a female square. Note that the position and stance of the *ch'i-lin* has not changed from the male squares. Only the shift of the sun to the viewer's right side clearly indicates that this was designed to be worn by a woman. Another clue is the introduction of pink into the square's palette. Although not a reliable indicator by itself, the colors used for female squares were sometimes different from those used in squares designed for men. The green Peking knot eyebrows add a bit of whimsy.

The lion initially served as the insignia for the first and second military ranks. The *ch'i-lin* replaced it for the first rank in 1662, but the lion retained its place as the second rank animal throughout the Ch'ing Dynasty. Lions were frequently colored white, but could also be blue. Their appearance on mandarin squares are more akin to temple guardian lions, than of more naturalistic animals. This resemblance is carried over into the representation of the mane which is invariably very curly, representing the conical tufts of hair seen on temple lions. In fact, this curliness is the best way to differentiate between the lion and the bear. The lion has curly hair at both the base and at the tips of its mane and tail, while the bear's curls appear only at the base. Late in the Ch'ing dynasty, the hair continued from the mane around the head down along the back to the tail. When seen in this configuration, the tips of the hair along the back is typically also curled.

@@ *Above:* 13.004 Ch'i-lin, after 1850, metallic thread couched on silk, female. (Provided by Corrie Grové, Peninsula Photographics) @@ *Opposite:* 13.005 Lion, after 1850, *k'o-suu*, female. (Provided by David Hugus, photography by John Levin)

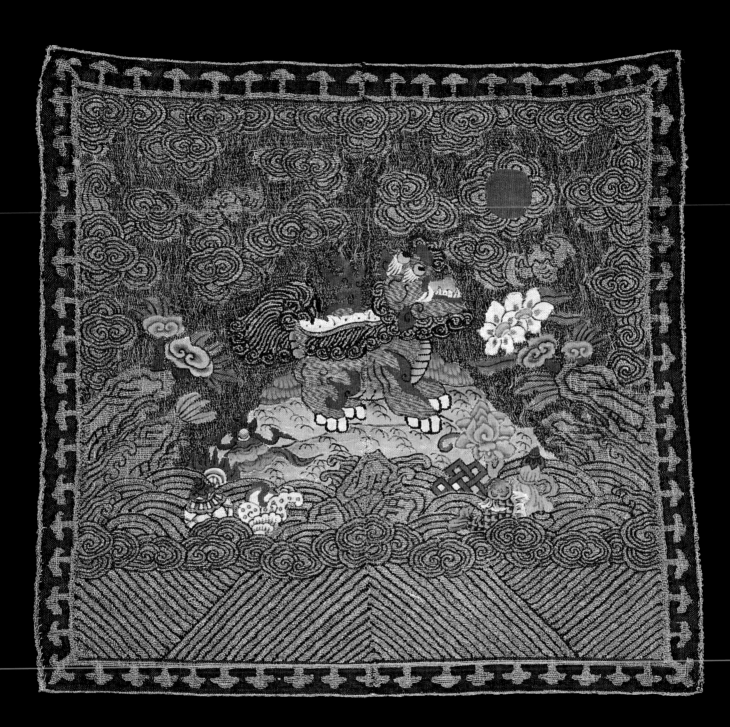

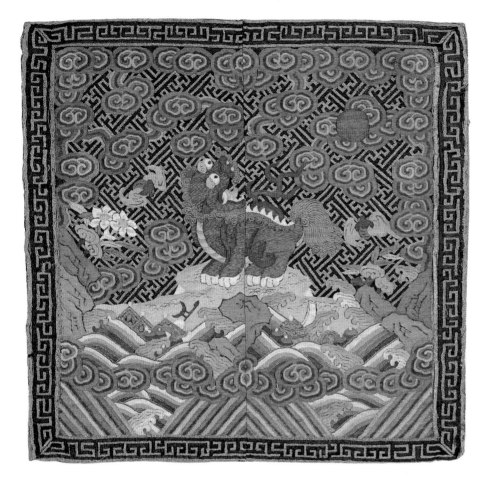

Although all of our colored lions are blue, recall that white is also an acceptable color for lions. Note that the hair of each of the lions is appropriately curled at the tips of the mane, back and tail. Note the flames peculiar to mythical creatures incorporated into each design. Example 13.005 is a female square, the others are male. It was probably made to be worn when the wearer's husband wore a special square designed exclusively for social occasions. That is, one that had the body and head aligned from the wearer's left to right, looking away from the emperor. Such a square would not have been worn at court where the implied insult to the emperor would have been dangerous to the owner's continued health and well being. The peacock feather background in 13.005 is largely intact. For *k'o-suu* squares like this one, the peacock feathers were woven into the design

like threads. Example 13.006 shows an unusual interleaving and layering of the deep water and roiled surface patterns. It also displays the tendency to fill the background at any cost. In this case, it at least introduces a good luck symbol (the swastika for abundance) into the square. Example 13.007 shows that even when directed to simplify the squares, some artists couldn't help adding a rebus or four just for good luck. Example 13.008 would have looked much like 13.005 does when it was new. It now shows the typical blue and white design *of k'o-suu* from the mid to late mid-nineteenth century surrounded by brown base threads rather than the shimmer of peacock feathers as it did when new.

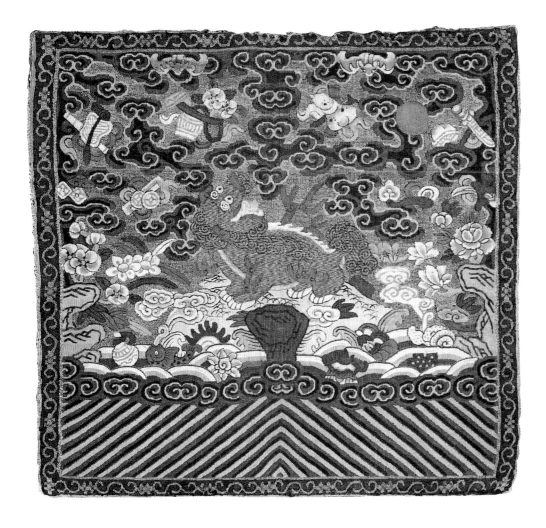

©© *Opposite top:* 13.006 Lion, after 1850, *k'o-suu*, male. (Provided by David Hugus, photography by John Levin) © *Opposite bottom:* 13.007 Lion, after 1898, metallic thread couched on silk, male. (Provided by David Hugus, photography by John Levin) ©© *Left:* 13.008 Lion, after 1850, *k'o-suu*, male. (Provided by Jon Eric Riis, photography by Bart's Art)

The leopard and tiger shared the third and fourth ranks in the Ming Dynasty. On some badges they were shown together as though the cats were mates. When shown together, they were often colored the same. During the transition to the Ch'ing Dynasty, the tiger achieved a temporary ascendancy over the leopard by taking sole possession of the third rank. However, this exalted position lasted only a decade. In 1662, the positions of these two animals were permanently reversed. The leopard was typically shown with life-like spots. However, as the Ch'ing Dynasty progressed the spots sometimes became circles. The leopard also occasionally had a circular star with radiating lines on its forehead. Although this was one of the few rank animals that was not considered

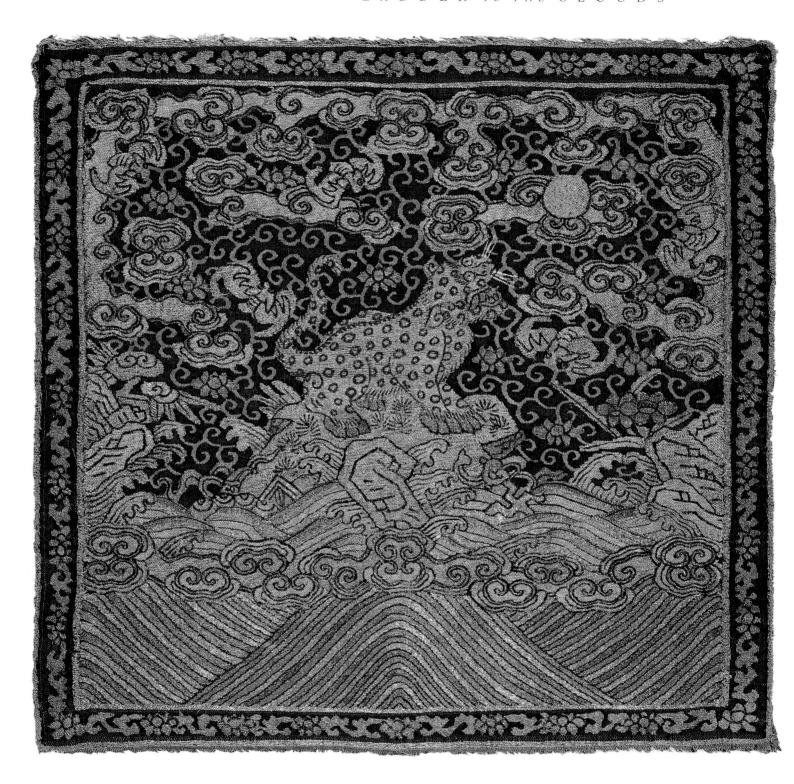

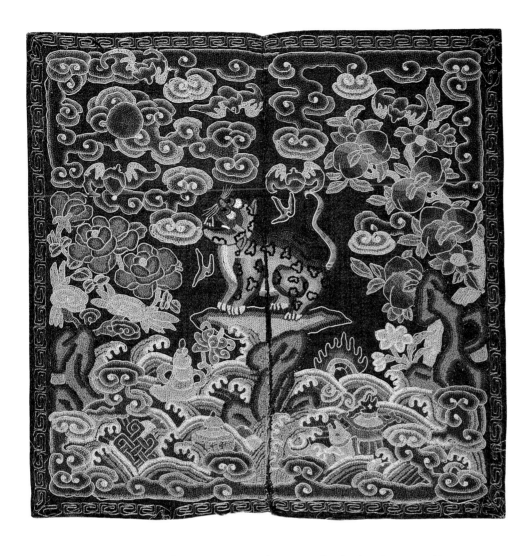

෨ඏ *Opposite:* 13.009 Leopard, after 1850, metallic thread couched on silk, female. (Provided by Vincent Comer, photography by John Levin) ෨ඏ *Left:* 13.010 Leopard, circa 1840, embroidery, male. (Provided by David Hugus, photography by John Levin)

mythical, flames are often seen somewhere on the badge, but usually not as a part of the leopard's body.

Our examples show the leopard in four different media. In all cases the spots are clearly shown with three displaying the open spots that were typical during this period and one with filled spots. The tri-color metallic female square, 13.009, is unusual in three respects. First, the preservation of the metallic thread is quite good in all three colors. Second, the pattern of deep water is somewhat atypical and interesting. Finally, there is an unusual reversal of the colors and media in this square. Normally, the square would have been made of

191

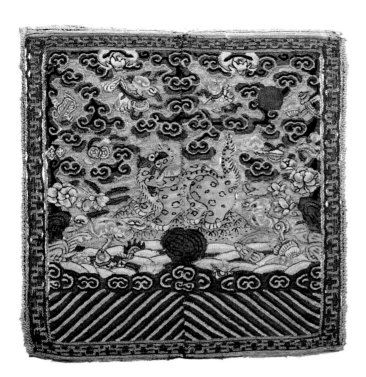

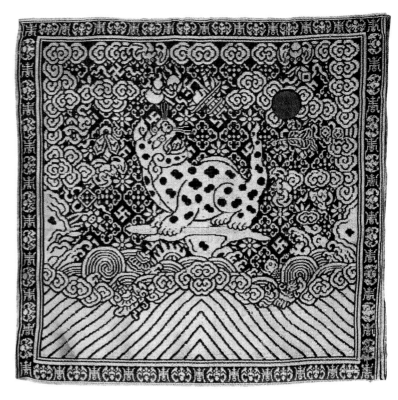

◎◎ *Above left:* 13.011 Leopard, after 1850, *k'o-suu*, male. (Provided by Beverley Jackson, photography by Kevin Delahay) ◎◎ *Above right:* 13.012 Leopard, after 1850, brocade, male. (Provided by David Hugus, photography by John Levin)

colorful silk with gold in the background for some flash and a hint of wealth. Here the square is nearly all gold with a background of blue silk curls to give some contrast.

The male square, 13.010, is one that had to have been made strictly for informal use. Since the leopard would have looked away from the emperor, it would have constituted an intolerable insult. This is also an example of a nonmythical animal in a square with flames, but true to tradition, the flames do not touch the leopard's body. The perky little guy with green eyebrows in 13.011 represents a typical *k'o-suu* piece of his era. The mainly blue and white color scheme, the painted details and the Taoist longevity symbols are all typical of this period. Unlike some of the bird brocades, the black and white representation of the leopard in 13.012 only makes it easier to identify him. Although the good luck charms blend into the background and are lost to a casual glance, the leopard himself stands out in sharp relief.

192

The tiger is indigenous to China and the king of all wild animals. The white tiger is the emblem of the west, a symbol of bravery and courage; and a totem of military prowess. Since the tiger is an object of special terror for demons, it is used to shield graves and households from possession. For the same reason, children's shoes and hats were often embroidered with grinning tigers. Like the leopard, it is also depicted in a more naturalistic fashion than other rank animals. Also like the leopard, its distinctive markings lost definition over time, sometimes looking more like commas toward the end of the imperial period. The tiger was another animal that was not considered mythical. However, in recognition of its status as the king of beasts, it frequently had the symbol for king or prince on its forehead.

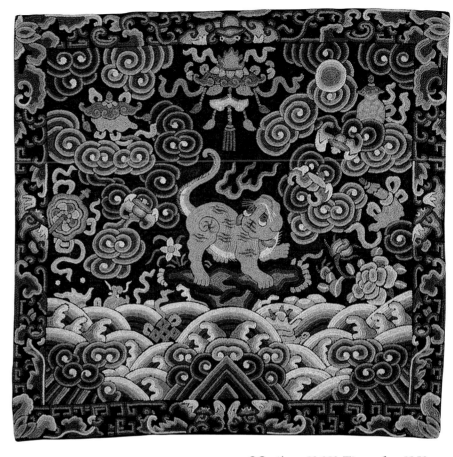

◔◑ *Above:* 13.013 Tiger, after 1850, embroidery, female. (Provided by Corrie Grové, Peninsula Photographics)

Our four examples of tiger squares show a variety of ways in which the stripes were represented. Example 13.013 is a square that was worn by the wife of a military official. Its tiger shows its stripes as sets of three wavy lines. The square also has a number of Buddhist symbols incorporated into the design. Of special prominence is the large canopy suspended over the tiger's head, sometimes interpreted as Buddha's protection for his followers. In this context, it provides that protection to the tiger and, by extension, to the wearer of the square. Once again flames are included in this design but do not touch the tiger's body. Note the symbol for king or prince (three horizontal lines connected by a single vertical mark) on the tiger's forehead. This tiger also displays the pinwheel design on its flank. While this configuration of stripes is common, I am not aware of any significance that attaches to it.

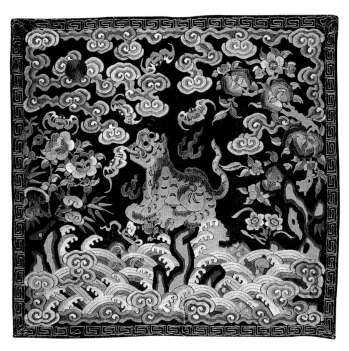

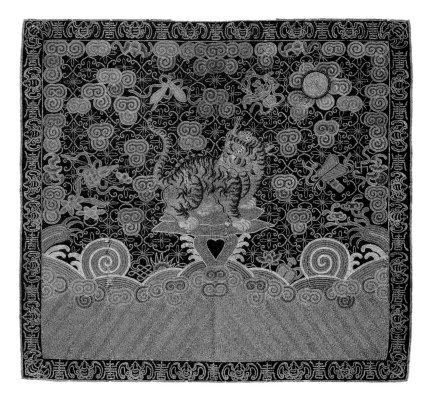

⊚⊚ *Above left:* 13.014 Tiger, circa 1830, embroidery, male. (Provided by David Hugus, photography by John Levin) ⊚⊚ *Above right:* 13.015 Tiger, after 1850, metallic thread couched on silk, female. (Provided by Jon Eric Riis, photography by Bart's Art) ⊚⊚ *Opposite:* 13.016 Tiger, circa 1830, embroidery, female. (Provided by Corrie Grové, Peninsula Photographics)

Example 13.014 is a male square that was clearly meant for informal (not court) use since it would have faced away from the emperor at court. Here we see the tiger's stripes portrayed as open crescents with the symbol for king or prince clearly displayed on his forehead. He also has the pinwheel design on his flank, and the flames do not touch his body. Example 13.015 contains a tiger that, to my eye, exudes personality and verve. Unfortunately, this tiger is on a confused square. The body configuration suggests a female square in the mirror image format. However, if this were the case, the sun would have been in the opposite corner. As it is, the sun is placed in the same corner as the sun in 13.013, which leads us to expect that this tiger would be in the same position as the tiger in 13.013. Since this is obviously not the case, I am forced to conclude that the unusual combination of body configuration and sun placement in 13.015 is either a mistake on the part of the maker or an intentional deviation from standard practice. The character for king can be discerned if, in your mind's eye, you are willing to

194

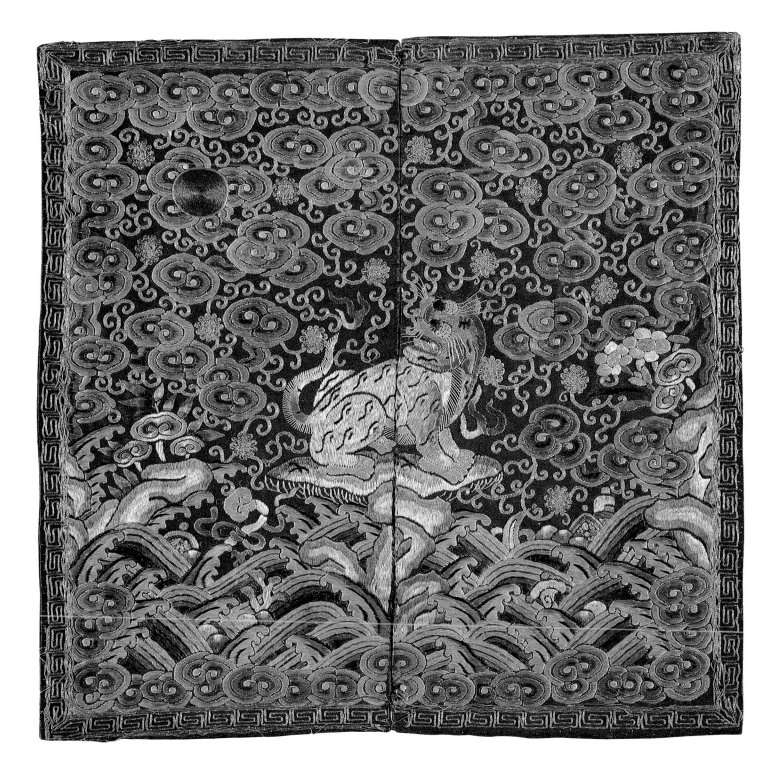

⊚⊚ *Opposite top left:* 13.017 Bear, after 1850, *k'o-suu*, female. (Provided by Vincent Comer, photography by John Levin) ⊚⊚ *Opposite top right:* 13.018 Bear, after 1850, *k'o-suu*. male. (Provided by David Hugus, photography by John Levin) ⊚⊚ *Opposite bottom left:* 13.019 Bear, circa 1830, embroidery, male. (Provided by David Hugus, photography by John Levin) ⊚⊚ *Opposite bottom right:* 13.020 Bear, after 1870, embroidery on gauze, male. (Provided by Corrie Grové, Peninsula Photographics)

straighten out the wavy lives on this tiger's forehead to produce a proper calligraphic symbol. The pinwheel design is shown on both the front shoulder and rear haunch.

Example 13.016 shows a more conventional animal and sun placement for the female mirror-image design. The princely symbol appears on the tiger's forehead, but the pinwheel is absent from the flanks. The stripes have been stylized into a wavy line and a short line. Flames are included, but not attached to the tiger.

The bear stands for strength and courage. The birth of a son was thought to be preceded by the mother dreaming about a bear. Although an animal indigenous to China, the bear is normally shown with the mythical flames emanating from its body. As a heraldic device on mandarin squares, the bear is frequently mistaken for a lion. Since both could be either white or blue, color does not aid in differentiating between the two. In earlier squares the bear has a longer muzzle and more pronounced claws, but those distinctions were lost over time. Since both bears and lions had curls at the base of their manes and tails, the only way to decisively tell a bear from a lion in a late Ch'ing Dynasty square is to look at the ends of the mane and tail. Bears had straight hair where lions had curls.

Curls at the base of the tail is evident in all of our four examples of bears, all are equally devoid of any curl at the ends of the mane, back or tail. Although one square, 13.019, pushes the limits of acceptability by having curls at the base of his back hair, he does adhere to the restriction that the ends of the hair be without curl.

Both 13.017 and 13.018 use the two shades of blue (blue and green) to provide variety to the hair coloration. In some cases this can lead to confusion when inexpert experts misidentify the two tufts of hair that are, in fact, one color as the horns of a *ch'i-lin*. I have seen this mistake on more than one occasion. Examples 13.017 and 13.018 also show how male and female squares would look together when the male square used the official court posture of the animal and the wife wore a mirror image square. The background in 13.017 was originally peacock feathers.

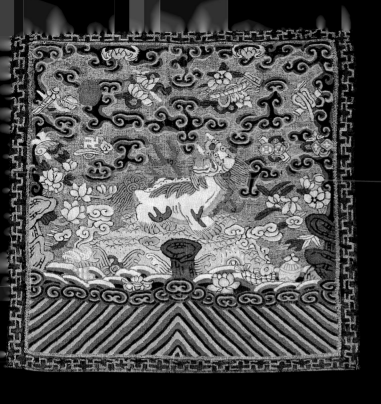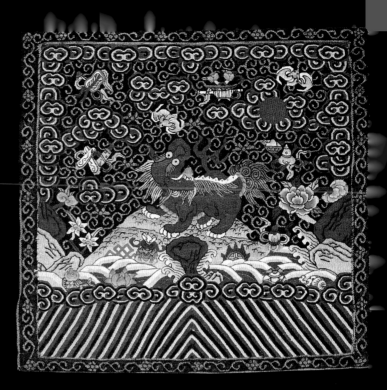

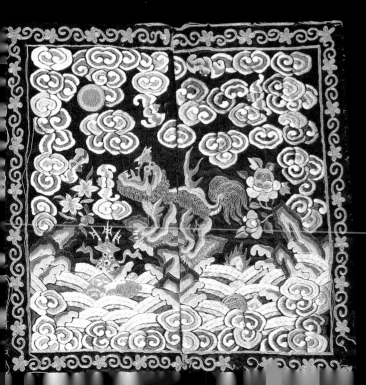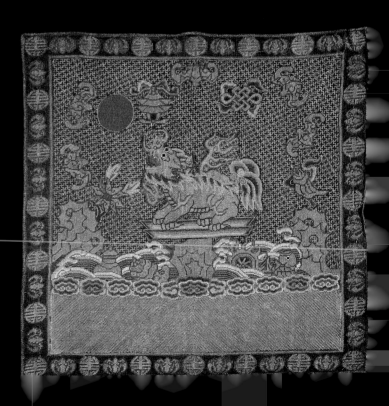

Example 13.020 shows the impact of the aniline dyes in use in the late nineteenth century, particularly the purple. It also was created with an unusual spiral technique that wraps the threads around the gauze grid.

The Chinese consider the panther to be a cruel and savage creature. A beautiful, headstrong woman is sometimes called a flowery panther. Through the

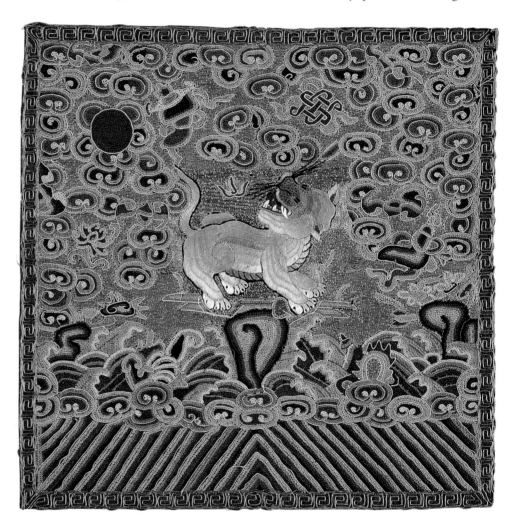

Ming Dynasty and the first part of the Ch'ing, the panther was the symbol of both the sixth and seventh military ranks. In the revisions to the court regulations promulgated by the Chien-lung Emperor in 1759, the rhinoceros replaced the panther for the seventh rank. The panther's place as the sixth rank animal was

not changed. The panther as seen on squares is a life-like, tawny-yellow or pale brown animal. It will sometimes have a white chest and a star on its forehead.

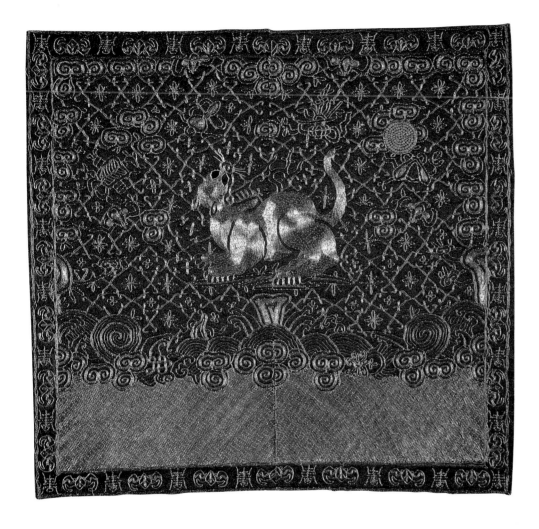

❦ *Opposite:* 13.021 Panther, after 1850, embroidery, female. (Provided by Judith Rutherford, photography by Jackie Dean) ❦ *Left:* 13.022 Panther, after 1850, metallic thread couched on silk, male. (Provided by Corrie Grové, Peninsula Photographics)

None of our panthers have the star on its forehead. The general rule is that if it looks like a cat, but it has no distinguishing marks, then it is a panther. 13.021 and 13.022 show the appearance of man and wife when using the court design for the male and mirror image for the female. Example 13.021 is quite appealing to my eye. The satin stitch shading on the panther is nicely made while the surrounding details are executed in Peking knot. The is highly unusual as the important parts of the design would typically have been done in Peking knot.

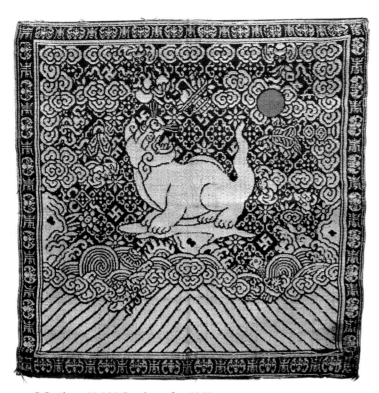

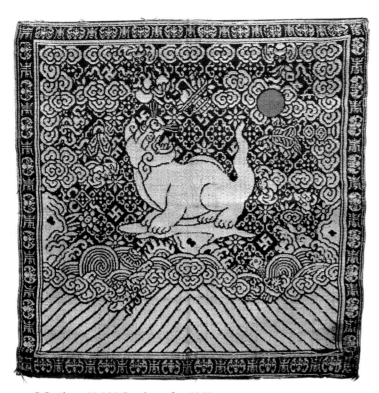 *Above:* 13.023 Panther, after 1850, monochrome brocade, male. (Provided by Beverley Jackson, photography by Kevin Delahay) 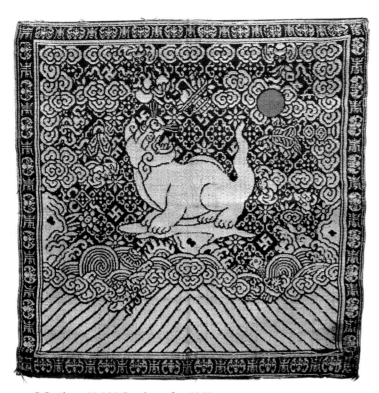 13.025 Detail panther, after 1850, embroidery, male. (Provided by Gim Fong, photography by John Levin) 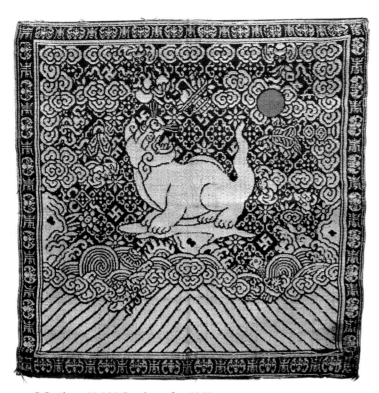 *Opposite:* 13.024 Panther, after 1850, embroidery, male. (Provided by Gim Fong, photography by Leonard M. Cohen)

The gold background adds elegance to this square. Flames present in the design, but not attached to the body of the panther because it was not considered mythical.

A good example of a metallic thread square with "coral" beads for the sun is 13.022. Most of the silver-wrapped threads have survived the ravages of the free oxygen in the atmosphere. The monochromatic design of this square and that of 13.023 provides no difficulty to identifying the panther, but does tend to cause the background patterns and the good luck charms to merge.

Example 13.024 is similar in execution to 13.021. However, this square was created entirely in the Peking knot technique. The artist appears to have used a set of retiring colors, but this is deceiving. As seen in the detail in 13.025 the unfaded silk threads on the back prove that, when new, this shy looking peach and lilac panther was a combination of bright orange and screaming purple. The lesson for us is that the subdued palette of some squares is the result of time and fading, not of restraint on the part of the creators. This square also has flames that do not touch the panther as part of the design.

It is difficult to be authoritative about something you have never seen. Like all other collectors in the West, I have never seen a rhinoceros square. Some books do have representations of such squares, but they are usually transparently recent reproductions or fragments from textiles other than squares. In Ming textiles, the creature called a rhinoceros is normally shown as a spindly legged, hoofed, spotted, cow-like creature with a single horn curving down from its forehead toward its snout and a long thin tail. Clearly, there was some initial difficulty in translating this creature's name into English for it would be difficult to imagine a creature less like the massive Asian rhinoceros. There are some scholars, collectors and dealers who have mistaken the censor's *hsieh-chai* for a rhinoceros. Both have a single horn, and it is difficult to say exactly what a Chinese rank

200

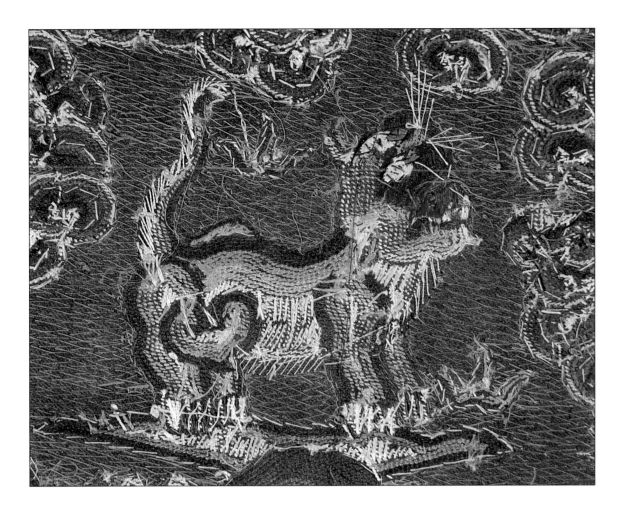

rhinoceros looks like. However, if the creature has paws, rather than hooves, then, in my opinion, it is a *hsieh-chai*, not a rhinoceros. The rhinoceros was exclusively the rank animal for the eighth military rank until 1759 when it became the symbol for both the seventh and eighth military ranks.

While sea horse squares are not known to exist in the West, it is rather easier for me to imagine a sea horse square than a Chinese rank rhinoceros. The "sea horse" is not an aquatic creature at all, but an actual white horse shown galloping across the waves of the sea. Although some references refer to this creature as a seal, it bears no resemblance to that animal. The sea horse was the rank animal for the ninth military rank throughout the Ch'ing Dynasty.

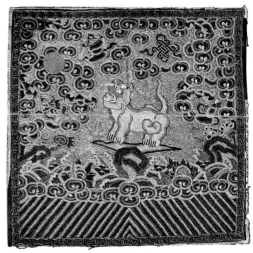

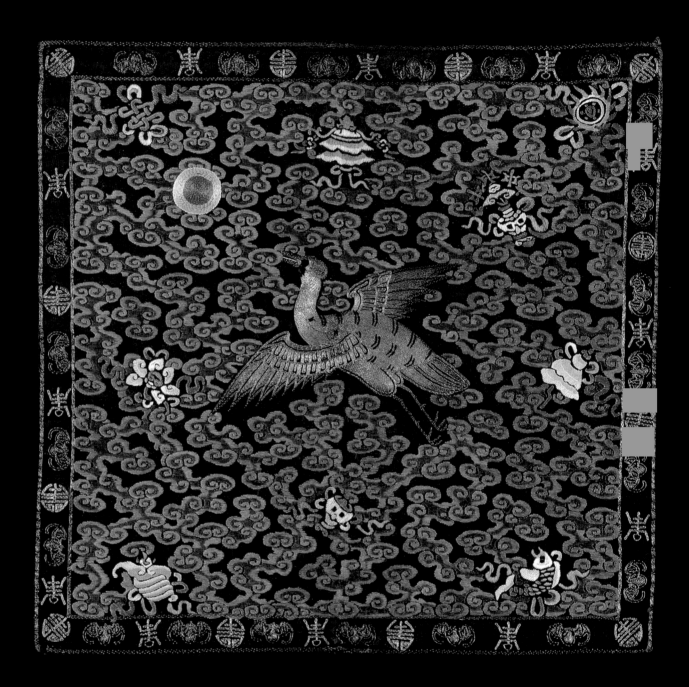

CHINESE SYMBOLOGY

S ymbols were widely used in China to convey ideas and meanings. They were especially effective since they did not require that the viewer be literate to understand what was intended. This had obvious advantages when trying to communicate across different levels of sophistication, literacy, and knowledge. As we attempt to explore the subject of Chinese symbology, we need to understand that our current interpretation of Chinese symbols may be somewhat in error. One of the characteristics of an effective symbol is that it is recognized and understood. Frequently, the meaning of a symbol was not recorded when it was introduced. If it needed an explanation, it would not have been effective. When the meaning of a symbol from earlier times was defined, the explanation was subject to reinterpretation it in terms of the current culture, not the culture that produced it. Once recorded, the meaning became nearly sacred, given the Chinese reverence for writing and the honored place that all past writers held. Therefore, once a mistake was made, it was difficult to correct it. So we need to temper our exploration of symbols with a little skepticism. But this should not cause us to ignore this very fertile and interesting part of Chinese culture that played an increasingly important role in the development of the mandarin square as the Ch'ing Dynasty progressed.

While obviously not the only way to parse this issue, I will divide symbols into four broad categories: sets of eight, plants, rebuses and written characters.

◎◎ *Opposite:* Wild goose, after 1898, metallic thread couched on silk, male. (From a private collection)

◎◎ *From left to right:* Precious Treasures; Pearl or Jewel, Pair of Scrolls, Musical Stone, Ingot, Ruyi Sceptre, Swastika, Pair of Rhinoceros Horns, Lunghzi Fungus, and Coral. (Drawings by Beverley Jackson)

The three "religions" of China, Confucianism, Taoism and Buddhism each contributed a set of eight symbols that were used in mandarin square design. The first to be incorporated was the set of Eight Precious Things of Confucianism. Although the actual number of precious things that appeared in lists of "eight" was much larger, the lists themselves contained only eight items. The items that appeared on the lists were pearls, circular and rectangular gold ornaments, a *ruyi* scepter, coral, a jade chime, rolls of silk, paintings, books, an artimesa leaf, an ingot of silver, ivory tusks, a swastika and a rhinoceros horn. In general, they represented things of intrinsic value or material wealth or were thought to have healing powers. The Chinese thought that by surrounding themselves with symbols, the objects symbolized would be attracted. These sym-

bols were sparingly used during the early Ch'ing period, but appear in great proliferation toward the end of the dynasty.

Taoism contributed its set of eight symbols to mandarin square design indirectly through its quest for long life and immortality. Taoist lore venerates eight people who achieved immorality by esoteric studies. Each was represented by an implement or object that was associated with his life: the fan for Zhongli Quan, the sword for Lu Dongbin, the double gourd and crutch for Li Tieguai, the castanets for Cao Guojiu, the basket of peaches (or flowers) for Lan Caihe, the bamboo tube and rods for Zhang Guolao, the flute for Xiangzi and the lotus pod for He Xiangu. While each object started out representing an important

205

◎◎ *From left to right:* The Taoist Eight Precious Things; Fan, Sword, Gourd and Crutch, Castanets, Flower Basket, Bamboo Lute and Rods, Flute, and Lotus. (Drawings by Beverley Jackson)

aspect of the life of an Immortal, by the Ch'ing Dynasty they had degenerated into general good luck symbols and wishes for long life.

Buddhism contributed its set of eight also. The conch shell called worshipers to service. The large canopy represented protection, but could be interpreted as the protection provided by a just ruler or Buddha's protection of his congregation. The vase could represent purification, or be the container of the water of life (immortality), or could be a rebus for peace. The lotus was a symbol for purity rising pristine and white from muddy water. The parasol represented an incorruptible official (who provided protection for his subjects) or just government in general. The two fishes were a rebus for plenty or abundance. The endless knot stood for Buddha's undying love or long life. The

(flaming) wheel of law was supposed to have been set in motion with Buddha's first sermon. It also represented the continual transmigration of souls in the quest for ultimate enlightenment. The Buddhist precious things were also associated with body parts: canopy (lungs), wheel (heart), endless knot (intestines), conch shell (voice), lotus (liver), vase (stomach), fish (kidney), parasol (spleen).

The use of these symbols will be explained in greater detail when we trace the evolution of the mandarin square during the Ch'ing Dynasty. Generally, the Confucian eight precious things were used first, but sparingly. They lost favor for a short while after Kangxi's reign, but returned in the Ch'ien-lung period. They proliferated during the first part of the nineteenth century, were first joined by

the Buddhist symbols and later by the Taoist Immortals. By the end of the dynasty you could find some or all of these sets of eight mixed in profusion in an apparent attempt to protect the wearer against the increasingly unstable political situation of the declining Ch'ing Dynasty.

Nature was a source for a wide variety of Chinese symbols. Not only did virtually every plant have a meaning associated with it, but combinations of plants were attributed with their own meanings. We will cover those most useful for understanding and appreciating mandarin squares. The four noble plants were the prunis (plum blossom), bamboo, chrysanthemum and orchid. Each had a special meaning. The prunis represented perseverance and purity because it bloomed in harsh weather. Bamboo was linked with courage in adversity and longevity. Its straight growth reflected the attributes of an incorruptible official. The chrysanthemum bloomed late in the year and so was associated with reclusiveness, a noble personality, contented middle age and friendship. The orchid stood for nobility and friendship based on sincerity.

Certain plants were also associated with the seasons. Most authors have associated the prunis with winter; the peony with spring; the lotus with summer and chrysanthemum with autumn. Some associate bamboo with winter and the magnolia with spring. The symbolic meaning of most of these season-related plants was provided in the previous paragraph. The most important of the flowers not already discussed was the peony which was widely used in the design of mandarin squares after 1800. The peony tree was grown in the gardens of the Sui and T'ang Emperors. This associated the peony with the imperial household and hence with wealth, advancement, riches and honor. The large size of the flower adds to the association with greatness and hope for advancement. The lotus's association with purity and honesty was covered under the eight Buddhist symbols. The magnolia was once grown only by Chinese emperors and roots were bestowed on those who had gained special favor. In later times it was most closely linked with feminine beauty.

One of the most ubiquitous symbols in later Ch'ing squares was the *lungzhi* mushroom (see illustration on page 204), a popular symbol for longevity and

immortality. This connection sprung from two situations. When dried, the mushroom could be stored for long periods. In addition, it was used in a Taoist concoction that was supposed to prolong life. The Chinese preoccupation with long life can be inferred by the wide use of longevity symbols. Not only did this mushroom frequently appear in square design, but it also influenced two of the most important symbols in Chinese art. The head of the *ruyi* scepter and the shape of clouds in late Ch'ing squares are modeled on the shape of the *lungzhi* mushroom.

Another longevity symbol was the peach. Chinese mythology held that Xiwangmu, Queen of the West, grew the peaches of immortality in her garden high in the Kunlun Mountains. According to the story, the peach trees took 3000 years to bloom, the peaches another 3000 years to ripen. Anyone who ate one of the ripe peaches was granted life until the next harvest. Although the peach is most closely linked with longevity, it is also associated with feminine beauty and has various sexual connotations.

The pomegranate carried a connotation of plenty, particularly an abundance of sons, because of its many seeds. The Buddha's hand, a citrus fruit, is a form of rebus. Its Chinese name is *fushou*, which can be decomposed into *fu*: happiness and *shou*: long life. Because it is associated with two things highly desired by the Chinese, it is often seen in art motifs, although it was introduced as a design element for squares quite late in the Ch'ing Dynasty.

The narcissus is frequently seen on squares and represents a brand of purity and cleanliness because it could grow in a container of pebbles and water without soil. This exemption from the need for dirt also implied a link with honesty and lack of corruption. Blooming narcissus around the lunar new year were supposed to insure good fortune for the remainder of the year. The pine tree is another of the nearly endless list of things associated with longevity. Because it maintained its green color and foliage throughout the year, it was also associated with vitality and strength.

In addition to their individual characteristics, groups of plants sometimes had additional names or meanings. The peach, pomegranate and Buddha's hand together were collectively known as the three plenties: longevity, abundance,

happiness and long life. Another more complicated combination of the peony, peach tree with nine peaches, *lungzhi* fungus and the narcissus together formed a rebus that meant: divine spirits invoke longevity.

Even colors had symbolic meanings. In the Chinese view of the universe there were five directions, each with its own meaning, color, element and animal. In addition to the four cardinal directions, the Chinese added a direction for center. From this perspective, east is associated with blue (which is the same color as green for the Chinese), the blue dragon, the element wood and the impetuosity of youth. South is linked with the color red, the red bird, fire as an element and happiness. West is connected with the color white, the white tiger, the element metal and mourning. North is ruled by the color black, the tortoise and snake of the warrior, water is its element and darkness is its emotional orientation. Center is colored yellow, with the yellow dragon, earth as an element, and the reasoning powers of adulthood. The colors, known as the five colors of the universe, are the most important elements from this cosmology. And of the colors, red, the color of happiness, is paramount. However, it should be noted that five-color clouds were considered an unusually auspicious natural occurrence, worthy of being recorded in historical annals. It should not be surprising that we will encounter five-colored clouds in the design of squares.

The Chinese language is conducive to puns. Since Chinese contains four different tones, the same syllable or word can be pronounced in four different ways. This common root word pronounced differently produces some interesting linkages in Chinese between what would otherwise be totally different concepts. Mandarins were experts at this kind of word play since they played an important part in the essay portions of the examination process. Given this close association, it is understandable how this kind of word play found its way into the design of mandarin squares. Frequently these puns made substitutions between similar sounding words or changed the pronunciation in subtle ways to invoke a different meaning. The term rebus has been associated with this complex system for playing on words, recalling a much simpler word game popular in the United States earlier in this century. We have already encountered one example in the

description of the symbology of plants where the peony, fungus, peach and narcissus referred to divine invocation of longevity.

The bat is one of the most commonly employed rebuses. The Chinese word for bat and happiness share the same root word, *fu*. Unlike its sinister association with night and evil in the West, for the Chinese the bat is associated with happiness. So every time a bat is displayed, it is a simple rebus for happiness. And since red is the color of happiness, a red bat would give you a double dose of happiness. Additional elements, when associated with bats, combine to form other popular and frequently encountered rebuses. The bat with a peach in its mouth can be read as "may you live long and happy." When an inverted v-shaped musical instrument is swapped for the peach we have "may you have happiness and prosperity." A bat carrying a swastika means "may you have the greatest (ten thousand times) joy." Even the orientation of the bat can influence the subtle meaning it represents. The Chinese character for "upside down" is itself a pun for "arrived." Thus an upside down bat is "happiness has arrived." Bats associated with clouds or the sky can be interpreted as "blessings (happiness) descending from heaven." Red bats in the sky become "happiness as vast as the sky." A bat hovering above or carrying a coin "happiness before your eyes."

Another very important element in the art of forming rebuses is the *ruyi* scepter which means "as you wish." A vase has the rebus-derived meaning of peace. The halberd, a pike-like weapon, means step. Thus a vase containing a scepter and three halberds can be read as "may you advance three steps in the hierarchy peacefully (without opposition)." A scepter alone in a vase is interpreted as "peace and fulfillment of your wishes."

Other common rebuses include: a halberd and a musical chime "good luck and good fortune;" a halberd, a jade musical chime and a scepter "as much luck as one desires;" a scepter, a scholar's brush and an ingot of silver "everything will certainly be as you desire;" a brush through a wheel "hope for success." A bell with a scepter is a pun on the name of *Zhong Kui*, the demon queller. So it is a wish for protection from evil spirits or bad wishes. A tray with two bronze vessels can be interpreted as "may I rise two ranks."

◎◎ *From left to right:* Symbols of Good Fortune; Shou (Longevity), Shuangxi (Double Happiness), Ji (Luck), Xi (Joy), and Wan (Ten Thousand). (Drawings by Beverley Jackson) ◎◎ *Opposite:* Silver pheasant, after 1898, embroidery, female. (Provided by David Hugus, photography by John Levin)

The Chinese language is marvelously versatile and can be used to infuse various combinations of ordinary objects with wistful hopes for good luck, good fortune, long life and happiness. While someone who is not a Chinese language scholar will never be able to interpret all of the subtle elements of the designs imbedded in mandarin squares, the knowledgeable layman can learn to recognize several of the more common rebuses and be aware that an unusual and counterintuitive combination of objects is likely to be a wish for something good for the wearer.

In some instances Chinese characters are used for decorative purposes to invoke the meaning of the characters themselves for the wearer of the garment. When used in the design of a square, this is usually restricted to border designs. The long life, joy and happiness characters are commonly used in this way. The swastika is frequently seen represented in some of the fret and meander patterns used for borders and interior designs. Since the Chinese felt that the use of a symbol would produce what the symbol stood for, these characters are found throughout the Chinese decorative arts, including mandarin squares.

This short primer on Chinese symbology will be important as we trace the evolution of the squares through the Ch'ing Dynasty. They are frequently the parts of the design that changed with the prevailing fashions. Changes in fashion were what drove clothing designs from period to period. As such, they provide valuable insights with respect when squares were originally produced.

212

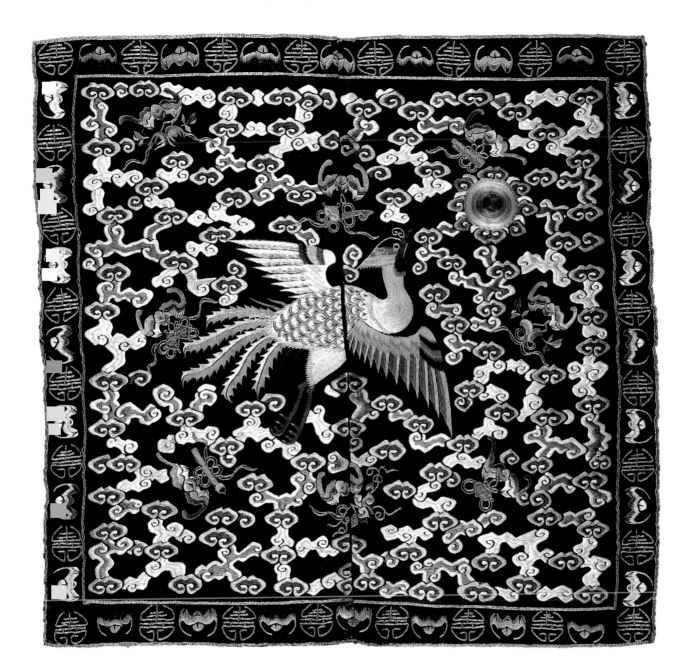

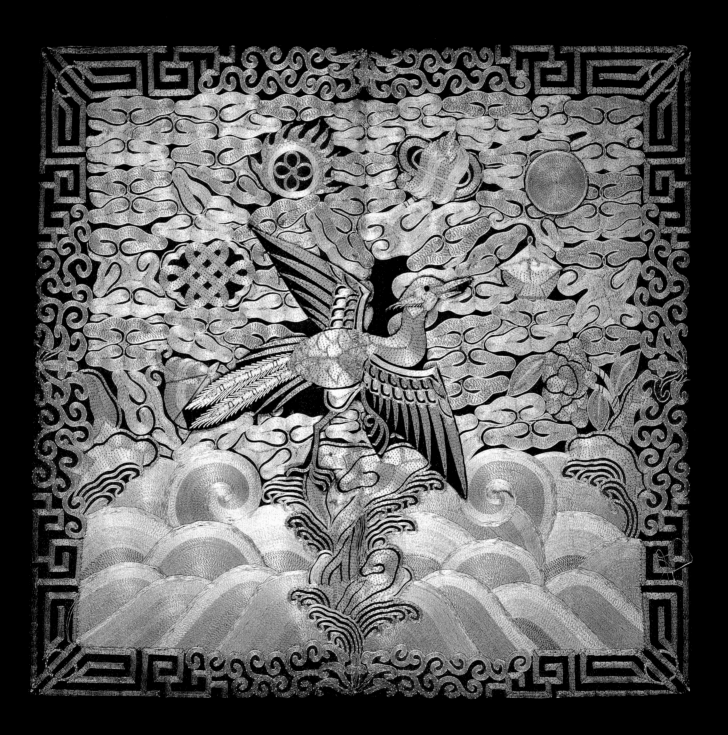

EVOLUTION OF CH'ING DYNASTY SQUARES

M andarin square design was controlled only generally by regulation. For the most part, changes were driven by custom or current fashion. During the Ch'ing Dynasty, there were only two significant revisions of the laws governing mandarin squares. The first was the original laws promulgated when the Manchus finally subdued the country in 1652 and prepared their full set of regulations governing the court. The second was in the reign of the Ch'ien-lung Emperor when he had the regulations revised and published in 1759. As we will see, the style and design of the squares changed far too frequently and radically to be caused by these infrequent regulatory revisions.

Nearly everyone, myself included, has fallen into what I consider to be the intellectual error of referring to squares by the name of the reigning emperor when the square was produced. I believe that this is an error because the actual situation was much more complicated than this simple designation procedure suggests. I find it inconceivable to believe that an emperor, on his first day in office, would decide what style the squares would take during his reign and then decree that all squares be altered that day. A more reasonable orientation is to believe that the squares were in a constant state of flux. That what we now call, for example, the Kangxi style is more an historical artifact for the convenience of collectors and museums than a real life concept that influenced the designs as they evolved.

◉◎ *Opposite:* Golden pheasant, after 1850, metallic thread appliqué, female. (Provided by David Hugus, photography by John Levin)

While I still use the terminology and will, in fact, do so here for convenient reference, we need to keep in mind that this way of referring to squares is probably not accurate. The squares worn during an emperor's reign were not changed when he ascended the throne, nor were they static during his tenure as the Son of Heaven. It would be more correct to describe a square as "one of the styles worn during the reign of the Ch'ien-lung Emperor" rather than as a "Ch'ien-lung square." However, this tendency undoubtedly came into use for its convenience and for this reason, I will continue to use this shorthand form of reference.

I have made a conscious decision to avoid intellectual conservatism in this book. The difficulty in precisely dating even a single square, along with the tremendous diversity in their manufacture, make tracing the evolution of the square design an inexact science. I have great sympathy for academics who have published in scholarly, refereed journals on this subject, who, their professional reputations on the line, have tended to be conservative when specifying dates and changes in design. Consequently, there is relatively little written about the way the mandarin square evolved over the centuries and no coherent treatment of the subject in a single work.

My attempt to trace the design evolution of the Ch'ing badges will, I am sure, contain errors, because understanding the way the squares changed over time is a mixture of knowledge and experience. This is an interactive process. Thus, my opinions are, to a degree, a function of my experiences with squares I have seen over the course of my collecting. Since I haven't seen all the squares in the world (I'm working on it), there are surely holes in my knowledge. I may eventually see squares that will require me to modify the opinions and attitudes I now hold. So what you have here is the understanding that I have been able to assemble to date. It may change. I encourage you to consider it as a reasonable starting point for your own investigation, but don't be afraid to modify your own ideas and opinions if you encounter squares that fall outside the descriptions you find here.

One of the more challenging aspects to collecting or appreciating mandarin squares, is ascertaining when the square was produced. As we will see, there are

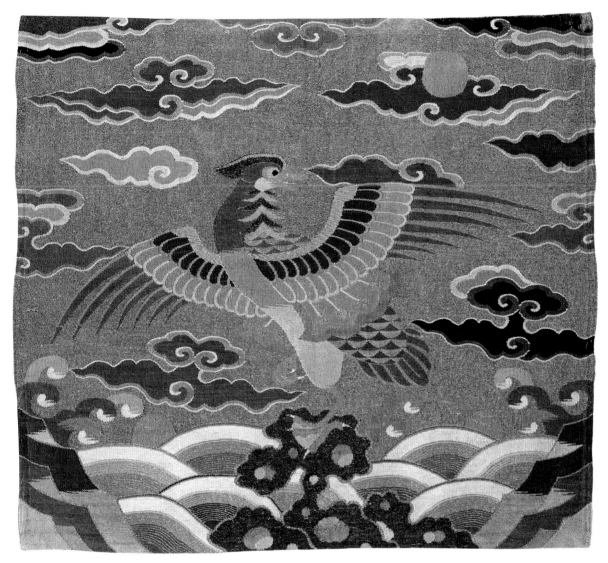

◐◑ 15.001 Mandarin duck, mid-1600s, *k'o-suu*, female (From a private collection)

some significant milestones along this evolutionary path. A little knowledge will allow a reasonable assessment of the century within which a square was made. More information will allow a more refined judgment.

During the initial phase of the Ch'ing Dynasty, the nascent rulers were more concerned with subduing the country than governing it. Regulations concerning court dress and other official costumes were left somewhat adrift between Ming and Ch'ing styles. It was not until 1652 that the Ch'ing rulers were secure enough

217

to turn their attention to the organized running of the people they had recently conquered. The first Ch'ing Emperor was Shunzhi who reigned from 1644–1662. This relatively short period was one of transition for mandarin squares.

Comparing the Ch'ing female mandarin duck, 15.001, with the late period Ming male crane square, 07.005, shows both the similarities and differences that existed during part of the transition period between the two dynasties. In the Ch'ing square, the cloud formations maintain the same general shape and pattern, but are smaller and had pointed ends on both sides. In addition, the Ch'ing clouds hint at the fungus design that invoked longevity for the wearer, and are placed in greater profusion on the square, especially the area around and beneath the bird's wings. The central rock on which the bird perched has become more elaborate, convoluted and pierced, resembling those used as natural sculptures in many Chinese pools and gardens. The wave pattern has been standardized into a roughly circular shape. The foam, shown as series of curls at both sides and on the right of the rock in the Ch'ing square, are a development and extension of the very tentative wave forms in the Ming square, shown as two nearly horizontal curled, black and white forms. However, the shape of the rocks at either corner was largely unchanged. The precious things are very limited in number: a single pearl on the left and a pearl and rhinoceros horn on the right, very similar to the Ming design. In addition to being an interesting link between the two dynasties, this square is aesthetically wonderful. The workmanship is impeccable. It is one of the few squares of this age that still has most of the peacock feather intact, including the duck's topknot and neck feathers and the rock. This early Ch'ing square is a wonderful testament to the fact that not all Ch'ing *k'o-suu* was markedly inferior to Ming.

The male *hsieh-chai* square in 15.002 is another example of this period, although it probably occurred slightly later than the duck. The influence of the Ming style on animals, especially their manes and tails, is quite noticeable with the "I just stuck my paw in a light socket" look strongly present. Notice that the clouds are even more abundant than in the duck square. They also show the impact of the fungus design element in their construction. The main differences

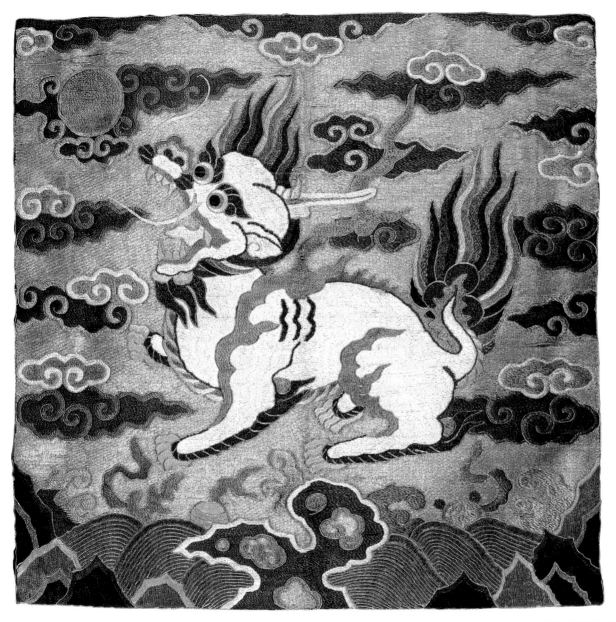

∽∾ 15.002 Hsieh-chai, mid-1600s, embroidery, male. (From a private collection)

occur primarily toward the bottom of the square where the wave forms have been modified from the nearly circular form into a more pronounced hump shape. The side rocks are farther apart and appear as several distinct entities, instead of one solid figure. This square too has remarkably preserved peacock feathers in the animal's eyebrows, nose, whiskers, leg feathers and at the base of its tail. The

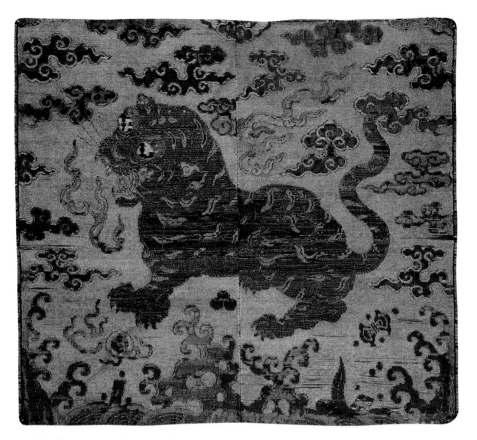

@@ *Above:* 15.003 Tiger, mid-1600s, brocade, male. (Provided by David Hugus, photography by John Levin) @@ *Opposite:* 15.004 Crane, mid-1600s, embroidery, male. (Provided by the Royal Ontario Museum)

embroidery is of very high quality. It is overall quite a wonderful example of a transition square.

The male tiger brocade of 15.003 demonstrates two interesting facets of the transition period. Unlike the two well-preserved examples we saw previously, this badge is in a condition more typical of squares from this era. The tiger was once a resplendent blue and green since his body was originally covered with peacock feathers woven into the fabric. The proliferation of clouds and the lack of concern for symmetry puts this square on a time scale with the first two squares we examined. It is also a reasonably clear indication that military squares did, in fact, lag behind their civilian counterparts in including the sun disk as part of the design. Notice that this tiger square, like many others, included flames in the design, but adhered to tradition by not allowing them to touch the tiger's body, acknowledging that it was not a mythical creature.

The male crane square in 15.004 shows that not all transition squares had gold backgrounds. This square, probably made late in the transition, shows some of the quintessential Kangxi style. The cloud patterns have taken on the classical Kangxi cruciform or partial swastika form. The number of clouds has been reduced and the placement shows a much greater concern for symmetry than the previous squares. This concern extended to balancing the color of the sun with a cloud of the same general size, color and placement on the corresponding cloud mass on the other side of the square. The side rocks are evolving into the classical "sacred mountain" form that appeared on court robes. The waves are

formed into a Kangxi-type of hump. I find it interesting that the central rock is missing altogether. A final comment about the shape of the crane. This contortion of the bird into a circle is a device that started in the Shunzhi transition period and was continued into the Kangxi period. I feel that this was a way to more closely associate the mandarins with the emperor by incorporating one element of his taboo symbology, the circle, into their rank emblems. This design element was not in wide usage for long. Although it is interesting to speculate on whether the lack of persistence was due to the fickleness of fashion or whether the emperor discouraged its use, to my knowledge, no definitive information that would illuminate this particular subtlety in the evolution of square design exists.

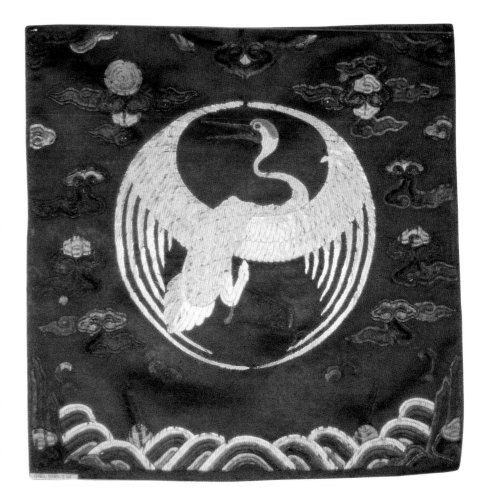

Two important things should be associated with Shunzhi's period on the Throne of Heaven. The first is the significant shift in design from the Ming to the Ch'ing. Ch'ing squares were smaller than their Ming counterparts. They also had ornamental borders, once the transition period was completed. The design included the three parts of the universe: earth, water and sky. Ch'ing badges quickly evolved to having a single rank animal or bird. The sun disk was also added with the military lagging in its introduction by a significant period of time.

The final thing to recall about Shunzhi badges is that the technical execution was, to a degree, controlled by the political and economic circumstances surrounding the establishment of the Ch'ing Dynasty. Although the Ch'ing army was invited into China to expel a bandit leader who had caused the Ming Emperor to

221

commit suicide, it had to conquer the majority of the country after defeating the bandit forces. The southern provinces put up the greatest resistance with the consequence that the devastation in that part of the country was commensurate with the degree of defiance. For our purposes, the implication of this development was that the southern provinces were where the silk production and weaving industries were concentrated. With the virtual destruction of several cities, notably Yangchow and Nanking, the silk industry was badly crippled. This, quite naturally, lead to a severe shortage of silk during the first few years of the Ch'ing Dynasty. The shortage was so severe that economies had to be observed even in the production of clothes for important officials in the Ch'ing court. Mandarin squares from this period frequently are executed using a surface stitch technique.

This technique is designed to save silk by using only a minimal amount of thread on the rear surface of the square. With conventional embroidery, the artisan inserted the needle from the back of the piece and took a stitch, returning the needle to the back side where the thread would be drawn back along the stitch that had been taken, and the needle thrust from back to front next to the place where the first stitch had been started. This produces a design that is essentially the same on both the front and back of the piece. When conserving silk is essential, one can return the needle to the front immediately adjacent to the point where the first stitch ended, rather than return it to the place where the first stitch started. Thus the silk on the back is limited to the width of the stitches taken. This uses a minimum of silk while not affecting the design as it is seen from the front. Squares from the early part of the Shunzhi are frequently made in this way. Obviously, one ought to have the square in hand and be able to examine the back side before claiming that this technique has been used.

The Shunzhi Emperor was followed by one of the most famous and long-reigning emperors of the Ch'ing Dynasty, the Kangxi Emperor. Kangxi squares are bold, bright, flashy, and richly ornamented with gold bullion. It is tempting to believe that their striking appearance is largely a function of a barbarian's lack of taste when confronted with unimaginable wealth. However, this attitude should be tempered with an appreciation of the actual situation. While the silk

shortage had been addressed to the degree that the surface stitch was no longer required, silk was still not abundant. However, gold and peacock feathers were plentiful in the imperial storehouses which would at least partially explain their extensive use during the reign of the Kangxi Emperor.

Nearly all Kangxi squares have bright, striking gold backgrounds. The rank animals and birds are large and dominate the square, as one would expect. Animal bristles or other substances were used as padding to produce a three-dimensional effect. The colors, typically bold and bright, are sharply separated with straight lines. The use of encroaching satin stitch (or long and short stitch) to blend colors is not seen. Peacock feathers are used as background for the gold, scrollwork-decorated border and to fill the rock on which the rank creature stands. The sun disk was normally included. The rock, which represented the earth element in the universe and supported the rank creature, is artistically sculptured and pierced. The lucky objects were invariably taken from the secular (Confucian) Eight Precious Things. Usually, they were limited to two objects on each side of the rock. Typically they will be a rhinoceros horn and pearl on one side and a roll of silk (or book or painting, depending on how you want to interpret the figure) and a pearl on the other.

The technique used in 15.004 was not the only way to incorporate a circle into the design. Sometimes two birds were used with each individually contorted into its own circle, or each forming a semicircle and facing the other to complete the circle. During this period, the sun was typically composed of concentric circles. Small clouds had a single tendril extending from the bottom that tapered to a horizontal point. Larger cloud masses frequently had the distinctive tapering tendril on both the top and bottom (pointing in opposite directions), forming an incomplete swastika with the horizontal component of the mass. The cloud mass associated with the sun disk was often balanced artistically by a cloud mass of the same color and general shape on the opposite side of the square.

The gold threads on these and other Ch'ing squares is actual gold bullion formed into foil and wrapped around silk, animal tendons, or cotton thread. This fiber is laid on the surface of the square and tacked down with a series of

small couching stitches. The lavish gold background is also sculpted with the gold threads outlining the major elements of the design and then merging like ripples on the surface of a pond as they join each other. This not only produces a pleasing and artistic way to relate all the parts of the design, but it also serves to make the wearer more prominent. The different directions of the gold pattern would give a glittering appearance under nearly all light conditions. Unfortunately, peacock feathers appear to be a favorite meal for a variety of voracious insects. Nearly all squares dating from the Kangxi period have had their peacock feathers eaten away over the years. Should you find a Kangxi square with its peacock feathers intact, you have found a rare treasure indeed.

While the use of the circle for bird designs appears to be been more frequently used during the early part of the Kangxi period, examples also exist that were clearly made during the later part of this emperor's reign. Example 15.005 is an early female peacock Kangxi square. It shows the classic cloud pattern including the attention to sym-

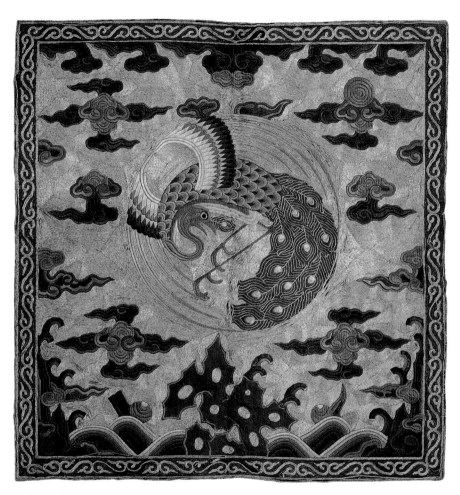

☯ *Above:* 15.005 Peacock, early Kangxi, embroidery, female. (From a private collection, Larry Kunkel Photography) ☯ *Opposite:* 15.006 Crane, early Kangxi, embroidery, male. (From a private collection)

metry and color balancing with the sun. The gold background is also typical with the gold outline around the major elements as are the number, selection and positioning of the precious things in the water. The only unusual aspect to this design is the configuration of the peacock. The male crane in 15.006 was made around the same time as the peacock. This use of the bird's wings to form a circle is more common than contorting the bird's body into that form. The basic design of this square mirrors those of the peacock in most major respects,

224

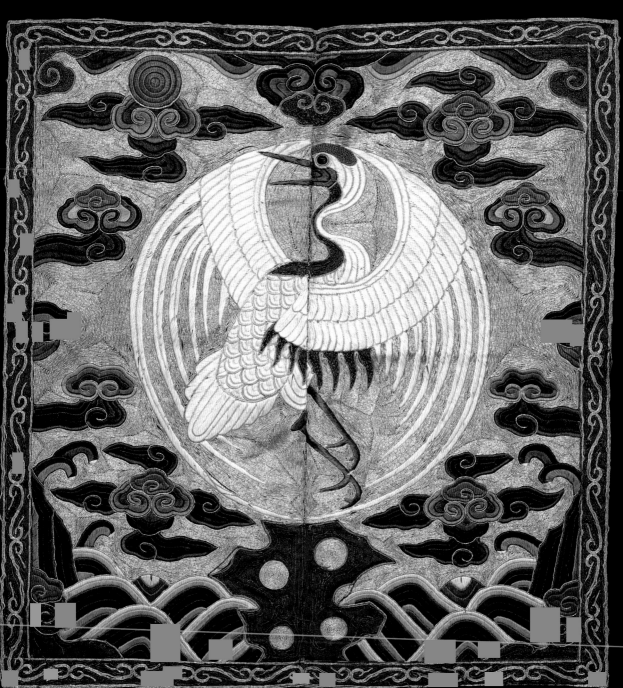

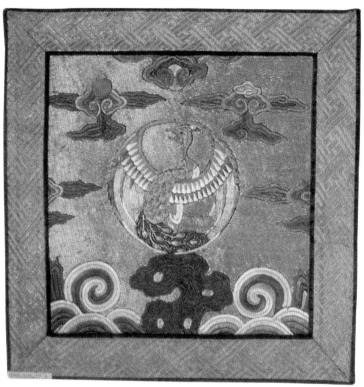 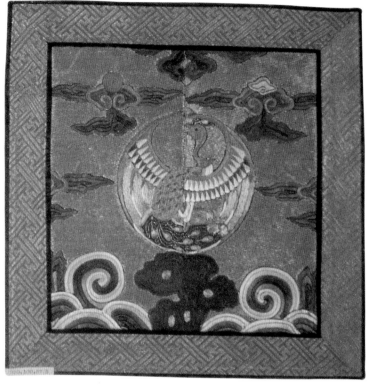

@@ *Above:* 15.007 Pair of Peacocks, late Kangxi, embroidery, male. (Provided by Royal Ontario Museum); the square on the right was worn on the front of the *pu-fu* and is split to accommodate the opening needed to don the garment. @@ *Opposite:* 15.008 Leopard, late Kangxi, embroidery, male. (Provided by Linda Wrigglesworth, photography by Alfie Barnes Art Photographers)

but two elements are worthy of note. The first is that, like the peacock square, there are four large cloud masses composed of partial swastikas; two below the bird's wings. This four-corner positioning of the large cloud masses was typical of early Kangxi squares. The second is the use of Peking knot to highlight the coloring of the crane's cap. It is widely believed that the use of this stitch for this purpose started during the Ch'ien-lung period, about one hundred years later than this square. So we have yet another instance where conventional wisdom serves us poorly.

Our third example of the use of the circle is 15.007. While the positioning of the bird is similar to the crane, other design elements place this square toward the later part of the Kangxi period, such as the relatively plain gold background, the modifications to the Kangxi-style clouds and the use of circles in the water element. (The border is covered by a piece of brocade, but I suspect that the border has been reduced to a couple of thin lines as well.) So we must conclude that

226

birds in a circular configuration were not restricted to the early part of the Kangxi emperor's reign, but appeared throughout this period.

My assertion that the use of the circle was developed to connect the officials to the emperor has been predicated thus far on the observation that birds were placed in this unusual position on Kangxi squares. However, there is additional evidence that square designs tried to exploit imperial symbology. Example 15.008 is a leopard square from the Kangxi period displaying the typical cloud formations and other design elements. However, the leopard's spots are connected in sets of three, mirroring the configuration of the constellation that was one of the emperor's

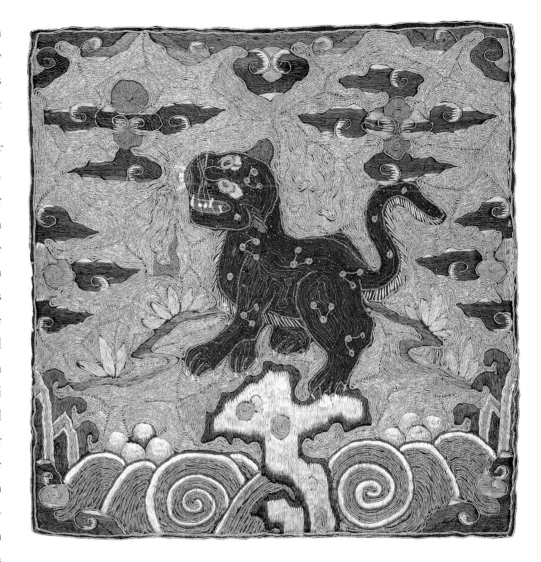

twelve symbols of sovereignty. (This constellation appeared above the dragon on the front of the emperor's formal court robes for many years. Later, these twelve symbols would be added to the emperor's informal court robes by the Ch'ien-lung emperor in the 1759 revision of court clothing rules.) The design on the leopard mimics the color, style and design of the emperor's constellation. However, 15.009 is a leopard from a bit earlier in the Kangxi period that has spots of the same color and placement as 15.008, but does not connect them, foregoing the imperial connection.

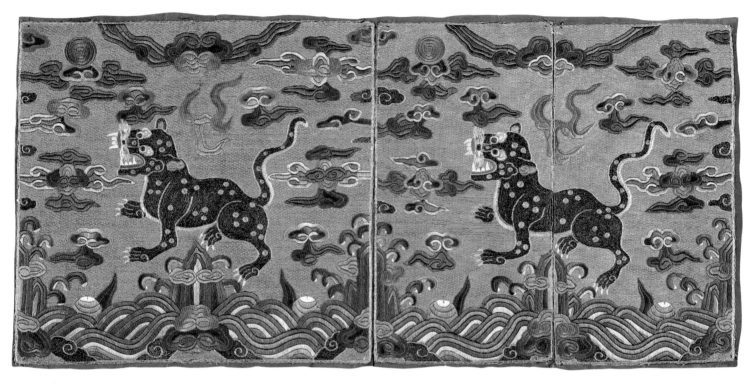

@© *Above:* 15.009 Pair of Leopards, late Kangxi, embroidery, male. (From a private collection); the square on the right was worn on the front of the *pufu* and is split to accommodate the *pufu* construction. @© *Opposite:* 15.010 Silver pheasant, mid-Kangxi, embroidery, male. (Provided by Linda Wrigglesworth, photography by Alfie Barnes Art Photographers)

The leopard in 15.008 has more to tell us about Kangxi squares. Note that the circular form of the water appears here as it did in the peacock square in 15.007. The border has also been modified by reducing the peacock feather-backed scrollwork to a few thin lines. Finally, the color striations in the clouds are more typically associated with the following emperor, Yongzheng. All this indicates that this square was produced very late in the Kangxi period and forms part of the transition to the new design that would be associated with Kangxi's successor.

The second type of Kangxi square changes only the physical configuration of the rank bird. In this period, the bird takes a heraldic stance, rather than being forced into a circular form. Most of the other design features are essentially the same as before. Example 15.010 is such a square. This male embroidered silver pheasant is typical of the heraldic stance and restricts the cloud placement somewhat by eliminating some of the area that was previously available in the lower corners of the square. Hence, we see the clouds placed higher in the square. The

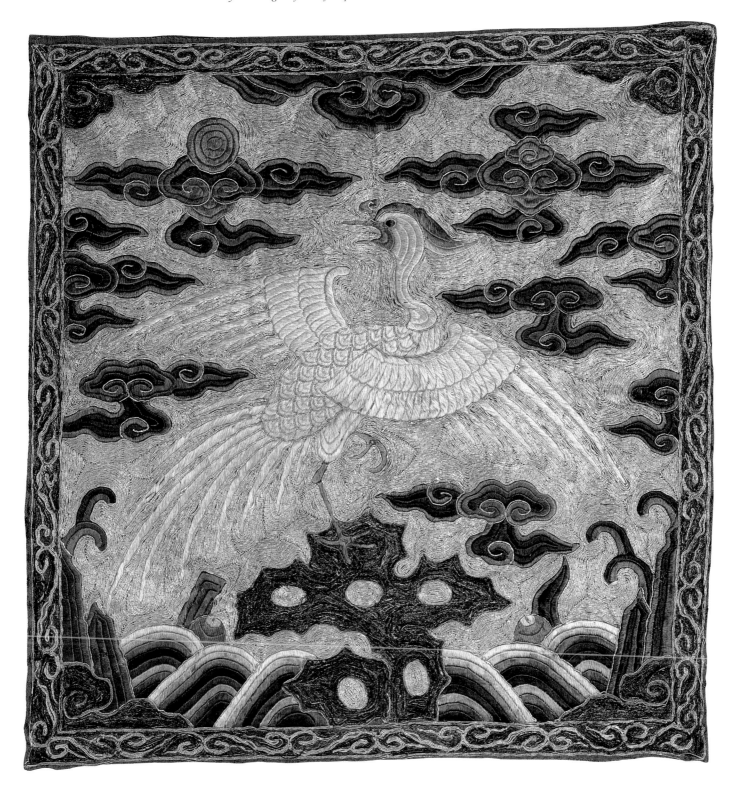

cloud patterns remain essentially the same and the background retains its patterned nature.

The third period modified three of the elements in earlier badges. Most noticeable is the change in the background to a plain pattern of horizontal lines, producing a more subdued effect. The second major change was the execution of the sun disk which went from the concentric circles of the first period to a spiral pattern. Finally, the incomplete swastika is not found here. The clouds are reduced in number and are less elaborate as they begin their transition to a later style. Formations show the mushroom shape prominently and have single trailing tendrils that taper to a point. The male embroidered silver pheasant in 15.011 reflects these design changes. Check the very tips of the wing and tail feathers. The deterioration of the silk allows you to see how foreign items, in this case wooden splints, were covered with silk to produce a three-dimensional effect on some Kangxi squares.

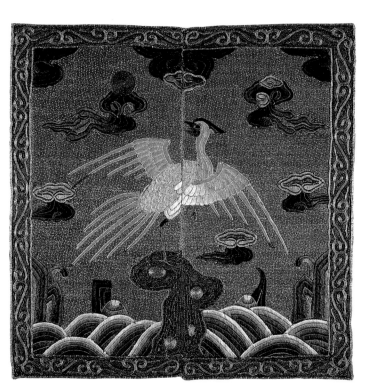

⊚⊚ *Above:* 15.011 Silver pheasant, late Kangxi, embroidery, male. (Provided by Corrie Grové, Peninsula Photographics) ⊚⊚ *Opposite:* 15.012 Mandarin duck, late Kangxi, embroidery, male. (Provided by Linda Wrigglesworth, photography by Alfie Barnes Art Photographers)

A final stage in the evolution of the Kangxi badge was the simplification of the border to a few thin gold lines. This would presage a virtual elimination of the border in the next emperor's reign. The male embroidered mandarin duck in 15.012 shows this and has clouds that are even more restrained and simple than in our previous example.

Let me now make two observations. First, my objection to the use of the term "Kangxi square" may start to be apparent. If you compare the last Kangxi peri¬od mandarin duck to the first example of the contorted peacock with the elaborate cloud formation, scrollwork border and sun composed of concentric circles, there are many more differences than similarities. Calling both of these squares "Kangxi" as though they were the same lacks appeal.

Second, some readers may have noticed that there are differences between the physical descriptions of the birds and animals in Chapters 12 and 13 and the

Kangxi-period birds and animals shown here. Those differences are real. The crane's tail feathers were not separated during the Kangxi period as they are later. Nor do they necessarily form the pointed, spade shape. The silver pheasant's tail feathers were not always five in number and lacked the characteristic scalloped or

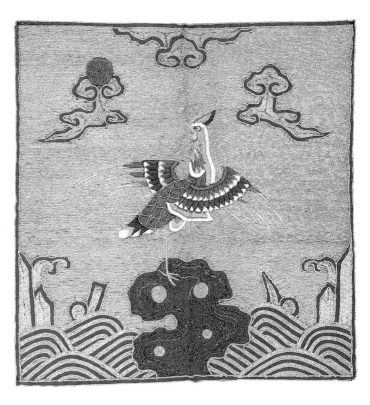

serrated edges found in later birds. The mandarin duck's two-tiered neck feathers were concentrated in the front of his neck, unlike the examples in previous chapters which are from later periods. The individually articulated wing feathers are not like the conventional wedge-shaped wings of the nineteenth century. And certainly the color of the leopards were nothing like the real animal. The descriptions in previous chapters will give you a basic understanding of the birds and animals you are most likely to encounter and focused on squares made after 1800. I can only reiterate that there are no rules that will serve you equally well in all cases.

⊚⊚ *Opposite:* 15.013 Goose, early Yongzheng, embroidery, female. (Provided by Judith Rutherford, photography by Jackie Dean)

The Yongzheng Emperor had the unenviable position of serving between the two Ch'ing Dynasty emperors who both served for a great cycle (sixty years, sufficient to encompass all the possible combinations of the twelve zodiac animals with the five elements). His relatively short reign (1623–1635) must have seemed like an temporary position when compared to the emperors who preceded and followed him. However, his short reign as the Son of Heaven produced a surprising variety of design changes. The flashy gold background of the Kangxi period is replaced with a very subdued black silk field. The Yongzheng squares are the smallest of the Ch'ing period, nearly small enough to be mistaken for a late Ch'ing child's square. The border is more subdued and the fancy gold scrollwork backed by peacock feathers is replaced with either a simple, thin gold border or with no border at all. Frequently the square's border is formed by the clouds themselves. The sun disk went through two changes. Originally, it retained the Kangxi-style spiral execution. This changed back to an earlier style of concentric circles, but with different shades of color, red, pink and white. Finally, the sun was rendered as a plain red circle worked horizontally, and usually outlined with a thin gold line. The precious things in the water are present both in slightly greater profusion and also in greater variety. We see the first use of rebuses during this period. And clouds show a wide variety of designs, the only common thread being a tendency to elongate and attenuate them in their various forms. The water design also shows elements of innovation. The complete circle in the water that was occasionally seen in Kangxi squares becomes almost mandatory in the Yongzheng period. And in a change that will anticipate a major change over one hundred years later, small, wavy, slanting, multi-colored lines are added to the bottom of the water area. This was a hint at the *li shui* (deep water) design that was being introduced at the hem of court robes.

The embroidered female goose in 15.013 serves as an excellent transition between the Kangxi and Yongzheng. It contains the same kind of heraldic stance that characterized the late Kangxi squares. The bird designs continue the articulation of long single feathers in the wings. The attenuated clouds are an extension of the design that occurred in the previous two Kangxi squares. Even the

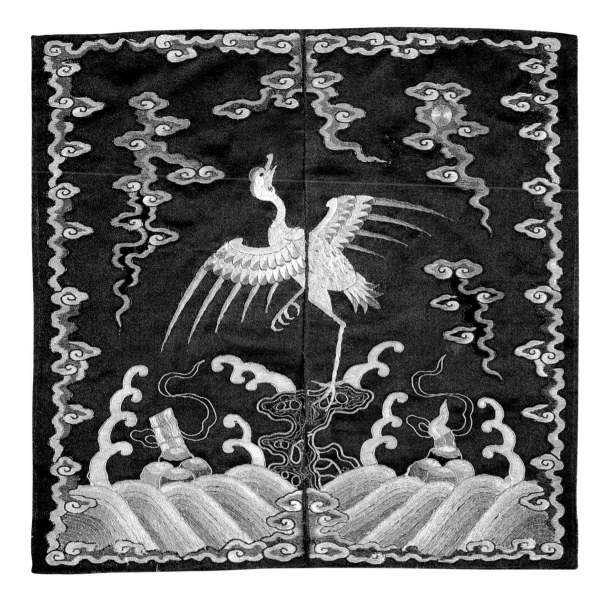

multicolored pattern for a single cloud is more fully explored here. The border that shrunk to a few thin lines in late Kangxi has disappeared altogether in favor of a border defined by the clouds themselves, an instance of the picture providing its own frame. Although we have lost the rocks that occupied the lower corners of Kangxi squares, the wave form and rock style are easily recognized. Keeping the number of precious objects down remains in force, although the pearls are beginning to proliferate.

The female peacock 15.014 is from the same general time period as the goose. The major differences between the two designs are the borderlessness of the second example and the inclusion of full circles in the water form. But the other design elements of the goose square are found in this square as well. The execution is unusual. The design is entirely composed of metallic gold thread, but instead of the usual loops to hold the metallic thread in place, this square is made with an unusual spiral couching that coils the couching thread around the metallic thread and almost obscures the fact that the gold is there. The couching thread provides a variety of colors while the gold provides a consistent background flash. The square is more impressive in real life than it is reproduced here. But its subtle glitter can be seen in the water region, a portion of peacock's body and in some of the clouds.

Examples 15.015 and 15.016 are brocade leopard and silver pheasant male squares that were produced slightly later than the first two examples. The key changes are in the representation of the sun, which is now concentric circles of different colors, and the proliferation of the precious things in the water. Coral and gold ingots appear in these squares. In addition, we may well have the first instances of rebuses in the water with the two vessels in the silver pheasant square. The cloud forms are somewhat modified, but not in a spectacular fashion. They retain the interleaved multicolor as before, but have lost some of their vertical attenuation and are now more horizontally constructed.

The embroidered male bear in 15.017 is important primarily for the reintroduction of a thin border that is both external and obviously separate from the square itself. In a kind of belt-and-suspenders approach to framing the design, the square provides an external border of gold lines plus the inside border defined by the clouds. The lack of circles and precious things in the water may be due to a possible difference between the general design of military and civil squares. The sun is now a single flat, unembellished color. The continuing influence of the Ming design for the animals' tails and manes and the "crocodile" shape of the muzzle are evident as well.

The female silver pheasant in 15.018 is a counterpart to the bear we just examined. It too shows the double border of lines and clouds. However, like its

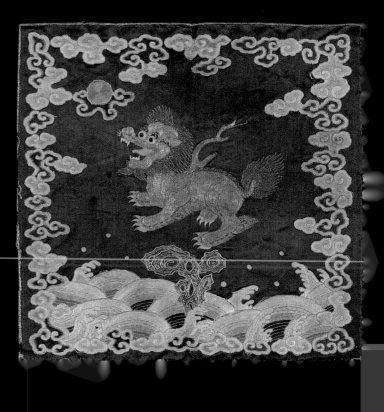

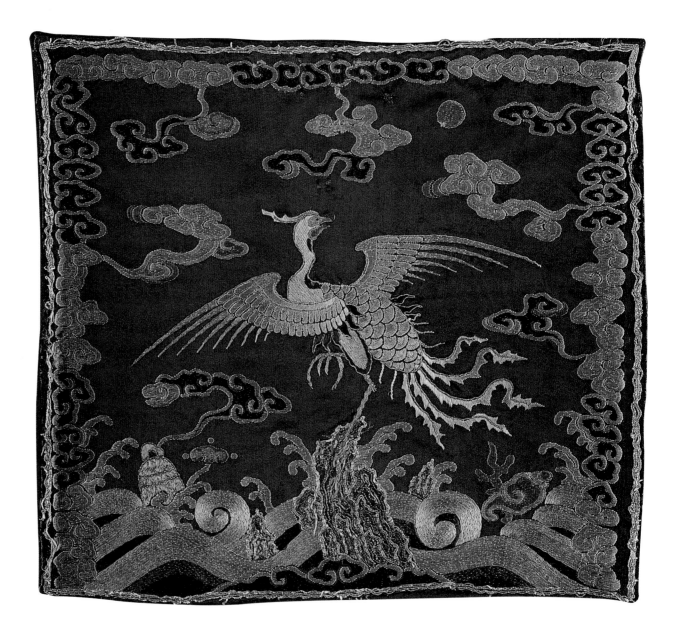

civilian contemporaries, it displays both circles and precious things in the water. We also probably have another example of a rebus with the bell and scepter in the lower lefthand area of the water. I am struck by the simple elegance of the design of this square. The delicate scale and ample empty space are appealing to my eye. This is an obvious predecessor to the excellent and elegant Ch'ien-lung squares to follow.

236

Example 15.019 is a radical departure from the simplicity and elegance of the previous square. Nevertheless, the commonality of design that this male goose example shares with other Yongzheng squares is also obvious. The clouds have proliferated to an extraordinary degree, completely filling the interior of the square. Logic suggests that a change in cloud design of this magnitude probably did not occur all at once. I suspect that there were several steps between the sparse clouds of the previous squares and this example. However, none has come to my attention yet.

The wavy multicolored lines in the water have been introduced for the first time. They reflect the design of the deep water on the hem of court robes. They do differ from the robe incarnation since they have a small fungus-shaped cloud at the top end. However at this juncture, these wavy lines will die a quick death only to be resurrected a little more than a hundred years later. We have an unambiguous rebus contained in this square: the jar, three halberd and jade chime rebus placed to the right of the rock supporting the goose.

꿍꿍 *Opposite:* 15.018 Silver pheasant, late Yongzheng, embroidery, female. (Provided by Judith Rutherford, photography by Jackie Dean) 꿍꿍 *Above:* 15.019 Goose, late Yongzheng, embroudery, male. (Provided by the Royal Ontario Museum)

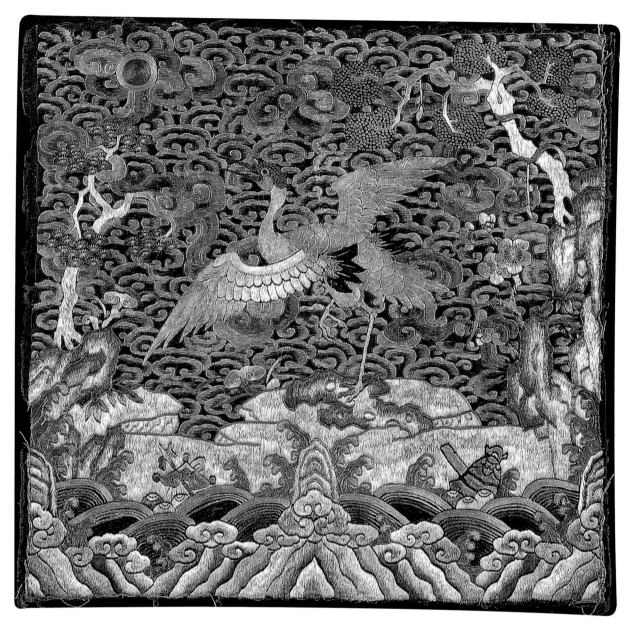

15.020 Crane, early Ch'ien-lung, embroidery, male. (Provided by Chris Hall Collection Trust)

The Yongzheng period is a relatively unknown and underappreciated period of mandarin square design. The modifications during this period were varied and extensive. In general, these changes lead to a more refined and elegant square. For this reason, they are, I believe, a worthy predecessor to the widely hailed and universally praised masterpieces of the Ch'ien-lung period.

238

The reign of the Ch'ien-lung Emperor was a time of wealth and refinement for the Chinese, clearly reflected in the elegance and sophistication of its early squares. The early part of the Ch'ien-lung period is marked by a shift in the way that squares were designed. From a reasonably rigid heraldic pose, Ch'ien-lung birds and animals of the period were placed in a setting that more closely reflected the real world. Rather than a single rock jutting from the waves, we often find patches of ground supporting the rank creature. The water element is represented by waterfalls and streams. Natural vegetation (primarily pine trees) is included. Pagodas are frequently added. The clouds, initially spread throughout the background, are clustered into concentrated groups. During this transition, the clouds also become more circular, renouncing, at least for a time, the fungus shape that had been introduced in the Kangxi and continued during the Yongzheng reign. Precious things are still tucked away in the water. The use of the limited deep water design that was introduced in the previous reign is seen sporadically throughout the Ch'ien-lung. However, it does not appear to have been restricted to any particular time period. Rather it was used at the whim of the artisan or wearer of the square. The border was reintroduced as one to three thin lines or a thin solid gold border. These borders were very fragile, easily damaged and were frequently removed before export. Thus, we often find Ch'ien-lung squares with no border at all. The net effect of these changes was to produce a more natural setting for the universe depicted in the squares.

Example 15.020 is clearly coupled with the goose square that was the last representative of the Yongzheng period. The dense clouds in the background and the use of the multicolored, cloud-topped deep water at the bottom of the square tightly link these two squares. But the male crane square in 15.020 has added the characteristic pine tree of the Ch'ien-lung Emperor's squares. In addition to the dense blue clouds that cover the background, there is an overlay of multi-colored clouds that are a combination of mushroom and circular shapes. I have not seen this double layer of clouds on any other square. Two rebuses are present in the water: halberd and jade chime (good luck and good fortune) on the left and the demon protecting bell on the right. Peking knot was used to

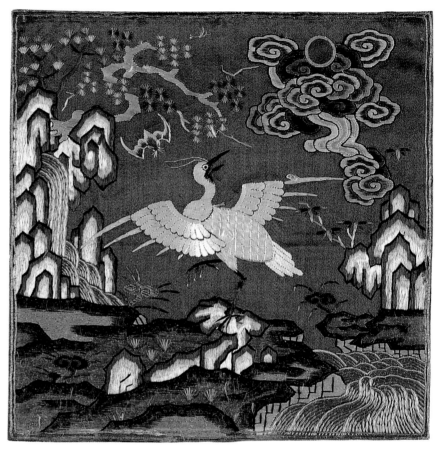

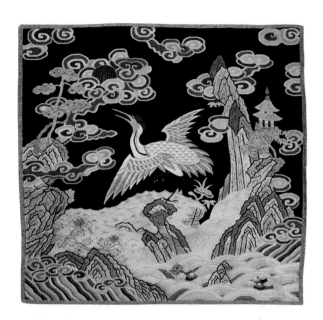

⊚⊚ *Above:* 15.021 Crane, early Ch'iem-lung, *k'o-suu*, male. (Provided by David Hugus, photography by John Levin) ⊚⊚ *Right:* 15.022 Egret, early Ch'ien-lung, embroidery, female. (Provided by Judith Rutherford, photography by Jackie Dean)

highlight the crane's cap as early as the Kangxi period and it has been used here as well, but this stitch has also been extended to the tree on the right. Finally, the crane's wing feathers are beginning to depart from the single articulation of previous eras and evolve into the wedge shape that will characterize the later Ch'ing birds. The sun is again multicolored concentric circles. The border is a simple, thin gold line.

The male *k'o-suu* square in 15.021 shows the next step in the evolutionary process. The dense background of clouds is gone, replaced by a welcome expanse of open silk. The sun as a pure, bright red disk is partially obscured by the clustered multicolored clouds. The rock that supports the crane is surrounded by a land mass. The water has been divided into three parts: the wavy, deep water is split into two small areas in the bottom corners, the traditional wave forms are

concentrated in the right corner, and a stream flowing from a "mountain" is added. The mountain also supports a pagoda. Although there are no rebuses, precious things still appear in the water. The crane's wings are another step closer to the wedge shape. The border is a slender woven line of gold.

Of course, during a reign as long as the Ch'ien-lung Emperor's, the squares went through several steps in their evolution. The move toward naturalization became more pronounced. The design was simplified with several elements dropping from favor. The pagoda and precious things vanished around the middle of the period. The five-colored clouds, referring to a peaceful kingdom, were consolidated into a single group, while the birds and animals retained their large size and prominence.

This naturalistic period is epitomized by 15.022. The land mass covers the entire bottom of the square, cut only by the stream that is the extension of the waterfall flowing from the lefthand mountain just below the pine tree. Gone from this natural landscape are the obvious rebuses and precious things. However, we do have a subtle rebus in the form of a single red bat, the first example of what was to become a prolific design element. The clouds are clustered into a single mass surrounding the concentric circles representing the sun. The egret's wings are a retrograde move toward the Kangxi style of long, single feathers for wings. The border has become a pair of thin gold lines.

From this point of greatest simplicity, the Chinese started a long trek toward a design that would, by the middle of the next century, reduce the rank creature to a restricted and cramped position amid a vast clutter of lucky talismans.

In 1759 the Ch'ien-lung Emperor issued a new set of regulations covering the costume and rituals of the court. They did not materially influence the specific design of the squares and were the last costume regulations issued during the Ch'ing Dynasty. Some experts have claimed that it wasn't until 1760 that the Peking knot technique was introduced into Ch'ien-lung squares. However, we have seen that this technique actually started in the Kangxi period and was used both in the Yongzheng and early Ch'ien-lung as well. The actual innovation in the use of this stitch was in its application to other small objects in the square's

design and it began very early in the Ch'ien-lung Emperor's tenure on the throne of Heaven.

The male golden pheasant in 15.023 represents the start of the retreat from the naturalistic approach to mandarin squares. The pagoda has reappeared along with the pine tree. The clouds have broken up into several groups, but still retain their basically circular shape. The large land mass is gone, replaced with the more traditional wavy water. The water again contains some precious things and a rudimentary rebus in the form of the *ruyi* scepter. The pheasant's wings now conform to the general wedge shape that will be the norm for the rest of this century and most of the nineteenth century. This square continues the border evolution that will follow a long and interesting path. It starts simply enough with the addition of a second gold line. Incidentally, the difference in the background color is the result of a deterioration of the silk. It is not a subtle part of the square design.

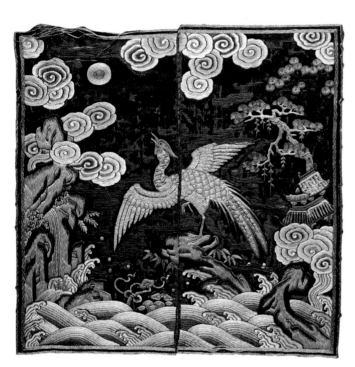

◎◎ *Above:* 15.023 Golden pheasant, mid-Ch'ien-lung, embroidery, male. (Provided by Beverley Jackson, photography by Kevin Delahay) ◎◎ *Opposite:* 15.024 Peacock, mid-Ch'ien-lung, embroidery, female. (Provided by the Asian Museum of San Francisco)

The female peacock in 15.024 is closely aligned to the previous square. It too has the double golden line for a border. However, it extends the evolution of the cloud pattern by starting to link the cloud masses into rather elongated groups that extend nearly the length of each side. The water includes two design elements from previous stages of the evolution: the circles in the waves and the wavy mutlihued, fungus-topped deep water from the Yongzheng period. Pearls are still the main symbols of wealth in the water although two small brown jade chimes are also included. The bird's wings are wedge shaped.

The paradise flycatcher for female use in 15.025 does not fit neatly into any sequence. It remarkable for the rules it breaks, rather than those it modifies. The three tail feathers are a throwback to the Ming period when three tail feathers were a common part of this bird's representation. But its brown color has no known precedent. It is also the earliest square in this book that introduces vegetation and multiple bats. Its Greek fret border marks another shift in the border

242

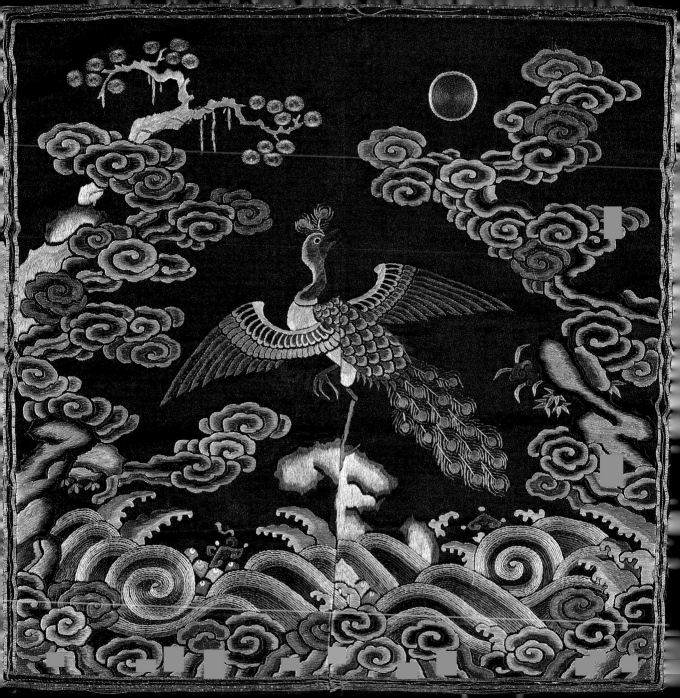

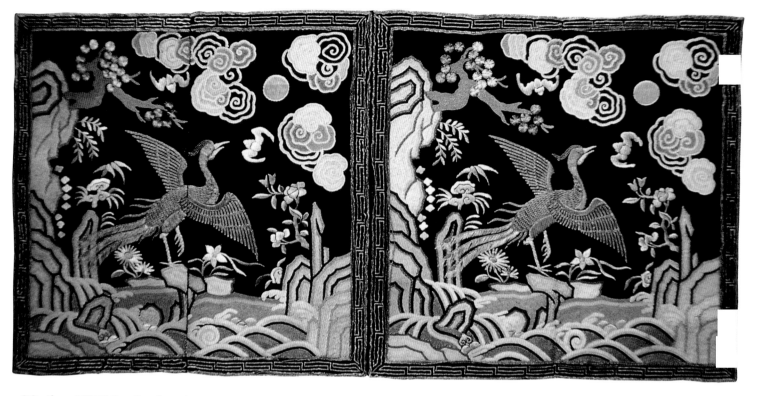

◎◎ *Above:* 15.025 Paradise flycatcher, late Ch'ien-lung, emboridery, female. (Provided by Chris Hall Collection Trust) ◎◎ *Opposite:* 15.026 Silver pheasant, late Ch'ien-lung, embroidery, female. (From a private collection)

design for this period. The clouds are still circular and grouped into masses. The water is a more simplified version of the previous square.

The clutter that eventually took over mandarin rank squares started innocently enough. A red bat here. A precious object there. Cloud groupings multiplied. But eventually the rank bird was surrounded by the five red bats, some with precious objects hanging from ribbons in their mouths, a large pine tree, additional flowers and with little, if any, empty background space. About 1780 the borders were expanded beyond the traditional thin gold lines to include a Greek fret pattern. Simple borders were lost forever. Unfortunately, this cluttered appearance was a harbinger for the future during the remainder of the Ch'ing Dynasty.

The male silver pheasant in 15.026 is itself something of an anomaly in the typically staid and reserved form for squares during this period. It is more closely aligned with later squares that packed as much detail into the square as

244

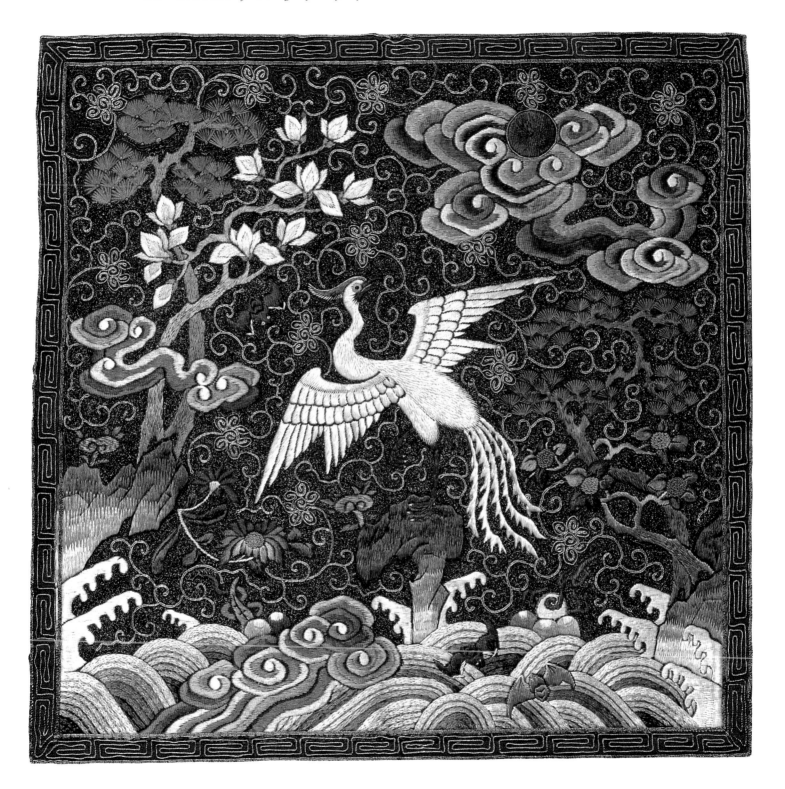

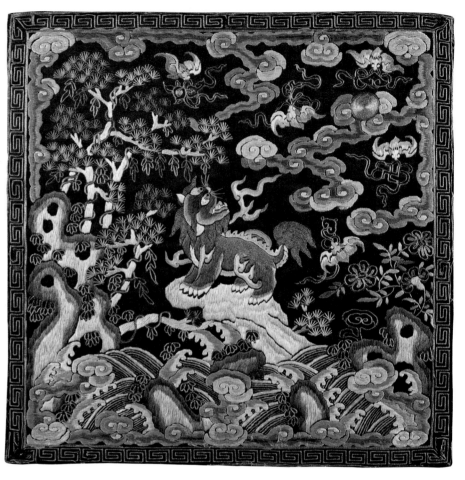

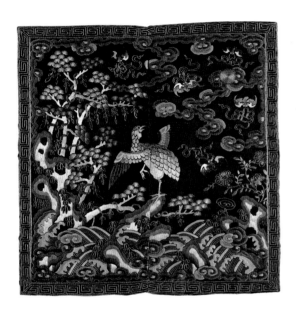

@@*Above:* 15.027 Quail, late Ch'ien-lung, embroidery, female. (Provided by David Hugus, photography by John Levin) @@ *Right:* 15.028 Bear, late Ch'ien-lung, embroidery, male. (From a private collection) @@ *Opposite:* 15.029 Mandarin duck, late Ch'ien-lung, *k'o-ssu,* male. (Provided by the Royal Ontario Museum)

could be fit. The pine trees on either side now have, to Western eyes, blue needles (remember that the Chinese considered blue and green to be the same color). The clouds masses are elongated somewhat in a trend that will be continued to an extreme in the near future. Following the lead of the previous square, this one introduces additional vegetation into the design. But it is the background that sets this square apart from its contemporaries. The solid peacock feather, which is remarkably preserved, and gold scroll work completely cover the background and tend to dominate this square and make it appear more cluttered than most other Ch'ien-lung squares. The water has not changed appreciably, but the rhinoceros horn is now included among the precious things found therein. Multiple bats continue and are, interestingly enough, placed in

the water. Perhaps the background dictated this placement so they would not get lost amid the gold and feathers above the water. The border is in keeping with the previous square.

Example 15.027 is a female quail. It extends the use of the Greek fret border, but introduces a variety of changes. The clouds are now back in the mushroom shape and those in the sky are connected and extended across the upper part of the square. Bats have not only proliferated to the traditional five, but they also bear gifts that represent various rebuses associated with bats. The use of gold and silver metallic threads is a more restrained version of the previous square. This is an unusually high quality square for such a low ranking member of the bureaucracy.

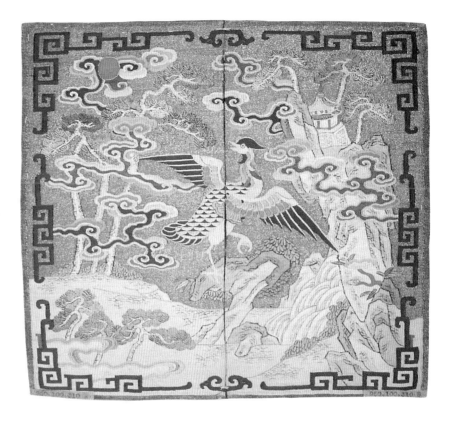

Example 15.028 is the military counterpart of the quail square. It is the same to a remarkable degree with the bird replaced by the bear emblem of the fifth military level. But the design is so similar down to the number and configuration of the pine tree's limbs, location of the clouds and even the placement of the bats and the ornaments they carry, that I wonder if the two squares were made in the same shop. The bear has evolved into the traditional Ch'ing style with a blunt muzzle and curved tail with curls at the base.

The male mandarin duck 15.029 is an excellent example of the woven silk squares from this period. Its gold background reflects the Kangxi influence. The woven detail in this square demonstrates a high level of artistic skill and craftsmanship. But in spite of its aesthetic appeal, I consider its contribution to the evolution of square design to be its primary interest. Two things have happened in this square that will foretell the design of squares throughout the next emperor's reign. The first of these is the elongation of the clouds into small

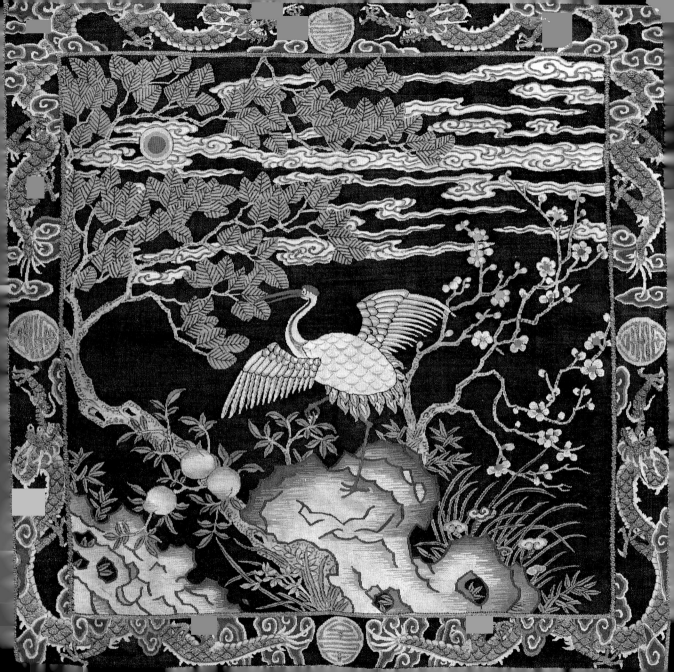

masses connected by long, thin tendrils. This will evolve into one of the more puzzling characteristics of the next emperor's squares. The second is the modification of the border to incorporate a heretofore unknown border design that represents a dragon in such a stylized form as to be unrecognizable if you are not familiar with it. This design will also be carried forward to the next period of mandarin square evolution.

The peach and peony were introduced toward the end of the Ch'ien-lung period. Symbols of longevity and riches and honor, respectively, they had a short life after their original introduction, but came back with a vengeance in the early 1800s, becoming part of a standard that held sway for most of the century.

Example 15.030 is the first representative of the Ch'ien-lung period that contains the peach emblems. This is a marvelous example of the squares of this time. The skill imbedded in this male crane square is of the highest order. The blending of colors in the rocks, peaches, leaves on the tree and the crane's feathers is truly mind boggling. While some details are painted, as was common on even the best *k'o-suu*, these details are represented with skill and delicacy. Note the gnarls and knots on the tree trunk, the veins on the leaves, and the black outlines of the clouds. This square even includes a bit of whimsy with the crane biting one of the tree leaves.

However, to my mind, its most important contribution is to form a link with the next emperor's squares. The Chia-ch'ing Emperor's squares are an enigma, with most researchers avoiding any discussion of these interesting and unusual squares because they are so anomalous. The reason for this avoidance, I'm sure, is a total lack of any connection between mainstream design development and the squares of the Chia-ch'ing period. This square provides an intellectual bridge to some of the design forms of the Chia-ch'ing period, while continuing the trends noted in the previous Ch'ien-lung mandarin duck. The clouds have been extremely attenuated into long thin lines with a smattering of small fungus-shaped clouds. In addition, the stylized dragons of the previous square are presented in a more recognizable form. The *shou* symbol of long life has been added. The cloud formations and the border design are a definite link with the Chia-

∽ *Opposite:* 15.030 Crane, late Ch'ien-lung, *k'o-suu*, male. (From a private collection)

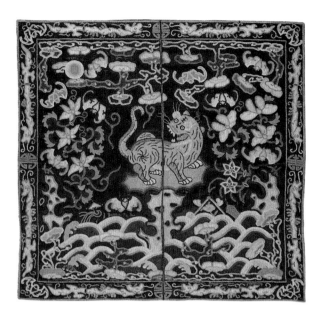

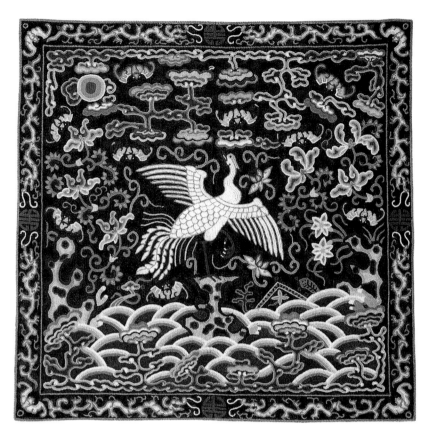

◎◎ *Above:* 15.031 Tiger, circa 1795, embroidery, female. (Provided by David Hugus, photography by John Levin) ◎◎ *Right:* 15.032 Silver pheasant, circa 1795, embroidery, male. (Provided by David Hugus, photography by John Levin) ◎◎ *Opposite:* 15.033 Mandarin duck, circa 1805, embroidery, male. (Provided by Jon Eric Riis, photography by Bart's Art)

ch'ing squares. Less important, but also significant, is the fact that the sun is now represented as three concentric circles of red, pink and white once again.

From the Ming Dynasty on, it had been possible to buy a rank by making a sufficiently large donation to the imperial treasury, rather than study and pass the competitive examinations. However, the Ch'ien-lung Emperor was the first to officially publish a table reflecting the cost of the various ranks that were for sale. This set an unfortunate precedent that had a significant effect on mandarin squares' design and execution late in the Ch'ing Dynasty.

The Ch'ien-lung Emperor was followed by the Chia-ch'ing Emperor (1795–1820). It is difficult to account for the radical departure from previous designs that the Chia-ch'ing squares represent. Nearly everything about them was changed. It is though someone decided to design a mandarin square from scratch with no reference to what had been done in the past. Only our last exam-

ple will tie the late Ch'ien-lung squares to some of the design changes we now find.

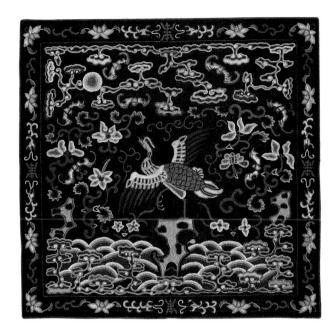

The sun disk has reverted to the earlier assemblage of three concentric circles of varying shades; red in the center followed by pink and white. The long, thin clouds of the last Ch'ien-lung square have been significantly modified into a highly stylized, vine-like arrangement where the balloon-like clouds are connected by a tendril. The bats have multiplied from the traditional five to nine. And instead of being the uniform red of happiness, some are red and some are blue. The pine trees or peach and peony combination are replaced by three large red flowers that may be summer orchids. The border containing naturalistic dragons and gold *shou* symbols has been slightly modified to a combination of archaic, but recognizable, dragons and *shou* symbols. The embroidery technique was changed to the Peking knot which heretofore had only been used very sparingly in squares. Even the color palette of the Chia-ch'ing badge has changed to reflect dark blues and greens, colors usually favored only by the court eunuchs. This gives the squares a brooding, almost sinister cast to my eye.

The female tiger, 15.031, and male silver pheasant, 15.032, exemplify these changes. In addition to the changes noted above, there is a subtle change in the representation of the animals and birds during the Chia-ch'ing period. While difficult to put into words, the changes should be relatively easy to notice. You should note that sometimes the bats are difficult to identify because they are frequently surrounded by other objects and sometimes placed very close to the water.

Even over the relatively short twenty-five-year reign of the Chia-ch'ing Emperor, the squares went through at least four versions, including the base design already described. The second version foreshortened the dragons and included a lotus in the border. In the male mandarin duck square 15.033, the border was further modified replacing the *shou*, for longevity, with *xi*, the symbol for happiness. The bats have been reduced to the traditional five, but all have ele-

☺☺ *Opposite top left:* 15.034 Silver pheasant, circa 1815, embroidery, male. (Provided by David Hugus, photography by John Levin) ☺☺ *Opposite top right:* 15.035 Silver pheasant, circa 1815, embroidery, female. (Provided by Jon Eric Riis, photography by Bart's Art) ☺☺ *Opposite bottom left:* 15.036 Lion, circa 1815, embroidery, male. (Provided by Corrie Grové, Peninsula Photographics) ☺☺ *Opposite bottom right:* 15.037 Bear, circa 1815, embroidery, male. (Provided by Jon Eric Riis, photography by Bart's Art)

ments of both blue and red in their coloration. But the basic design of the squares remains relatively fixed.

Next, the dragons were removed from the border and replaced by a design composed entirely of lotuses, alternating red and blue along a single side. The peaches and peonies were reintroduced along with this change in border. Other design elements remained relatively static. In some Chia-ch'ing squares, the proliferation of precious objects reached an almost ridiculous extreme, providing a water element that one could literally walk across without getting one's feet wet.

Example 15.034 is a male silver pheasant square whose main attraction is the gold metallic thread in the background. This technique, as we have and will continue to see, was occasionally used when richness and grandeur were desired.

Example 15.035 is another silver pheasant from the same period, but this one was worn by a woman. It illustrates the effects of the proliferation of precious objects in the water. These last two squares have the Yongzheng circles in the water.

The male lion in 15.036 sports an unusual border design for this period of alternating bats and swastikas. Classifying this square as a lion is a bit risky because, although the mane is clearly curled, neither the spine hair nor tail show any evidence of curl. While this is unusual, the definite curl of the mane classifies this as a lion, to my way of thinking.

Example 15.037 is a male bear whose design differs from those we have previously examined in that the entire background is done in Peking knot stitch. The labor associated with this effort is overwhelming to contemplate. This square also contains circles in the water as others of this era typically did.

The final modification was the reintroduction of the Greek fret to the border. There is some question whether this occurred during the Chia-ch'ing Emperor's reign or that of his successor Tao-kung. Whichever way it actually occurred, 15.038 is clearly a transition piece between the radical Chia-ch'ing design and that of the more traditional squares which followed it in the 1800s. This female silver pheasant contains the same entire Peking knot background as the bear square and has a less cluttered look that would be carried forward to the next emperor's reign.

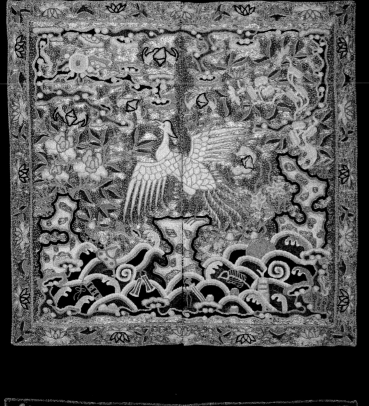
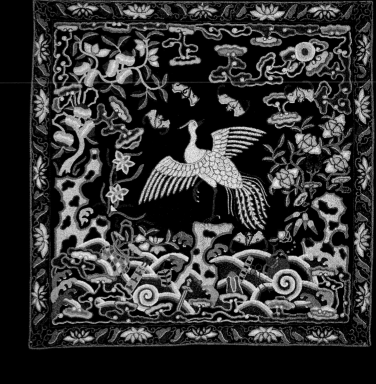
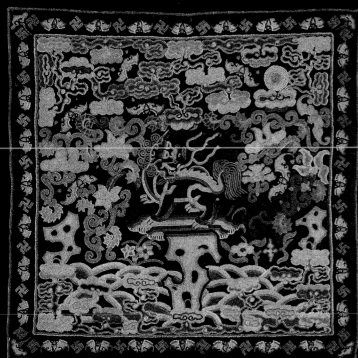
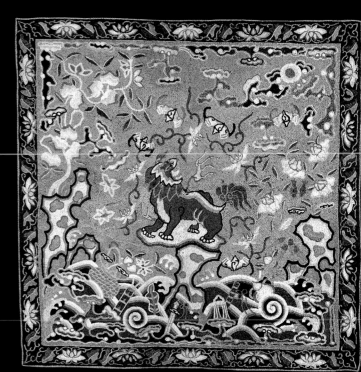

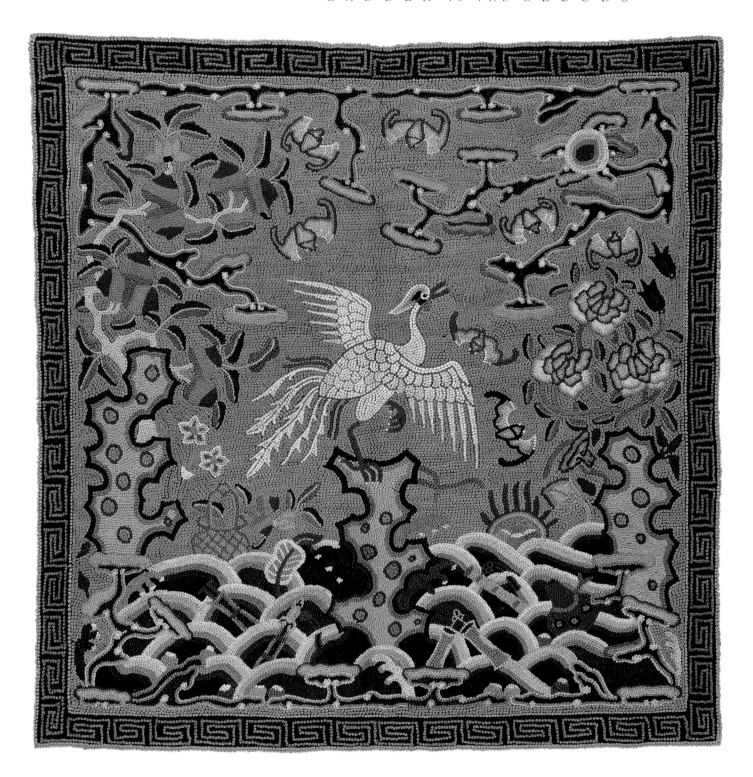

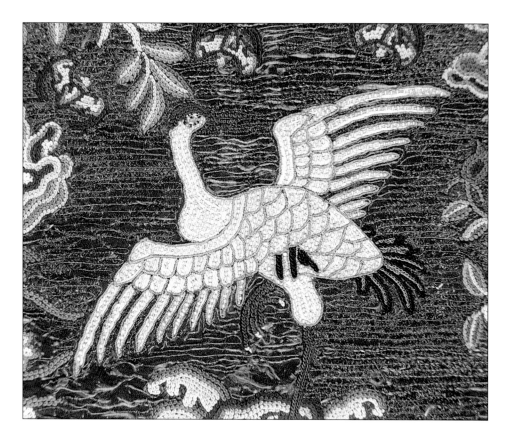

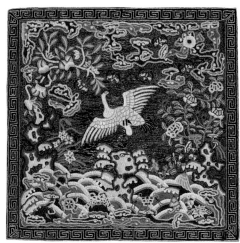

@@ *Opposite:* 15.038 Silver pheasant, circa 1820, embroidery, female. (From a private collection) @@ *Above:* 15.039 Crane, circa 1820, embroidery with seed pearls, female. (Provided by Judith Rutherford, photography by Jackie Dean) @@ *Left:* 15.040 Crane detail, circa 1820, embroidery with seed pearls, female. (Provided by Judith Rutherford, photography by Jackie Dean)

The regulations specifying the clothing for court contained specific prohibitions against wearing extravagant costumes which made little sense when you consider the cost, expense, effort and skill imbedded in these garments. However, every once in a while a square was produced that pushed the limits of this usually poorly enforced prohibition. The female crane square in 15.039 represents one of the most expensive squares created. Gold thread is used in the border, replacing the Peking knot used for most squares of this period. The inside background is completely filled with peacock feathers. But the capping element in this square are the seed pearls that cover the crane's body. A detail of the pearls can be seen in 15.040. The richness and expense of this example surely defines the outer limits of an artform that was supposed to avoid extravagance.

The final Chia-ch'ing square, shown here in 15.041, is possibly more appropriately classified as a Tao-kung (1821–1850) square. This potential controversy

15.041 Mandarin duck, circa 1820, embroidery, male. (Provided by Dodi Fromson, photography by John Levin)

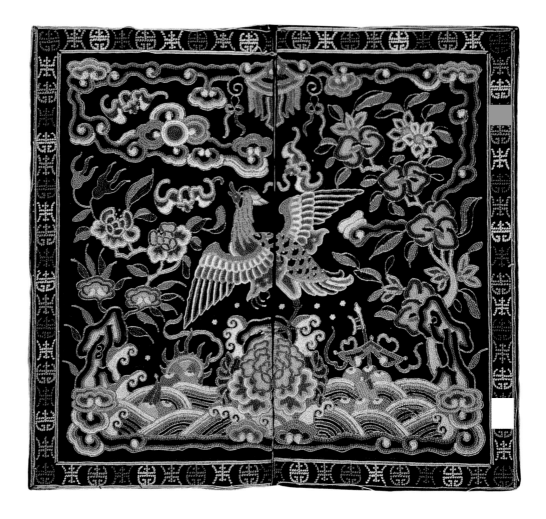

is one of the reasons why I do not like the practice of using emperors' names to classify squares. No one familiar with the evolution of squares during the Ch'ing Dynasty would dispute that this example fits between 15.039 and the later Tao-kung squares. The only real dispute might be whether it was made a couple of years before 1820 or a couple of years later. Given the paucity of information about the actual dating of individual squares, discussions of this nature quickly degenerate into statements of personal opinion and, as such, are relatively unproductive. So whether one agrees with my classification as to the emperor who was occupying the throne when the square was worn or not, this handsome square is in proper sequence with the preceding and succeeding squares. It also takes

another step in the evolution of cloud designs. The clouds come down the left side of the square and then break away from the border at a slight downward angle to encompass the sun disk, a prelude of styles to come.

From the Chia-ch'ing period on, the evolution of squares becomes much more fragmented. This was probably a reflection of the political and historical climate of the times. In the early nineteenth century China's relationship with the rest of the world underwent a significant shift—to China's disadvantage. Shortly after the Chia-ch'ing period ended in 1826, China became embroiled in the Opium Wars which dragged on through the early 1840s and established that, at least from a military perspective, China was not the preeminent power on earth. In addition to the political, intellectual, and emotional beating, the country also suffered a significant financial loss due to the reparations demanded by the Western powers. Shortly after the disastrous close of the Opium Wars, the T'ai Ping Rebellion was fomented by Hung Hsiu-ch'uan, a potential scholar who was not able to pass his second level civil service exams. While his agitation started as a religious movement, it developed into a political rebellion which eventually wrested the southern provinces from the control of the central government and nearly caused the collapse of the Ch'ing Dynasty. The period from 1851 to 1865 was one of internal strife and political uncertainty, as well as trouble in the international arena. While the treaties that ended the Opium Wars guaranteed "foreign barbarians" access to Canton, the Chinese were reluctant to allow this. Their contempt for foreigners lead to deteriorating relations with virtually all the Western powers, resulting in armed conflict on a number of occasions starting in the late 1850s. While it is not my intention to engage in a lengthy discussion of Chinese history, I believe that it is important to understand the degree of turmoil that was present in China at this particular period, because the political and financial situations had, in my opinion, a significant influence on the course of mandarin square design.

During the reign of the Tao-kung Emperor on the Throne of Heaven, the square design returned to a more traditional mode. A typical pattern emerged that formed the basis for most of the squares produced for the rest of the century. The

258

universe was represented by a stylized version of the three elements: sky, water and earth. Clouds designed to reflect the shape of the auspicious fungus are found in the five colors. The earth and water were represented by three rocks projecting from a roiled sea. The central rock served as a perch for the rank creature, the others anchored various auspicious vegetation, often including a combination of peaches, peonies, narcissus and fungus among others. The key difference during this period was the noticeable increase in the use of elements associated with good luck and auspicious outcomes. Early in the Tao-kung period the number of bats stabilized at five, indicating the five virtues: health, wealth, happiness, long life and an easy death (after a life filled with honors). By the end of Tao-kung's tenure, the combination of clouds, bats and vegetation was executed with such profusion that the rank creature was almost crowded into obscurity amid all the other elements. As the century progressed, the incidence of the Eight Precious Things grew significantly. When the Buddhist Eight Precious Things joined their secular brothers they were followed almost immediately by the Taoist symbols of the Eight Immortals. So by the middle of the nineteenth century, the squares were more of a plea for good luck than a reflection of the rank of the wearer. It is not much of an intellectual stretch to associate this design development with the extreme internal and external difficulties that China was experiencing at this time.

Example 15.042 represents the beginning of the Tao-kung period. The cloud pattern, particularly along the lefthand side of the square follows the pattern set at the end of the Chia-ch'ing's reign. The peonies and fungus are displayed on the left; the peaches and narcissus (white flowers immediately below the peaches) on the right in what will become the standard configuration. However, in this instance, the scale of the vegetation and other elements is more delicate and surrounds the male egret with some open space. This makes the bird the focus of the scene. Pearls in moderate profusion are placed in the water. Bats number only two. Examples from this period are among most appealing to me from the nineteenth century.

Example 15.043 is a male crane square made just a little later than the egret. The only real differences are that the precious things are displayed in greater

∽ *Opposite:* 15.042 Egret, circa 1830, embroidery, male. (Provided by David Hugus, photography by John Levin)

259

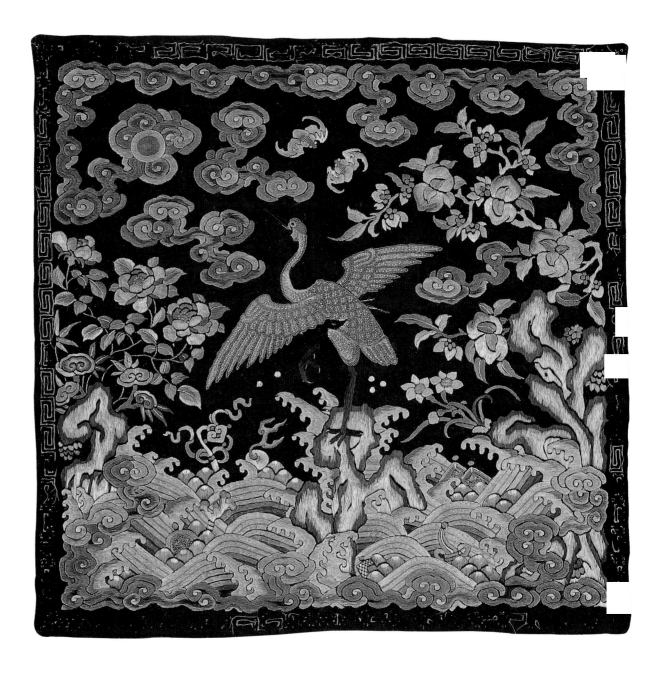

numbers and included the *ruyi* scepter and that their scale has increased slightly, cramping the crane a little, trends that will continue. This crane's body is enhanced by the application of tiny seed pearls—another instance of an artisan's disregard for the prohibition against extravagance.

260

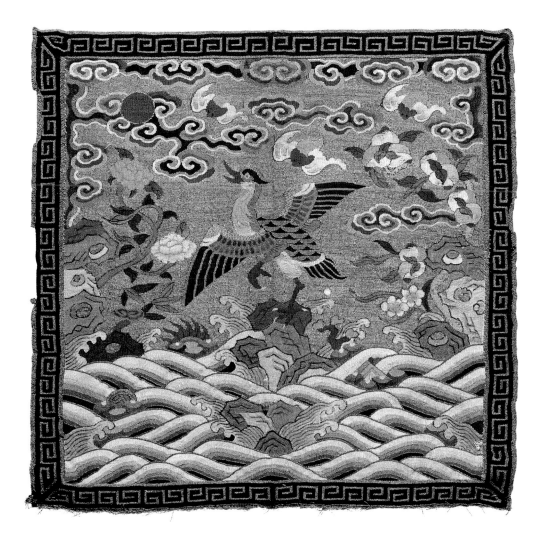

❦❦ *Opposite:* 15.043 Crane, circa 1830, embroidery with seed pearls, male. (Provided by Judith Rutherford, photography by Jackie Dean) ❦❦ *Left:* 15.044 Mandarin duck, circa 1830, *k'o-suu*, male. (Provided by Beverley Jackson, photography by Kevin Delahay)

The male mandarin duck in 15.044 is from this same period and represents *k'o-suu* squares from this era. It shows some respect for the prominence of the bird as opposed to the good luck symbols. In addition, the precious things are now showing a greater variety. The Buddhist wheel of law (the burning wheel to left of the duck) is considered a good luck symbol, not a Buddhist symbol. It is often mixed with the secular Eight Precious Things during this era.

Example 15.045, 15.046, 15.047, and 15.048 are all male examples of a mandarin duck, crane, golden pheasant and peacock, respectively, that illustrate the next step in the design evolution. The mandarin duck square has only four bats.

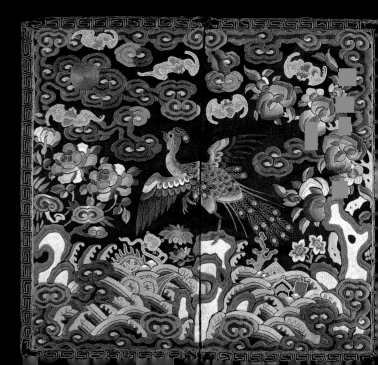

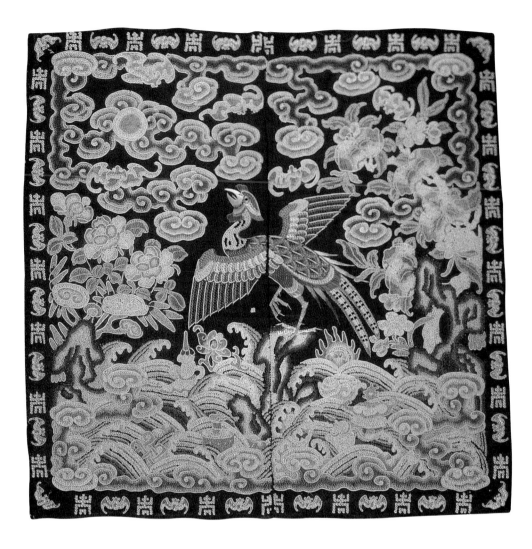

≈ *Opposite top left:* 15.045 Mandarin duck, circa 1840, embroidery, male. (Provided by Gim Fong, photography by Leonard M. Cohen) ≈ *Opposite top right:* 15.046 Crane, circa 1840, embroiidery, male. (Provided by David Hugus, photography by John Levin) ≈ *Opposite bottom left:* 15.047 Golden pheasant, circa 1840, embroiidery, male. (Provided by David Hugus, photography by John Levin) ≈ *Opposite bottom right:* 15.048 Peacock, circa 1840, embroidery, male. (Provided by David Hugus, photography by John Levin) ≈ *Left:* 15.049 Golden pheasant, circa 1845, embroiidery, male. (Provided by David Hugus, photography by John Levin)

The other three have the traditional five that would become standard for embroidered squares of this period. These colorful examples show the proliferation of precious objects in the water and an increase in the scale of the objects surrounding the rank bird. There is now only scant room between the birds and the good luck symbols surrounding them. The golden pheasant and the peacock show the beginnings of an expanded use of Peking knot stitch in their precious things and bats.

Example 15.049 and 15.050 are a male golden pheasant and a male egret that show the effects of the ultimate use of Peking knot. Each square is done entirely

◎◎ *Right:* 15.050 Egret, circa 1845, embroidery, male. (Provided by David Hugus, photography by John Levin) ◎◎ *Opposite:* 15.051 Mandarin duck, circa 1845, embroidery with seed pearls, male. (From a private collection)

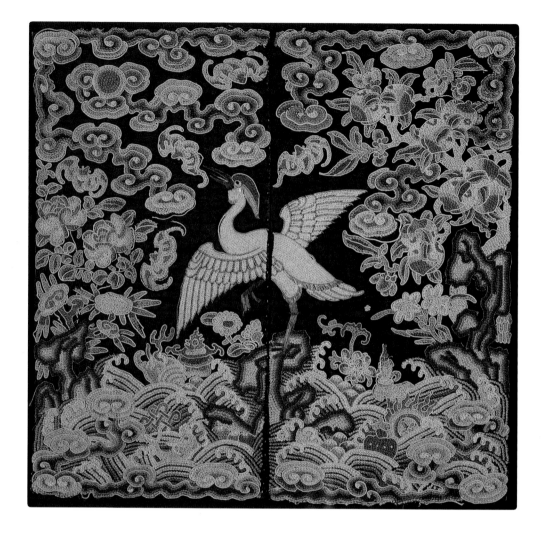

with this technique. They also introduce the Buddhist symbols to the water area. Since these symbols were the next-to-last innovation of the Tao-kung period, we know that these squares were among the last produced during this emperor's time on the throne. The male mandarin duck in 15.051 takes extravagance one step further. Not only is this square embroidered exclusively in Peking knot, but the body of the duck is decorated with seed pearls. The wild goose in 15.052 exemplifies the extent to which designers went to fill every last millimeter of the square. In this example, the small space that had been left to the goose is completely filled with gold scroll work. Example 15.053 is a male silver pheasant

264

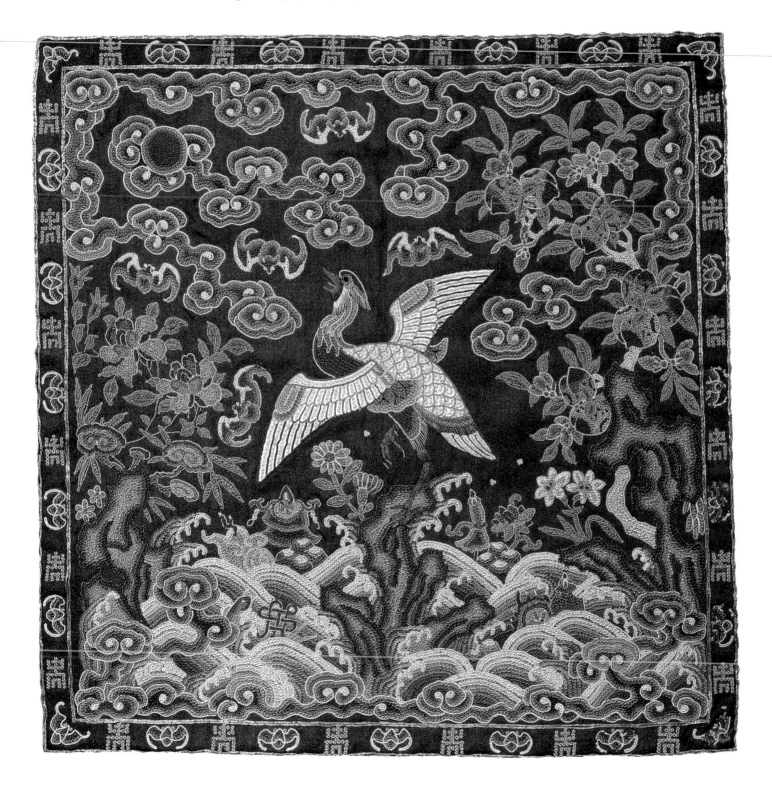

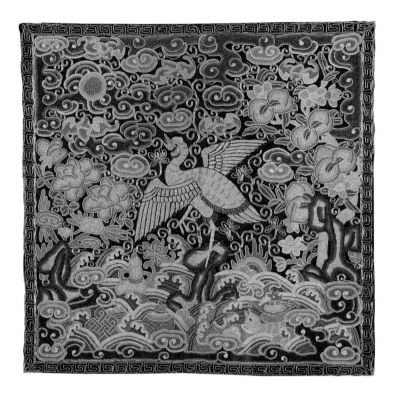
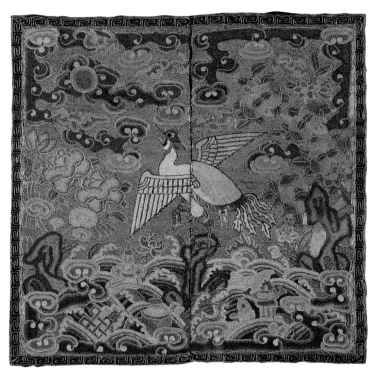
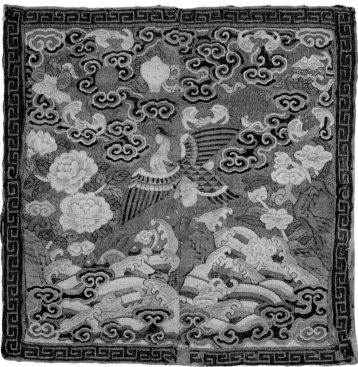
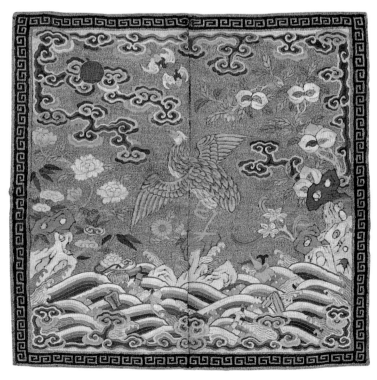

with a gold bullion background. (The apparent shading on the right side of the pheasant's body is a stain, not part of the design.) The male mandarin duck in 15.054 shows how the use of gold extended into the realm of *k'o-suu*. The metallic threads are woven into the square to produce a flashy, extravagant appearance. The silk provides the color for the basic design.

The *k'o-suu* male quail in 15.055 introduces the Taoist Precious Things into the design. The water now contains the symbols of the Eight Immortals, wishing long life to the wearer. This square is also noteworthy because the quail has an unusual crested topknot instead of the typical rounded head. True to the nature of the times, the background is gold bullion thread.

The mid-nineteenth century saw an expansion of the designs used for the borders. The *k'o-suu* male wild goose with a coin and bat border in 15.056 never was accepted as standard. But there was a lot of experimentation with border designs at this time.

Since China had suffered through the Opium Wars and some of their immediate aftermath, this tendency for more elaborate and opulent squares may have reflected a desire on the part of officials, trying to administer a country in increasing disarray, to forget their temporal difficulties by displaying their wealth and position with even greater prominence. It's almost as though they needed to remind themselves that they were important men in a prosperous country in order to compensate for the indignities China had been subjected to by the rest of the world.

In addition to the design changes likely caused by the political uncertainties, the financial situation was destined to have an even more significant effect on mandarin squares. With the drain on the treasury associated with the reparations for the Opium Wars and the loss of revenues due to the T'ai Ping Rebellion, the central government started selling ranks with much greater frequency. Granting the right to wear a mandarin square in return for a substantial monetary contribution for "worthy projects" was established during the Ming Dynasty. But the Chien-lung Emperor was the first to publish a table of prices for the each rank during the late eighteenth century. By the mid-nineteenth century the selling of

◎◎ *Opposite top left:* 15.052 Wild goose, circa 1845, embroiidery, male. (Provided by David Hugus, photography by John Levin) ◎◎ *Opposite top right:* 15.053 Silver pheasant, circa 1845, embroiidery, male. (Provided by David Hugus, photography by John Levin) ◎◎ *Opposite bottom left:* 15.054 Mandarin duck, circa 1845, *k'o-suu*, male. (Provided by David Hugus, photography by John Levin) ◎◎ *Opposite bottom right:* 15.055 Quail, circa 1830, *k'o-suu*, male. (From a private collection)

ranks became widespread. This caused two developments which are reflected in the design and execution of the squares. First, it induced the mass production of squares to accommodate the increased demand. And second, it encouraged the

Right: 15.056 Wild goose, circa 1850, *k'o-suu*, male. (Provided by David Hugus, photography by John Levin) *Opposite:* 15.057 Paired mandarin ducks, after 1850, *k'o-suu.* (Provided by Judith Rutherford, photography by Jackie Dean)

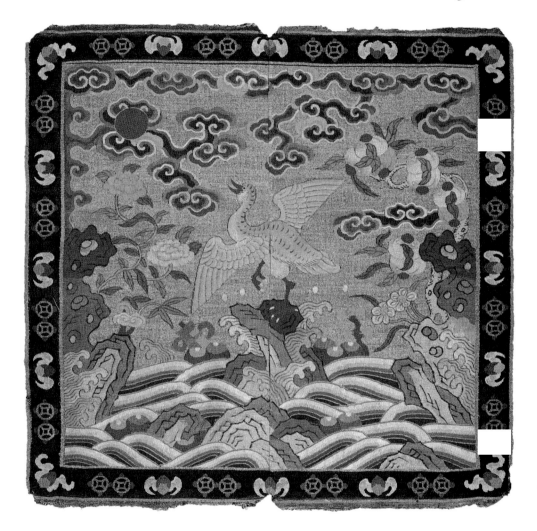

use of pattern books by needleworkers for the quick lay-out of a square. With minor variations, nearly all squares from this period have a sameness that contrasts sharply with those of most previous periods. This standard pattern can be seen in squares from the Tao-kung Emperor's reign.

The Hsien-feng Emperor ascended the throne in 1850. It was about this time that the last change to the linear design that we have been tracing occurred,

the introduction of a border of *li shui* or "deep water" to the bottom of the square. This design was modeled on the depiction of the sea on the hem of court robes where multicolored wavy lines were used to represent the depth of the ocean. This general design was reproduced on squares but without the traditional colors used for robes. This border addition exacerbated the clutter on the squares and even further reduced the space available to the rank creature that should have been the focus of the square in the first place.

Example 15.057 shows an unusually well-matched pair of male and female *k'o-suu* mandarin ducks that include the deep water design feature. While not a matched husband and wife pair, the two squares are remarkably similar in design and execution. Both contain Buddhist symbols in the same color and position. The borders, color scheme and background scroll work are also similar. Since these were not made as a set, the similarity may be attributed to the use of pattern books, as indicated earlier.

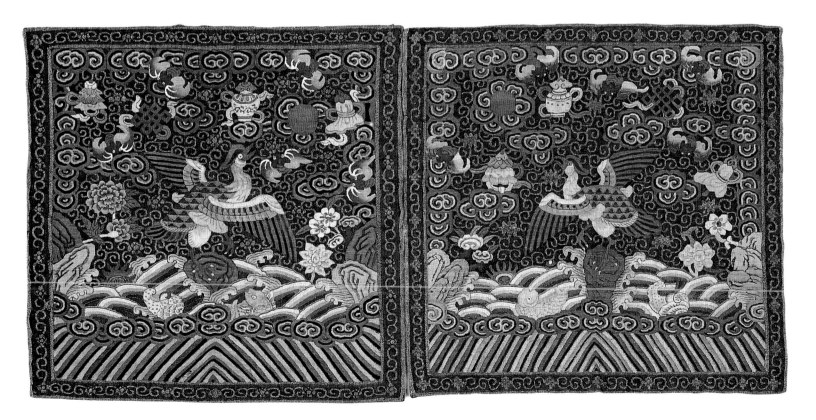

Right: 15.058 Leopard, after 1850, counted stitch on gauze, male. (Provided by David Hugus, photography by John Levin) *Opposite:* 15.059 Empty background, after 1860, emboridery, female. Normally, the background was constructed without a sun. The sun disk would have been added along with the rank bird. (Provided by Corrie Grové, Peninsula Photographics)

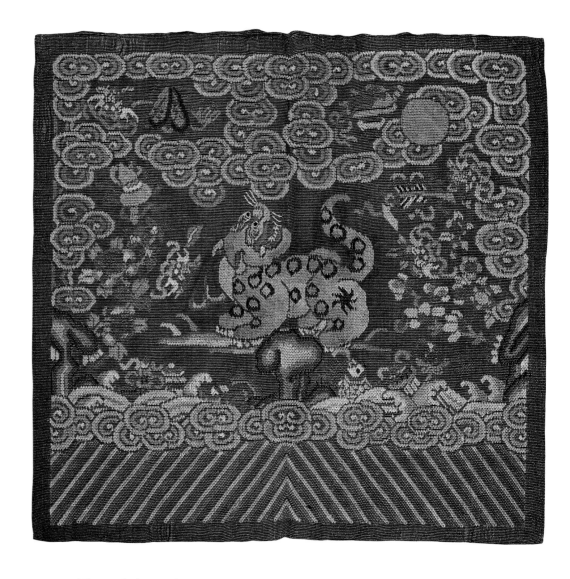

The male leopard square in 15.058 is from this same period decorated with the Taoist symbols that were popular during the mid-1800s. Numerous other examples of the deep water design can be found in Chapters 12 and 13 where the rank creatures are described. See 12.003, 12.004, 12.005, 12.006, 12.009, 12.010, 12.013, 12.019, 12.020, 12.022, 12.024, 12.026, 12.027, 12.029, 12.030, 12.034, and 12.036 for bird squares of this type. 13.002, 13.003, 13.004, 13.005, 13.006, 13.008, 13.009, 13.011, 13.012, 13.015, 13.017, 13.018, 13.020, 13.021, 13.022, 13.023, and 13.024 for similar animal squares.

From about 1850 on it is even more difficult to accurately date a mandarin square. This is because the process lost its coherence and fragmented in a series of different, simultaneous directions. In large measure we can attribute this as a reaction to the prevalent political situation combined with the impact of the standard design that had developed earlier. I believe that there were two primary influences that caused this. One was a direct extension of the systematic selling of civil ranks to augment the government's falling income. As this practice became more widespread, it produced one of the more significant changes in the design and production of mandarin squares. The appliquéd square was the solution for the ever-increasing demand for squares which never were cheap to acquire. Even for a wealthy merchant who could afford to buy his way up the Ladder to the Clouds, it would have been extremely expensive to acquire a whole new wardrobe every time he acquired a new rank. The solution to this problem was the organized production of background squares that lacked a central rank creature along with a series of birds and animals made separately and applied to the background as needed. So when one bought a new rank, it was unnecessary to even replace the square, one merely cut off the now out-of-date rank creature and slapped the new one on the old background.

Example 15.059 is a background "square" waiting for an appliqué bird or animal that would have been worn by a woman. The origin of the circular design of this rank badge will be addressed later. It is representative of the ready-made backgrounds that would have been made separate from any particular rank bird.

The oversized elements that simplified the design became a common feature. Example 15.060 is a set of metallic thread appliqués looking for a square. The upper two are a crane and golden pheasant for a male square; the lower two, a goose and quail for a female square. Matching the background with a separate rank bird would create a square for someone buying his rank.

There is a vast dichotomy among appliquéd squares. Some are executed with care and obvious skill. In fact, from a technical perspective, certain appliquéd squares rank among some of the most excellent work produced during this period. Others were what one might expect when a grandiose display rather than quality was the objective. Elements on some squares became almost caricatures of earlier designs. Backgrounds were reduced to a couple of gigantic symbols, often done in metallic threads. The sky was filled with repetitious cloud formations. They are, to my eye, garish, crude and tasteless. Some squares of this type used metallic thread and colorful couching thread to provide an interesting if somewhat gaudy effect. The metallic thread provided glitter while the couching thread is so dense that it virtually covers and certainly colors the area in which it is used. These flashy pieces, along with their less flamboyant cousins, are not my personal favorites, but do represent a legitimate example of mandarin squares of this period.

The golden pheasant badge in 15.061 was meant to be worn by a lady. It is a colorful, yet well-executed example of the appliqué technique. The metallic

∽∾ *Opposite:* 15.060 Appliqué birds, after 1850, metallic thread, male and female. (Provided by Corrie Grové, Peninsula Photographics) ∽∾ *Above:* 15.061 Golden pheasant, after 1860, embroidery, female. (Provided by Judith Rutherford, photography by Jackie Dean)

273

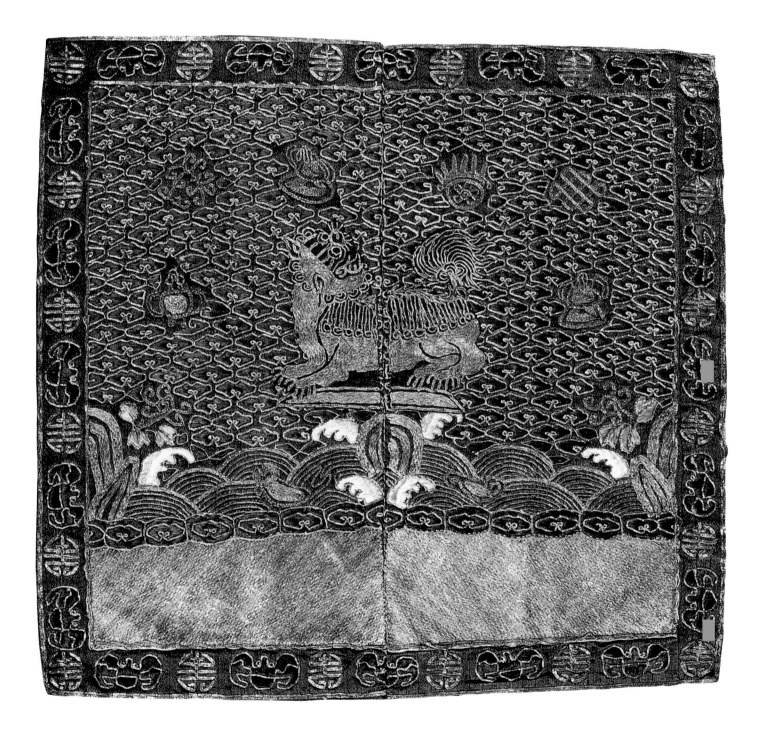

thread lion in 15.062 is representative of the average appliqué square. The background is a repetitive, unimaginative cloud motif with Buddhist symbols in the sky. Example 15.063 is a golden pheasant square for a lady that employs all metallic thread, but a variety of pastel colors for the couching. The cluttered design allows for maximum color and flash while minimizing the importance of the bird. Buddhist symbols add to the good luck the wearer wishes to accumulate.

The second influence that fragmented the design was a desire to differentiate a particular square from all the others that were made in essentially the same pattern. This lead to at least four different approaches which involved the construction of the square itself. One approach was the introduction of the counted stitch on gauze as a more mainstream concept. It also accounted for squares done entirely in Peking knot. And it may explain the increased popularity of woven silk (*k'o-suu* or *kesi*) squares. Many woven silk squares are crude by historical standards, but some are spectacular in their execution. Monochrome brocade badges were also a likely result of this media proliferation.

Another manifestation of this need to differentiate was, ironically enough, the continuation of early nineteenth century designs. This may have been a case of clinging to the "good old days" during a period of unrest and instability. Or it may have been a contrarian attempt to be different by refusing to change while everyone else was frantically trying a new design. Yet another way was a reversion to even earlier designs. One finds the full-circle depiction of waves in the water for the first time since the early eighteenth century. Other squares were copied from Chien-lung designs. This use of early design elements make it difficult to date some of these squares. Even the borders

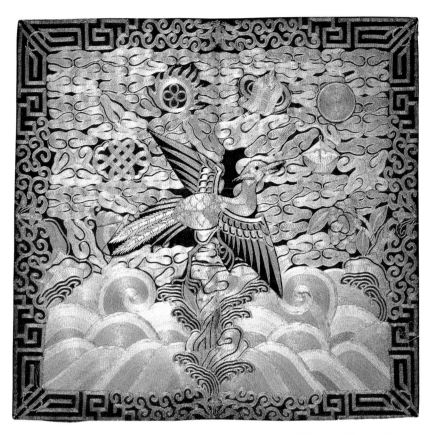

◎◎ *Opposite:* 15.062 Lion, after 1850, metallic thread appliqué, male. (Provided by Gim Fong, photography by Leonard M. Cohen) ◎◎ *Above:* 15.063 Golden pheasant, after 1850, metallic thread appliqué, female. (Provided by David Hugus, photography by John Levin)

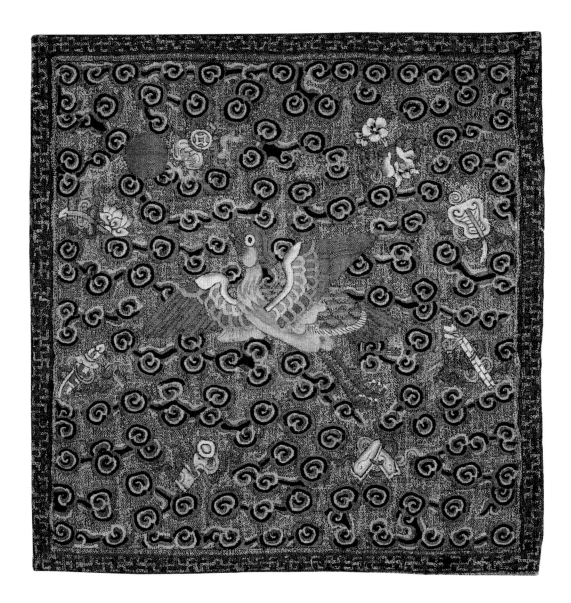

changed with coins, bats, lucky symbols and stylized dragons appearing frequently during this period.

There are three signposts that one can use as a general guide to date squares of this period. The *li shui* water was introduced about 1850. Aniline dyes were introduced from the West in about 1860. Squares with bright purple, green and red must post date this period. Example 15.061 is an excellent example of the colors produced by aniline dyes. And finally there was a radical departure in

276

square design that occurred in 1898, also predicated on the political situation at the time.

It must have been obvious by the late 1800s that the Ch'ing Dynasty and the imperial system were in trouble and losing control over the country. One reaction was an excess of conspicuous consumption and "style over substance" living. The Kuang Hsu Emperor (1875–1908) attempted to bring some reality to this situation by declaring a series of reforms which, while much more extensive than just clothing, also included a directed design for mandarin squares. In these so-called reform period squares, all decoration was supposed to be eliminated and the rank creature was shown against a cloud-filled sky. Only the sun, clouds and rank creature were supposed to be part of the design contained within the square.

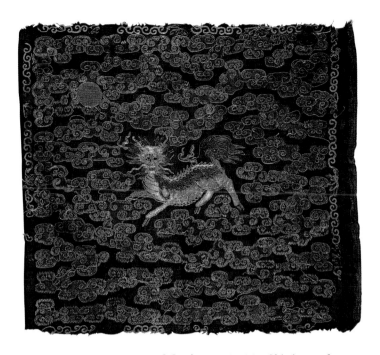

This reform effort was extensive and attempted to eliminate conspicuous consumption and corruption and establish a system of general education for all Chinese. However, this reform period was short-lived because it was opposed by many entrenched interests both at court and in the bureaucracy. The emperor was put under arrest and confined to an island in the Western Park where he died unexpectedly the day before the Dowager Empress Cixi's, demise. It was she who had been the real power behind the throne for many years. The mixed reaction to the reform can be seen by the variations in squares that were supposed to embody simplicity itself. Even plain squares include rebuses, lucky symbols and other elements. However, a square of this type, whether elaborated on or not, could not have occurred before 1898.

Example 15.064 is a male *k'o-suu* mandarin duck from the reform period. Example 15.065 shows a rare reform period *ch'i-lin*. Several other reform period squares were used to describe the birds in chapter 12. See 12.002, 12.007, 12.008, 12.011, 12.012, 12.014, 12.015, 12.017, 12.018, 12.028, 12.035, and 12.038. Animal examples are more limited. The lion in 13.007 is the only other example of a military reform period square.

◎◎ *Above:* 15.065 Ch'i-lin, after 1898, metallic thread on gauze, male. (Provided by Dodu Fromson, photography by John Levin) ◎◎ *Opposite:* 15.064 Mandarin duck, after 1898, *k'o-suu*, male. (Provided by Corrie Grové, photography by Peninsula Photographics)

Using the three guidelines of *li shui* water, aniline dyes and the reform period, one can make an attempt at imposing some order on what must have been a relatively chaotic period for the Chinese.

There was one final evolutionary step that squares took prior to the dissolution of the imperial system. As we will see, there was a distinct difference between badges of rank worn by nobles and imperial officials and those worn by the general bureaucracy. Imperial badges were circular in shape reflecting their close association with the heavens, while common bureaucrats wore squares representing the earth. With the breakdown of imperial authority, this distinction was eroded and finally destroyed.

The process by which this was accomplished is interesting in itself. Usurpation of imperial symbology was not undertaken lightly. The emperor, no matter how weakened, had the authority to put anyone to death on his personal whim. While there were attempts to curtail the random exercise of this despotic authority, he could essentially do as he pleased. Thus, the process of arrogating the ultimate imperial symbol for use by commoners was done gradually. At first, the internal square shape was softened by including a small design in the each corner. This lead to the routine inclusion of something, usually bats or flowers, in the corners which gave a circular appearance to the center of the design. This was followed by the enclosure of the central design with an unambiguous circle of clouds or flowers. The final step was the production of a circular badge of rank (we can hardly call them squares now) with symbols of the bureaucracy displayed. So the bureaucrats were finally able to arrogate to themselves the ultimate symbol of power. But ironically, they could only do so after the emperor was so weakened that neither he nor the imperial system could survive. These circular badges represent the bittersweet accomplishment of being able to use symbology associated with the power of the emperor, only when that power had largely ceased to exist. Circular badges are a clear indicator that the imperial system was about to founder and die.

Example 15.066 represents the tentative start of the circularization process. It is a male wild goose appliqué square. Note the very small flowers in each cor-

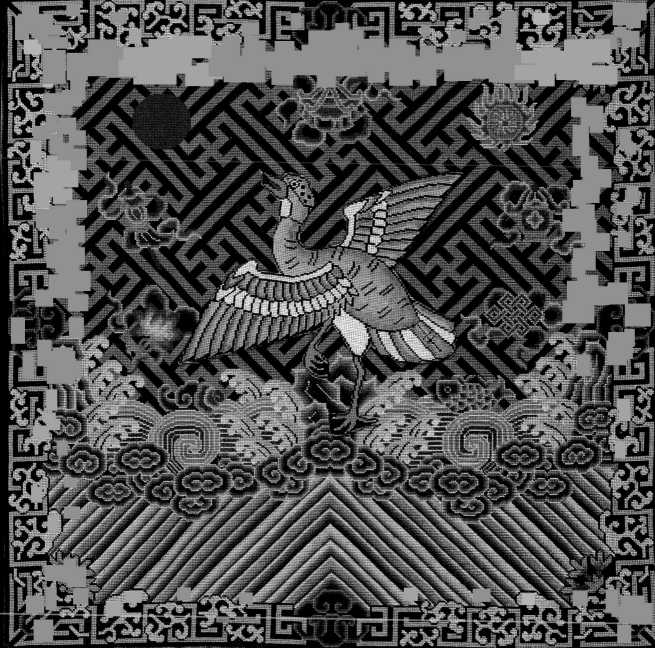

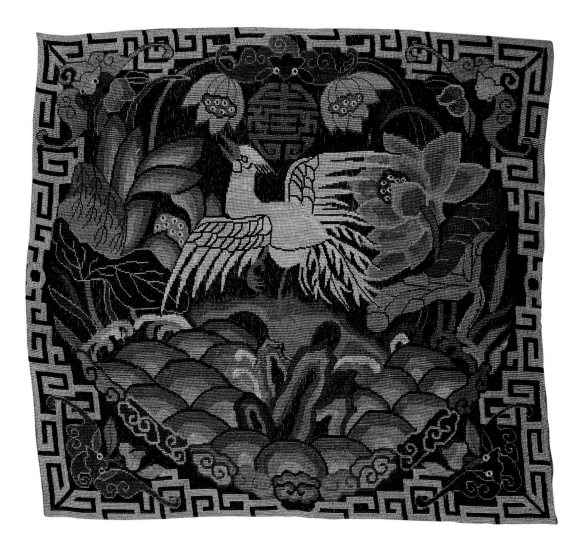

ner. The vivid purples and reds indicate the use of aniline dyes. The extremely stylized dragon border is borrowed from the Ch'ien-lung period. This is a design that was used late in that period (see 15.029).

The silver pheasant in 15.067 takes the process one step further. Note how the border design has been expanded toward the corners on each side to force the interior elements into a circle. The bats have replaced the flowers and grown in size to further constrain the interior. Finally, we have the beginning of a cloud border at the bottom of the square that is starting to define a recognizable circle. The sun disk probably became detached.

280

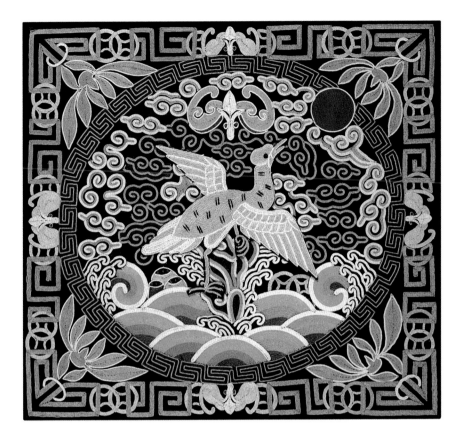

∽∽ *Opposite:* 15.067 Silver pheasant, after 1860, counted stitch on gauze, male. (Provided by David Hugus, photography by John Levin) ∽∽ *Left:* 15.068 Wild goose, after 1860, embroidered appliqué, female. (Provided by Vincent Comer, photography by John Levin) ∽∽ *Above:* 15.069 Silver pheasant, after 1860, embroidered, male. (Provided by Joan Ahrens, photography by Joan Ahrens)

The female wild goose in 15.068 takes us to the penultimate step. It is an uncompromising declaration that the interior of the square is a circle. Flowers in the corners provide the excuse for this form. Example 15.069 is a variation on the same design. However, there are sufficiently unusual elements to recommend its examination. The interior of the circle displays the deep water design. The main components of the background are the three plants known as the Three Plenties: peaches, pomegranates, and Buddha's hand (from left to right). There is a liberal dose of bats for good luck, not only in the background with the pheasant, but also in the four corners and in the border. The lack of a sun disk in an appliqué square can be easily explained by assuming that it has become detached over time. However, the lack of a sun on an embroidered square like this is more difficult to explain. One can only assume that the constraints of the circular design did not leave room for the sun.

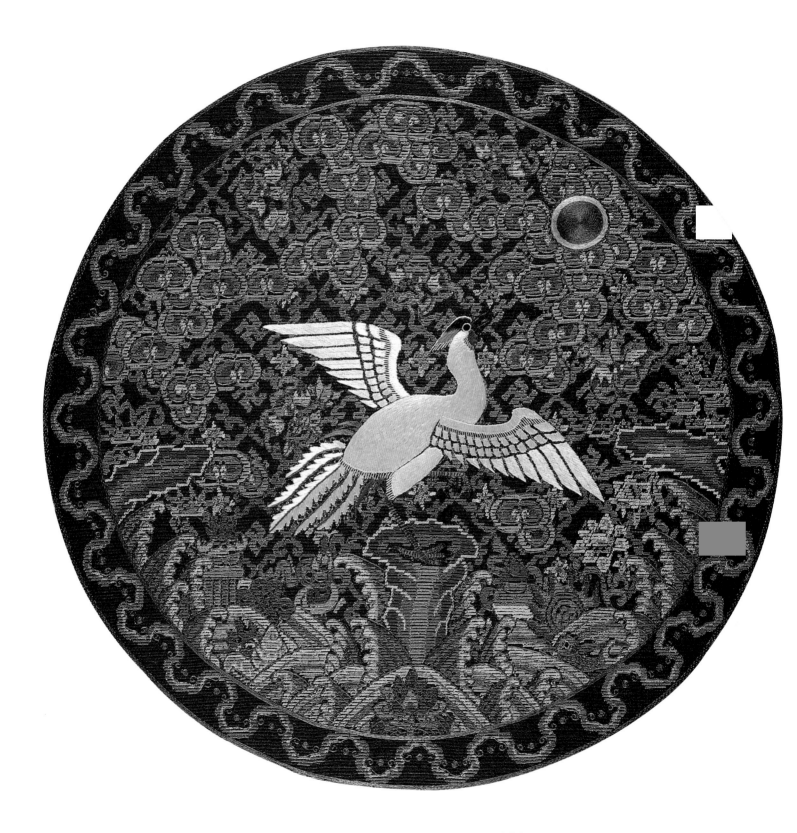

282

Example 15.070 and 15.071 show the badge of rank in its circular form. The embroidered silver pheasant in 15.070 was made for a lady. The composition of the badge is an especially interesting combination of counted stitch on gauze for the background and satin-stitch embroidery for the pheasant. This tends to mute the background and allow the rank bird to stand out in a way that is unusual for a period that seemed to value good luck symbols over the denotation of rank. The border is also unusual. A cursory examination would conclude that the meandering line was meaningless decoration. However, a closer examination reveals that the gold highlights transform the wavy lines into a subtle repetition of the *lungzhi* mushroom shape associated with a desire for longevity.

Example 15.071 is the same style of badge but shows a mandarin duck in the *k'o-suu* medium. It was also designed for a lady. This nicely made badge was really a cry for good fortune. It contains precious things in the water, Taoist longevity symbols in the air and is liberally sprinkled with swastika carrying red bats for an additional measure of luck.

The two rare examples in 15.072 and 15.073 blend the reform period and circularization designs. These are the only two examples of this kind that I have seen. They combine both the sky-only design with the arrogation of the circular form in an unusual and somewhat schizophrenic political

@@ *Opposite:* 15.070 Silver pheasant, after 1860, embroidered, female. (From a private collection) @@ *Below:* 15.071 Mandarin duck, after 1860, *k'o-suu*, female. (By kind premission of Valery Garrett from *Mandarin Squares: Mandarins and their Insignia* by Valery Garrett, Oxford University Press, Hong Kong, Third Impression 1997)

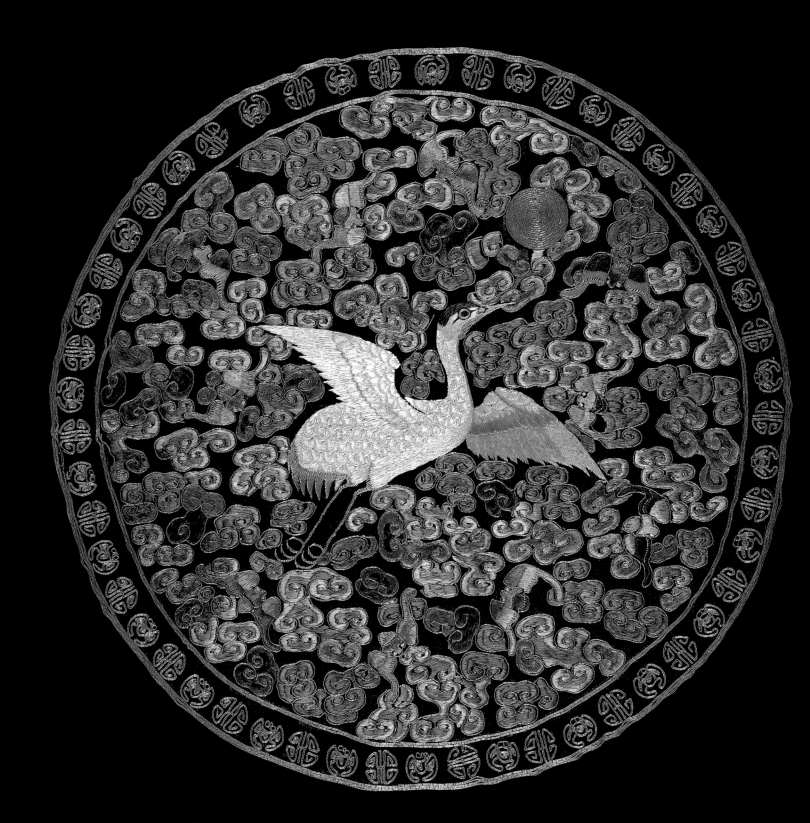

approach to badge making. The reform period aspect declares the wearer's support for the emperor's reforms, while the circular shape proclaims that the emperor is powerless—an unusual combination of messages. The bats in the female crane badge 15.072 suggest that some people could not bring themselves to adopt the true reform style. In several reform period squares ancillary symbology appear, possibly because the need to add some extra good luck to the square was too overpowering to resist. Note the unusual quail-like tail feathers on this crane. Example 15.073 is a more conventional version of this unusual design. Here the reform period style is unmodified by any ancillary motifs. The female silver pheasant of this design is alone in the cloud-filled sky.

It might be reasonable to expect that the subject of imperial rank badges would end with the overthrow of the imperial system, but reality differs from reasonable expectations. Yuan Shih-k'ai, the first president of the Chinese republic, was not totally immune to the trappings of power that the emperor had enjoyed. Shortly after his installation as president, he announced that he would maintain the traditional seasonal sacrifices with himself playing the same part that the former emperors had on these occasions. He designed, or had designed, an official robe for such occasions. In an attempt to maintain some of the symbology associated with the Sons of Heaven, the decoration

〜 *Opposite:* 15.072 Crane, after 1898, embroidered, female. (Provided by Vincent Comer, photography by John Levin) 〜 *Below:* 15.073 Silver pheasant, after 1898, counted stitch on gauze, female. (Provided by David Hugus, photography by John Levin)

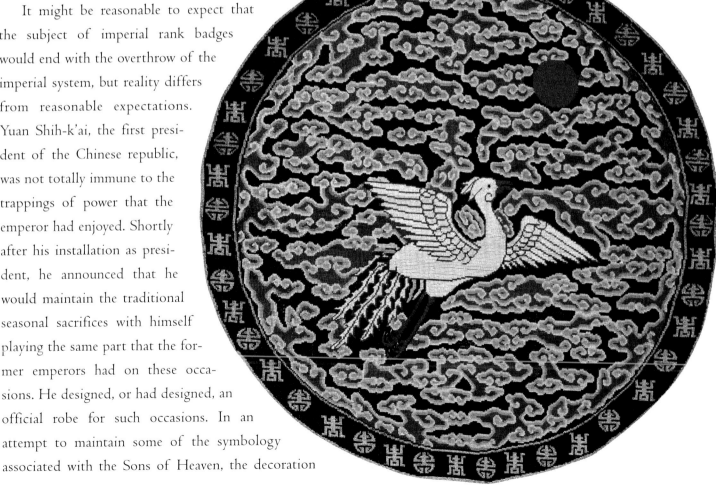

◎◎ *Below:* 15.074 Republican badge—nine symbols, after 1911, embroidery. (From a private collection) ◎◎ *Opposite:* 15.075 Republican badge—nine symbols, after 1911, embroidery. (From a private collection)

on this robe was composed of twelve circles containing all twelve of the traditional symbols of sovereignty: dragons, the moon, the sun, a mountain, a constellation, libation cups, fire, the water weed, a plate of gain, *fu*, an axe, and a pheasant. Lesser officials were to wear robes with fewer circles and fewer symbols in each circle. As one might guess, these attempts at maintaining the appearance of imperial power in a group of people who had been dedicated to the removal of the emperor did not go over well. Although the idea was largely stillborn, a small numbr of the medallions made for this purpose are still in circulation. Example 15.074 is a nine-symbol badge meant to be worn by a high official. Example 15.075 is an unusual execution of a nine-symbol badge. Its primary difference is that the bird, which symbolized all winged creatures ruled by the Chinese emperor, is a paradise flycatcher, rather then the typical golden pheasant (see other republican badges for comparison). Dots on the tail feathers and the more rounded head make this classification rather unambiguous. However, it's not even an accurate paradise flycatcher because it has three dots per tail feather rather than the more typical one dot per tail feather. Example 15.076 is a seven-symbol badge. It departs from the typical in that the usual number libation of cups at the top have been reduced to a single cup with both the tiger and monkey designs. Example 15.077 is a five-symbol badge designed for a lower ranking member of the government.

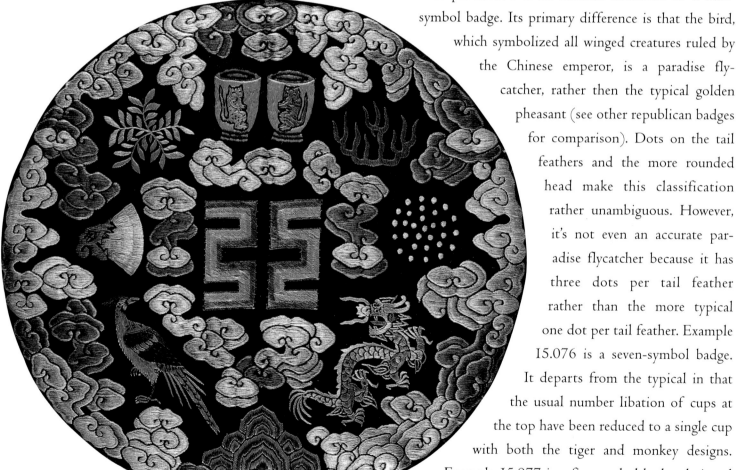

286

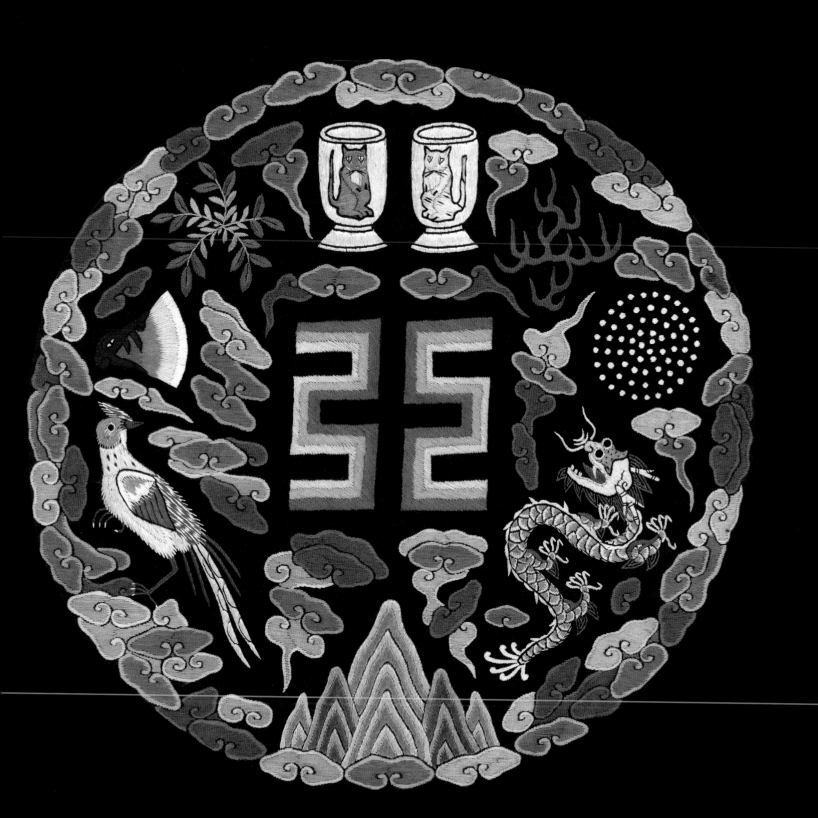

Below: 15.076 Republican badge—seven symbols, after 1911, embroidery. (From a private collection) *Opposite:* 15.077 Republican badge—five symbols, after 1911, embroidery. (Provided by Beverley Jackson, photography by Kevin Delahay)

There were three other classes of "badges" that fell outside the system of the official rank insignia. One was a four-character badge that read "conferred by imperial grace." This may have been the gift that is mentioned in Ch'ing records that was occasionally bestowed by the emperor upon men without rank, but of great age. Unfortunately, no record specifically identifies the nature of the gift.

A second class of "badges" were presented to officials upon their departure or retirement from a station. There was no set form or content for these badges, but they typically had some favorable comment or wish for good luck. The writing sometimes included the name of the person to whom the badge was presented and the date of presentation.

Finally, there were the burial "badges." Since the crane was associated with long life and immortality, it was a common motif at funerals. It was customary for male commoners to be buried wearing a robe with a crane badge. However, the badge was not allowed to look so similar to a real mandarin square that it could be mistaken for an official insignia. To insure this differentiation, these badges were done on red silk. Female commoners could wear the traditional phoenix badge on black silk because the phoenix was not a rank creature in the Ch'ing Dynasty.

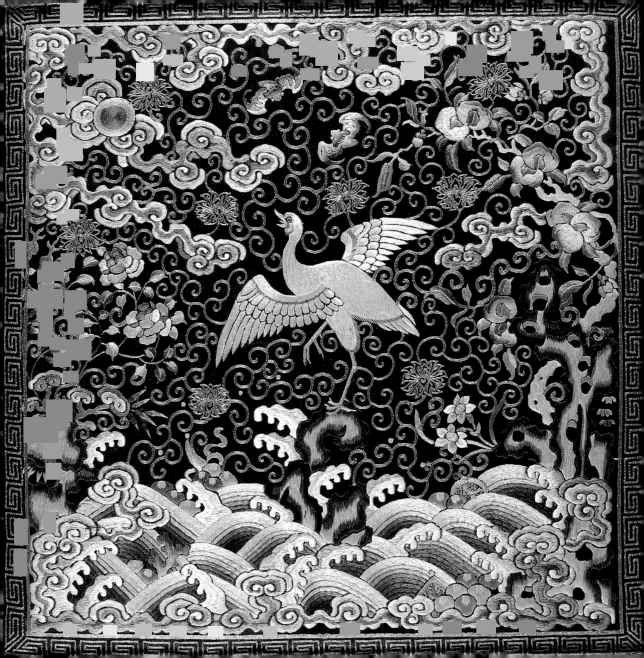

CHAPTER 16

DECEPTIVE AND NOBLES' BADGES

At various points throughout our discussion of mandarin squares, I have alluded to and pointed out some examples that were designed to mislead the observers. While subtle efforts to deceive were common-place, there are only a few clear cases where this effort has been blatant. Several of these rare examples are collected here.

The wild goose in 16.001 is from about 1830. As you can see there are some significant departures from the standard depiction of a goose. Made to look more like a crane, its body is white, rather than the yellow or mustard color nor-mally associated with the goose. It lacks the comma marks used to represent feathers on the body and neck. I believe that the wearer hoped a quick glance at his square would reveal only a white bird with a rounded head and thus cause the observer to conclude he had seen a crane instead of a goose.

Example 16.002 is a Ch'ien-lung badge of the same technique, except that here the wearer's intention was even more blatant. In addition to coloring his bird white and removing the telltale feather markings, a small red hemisphere was added above the goose's beak. While this spot of color is, on close examination, not where a crane's red topknot would be, the presence of this color on the goose's head is clearly there only to deceive. This square is remarkable in one other aspect. It is was created entirely in counted stitch on gauze, a technique that was very unusual during this period.

⊚⊚ *Opposite:* 16.001 Wild goose, circa 1830, embroidery, male. (From a private collection)

291

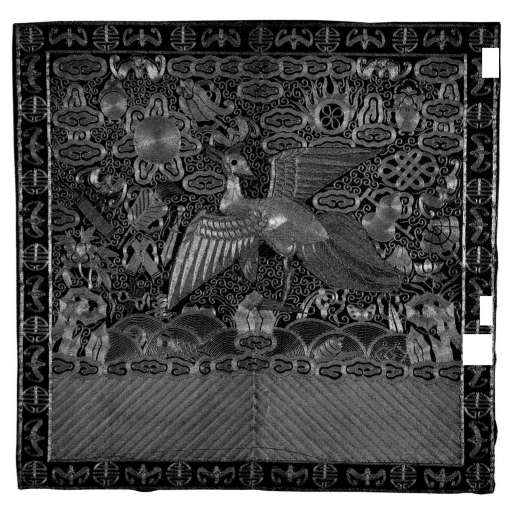

◎◎ *Above:* 16.002 Wild goose, mid-Ch'ien-lung, counted stitch on gauze, male. (Provided by David Hugus, photography by John Levin) ◎◎ *Right:* 16.003 Paradise flycatcher, after 1850, metallic thread on silk, male. (Provided by Corrie Grové, Peninsula Photographics) ◎◎ *Opposite:* 16.004 Paradise flycatcher, Yongzheng (1722–1735), embroidery, female. (Provided by Judith Rutherford, photography by Jackie Dean)

The paradise flycatcher in 16.003 is from the mid-nineteenth century. While it has properly represented its two tail feathers with the single dot, it has also enclosed them in a band of color that is designed to make its tail look larger and more like a silver pheasant's. The exaggerated side feathers add to the deception.

Example 16.004 is a very rare and wonderful Yongzheng square also showing a deceptive paradise flycatcher. The dot on the bird's crested head is proper. However, the edges of the "dot" have been rendered in a jagged fashion to try to incorporate its outline into the overall design of the crest and so disguise its true nature. Also, each of the tail feathers is properly represented, narrow at the base,

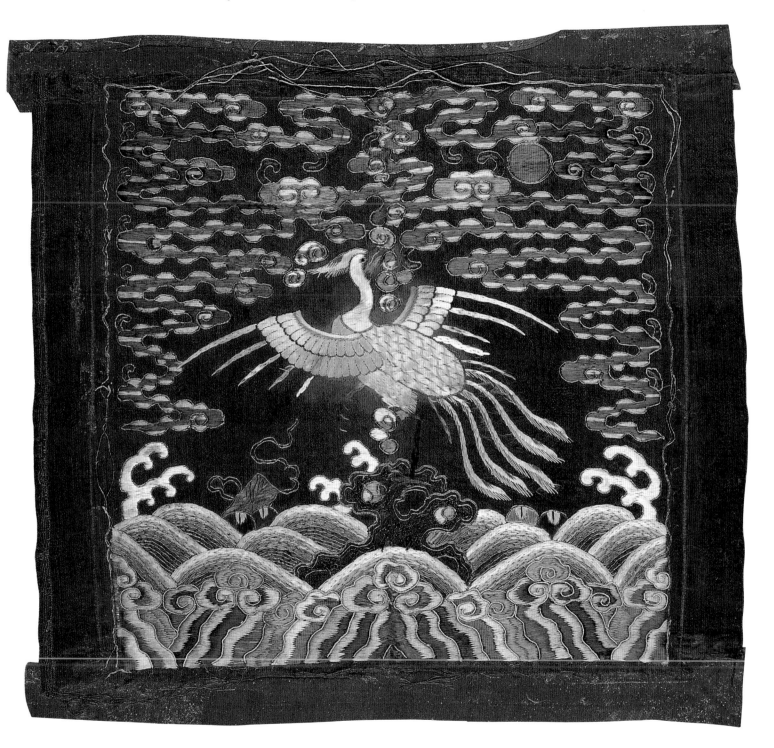

293

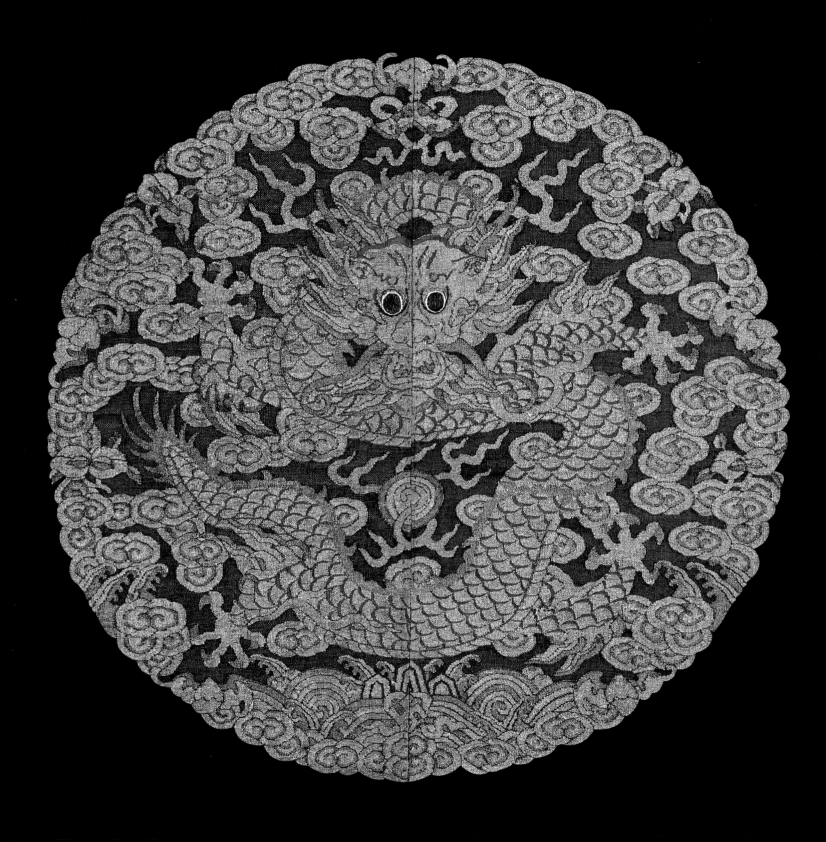

larger at the end, with a dot of blue at the tip. But there are three additional feathers to encourage the observer to see the higher ranking, five-tail-feathered silver pheasant.

Since this book focuses on the Chinese bureaucracy, it has, up to this point, addressed imperial and noble insignia only by reference. There were three types of badges worn by the nobility. The imperial badges worn by members of the emperor's household, the badges worn by men of noble birth and those worn by men who earned their nobility by service. Imperial badges were largely decorated with dragons, since dragons were closely associated with the emperor. The dragons in Chinese iconography are composite creatures with borrowed parts from nine different animals, including a deer's antlers, a camel's head, a devil's eyes, a snake's neck, a clam's (or sea monster's) belly, a carp's scales, an eagle's talons, a tiger's paws, and an ox's ears. It was supposed to have 9 x 9 or 81 scales. The number nine was closely associated with heaven and, hence, with the emperor. Dragons came in four grades depending on their posture and the number of claws on each limb. Five-clawed dragons (called *lung*) outranked four-clawed dragons (called *mang*), and front-facing dragons (called dragons of heaven) outranked profile or walking dragons. So the highest ranking dragon was a five-clawed dragon of heaven, followed by a four-clawed dragon of heaven, trailed by the five- and four-clawed walking dragon.

∽∽ *Opposite:* 16.005 Five-clawed dragon of heaven roundel. (From a private collection) ∽∽ *Below:* 16.006 Five-clawed walking dragon. (Provided by David Hugus, photography by John Levin)

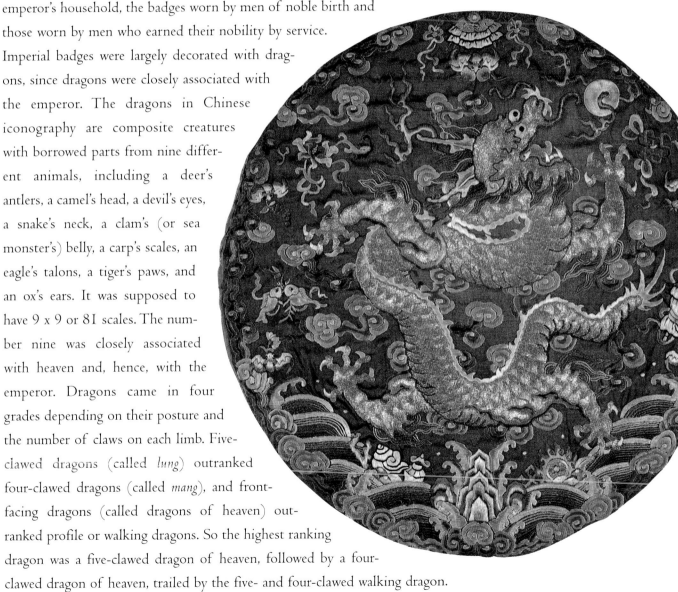

◎◎ *Below:* 16.007 Ch'i-lin noble's circle badge. (Provided by David Hugus, photography by John Levin)
◎◎ *Opposite:* 16.008 Five-clawed dragon of heaven, noble's rank badge, female. (From a private collection)

Example 16.005 is a five-clawed dragon of heaven. This would have been worn by a very high-ranking member of the imperial household, probably a member of the emperor's immediate family. It lacks one of the twelve symbols of sovereignty that would have been included had it been worn by the emperor himself. Example 16.006 is a four-clawed profile or walking dragon. This type of badge would have been worn by a low ranking prince. Example 16.007 is a very rare *k'o-suu ch'i-lin* badge done in the circular design. This would have been worn by a member of the imperial household, but by a person who was not closely enough related to the emperor to wear a dragon badge. The prince who wore this would have been outranked by the person who wore either of the dragon badges shown above. Example 16.008 is a female noble's badge. It is unusual for a noble's badge to have a sun disk so it must have been worn by the wife of a person who was a noble by appointment. This is reinforced by its square shape. A hereditary noble would have been courting death to "point at the sun and rise high" because the only way for him to do so was to replace the emperor.

A final category of squares deserves at least a mention. Although children were, by regulation, required to wear the costume of their father, this rule specifically prohibited the wearing of either a hat knob or rank square. Like all regulations toward the end of the Ch'ing Dynasty, this prohibition was largely ignored. Therefore,

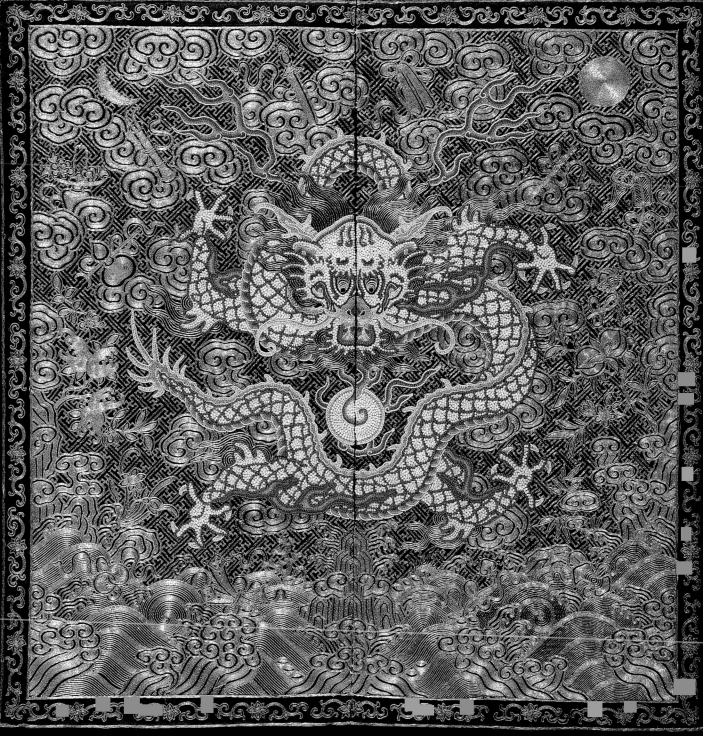

squares actually worn by children do exist. The most obvious difference between a child's badge and an adult's was size. Since the sizes of the images in this book have no relationship to the actual size of the squares, differences will be hard to identify here. A child's square could vary quite a bit in size, depending on the age of the child who wore it. The only other key to identifying children's squares lies in the quality of the workmanship. Since children are notorious for quickly outgrowing their clothes, the squares made for children tend to be of a lower quality than the average adult square. The embroidered appliqué paradise flycatcher square in 16.009 was made for a male child.

Right: 16.009 Paradise flycatcher, after 1870, embroidery, child. (Provided by David Hugus, photography by John Levin)

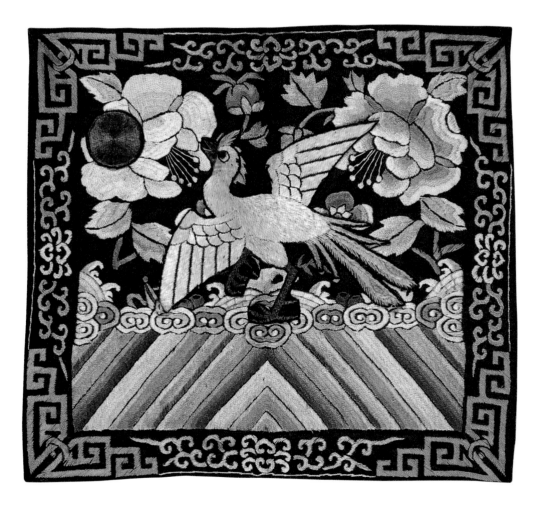

Left: Prince Tsai Hsun, brother of the Emperor Kuang Hsu, wears an imperial dragon rondel. He headed the Chinese Navy's mission to Europe. (From *China Under the Empress Dowager* by J.O.P. Bland and E. Backhouse, William Heinemann, London, 1908)

Bibliography

Bartholomew, Terese Tse. *Myths and Rebuses in Chinese Art.* San Francisco: Asian Art Museum of San Francisco: 1988.

Cammann, Schuyler. "Notes on the Development of Mandarin Square—Some Newly Discovered Ming Textiles." *The Bulletin of the Needle and Bobbin Club,* Vol 26, No 1 (1942): pages 2–28.

Cammann, Schuyler. "Development of the Mandarin Square." *The Harvard Journal of Asiatic Studies.* Vol VIII, no 2 (1944): pages 71–130.

Cammann, Schuyler. "Notes on the Origin of Chinese Kesi Tapestry." *Artibus Asiae.* Vol XI (1948): pages 90–110.

Cammann, Schuyler. *China's Dragon Robes.* New York: The Roland Press Company, 1952.

Cammann, Schuyler. "Chinese Mandarin Squares, Brief Catalogue of the Letcher Collection." *The University Museum Bulletin* Vol 17, No 3 (June 1953): pages 5–73.

Cammann, Schuyler. "Old Chinese Badges of Rank." *Hobbies- The Magazine for Collectors* Vol LIX no. 5 (July 1954): pages 56–7 & 60.

Cammann, Schuyler. "Embroidery Techniques In Old China." *Archives of the Chinese Art Society of America* Vol XVI (1972): pages 16–39.

Cammann, Schuyler. "Ming Mandarin Squares." *Textile Museum Journal* Vol IV, no 4 (1977): pages 5–14.

Cammann, Schuyler V. R. "Birds and Animals as Ming and Ch'ing Badges of Rank." *Arts of Asia* (May-June 1991): pages 88–94.

Chong, Douglas D. L. *Reflections of Time, A Chronology of Chinese Fashions in Hawaii.* Honolulu: Hawaii Chinese History Center, 1976.

Coleman, Teresa. *Dragons and Silk from the Forbidden City.* Hong Kong: The Guidebook Company, 1998.

Crouwel, Wlm. *The Forbidden City.* Rotterdam: Museum Boymans-van Beuningen Rotterdam, 1991.

Dawson, Miles Menander. *The Basic Teachings of Confucius.* New York: The New Home Library, 1942.

Dickinson, Gary and Wrigglesworth, Linda. *Imperial Wardrobe.* London: Bamboo Publishing Ltd., 1990. pages 120–142.

Eberhard, Wolfram. *A Dictionary of Chinese Symbols, Hidden Symbols in Chinese Life and Thought.* London: Routledge & Kegan Paul Ltd., 1986.

Eberhard, Wolfram. *Chinese Festivals.* New York: Henry Schuman, 1952.

Finlay, John R. "Chinese Embroidered Mandarin Squares from the Schuyler V. R. Cammann Collection." *Orientations* Vol. 25, no. 9 (September 1994): pages 57–63.

Fu, Chunjiang. *Origins of Chinese Festivals.* Singapore: Asiapac Books PTE, LTD, 1997.

Garrett, Valery M.,. *Mandarin Squares.* Hong Kong: Oxford University Press, 1990.

Hucker, Charles O. *A Dictionary of Official Titles in Imperial China.* University of Stanford Press, 1985.

Hucker, Charles O. *The Traditional Chinese State in Ming Times (1368–1644).* University of Arizona Press, 1978.

Latsch, Marie-Luise. *Traditional Chinese Festivals.* Singapore: Graham Brash (pte) ltd, 1988.

Luk, Bernard. "The Civil Service Examinations in Late Imperial China," *Orientations* Vol 13, no. 3 (March 1982): pages 20–29.

Martin, W. A. P (William Alexander Parsons). *The Lore of Cathay or The Intellect of China.* Fleming H. Rowell Company, 1901.

Marsh, Robert M.. *The Mandarins, The Circulation of Elites in China, 1600–1900.* New York: The Free Press of Glencoe, 1961.

Miyazaki, Ichisada. *China's Examination Hell: The Civil Service Examinations of Imperial China.* New York: John Weatherhill, Inc., 1976.

Pang, Dr. Mae Anna. *Dragon Emperor: Treasures from the Forbidden City.* Melbourne: National Gallery of Victoria, 1988.

Rutherford, Judith and Valerie. "Manchu Badges of Rank." *Australian Collectors' Quarterly* (May/June/July 1992): pages 52–7.

Rutherford, Judith. "Dragons Symbolism and Rank in Chinese Costumes." *Antipodes* no.1 (1997): pages 77–83.

Thorp, Robert L. *Son of Heaven, Imperial Arts of China.* Seattle: Son of Heaven Press, 1988. pages 72–87.

Vollmer, John E. *Five Colors of the Universe, Symbolism in Clothes and Fabrics of the Ch'ing Dynasty (1644–1911).* Edmonton: The Edmonton Art Gallery, 1980.

Vollmer, John E. *Decoding Dragons: Status Garments in the Ch'ing Dynasty China.* Eugene, Oregon: University of Oregon, 1983.

Williams, C. A. S. *Outlines of Chinese Symbolism & Art Motives.* New York: Dover Publications, Inc., 1976.

Williams, Edward Thomas. *A Short History of China.* New York: Harper & Brothers, 1928.

Wrigglesworth, Linda. *The Badge of Rank II, China.* London: an exhibition presented 27 November—20 December 1991.

Wrigglesworth, Linda. *"Making the Grade" The Badge of Rank III.* Hong Kong: a catalog, 1996.

Yale University. *"At the Dragon Court: Chinese Embroidered Mandarin Squares from the Schuyler V. R. Cammann Collection."* New Haven, Connnecticut: Yale University Art Gallery, 1993.

Index

൞ᗡ *Above:* American postcard showing a mother and her baby. Note that even immigrant Chinese dressed their young children to ward off evil spirits. (From the collection of Beverley Jackson)

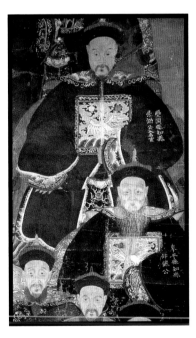

❧❧ Detail of an ancestor painting showing several generations of one family. (From the collection of Joan Ahrens)

French postcard showing a first rank civil official wearing his crane square. (From the collection of Beverley Jackson)